VOLUME 4

DIGITAL PAINTING
techniques

VOLUME 4

DIGITAL PAINTING
techniques

3dtotal PUBLISHING

3DTOTAL PUBLISHING

Correspondence: publishing@3dtotal.com

Website: www.3dtotalpublishing.com

First published in the United Kingdom, 2012, by 3DTotal Publishing

Softcover ISBN: 978-0-9568171-2-9

Printing & Binding: Everbest Printing (China)
www.everbest.com

Visit www.3dtotalpublishing.com for a complete list of available book titles.

IMAGE CREATED FOR EVERMOTION VFX

VOLUME 4

DIGITAL PAINTING
techniques

INTRODUCTION

Art is influential around the globe. Within every city of every country you will find at least one person who has an interest in art or who has creative flair. Each one of these potential artists will explore the opportunities available to them, and test out different media and tools until they decide how they would like to express their creativity. What you have in your hands now is a stunning collection of imagery and tutorials, created by artists who have made their choice, and have been kind enough to demonstrate and explain their digital painting techniques. Behind every successful game or movie is a talented team of digital artists, and each and every one of these artists will have practiced and tested their process countless times, in order to become efficient and flexible when creating pre-production art. To truly master this process takes time, effort and talent.

For many artists the only way to reach this level of proficiency is to spend a lot of time in front of a screen, painting and experimenting until they find the process that suits them. Once they have achieved this, they will then need to work out how to manipulate that process to meet the demands of any future projects.

Imagine how much easier it would be for those artists learning their trade to be handed a catalog of techniques and inspiration to help them perfect their methods. Regardless of whether you are a novice or an experienced digital painter, over the 288 pages in this book

COMPILED BY THE 3DTOTAL PUBLISHING TEAM

TOM GREENWAY	SIMON MORSE	CHRIS PERRINS	RICHARD TILBURY	JO HARGREAVES

you will find ways to develop your process, save yourself time, create new brushes or even take the initial steps towards creating your first digital illustration.

Digital Painting Techniques: Volume 4 boasts an unparalleled collection of tutorials that cover subjects from pin-ups and cartoon art, to sci-fi

droids and vehicles. If you are a digital painter, or would like to be, this book is a must-have resource and a font of inspiration, and will open doors and give you the foundation you need to progress in your own artistic endeavors.

SIMON MORSE
CONTENT MANAGER, 3DTOTAL

Free Resources

Some of our *Digital Painting Techniques* custom brush tutorial artists have kindly supplied, where appropriate, the brushes to accompany their tutorials for you to download to use along with their teachings.

All you need to do to access these free resources is to visit: **www.3dtotalpublishing. com**. Go to the "Resources" section and there you will find information about how to download the files. Simply look out for the "Free Resources" logo that appears on articles within this book where there are files for you to download.

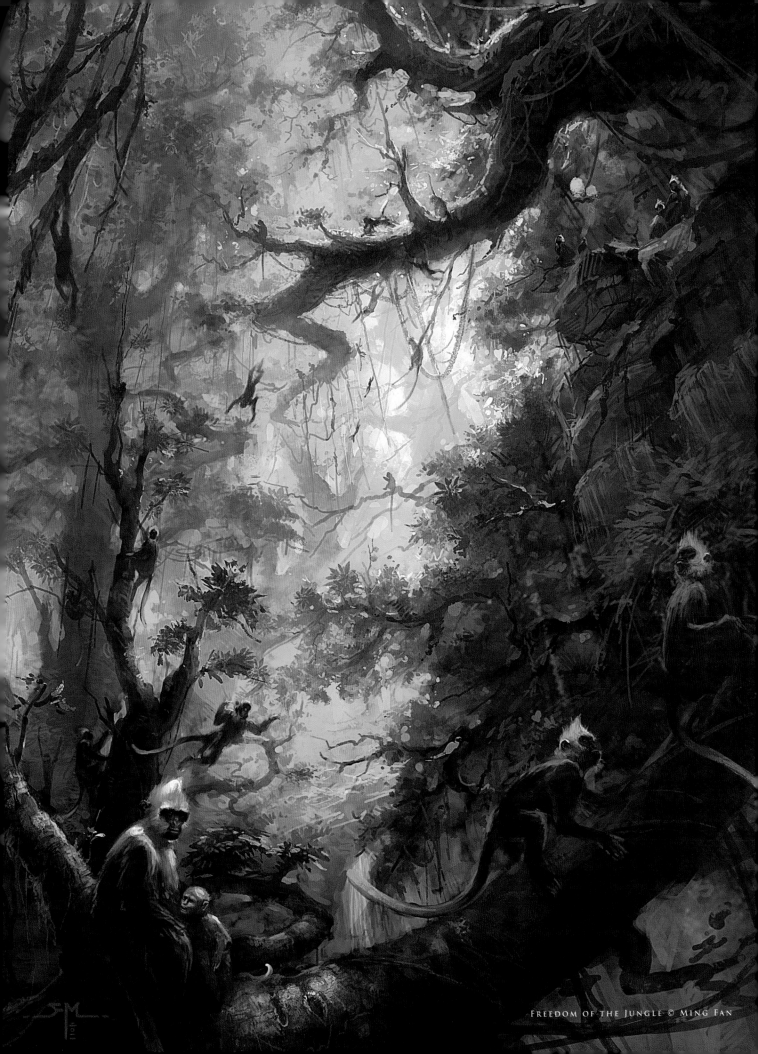

Freedom of the Jungle © Ming Fan

chapter 1 | SUBJECTS

Choosing a subject for your painting can be tricky. You can spend hours, possibly days, thinking about what you'd like to paint, and when you finally settle on a topic you still need to go through the even harder process of painting it. Taking a subject and turning it into a stunning concept or illustration is no easy task, but in the following pages the artists will demonstrate a plethora of techniques that you can adapt to your own artistic practice. Characters, environments and vehicles are all topics that feature in this diverse and inspiring section, which is primed to add direction to your workflow and help you create your own jaw-dropping images.

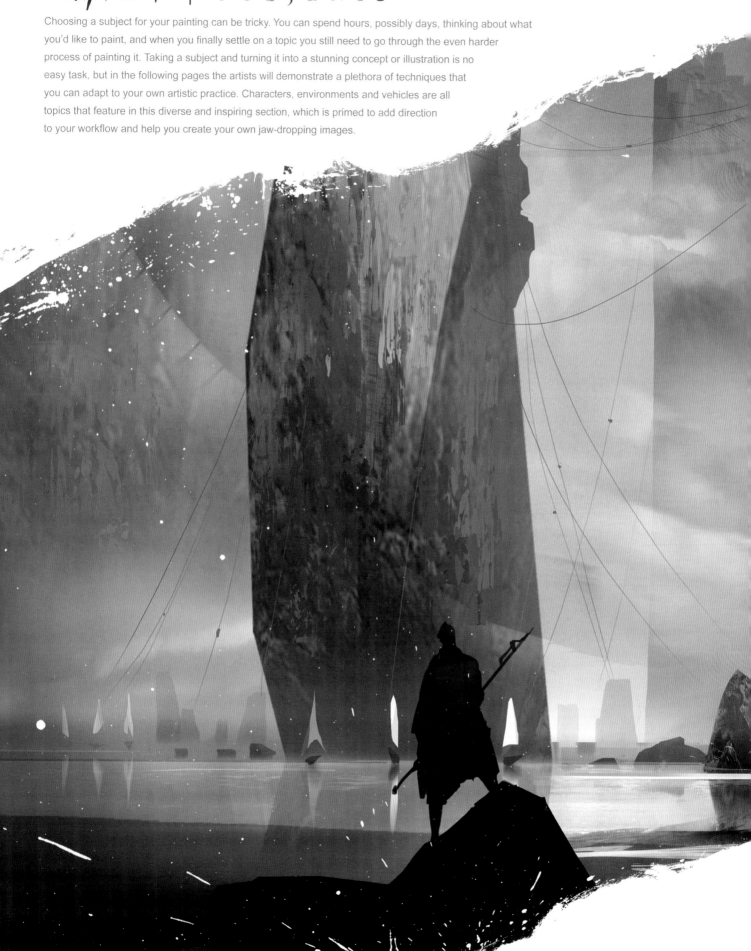

NATIVE AMERICAN
BY BRANKO BISTROVIC

INTRODUCTION

It's always a tricky thing, depicting historical stereotypes when character designing. How much accuracy do I lend to the concept? Do I make it entirely historical or do I suspend some of it for artistic liberty so that I can render something I think is more engaging instead? You also have to consider what might be offensive, as the wrong depiction could cause some headaches. The last time I checked, few people like headaches.

The motif of the Native American warrior has been part of Western culture for dozens of decades now, and has had its own road of evolution. Initially thought of simply as a wild savage, today's Native American warrior is still considered a brutal fighter, but also one of honor and wisdom. They also have a connection to the land they live in and its wildlife. They are more like introverted survivors than savages.

REFERENCE

Let's see if I can do the subject matter justice. As with any historical subject it's important to start with plenty of references! Search for pictures online of course, but don't neglect

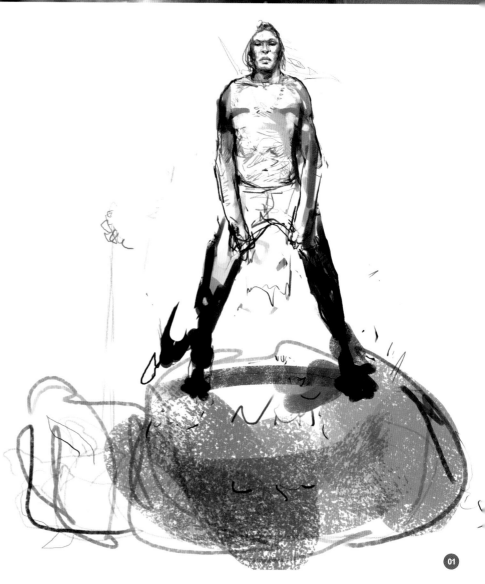

01

books on the subject. They allow for a more concise breath of knowledge since they're usually accompanied by captions or full-on explanations. Also look at films and documentaries. These are the best bet if you want to stay accurate, but if you're looking for something a little more fantastical then a good epic drama on the subject matter will help too. Anyway, on to the piece!

THE PAINTING

I generally like to start off loose so this sketch, although quick and dirty, was actually more focused than usual (**Fig.01**). At this stage I tried to capture the posture and the attitude of the warrior. I also considered composition, but since I knew that I was going to be changing it soon, I wasn't too concerned with it just yet. I sketched this out in Photoshop and simply used a hard round brush with Size Jitter set to Pressure (under the Shape Dynamics options).

I also attempted another, more dynamic, pose. I'll never know if it would have worked out better; it might very well have, but I already had an idea forming in my head with the former sketch and kind of wanted to see it through (**Fig.02**).

This is not the best way to go about starting a piece, at least from my experience. Usually, if your character is going to encompass a full scene – background and all – it's best to establish the dominant colors and lights in the scene first. This means that one should start with the background and then work on the character, as this way some of the background colors can naturally bleed through the colors of the character, grounding them in the piece. Yes, going about this image in the way I did resulted in some delightful hair tearing down the line when I tried to get the warrior to fit properly.

Speaking of the warrior, as you can see, I worked up some volume and an early indication of his skin tone (**Fig.03**). I was mainly still focusing on his posture though. I was imagining a scene in which he's just killed a buffalo and he's standing on his kill. I didn't want him to look arrogant, just raw, if that

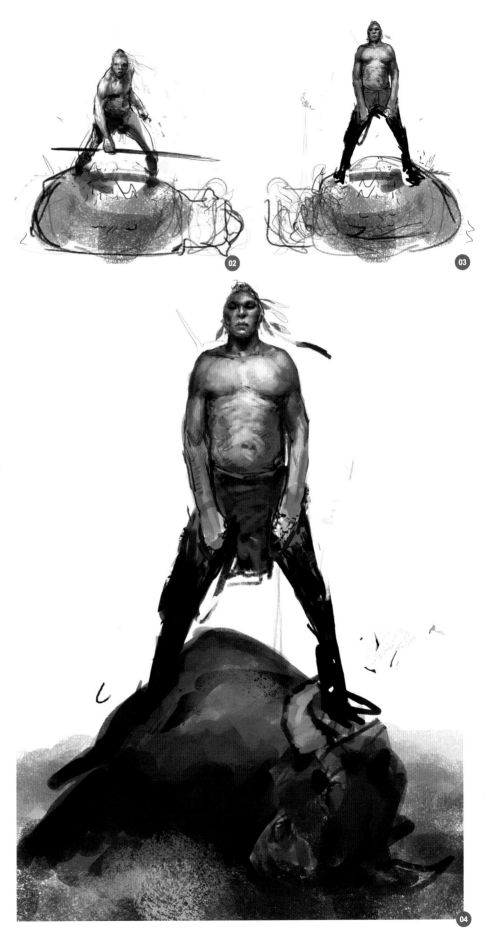

makes any sense. Kind of like, this is who he is and this is his environment.

There was something that wasn't quite working at this stage, but regardless of this feeling I moved on to quickly sketch out the buffalo and planted both of them on a surface (**Fig.04**). I used some warmer colors on the buffalo's coat, although I wasn't sure this was the best idea as the buffalo was supposed to be reading as dead and therefore shouldn't feel warmer than the warrior's flesh. I went for some vignetting here to add some drama to the scene. To paint the grass I used a hard-edged round brush, with the Dual Brush option clicked. I then bounced around the Dual Brush options depending on whatever secondary brush appealed to me at the time. Really, it's a very poor example of how grass should be done – the only reason it works at all is because of the light and color, which is okay. I'll be getting back to it later though, don't you worry!

I then think I worked out what was bothering me, which was mainly the fact that he was standing on his kill. It looked kind of cool, but like I stated earlier, I was aiming for a non-arrogant but confident air. The character standing on a dead buffalo didn't really project that so as you can see, I lowered him in front of his kill (**Fig.05**). It took away some of the dynamic factor, but I knew I'd find ways to work that back in later. At least now he didn't look like he was gloating.

Finally, after hours of delay, I got around to establishing the rest of the background. I was thinking of a cloudy, tempestuous, windy day on the plains. I used the Round Fan Stiff Thin Bristles brush that's native to Photoshop CS5. This is especially great if you have the Wacom art pen, since they preview the rotation of your brush, not just the tilt. On the negative side though they do have an annoying preview window that kept popping up no matter how many times I clicked off (**Fig.06**).

To recapture some of the lost dynamic I opted to tilt the whole piece about 20%. I simply grabbed all of the layers, went to Edit > Transform > Rotate and fiddled (**Fig.07**). I also

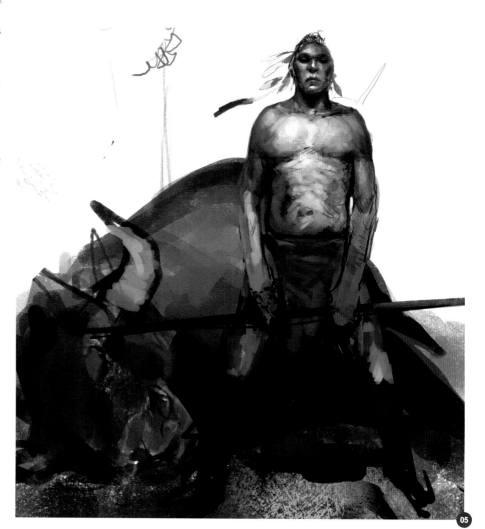

05

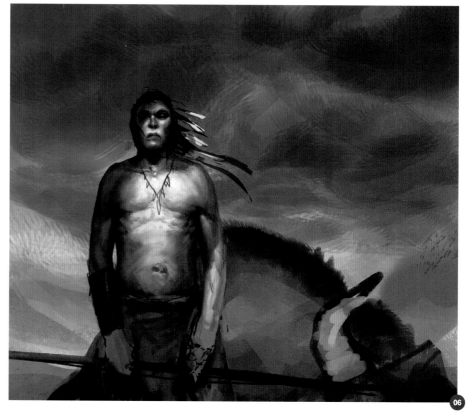

06

continued to work up the warrior, giving him a lean build. I decided I'd probably scale it back some though as it was a tad too ripped for me.

I also began focusing more on how to decorate him as I wanted to keep it simple, without too many adornments. That way the pose wouldn't be lost in a bunch of layers and nuanced details. I also worked up the buffalo, giving him a darker, shaggy coat. I started considering whether or not to just entirely darken the eyes and take out the little glint because it was quite difficult to project him as dead.

Enter doubt! I rotated the whole piece back to an even level. I wasn't sure if I liked it more like this, but I was still trying to figure out the composition. Tilted it looked a little wonky, but a part of me still liked it because it pulled me in. I continued to add detail, along with accent colors (the red straps coming from his hair) that helped drive more focus to his face (**Fig.08**).

Yep, back to a tilted piece (**Fig.09**). I decided to stick with this as I was starting to dig the slight sense of vertigo. I went back into the sky and reworked it, using the previously mentioned Bristles brush and a hard-edged round brush. I kept it all loose as I wanted to give the sky a sense of motion to counteract the stillness of the two subjects. Usually if you refine something you tend to make it look more static, which is pretty logical if you consider the fact that in real life the quicker a thing is moving the blurrier it appears. I also introduced some rim lighting to add extra drama. All of this was done with a hard round brush. I also cropped the canvas as I felt like the viewer was too far away from the character before.

I also started to build up the grass. I began by using the Grass brush that comes with Photoshop and angled it in the direction I wanted it to go. I also varied the size and spacing. Once the brush was set I simply began to layer it over the ground. There's not a big trick to this; you just have to study some grass references and figure out how much of it you want to accurately portray in your scene. I was going for semi-realistic, keeping it a tad on the fantastical side.

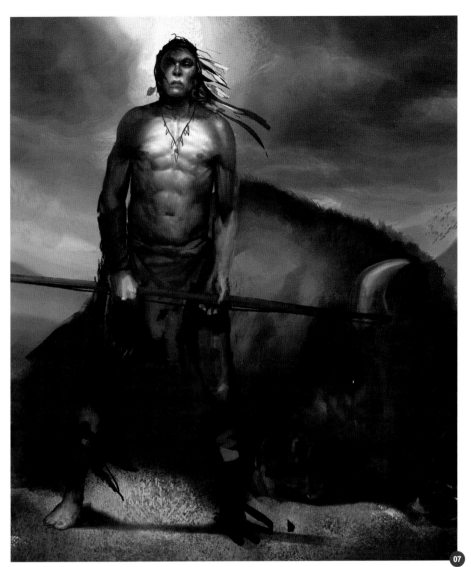

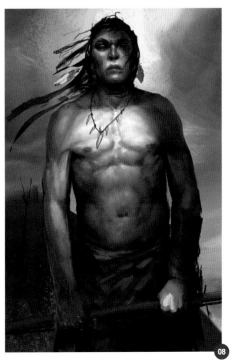

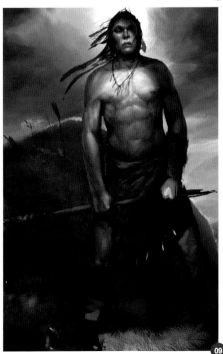

After I was finished with the initial laying in of the grass I grabbed a hard-edged round brush, set both the Size Jitter and Opacity Jitter to Control Pressure and went in to vary and touch up the grass some more. From this point onwards it was just a case of further refining (**Fig.10**).

Here we have the pseudo-final piece (**Fig.11**). I never really feel like my work is complete and this example is no different. There's plenty I'd still like to render, but for the sake of the tutorial and time this will have to do. I pretty much just went over everything and refined it further. I solidified the clouds just a tad more and also detailed the bison a bit more, trying to push its sheer bulk. I got the clumpy texture look by setting my hard round brush to a speckled brush. To do this, just enable the Scattering options in the Brush Options window and vary the sliders. Make sure to also play with the Spacing option of your brush for better results.

I also added some body designs, but nothing that would cover up the physique too much. I think a warrior's greatest tool (after his mind) is his body; the better he's honed, the deadlier he should be. For a quick and agile character like we have here, it's important to see his build.

As for the grass, I copied the former layer, set it to Overlay mode to pump up the contrast and then continued to paint on it. This gave it that extra kick of light to dark. I also made an Overlay layer for the body and just painted lightly over him with the aforementioned speckled brush, to give him a bit more texture.

So there you have it; a rather loose take on the iconic Native American. I hope you enjoyed the tutorial and best of luck in your version!

Note: Just for the fun of it, I also made a quick version with rain. It is not quite accurate – the skin should glisten more and the lighting is way too warm – but still, it was good to play around. I used the speckled brush on a different layer, then used Filter > Blur > Motion Blur. After that I just went in and did some hands-on smudging and painting of raindrops in motion. Remember to keep them blurry (**Fig.12**)!

10

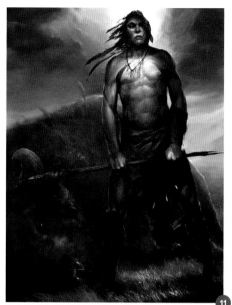

11

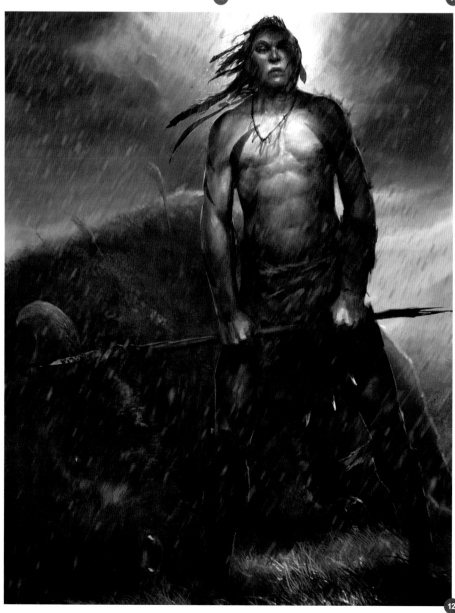

12

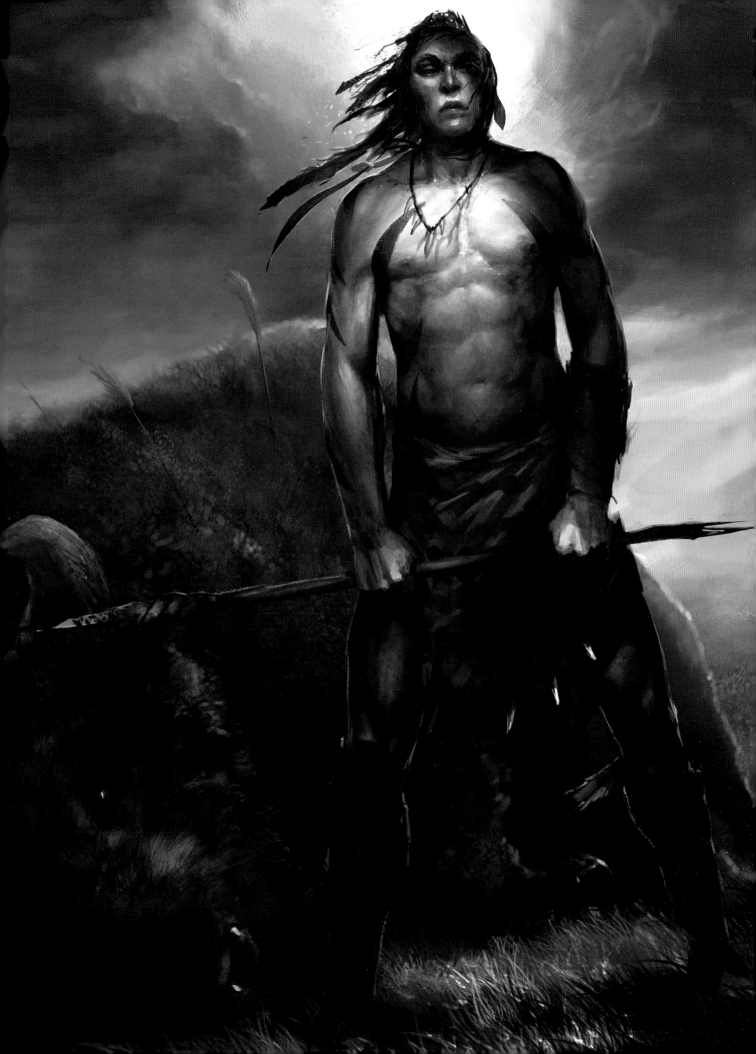

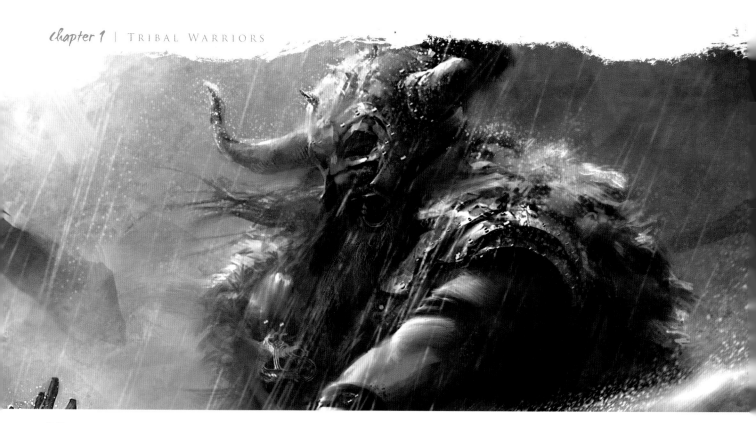

V I K I N G
B Y J O N M C C O Y

I N T R O D U C T I O N

For this tutorial I was set the task of creating a concept illustration based on a Viking. I started by coming up with some keywords for myself. This helped me settle on the aesthetic style of the painting, along with the lighting and mood. I wanted the Viking to be very powerful, and set against a foreboding and grim scenario. This helped me find a pose and expression that worked. I used references at every step and listened to music that help reflect the feeling I was aiming for. I hope you find this tutorial useful!

B L O C K I N G A N D
S I L H O U E T T E

With this image I knew I wanted something that had a strong silhouette, and that the silhouette should be as "Viking" as possible. Viking horns were an obvious way to do this. Once I'd blocked in a rough shape, I started thinking about the other elements I would need to develop the blobby scribble, such as indicating the arms and weapons. I blocked in using the standard Hard Round brush with Pressure Sensitivity turned on. I then used the same brush as my eraser to cut out the shapes I wanted (**Fig.01**).

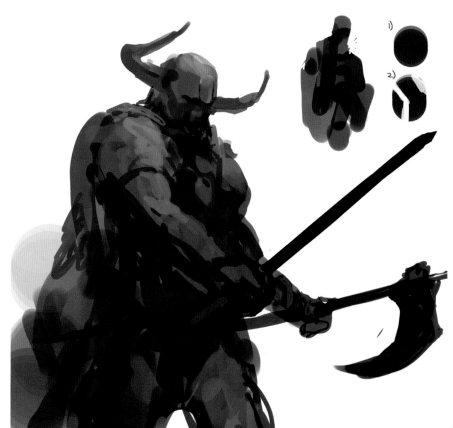

01

C O N T E X T U A L D E S I G N

When I had the Viking design down as I wanted it, I started thinking about what he was actually doing. At first I thought about having a wounded Viking taking his last defensive strike.

Then as I continued blocking in and moving elements around (such as the sword), I thought it would be interesting to show the Viking as an executioner. The man with the outstretched arm immediately worked for me. Everything

16

was in his hand gesture, and combined with the obvious striking angle of the Viking's sword, this gave real weight to the image. In this scenario contrasting elements help to define each other. If the Viking was chopping a tree down instead of a person, everything would be different, even though the pose and costume wouldn't be (**Fig.02**).

Another layer to the context was what the characters were wearing. Putting the characters in the clothing of the time and place meant researching what they would have worn, how they made their helmets, the decoration on their swords and shields, etc. You have to absorb as much of the style as you can.

ATMOSPHERICS AND DYNAMICS

Once I was happy with what the image was doing and saying, I started thinking about how I could increase the drama. I didn't want to get into the lighting of the scene yet, so I played around with losing edges, and adding smoke and cloud effects to increase a sense of depth and motion (**Fig.03**).

I did this by creating some brushes sampled from clouds and using them along with erasers. Another thing to play around with is the flow value, which will slowly build up the stroke and give your brushes a different look (**Fig.04**).

COMPOSITION PRINCIPLES

One thing that I was aware of at this stage was that the composition was looking very "side on". I knew I had to create a strong graphic pattern with my characters to keep the image interesting. Negative shapes and composition design lines helped me find interesting abstract shapes, such as the negative shapes around the axe and hands. I tried to make sure no more than two of the composition lines ever crossed over at a perfect "X". You can see in the example the small triangle made by the sword hand, axe and arm/leg line. If all the lines crossed at the exact same point, the composition would distract and annoy the eye. A good principle to study is "Informal Composition" by Andrew Loomis (**Fig.05**).

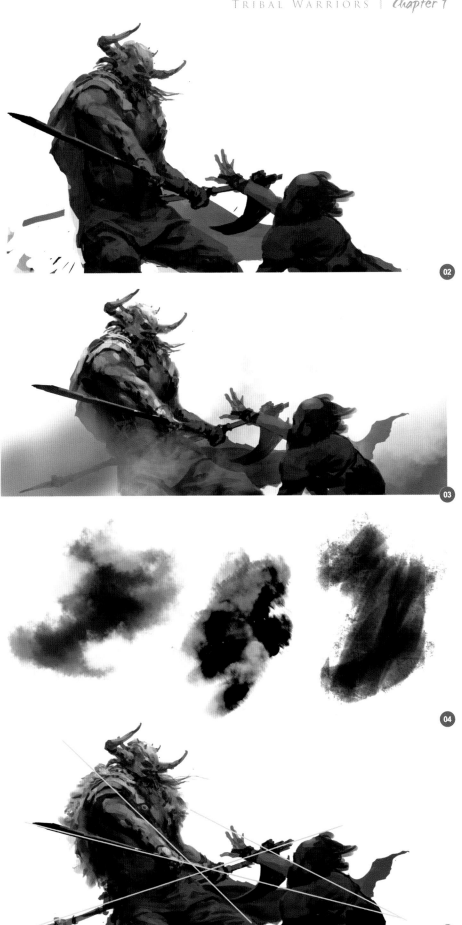

02

03

04

05

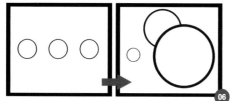

A good exercise for practicing your composition is to take three circles. Order them in a neat and boring way in a frame. Then create a set of "mini-compositions", with the most dynamic combination of the three circles that you can come up with (**Fig.06**).

USING MULTIPLY FOR THE BACKGROUND

I intentionally left the background white in the beginning for two reasons. I wanted to stay focused on the characters as much as possible for the blocking in, and I knew I could use Multiply to make it work later on down the line. So once I was happy compositionally and contextually with the image, I created a Multiply layer at the top of the layer stack. Since the background was pure white, it could only go darker. Using the Multiply layer mode has a nice layering effect that builds the darks very well. I used large soft airbrushes and cloud custom brushes, focusing on establishing a lighting gradient more than anything else. Then I erased out the areas on my characters where it had gone too dark. This was how I established the mood and general lighting of the image (**Fig.07**).

Fig.08 illustrates exactly what I did for the Viking image. I painted the base painting and then painted in a Multiply layer above it. Finally I deleted the parts of that layer that were in the highlighted areas.

OVERLAY, COLOR BALANCE AND HARD LIGHT

Different layer modes are the way I would usually apply color to a piece. For the Viking image, I applied a wash of blue with orange to get a basic idea of the color temperature (warms and cools). Then I used Hard Light in the darkest darks to paint pure red into areas. Overlay wouldn't be able to do this as it doesn't affect pure blacks or whites. Hard Light,

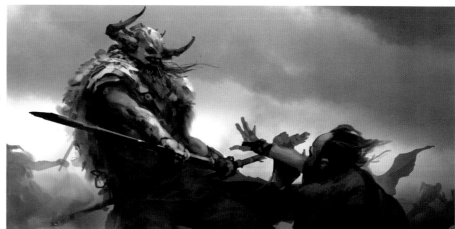

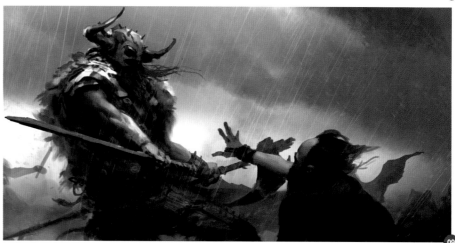

however, brings the black point up really well. I then used a Color Balance adjustment layer to grade the image to a tone I wanted (**Fig.09**).

Fig.10 shows the interesting colors achieved by using just one Overlay on top of a black and white image. A good thing to do after this is to

paint opaque (Normal layer mode) back over the top as this helps to get rid of the obvious washed look.

SKIN TONE

Sometimes when using Overlay and Hard Light layers, the skin on characters doesn't

look right. It's very easy to make skin look dead in an image. This is usually because one hue has been used to paint the form of the character's skin. Skin contains so many hues and saturation levels it takes more to make it look believable. It's something that needs a lot of practice, but it is key to making character illustrations look strong. So I re-graded my image, focusing only on the skin. I had the previous version's color palette to go back to later. Once I felt the skin looked natural color-wise, I copied them back into the blue, grim lighting version (**Fig.11**).

Studying subsurface scattering will really help you to understand how skin works and how it can look authentic. In **Fig.12** you will see how sphere 1 has only one hue going from light to black. Sphere 2 goes through many hues and ramps up in saturation before it gets anywhere near true black.

POSE REFINEMENT

I continued to refine and add details specific to Vikings, such as leather straps, belts, studs and armor all sourced from references. At this stage of an image I always try to stop and take a step back. I try to re-analyze the poses and make sure everything is as good as it can be. With this image I moved the peasant's hand and head around, but decided not to change anything. The Viking's head, however, was bothering me. So I lasso-selected his head/helmet and used Copy/Merge and Paste to create a flattened selection I could move around. After trying multiple options, I settled on a slight position and rotation change (**Fig.13**). This increased the impression of him swinging his sword. Every time you change something in a piece, question whether it dilutes or enhances the image.

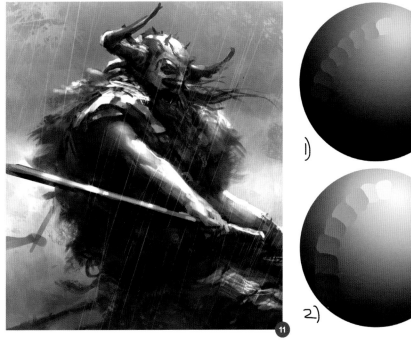

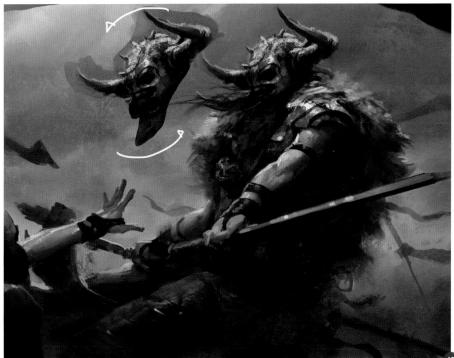

PARTICLES AND FINISHING EFFECTS

I knew from the start that I wanted this image to have a lot of depth and visual effects. As the weather in the image seemed very dull and grim, I thought I'd try making the rain from one of the previous attempts work. Rain can give an image great mood by adding a lot in terms of reflections, specular highlights, particles and things like water splash. For the rain, I created a custom brush using the standard Hard Round that I then flattened in the Roundness setting as much as possible. I then just played with scattering values until I thought it read like rain.

I also used other particle custom brushes to add miscellaneous texture effects like grit and mud into the image. Applying a small amount of Motion Blur to these elements adds a lot of depth (**Fig.14**). At the end I added a vignette to the image and blurred the edges whilst sharpening my focal points (**Fig.15**).

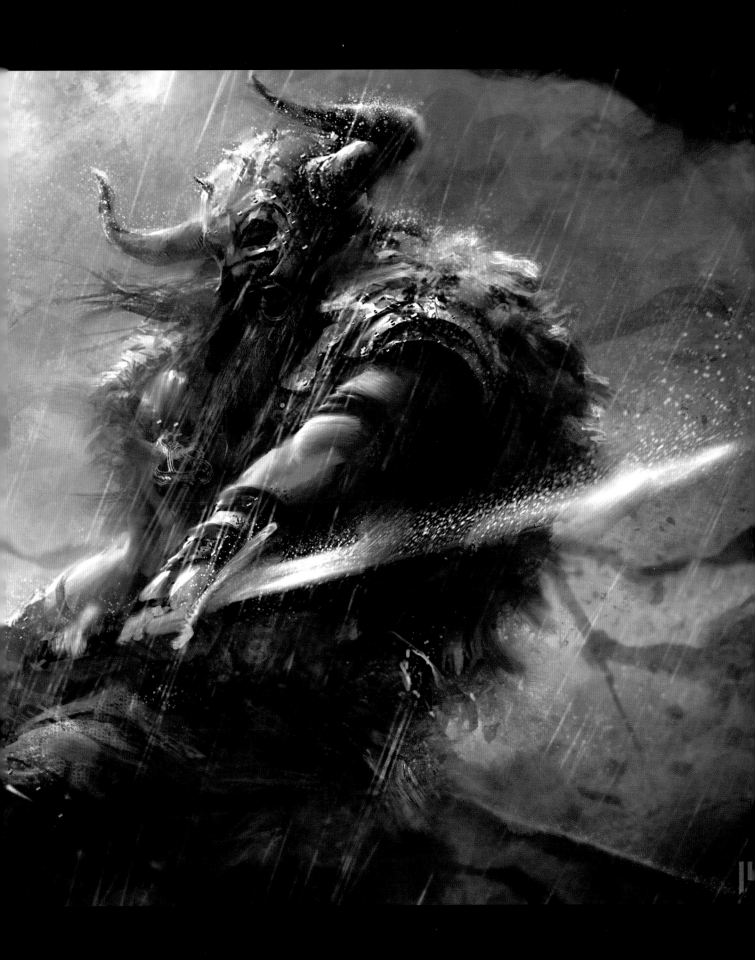

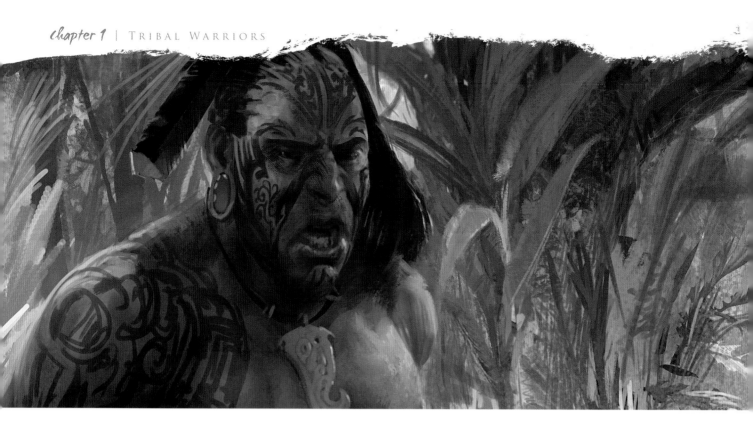

MAORI
BY CHASE TOOLE

MY PAINTING

I usually start my pieces by using color to sketch out fairly abstract shapes, using an approximate palette. Since the piece I am working on is set in a jungle environment it seems appropriate to use greens, blues and yellows (with some reds and purples to balance). I tend to use a lot of large brushes with rough edges at this stage so I can try and get some "random" shapes that might help inspire my ideas and push the concept along (**Fig.01**).

Adding some figures early on is pretty important because it helps maintain a cohesiveness in the colors and in the shape of the composition. This part is usually pretty tricky because you must think about the composition, narrative, scale, mood, etc. I indicate the light direction and intensity in this part because I like to see the potential drama (**Fig.02**).

Eye movement within an image is important and I try to do this by creating blocks of interest and visual noise. I create the visual noise using custom brushes. I like painting textures so this stage is usually the most fun (**Fig.03**).

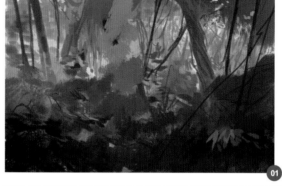
01

02

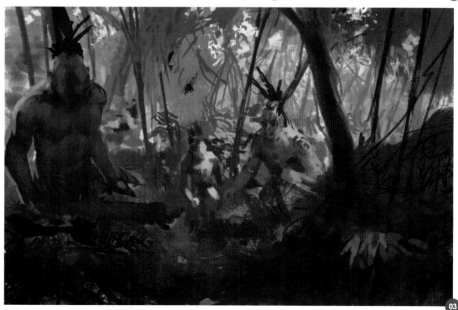
03

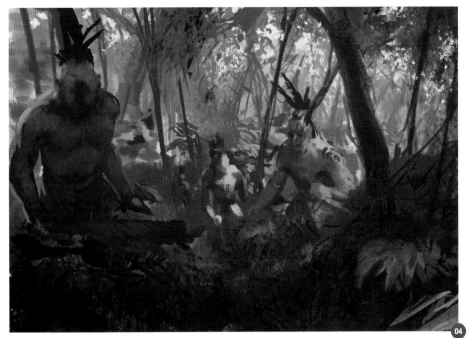

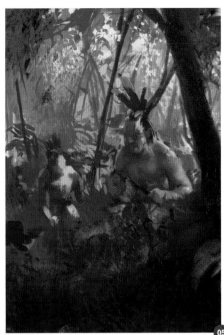

When I want to really ramp up the amount of noise in an image I create a new layer in Photoshop and make a lot of large, choppy marks. I then create a Layer mask and mask parts out using a smaller textured brush (**Fig.04**).

Since the guy in the middle (farthest to the right) is pretty centrally located and has a decent amount of contrast on him, he's basically the main character of the narrative. I start fleshing out his design first (**Fig.05**).

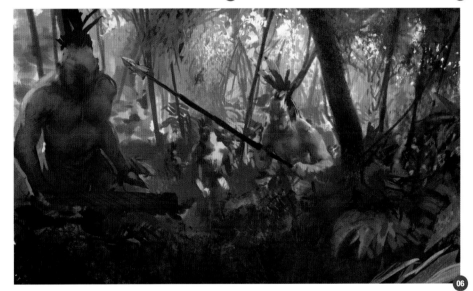

As I move forward with a piece I usually play with color adjustments and levels just to freshen my eye. Sometimes I find some nice color schemes this way. I also have two hotkeys set to flip the canvas; one flips vertically and the other flips horizontally, and this has been pretty important in helping me to see errors in my paintings (**Fig.06**).

I want the channel of light to split the group of tribesmen to add a little depth and mood. The light hitting the forest floor is also creating some much needed eye movement across the illustration. I add a spear to chop up some of the verticals and create some framing for the background guys. It's a gamble to put the spear in there and I'll probably end up taking it out, but it's good to make these mistakes as they teach us more about ourselves (**Fig.07**).

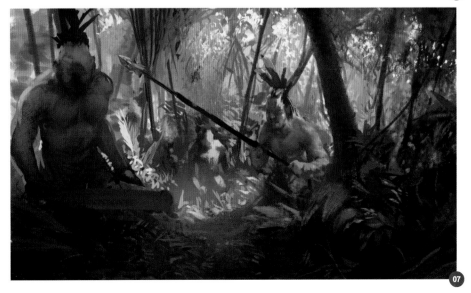

Whenever I start painting smooth surfaces like skin or leaves I try to make as few strokes as possible. When I start going over the same mark, I feel I can totally wreck what I am doing. I am trying to get into the habit of making the mark and walking away, so to speak. As I am working the details of the piece in I am constantly zooming out to see if what I just painted is helping or just causing unwanted noise. I also squint at my work so I can see the forms without all the details (**Fig.08**).

I am starting to see the potential for this brute in the foreground. His frame and posture are going to become pretty important so I'll be revisiting him quite a bit too. I want him to be really imposing so I use the Lasso tool to select him, and copy and paste him into a new layer, where I modify his body and give him the beginnings of a face (**Fig.09**).

I start flipping through my references at this point to make sure I am heading in the right direction with the weapons and apparel. Oh and tattoos – it wouldn't be Maori if there weren't tattoos (which is a good point; whatever it is you're illustrating, find the essence and make it very visible) (**Fig.10**).

> **Quick Tip:** I finally get rid of the spear and add more leaves and trees. A good and easy way to do leaves is with the Lasso tool. It gives you nice edges and a lot of freedom to experiment while not contaminating the rest of the piece. Generally I stay away from leaf brushes as they tend to stick out like sore thumbs if not used properly. Besides, leaves are fun to paint so why not do the fun thing (**Fig.11**)!

I don't like how the central guy isn't really engaging with the viewer so I change him again. He also has a lot of over-painted marks, so I want to start afresh with him (**Fig.12**).

I notice the scene's light source is kind of losing its power so I create a new layer and set the layer to Screen. I then pick a yellowish orange and airbrush my light back in. It's pretty easy to get carried away when airbrushing light rays, so I try and leave that for the end.

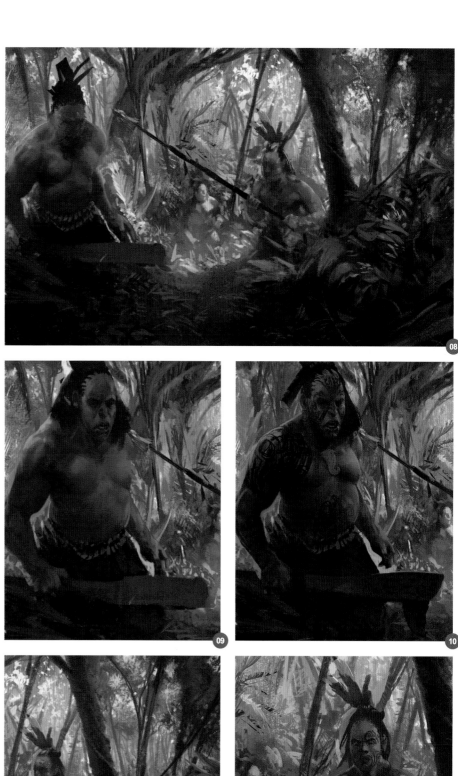

08

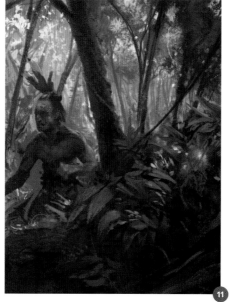

09

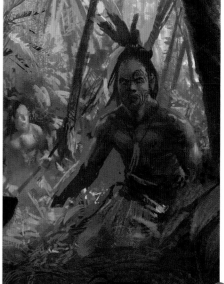

10

11

12

For detail work I try and keep the brushes as large as possible, and edit the brush properties as needed. It also helps to figure out where the eye is moving around the page and polish stuff on the way (**Fig.13**).

I'm trying to resolve the key points to make them readable with as little effort as possible. I'm also flipping my canvas a lot more to catch anything I might have missed, now that I am almost done. Moving around the page I can see that there are lots of little spaces where I can hide some more color and noise. I use the Smudge tool a lot; usually I will do two or three strokes and then smudge the transitions between the strokes to emulate (or try at least) fresh paint (**Fig.14**).

The final step is adding the last few touches and helping the composition along as best I can. I do a few color and level adjustments at the end to separate the colors more. I also use a slight Unsharp mask at the end to pop

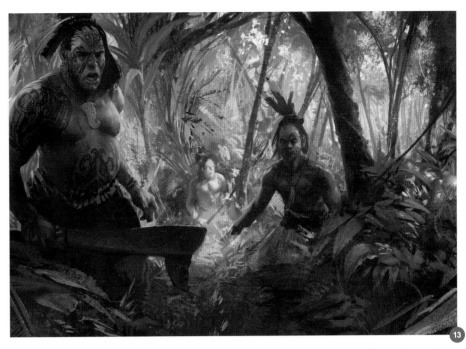

13

the edges a little more (I find that the amount of sharpen is relative to the size of the image – e.g., bigger image = less sharpening ability). Adding the soft light rays and some dust particles should occur after sharpening and color adjustments because you want as much control over the light as possible. And I think it's done (**Fig.15**).

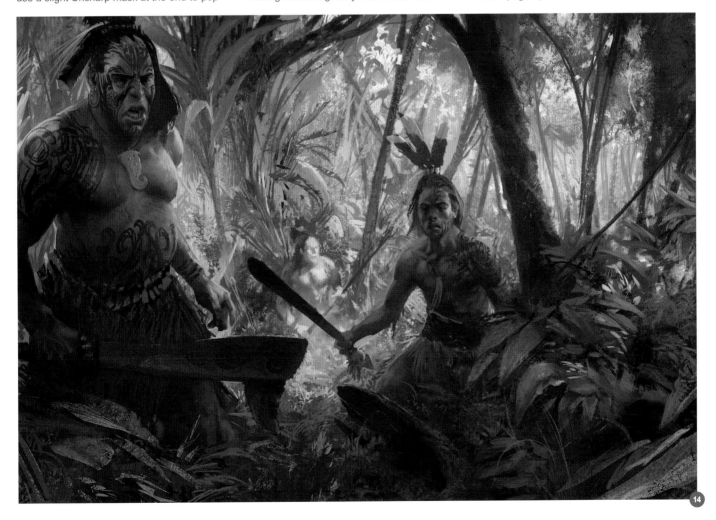

14

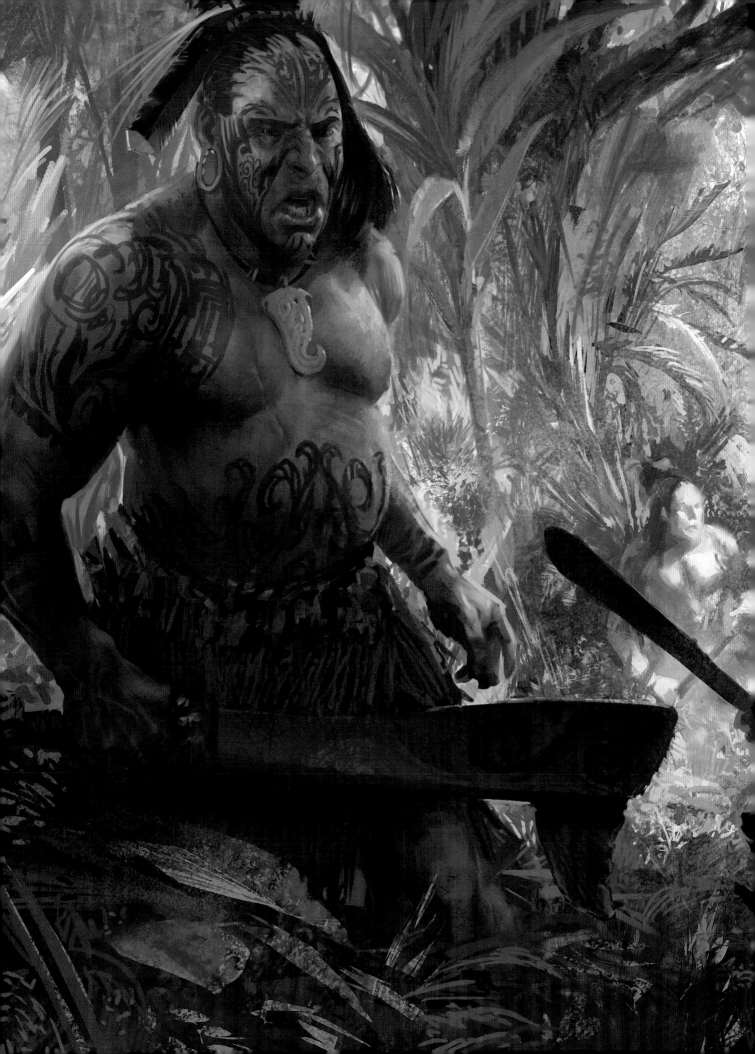

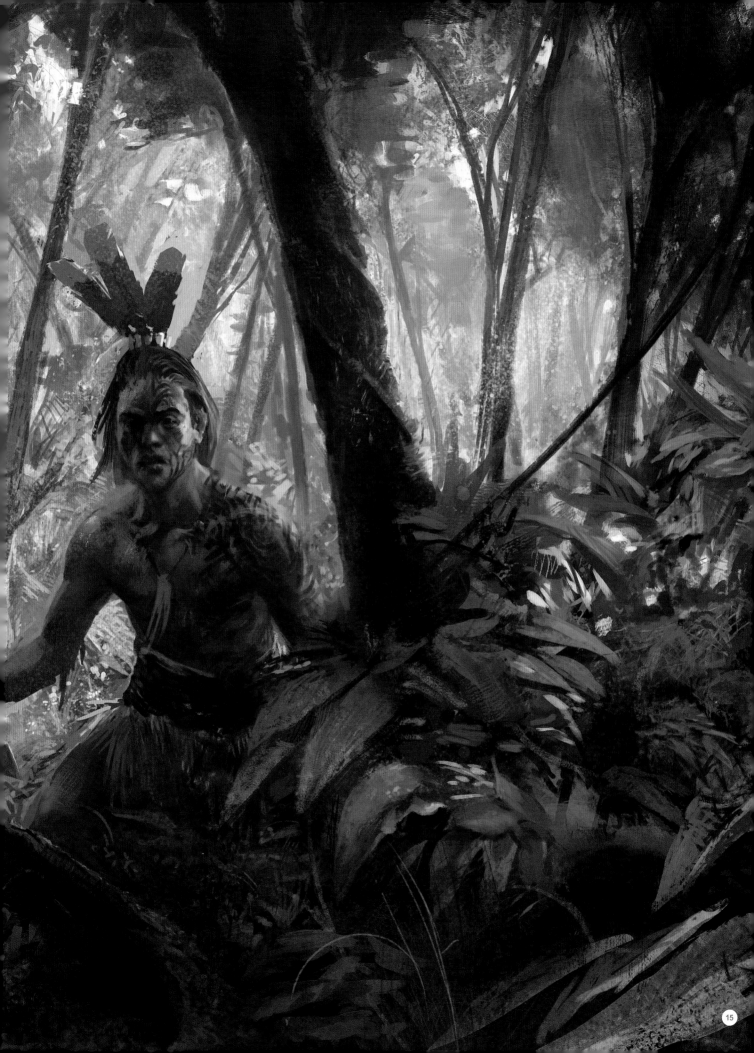

AZTEC
BY RICHARD TILBURY

INTRODUCTION

The Aztecs were a group of people in central Mexico who were prominent between the 14th and 16th centuries. Their civilization accomplished some great artistic and architectural achievements, and their history demonstrated some rich traditions. Perhaps one of their most commonly known traditions is that of human sacrifice, which can be seen illustrated in manuscripts from the time.

In terms of finding reference material there are obviously no photographs from the period and so you can only rely on painted manuscripts and costume recreations. For the purposes of this tutorial I thought it would be interesting to create a semi-realistic character that was partially based on actual records and manuscripts, and combine this with an imaginary element.

BLOCKING IN

Due to the colorful nature of Aztec culture and society, together with the area that they once inhabited, I decided straight away that I wanted this painting to have a rich palette with lots of saturated colors. From looking at various reference images I got the impression of

elaborate, exuberant costumes and beautiful, decorative jewelry. These were most likely used for ceremonial purposes; however I liked the idea of adorning my warrior with something similar to make him look more interesting. I

therefore imagined that he was dressed up slightly for some form of ritual or ceremony.

The first stage was to fill in the background with some vivid greens and the suggestion of jungle

foliage and ground. **Fig.01** shows the initial block-in using some textured custom brushes.

The brush I used to create the leaf shapes can be seen in **Fig.02**, which has scattering and uses the Dual Brush option. The other brush I used can be seen in **Fig.03**. At this stage it was just a case of getting rid of the bland white background and providing a base to work on. As this background would be on a separate layer to the character it didn't matter if it

> IF YOU ARE WORKING IN THE GAMES INDUSTRY IT'S GOOD PRACTICE TO SEPARATE YOUR PAINTING INTO LAYERS IN CASE YOU ARE ASKED TO CHANGE ANYTHING

remained vague at this stage as it could always be modified throughout the painting process.

With the backdrop roughed in I started blocking in the warrior (**Fig.04**). I filled in most of the body with a single, mid-tone color. On this base color I could work in shadows and highlights.

BUILDING UP THE DETAIL

Fig.05 shows the next stage in the process,

which now incorporated a third layer where I began to add some clothing and accessories. If you are working in the games industry it's good practice to separate your painting into layers in case you are asked to change anything. Having the clothing on a different layer to the character means it can be modified with ease. Your art director may require changes to the costume and so splitting up elements can save a lot of time and headaches.

I roughed in a feathered headdress, which was something that seemed prominent in much of the Aztec art I researched and was an aspect that I was very keen to include. I also started to develop the features of my warrior's face a

little more, and added a light source that was somewhere to the left of the picture frame.

Using a textured chalk brush, I started to build the anatomy (**Fig.06**). I also moved the character slightly up and to the right on the canvas as he looked a little squashed.

I added an extension to his ceremonial headwear, which can be seen in **Fig.07**. To create a highlight across the left side, where the sun is hitting it, I duplicated the layer this was painted on and then set the blending mode to Screen (inset 1). I then used the Eraser to delete the areas that weren't directly in the sunlight, leaving just a small section (inset 2).

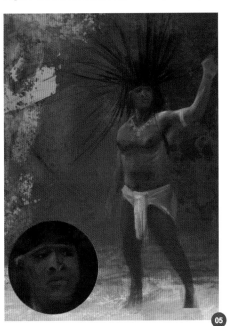

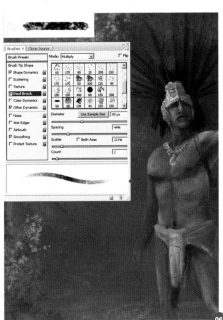

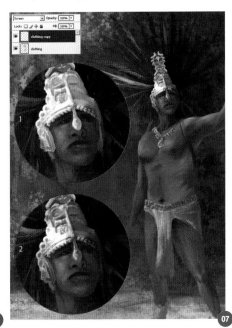

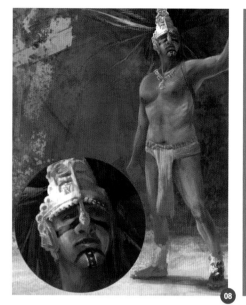

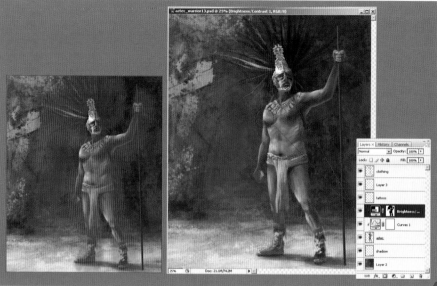

I wanted to add some war paint across my warrior's body and so created a new layer for this so I could experiment with the color and blending mode easily without it affecting the main image. I started with the face and in the end chose Normal as the blending mode as this best suited my needs. To make sure the paint was consistent with the lighting I used the Eraser tool to make the highlighted areas semi-transparent (**Fig.08**).

The skin tones looked a little flat and so in order to increase the contrast, I applied a Brightness/Contrast adjustment layer. I increased the values by around +30 in both cases, and then used black to paint into the

mask and restrict the adjustment layer to the left-hand side of the character (left image in **Fig.09**). You will also notice that I have added some extra decoration around his neck and chin now, labelled "Layer 3" in the palette above tattoos.

I wanted to have a few tattoos across my warrior and so created a new layer in order to experiment, as I'd done with the face paint. The Overlay blending mode was probably the most suitable setting and, using a chalky green, I painted some shapes across his torso and limbs (**Fig.10** – inset). You can see how these finally appear in the full image when the blending mode has been altered.

The overall lighting was another aspect that was troubling me at this stage as it seemed dull and did not have the vibrancy that I initially intended. To rectify this I merged the two previous adjustment layers with the character layer and then applied two more: a Curves and a Brightness/Contrast layer. On the left is the image before these were applied and on the right is the effect of these, along with their settings. You can see now that the general color scheme has been enriched and the light feels much warmer and more tropical.

During the painting process I realized that the right leg looked a little twisted and the curvature through the lower leg seemed

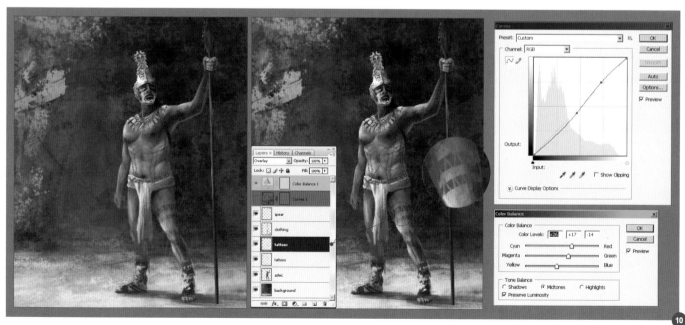

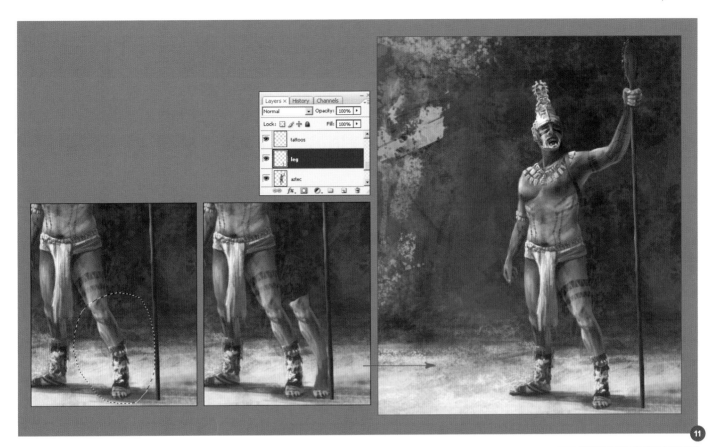

exaggerated. I decided to change it by making a selection area from the knee down and then rotating it (**Fig.11**). You can, of course, opt to use the Warp tool in Photoshop although this can sometimes distort the overall contours of the image. Either way works fine really; it just depends on your preference.

Once the lower leg was duplicated I rotated it and then used the Eraser tool to delete the unwanted areas on the character layer, as well as blend any obvious seams. Here you can see the before (upper left) and after (right) results. After doing this I then rotated the ankle decoration on the clothing layer to match the new position of the leg.

You will have noticed that I have also deleted the red feather headdress, which I felt was somewhat out of balance. I was quite keen on this part of his costume and so replaced the feathers with a smaller bunch (**Fig.12**).

Although our character is wearing some ceremonial clothing, he is a warrior nonetheless and so I thought it only fitting to supply him with a typical Aztec weapon:

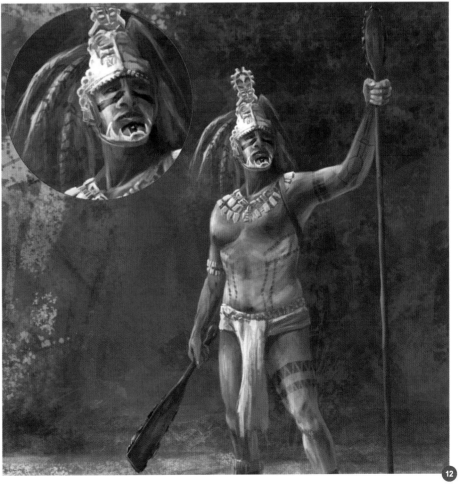

the maquahuitl. This was a weapon that was somewhere between a club and a sword, and was made from wood. Embedded along its edges were pieces of obsidian (volcanic glass). This material was naturally robust and sharp, which made it perfect for cutting and piercing (**Fig.13 – 14**).

FINISHING TOUCHES

At this point, the picture was reaching its final stages, although there were a few adjustments that could help improve things. Although I wanted to focus the attention on the warrior and not the background, I thought that some textural realism might help in the way of some foliage. I looked through the free library of photos available on 3DTotal and found two images that were perfect for the task. You can find these textures via the link at the end of this tutorial.

In the case of the first one, I made a selection area around the large foreground leaves and then pasted these into the painting (**Fig.15**). Once both pictures had been pasted in, I color corrected each by reducing the contrast and also the saturation of the leaves in the lower image.

I also found a useful image of some ground with scattered grass and earth, and decided to overlay this across the jungle floor (**Fig.16**). I used the Transform tool to scale it vertically in order to create a more accurate perspective and then set the blending mode to Soft Light (lower image).

I decided to increase the contrast in the Curves adjustment layer and then added one final layer, which was some reflective light across the warrior's right side. With this the painting was complete.

You can download some reference (JPG) files to accompany this tutorial from: **www.3dtotalpublishing. com**.

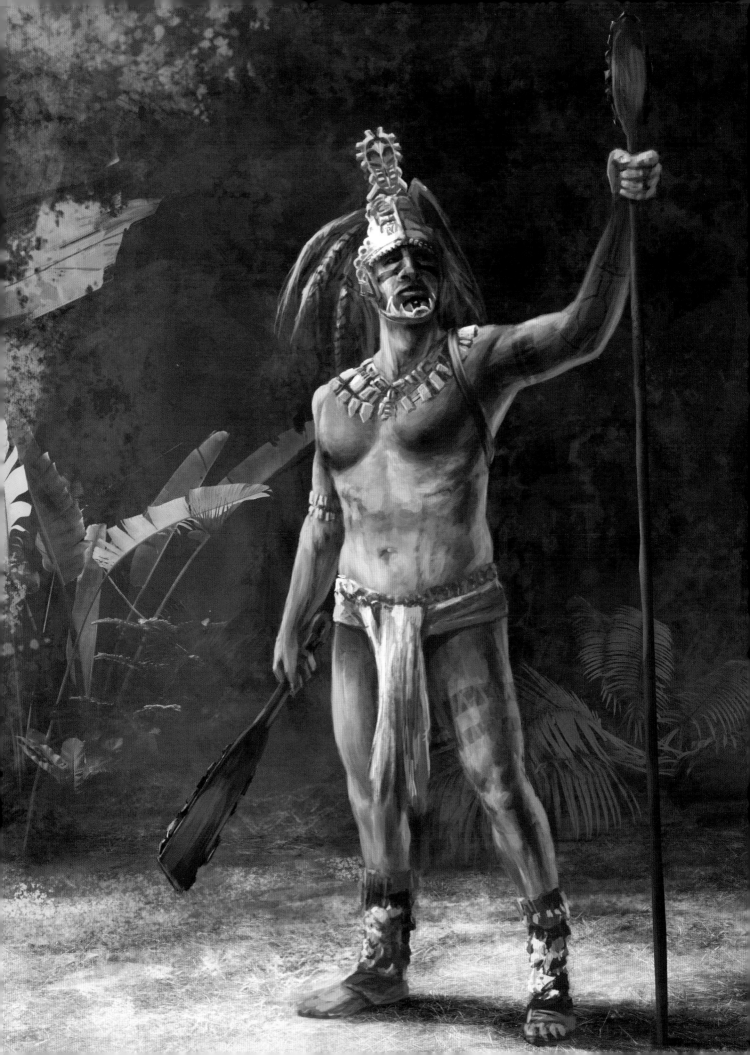

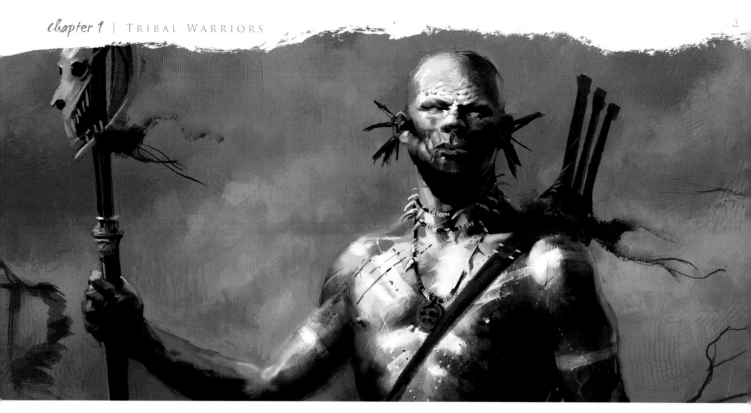

FANTASY
BY IGNACIO BAZAN LAZCANO

INTRODUCTION

How do you paint a picture with well-defined volume, depth and composition? I'm going to tell you how to work on the dynamics between the figure and the background, and also how to understand figures and handle light and shadows. My idea is to make it fun and easy to understand.

Let's start by defining the drawing's details the best we can, so when we switch to color it'll be easier to model it. I'm naturally impatient and like to go directly to color, but this time I'm going to calm down and set the picture a little better before diving into the pool of color.

These are the subjects I've chosen to discuss:

• How to select base colors
• Figure modeling and light direction
• How do you make the colors match
• Final details
• Bonus track

HOW TO SELECT BASE COLORS

To find out what base colors we should use, we must keep in mind several things:

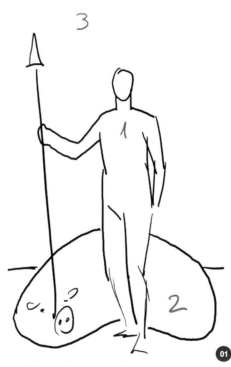

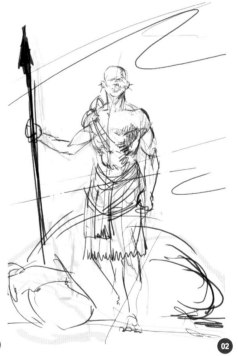

• Whether the scene takes place during the day or night
• What kind of environment or scenery we have (desert, forest, etc.)
• How many characters there are in the composition
• What we want to show in the painting and what is in the background

As you can see, there are three elements in the drawing: a warrior, a wild pig and the background (**Fig.01**). The warrior is the most important part as he is what I want everybody to look at (**Fig.02**). For this reason, we should try to separate the character from other elements using colors.

Curiously, through colors you can say a lot of things. It is not foolish to plan which colors you are going to use from the beginning. **Fig.03** shows three different examples you can look at to work out whether the selected base colors are right or wrong.

03

In the first example the color palette is cool, therefore warm colors stand out immediately – in this case the wild pig. This is not useful because the warrior is supposed to command the viewer's attention. In the second example, all the elements are warm, therefore nothing stands out and it is very difficult to guide the viewer around the image. Finally, in the third example we find the best option. The warm background and the wild pig blend well, and the warrior in the blue color stands out from the secondary elements. At the same time the warrior shares a cold color range with the wild pig's body (**Fig.04**).

> ❝ REMBRANDT WAS
> ONE OF THE GREAT ❞
> MASTERS OF THIS
> MOVEMENT. IN HIS
> WORK WE FIND
> GREAT EXAMPLES OF
> THE USE OF LIGHT
> AND SHADOW

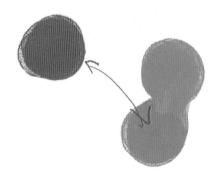

OPPOSITE AND COMPLEMENTARY

COLD COLORS

CONTRAST

04

To put in your new color choices you simply need to set your sketch to Multiply and paint in the three colors (**Fig.05**).

FIGURE MODELING AND LIGHT DIRECTION

To start painting let's define the strong lights and shadows first. At this point we'll start to cover the original drawing's line with color. To guide the viewer's gaze I have chosen a theatrical light that isn't very realistic, but it makes the image look dramatic and interesting (**Fig.06**).

If you look at paintings from the Baroque period you will see clear examples of dramatic lighting and contrast management. Rembrandt was one of the great masters of this movement. In his work we find great examples of the use of light and shadow (**Fig.07**).

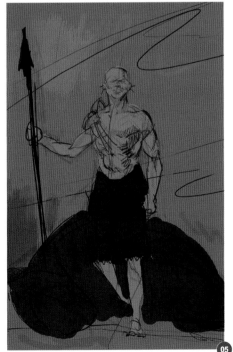

05

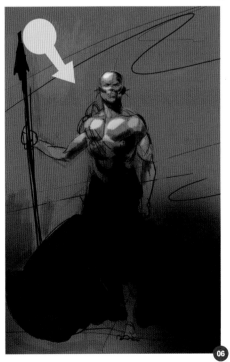

06

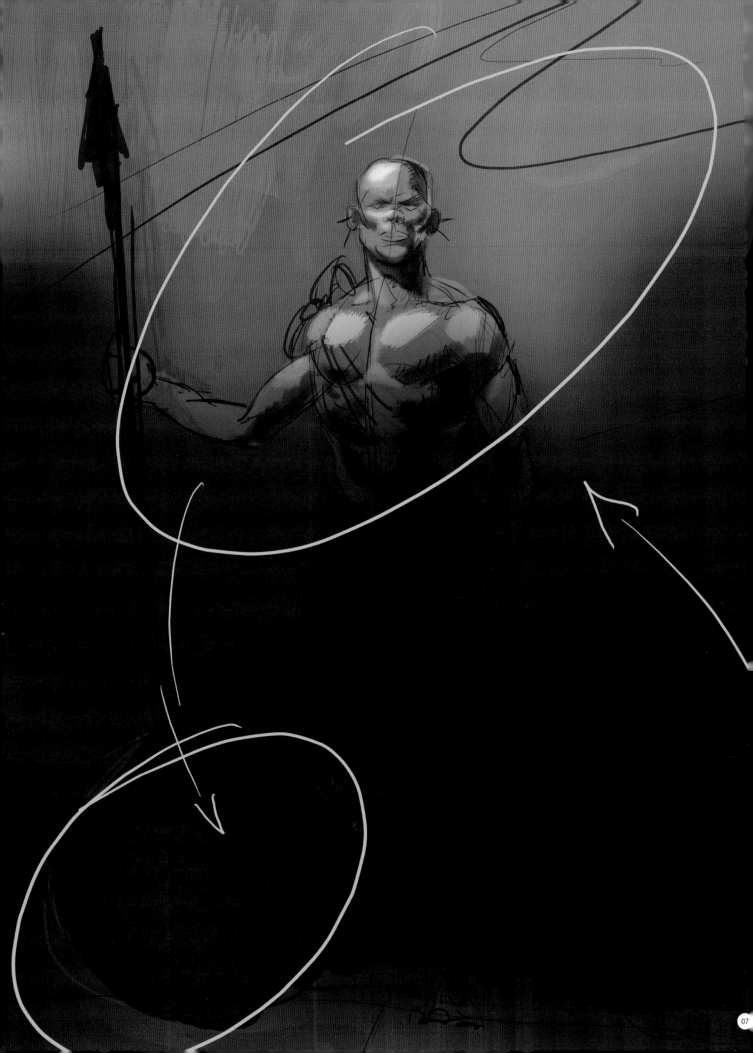

The next step is to start shaping the figure. To do that you must first understand the shapes, and use the direction of the light to try to understand how the character will look in the light. The warrior's head and face is composed of several geometric figures. You may have seen these shapes used in diagrams thousands of times before, but it is important to understand the shapes as these will help you paint the head to make it look 3D. You can see how these shapes work on the face in **Fig.08**.

Using this understanding that we now have, we can start to put color on the warrior's face. In image three you can see that I have added some backlighting. This means that I have added some of the background colors to the skin of the warrior, particularly on the darker side. This is to make the character look as if it is standing in its environment (**Fig.09**).

MATCHING THE COLORS

This part of the process is about adjusting the balance of the contrasting colors in the different elements of the painting. To explain this I've drawn a blue apple on an orange background (**Fig.10**). It is always easier to demonstrate a point with simple figures. Remember that when you paint with colors you must cover the whole painting with one color. This is the base or dominant color. Then add local color for each element that makes up the composition.

If we look at the following boxes, we can clearly see the contrast between the blue object and the orange background. As we want this object to be integrated in the background, but at the same time separate from it, we have to control the amounts of orange and blue we use. If the object is further in the background it will have much more orange on it than blue. That is to create a greater sense of depth or distance.

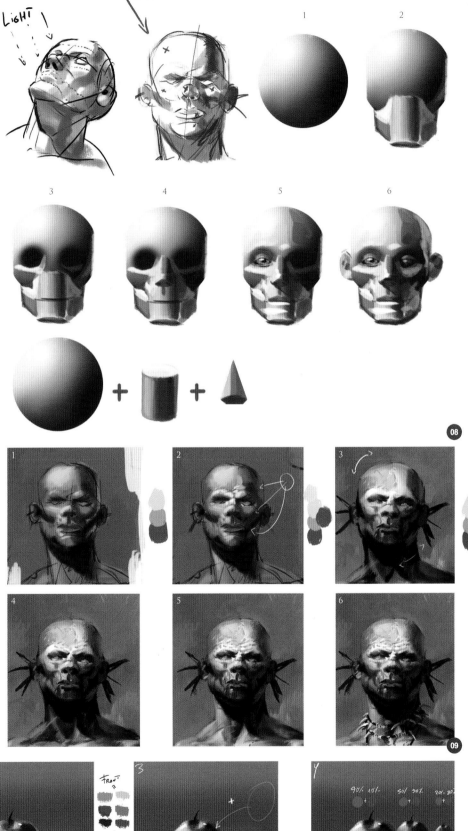

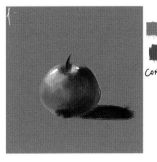
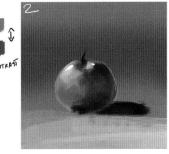
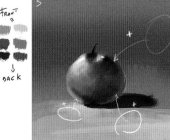

Depending on the material the object is made of, the object will reflect more or less light. This will allow us to differentiate a piece of cloth from a piece of metal (**Fig.11**).

FINAL DETAILS

If you already have the character and background defined, and the lighting established, you can add some interesting features that look visually appealing (**Fig.12**). Sometimes after working on an image for a long time you can feel a little bored of it and feel like you don't want to work on it anymore. If you feel like this, it's best to stop working on it for several hours. When you go back to it you can think about what you would like to adjust or if you would like to work on some of the main focus areas, like the faces of the characters.

In **Fig.13 – 14** you can see the points of interest that I've adjusted.

After some time I decided that I also wanted to do a cartoony version. You can see in **Fig.15** that the same principles apply whatever style of work you are doing. The other important thing to remember is that once you understand these things you can explore any style that suits you.

CONCLUSION

In almost all the tutorials I've already written I've avoided talking about programs, steps or special effects. My thinking is that anybody can draw using any tool they like. The truth is that you can paint amazing images with just one brush without using special layers or effects. The most important thing to know is the traditional techniques and to paint what you want to. Try to create a painting with only two layers – the first for the sketch and the second for the painted color. You'll see that you can do it and that it's fun. I hope you have enjoyed my tutorial (**Fig.16**).

You can download a custom brush (ABR) file to accompany this tutorial from: **www.3dtotalpublishing. com**. These brushes have been created using Photoshop CS3.

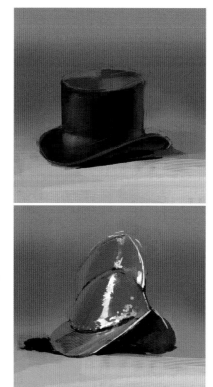

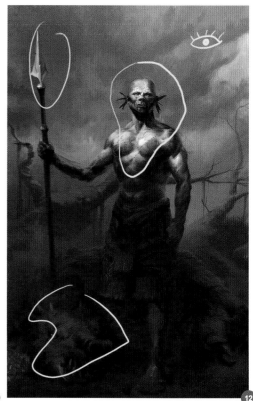

11

12

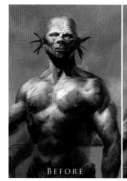
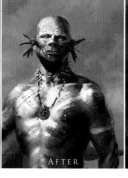

BEFORE AFTER BEFORE AFTER

13

LIGHTS

14

15

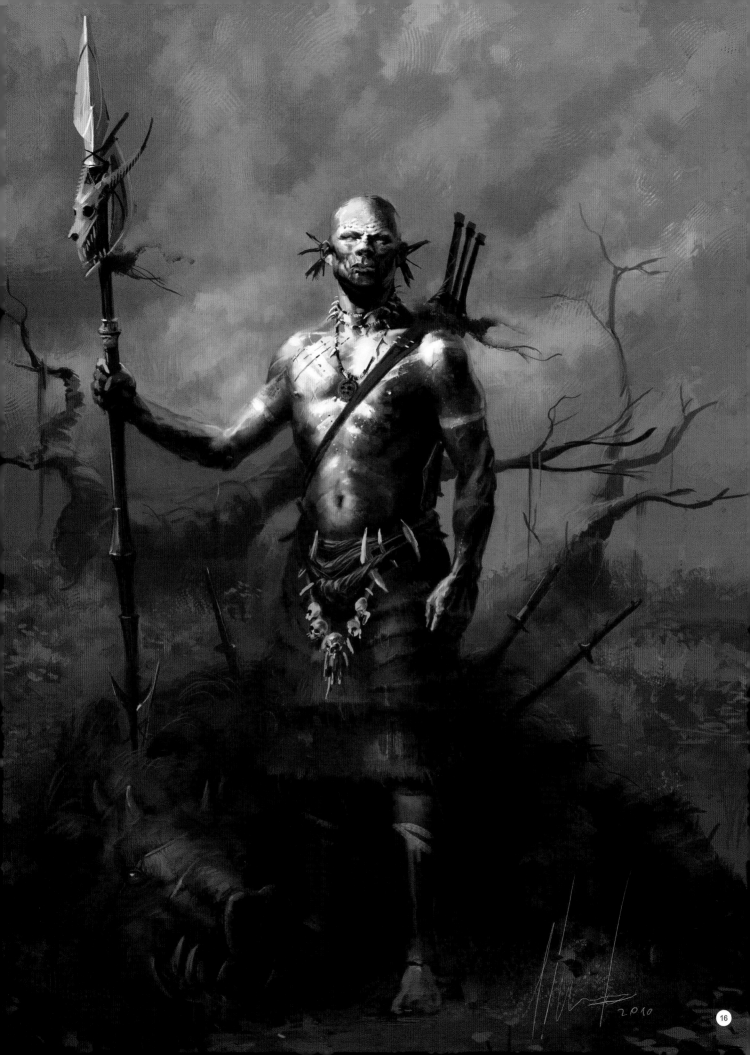

16

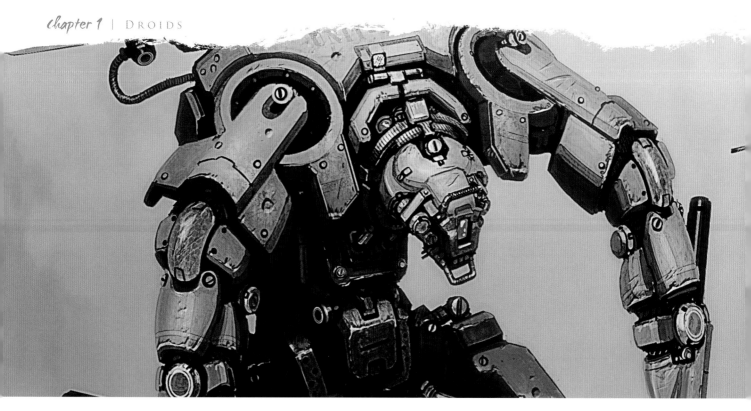

RECON DROID
BY ALEXANDER IGLESIAS

INTRODUCTION

Hello, my name is Alex. I draw mechs… a lot! Some might say it's a calling and they would be right. When you get down to it, robots are just plain fun to draw/design/model etc. It's practically a fact. The numerous aesthetic approaches one could take, the flexibility and functionally of a design and the miscellaneous cool factor that robots innately possess, mean that, at least for me, it's always been a fun endeavor. In the case of this image, the goal was to create a scout droid of some sort, so let's go on and explore that. The tools I used were an Intuos 3 Wacom tablet, Photoshop CS5, and various brushes and textures.

CONCEPT

While not always a necessity (as it very much depends on if the piece is for fun or a client, as well as how much familiarity you have with the genre) it often helps to stop and really think about what elements your design ought to have. Just mull things over for a bit. Think about what kind of role this scout is supposed to fulfill, what sort of equipment and configurations of parts it would need, and what the relative level of technology this design is supposed to be a product of.

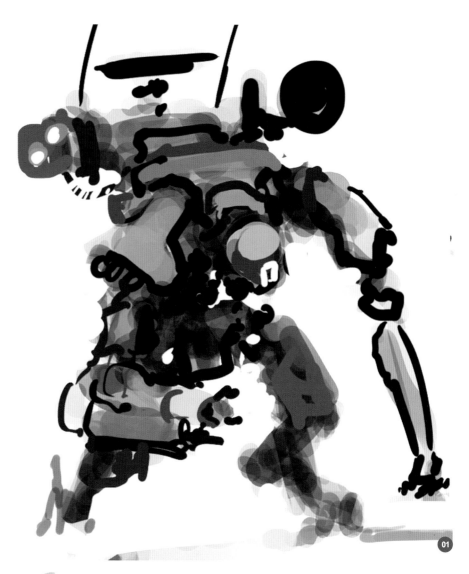

01

When I starting thinking about scout droids the first thing that came to mind was something lanky, lightly armed and armored, with a considerable amount of spotting gear and electronic countermeasures. Something that looked like it would have only just enough protection and armament to affect a speedy escape. In terms of relative tech level, as a matter of preference I went for something that would look like it could potentially exist somewhere within the next 25 – 50 years.

> I BEGAN BY REINING IN THE SHAPES, DEFINING THE ANGLES OF VARIOUS PARTS AND FURTHER DEVELOPING THE LOOSE SKETCHY SHAPES UNTIL THEY HAD A CLEARER FUNCTION

SKETCHING
After brainstorming for a few minutes I started messing around with various different silhouettes straight in Photoshop. When doing these I kept the requirements of the design in mind as I played with various shapes, poses and body configurations. More often than not if you go this route it might feel like taking a Rorschach test at the same time as you're creating one. As the silhouettes develop you should start visualizing the relative placement of parts and features, and begin extrapolating their general placement. In the case of this particular droid, I ended up going with my second design, as it seemed to convey the scout feel the best.

With the sketch decided upon I started to make a few subtle experimentations in black and white for the pose and form. These included shrinking the left arm a small amount and seeing how the image might look running instead of standing. While there is always room for adjustments later, it does help to sort of settle on a basic form from the outset (**Fig.01**).

DETAILS
Now I started the clean-up of the sketch. I

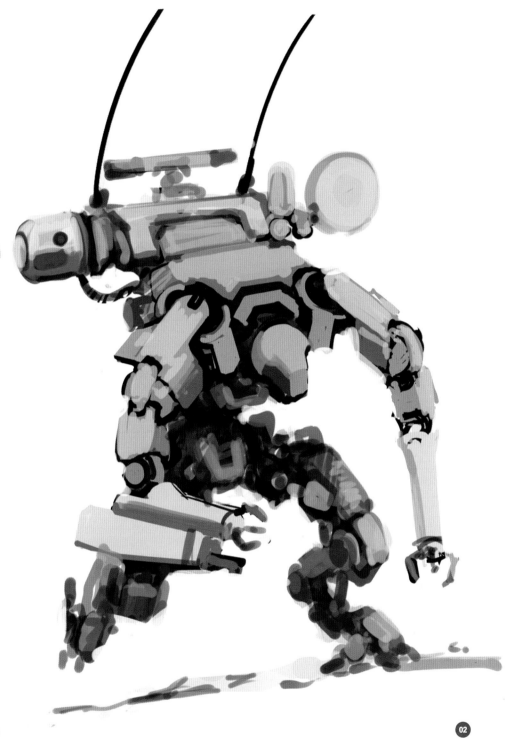

02

began by reining in the shapes, defining the angles of various parts and further developing the loose sketchy shapes until they had a clearer function. I established a particular shade of gray, which would become the relative base tonal value of the design that I would work off of later. I also made adjustments to the pose and proportions, as the hip area was not looking all that great to me anymore and the left arm felt too long (**Fig.02**).

As I continued I made further adjustments and alterations as I transformed the rough shapes of the design into more detailed forms, moving steadily into the detailing work. I also returned the pose to the original sketch's standing position as I felt it worked better.

ADDING COLOR
With the main figure more or less settled upon it was time to begin establishing the

environment surrounding this scout (**Fig.03**). Considering its scouty nature, I felt that the implication of an overlook of sorts would be fitting, and considering the machine's splayed feet and long flexible arms, it seemed suited towards picking through broken and potentially unstable terrain. So I went for a desert ruins motif. At this stage, I took a sandy yellowish color and applied it as a Color Burn layer to the entire image to set the basic starting hue.

> ## FEELING THE NEED TO HAVE SOME SPOTS OF MORE SATURATED COLOR IN AN OVERALL UNSATURATED IMAGE, I DECIDED TO GIVE THE DROID A BRIGHT ORANGE EYE

Continuing onward I began to add additional line work-type details, refined the shapes further and adjusted the position, size and angle of the droid's left arm. Feeling the need to have some spots of more saturated color in an overall unsaturated image, I decided to give the droid a bright orange eye (**Fig.04**). In order to establish a more defined set of shadows and highlights on the droid, I roughly painted into two separate Overlay layers – one white, the other black – where the general highlights and shadows were to go. I then used Gaussian blur to soften both layers and reduce their opacities.

Following that I copied and merged the image into a new layer and desaturated it completely. Then, using the Dodge and Burn tools as well as the Level Adjustment tool, I tweaked the overall contrast before setting the layer type to Overlay. I also significantly decreased the opacity so as not to make the design too contrasted.

At this stage it felt like the design needed to be made crisper, with slightly sharper-looking edges. To do this I copied and merged a new layer and used the High Pass filter, then set the layer type to Overlay, thus causing edges over the entire image to come in a little sharper.

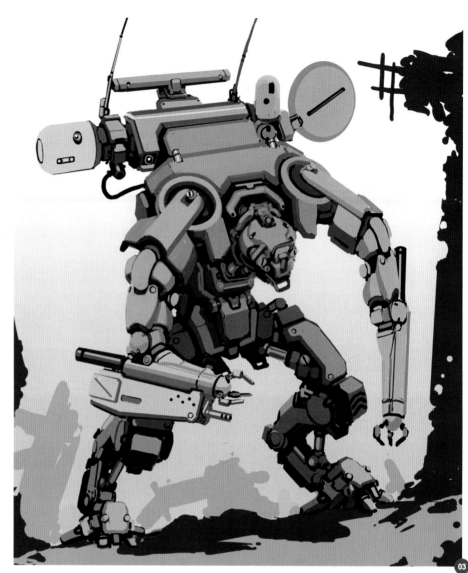

03

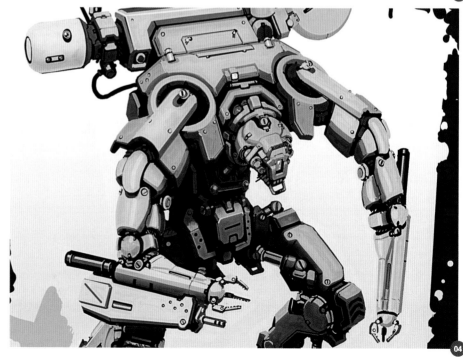

04

At this point I began to poke around the image looking for small details to correct/add and rough areas that could stand to be refined.

> THIS STAGE OF THE IMAGE'S DEVELOPMENT FOCUSED PRIMARILY ON ESTABLISHING SOME OF THE ATMOSPHERE IN THE ENVIRONMENT THAT THE DROID WAS STANDING IN

Later secondary and tertiary colors/tones were added to the droid, namely as orange striping and bare gray metal surfaces. In order to accent the edges further and brighten up the design a small amount, the image was copied and merged again, run through an Accented Edges filter, set to the lighter color layer type and dropped significantly in opacity so as not to be overpowering (**Fig.05**).

Although I continued to add small details and make slight tweaks, this stage of the image's development focused primarily on establishing some of the atmosphere in the environment that the droid was standing in (**Fig.06**). Using various sand and dirt textures set at a low transparency I was able to establish the terrain in the foreground. Various cloud textures were re-purposed as drifting smoke by adjusting their hues and transparencies. I set one layer to Soft Light, one to Overlay and a third as a subtraction layer, as this gave the impression of a bit of light bleeding around the sides of the figure. Additionally the entire image was copy merged and run through a darker setting of the Accented Edges filter to get more of an overall grittiness. Then the opacity was dropped. At the end of this stage the image was looking rather dimly lit.

Next I began to add weathering, scratches and bullet holes for a little extra authenticity. This was done via setting a layer to the Color type and then, in the blending options, I adjusted the Bevel and Emboss sliders as well as using a grimy metallic texture with the bevel/emboss

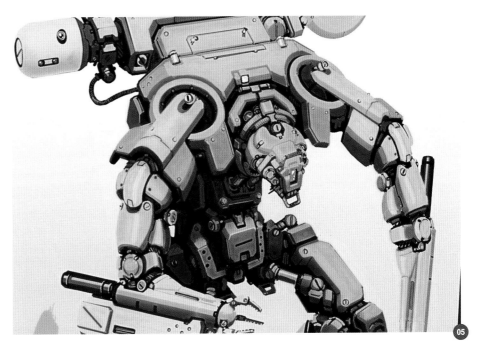

05

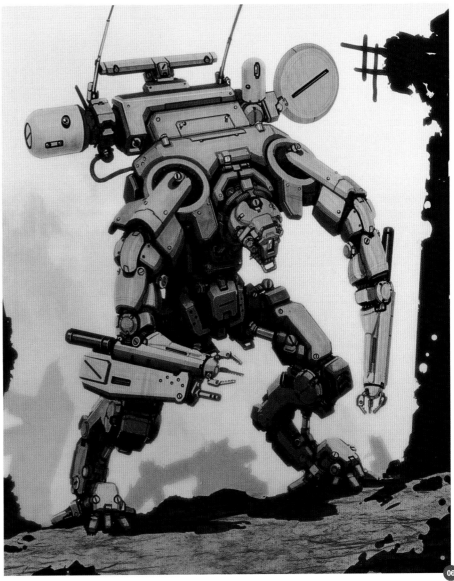

06

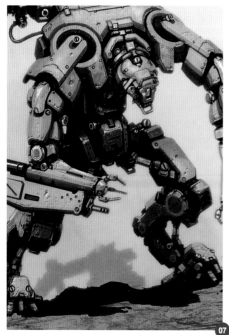

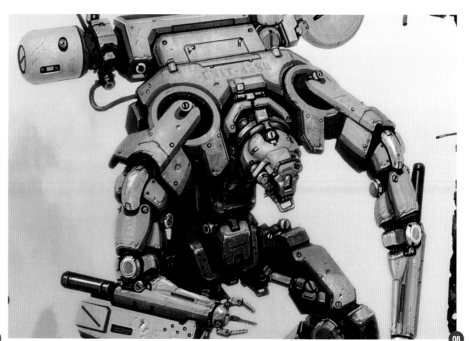

effect. I then began to paint scratches and dings in the most logical places. For example, near joints, on areas that would likely bump into things and areas that I just wanted to look battle-damaged to some extent.

In light of the overall dimness of the image, I used some Overlay layers and bright colors to make certain areas pop out more brightly and add color and highlights to the bare metal surfaces, as their specularity would be higher than the painted metal, and thus would take a hint of color from their surroundings. Also time was taken to use dedicated circle brushes to clean up some of the more irregular hand-drawn rivets, joints, bolts and assorted round areas (**Fig.07**).

At this point I was happy with the droid (though I did end up slapping a unit designation decal on it), which meant I could concentrate on achieving a good look for the rocks and broken ruins surrounding it. This was done by taking various images of broken concrete and resizing and reshaping them to match the breaks and cracks in the original silhouettes. I then erased the parts that were necessary. Certain foreground rock shapes were redone completely to make them fit the image better. The layers were color corrected from their original tones to match the sandy yellow hue of the rest of the image (**Fig.08 – 10**).

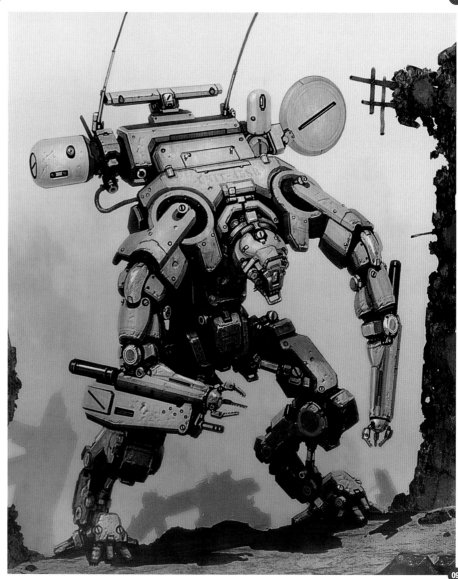

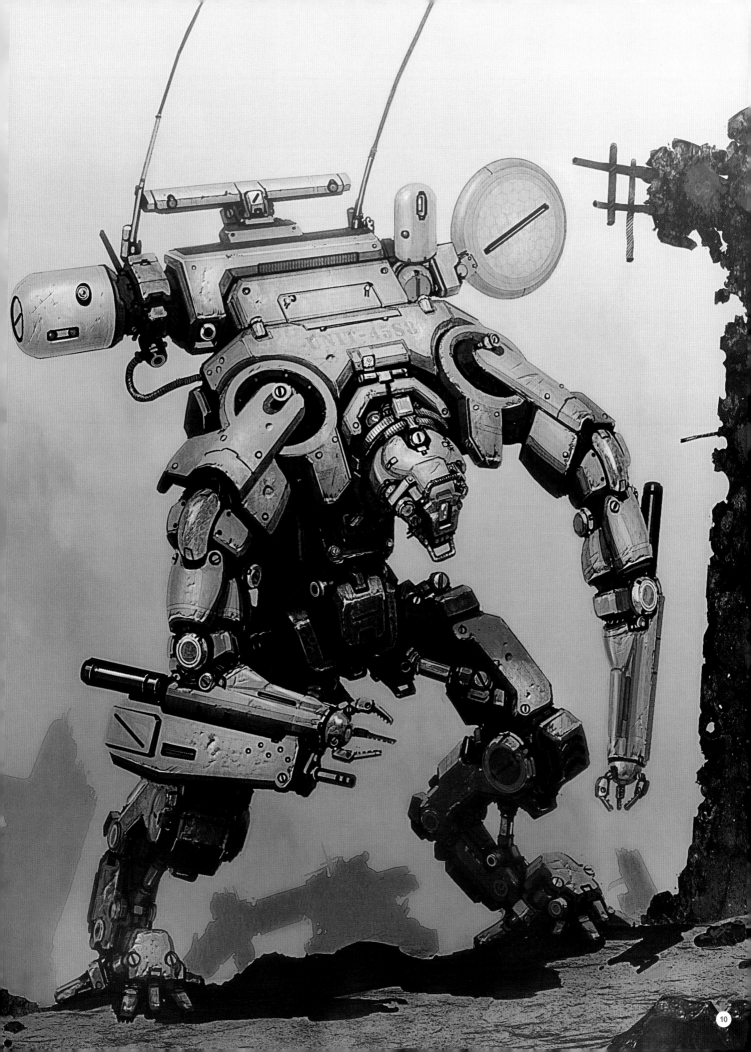

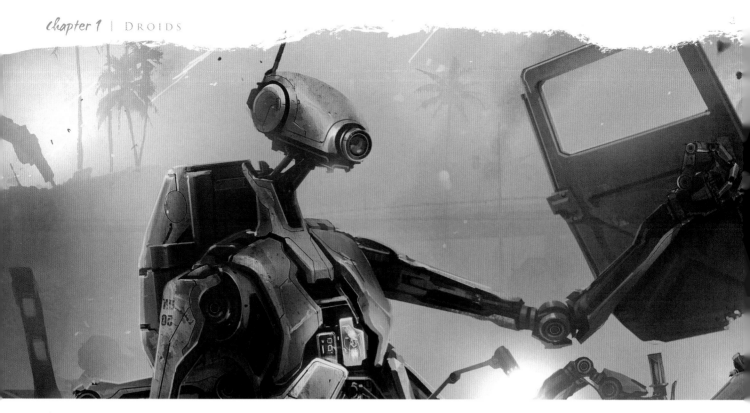

MEDI DROID
BY JEREMY LOVE

INTRODUCTION

In my opinion, the most important things to
learn when working for a games developer
are how to follow a brief, and how to develop
a style or closely follow an existing one.
A concept artist's job is not only to come
up with something visually appealing, but,
more importantly, it's to create an asset
that is functional, scientifically viable (or
at least believable) and which is based
on the parameters of the game's plot. A
process needs to be followed that enables
the art director (AD) to give ample feedback
throughout the development, and that also
makes the 3D modelers' jobs as easy as
possible. The more information supplied to the
modelers, the faster the model moves through
production. The concept artist has a huge
responsibility early on, hence the importance of
following a solid design pipeline.

I've written a short brief similar to that which
an AD would supply. The following steps are
based on a pipeline that – in its most basic
form – can be found in any games company.
This method is one that has worked well for
me. I've also added approximate times for a
typical work day as a rough guide to what is

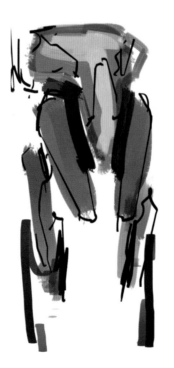

expected. Some artists are slower and some
are faster, but this is roughly the pace I work at.

DAY ONE: 9:30AM – BRIEF

The AD has requested a medical droid for
the front line level of our game. The setting is
Earth, approximately 2050, and a variety of

droids assist military efforts on the frontline.
The medical droids are used to assist injured
troops and they have GPS and communication
abilities to locate injured soldiers. Every soldier
has an encrypted tracking device that links
them with the medical droid and this device is
activated when needed. The primary function
of the droid is to locate and assist the injured

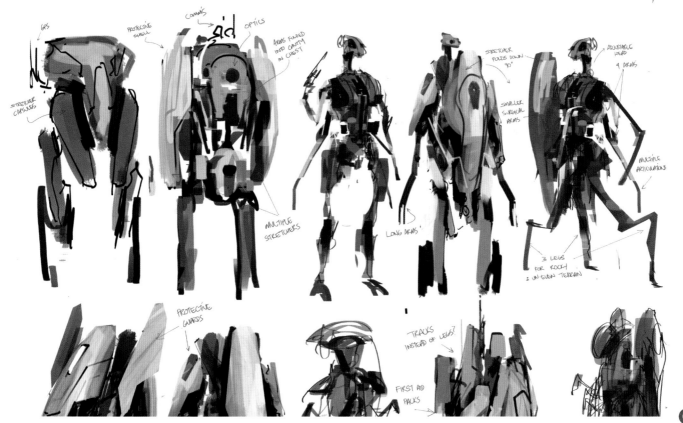

soldiers and, if need be, operate on location and safely transport the injured back to base.

In terms of design, the droids should be futuristic (not too slick and curvy), but still in-keeping with current military designs. Some organic shapes should be present for specialty areas, but they need a mostly hard and solid construction. Special metals and hard plastics should be used.

> ## IT'S IMPORTANT TO LET YOUR IDEAS FLOW ONTO THE PAGE WITHOUT JUDGMENT OR OVER-THOUGHT

You can't always hope for an in-depth brief, but basically the more information you have up-front the better your design is going to suit the game, therefore hugely cutting down on revisions and even do-overs.

DAY ONE: 10:00AM – RESEARCH

Research is the part I really enjoy. I learn about all sorts of subjects I would never usually read

about. It's also the best place to start. To assist you in your research, it's a good idea to first break down the brief into key words. That way you will cover everything in your design.

Here is my interpretation of the key brief points:

- Year 2050
- Frontline military medical droid
- Some curves, but mostly rigid construction
- Main appendages protected with high density composite cowling

Should have the following:

- Visible GPS and communications systems
- Transportation device for injured soldier (possibly stretcher)
- Arms to perform tasks such as lifting body, moving debris and performing surgery
- Audio and optical

At this point I then start looking for references on Google Images, using keywords that address each of the bullet points from the brief breakdown: army medic, military surgeon, military robot, army stretcher, medical robot and so on. I then compile all of the reference

images into one in Photoshop (PS) and place it on my second monitor. That way, it's always there so I don't stray too far from the brief when working on my thumbnails.

DAY ONE: 11:00AM TO 12:30PM – THUMBNAILS: FIRST STAGE

When starting thumbnails it can be difficult to get past the initial blank page. It's important to let your ideas flow onto the page without judgment or over-thought. Otherwise you can get caught up in detailing a single concept and before you know it, hours have passed. Panic of a deadline sets in and productivity drops.

There are many methods of starting thumbnails, from blocking in silhouettes to using random shape brushes. The method I prefer is simply to use a large brush to block in rough shapes, and then define them with quick lines and shadows. To save time when selecting brushes, I put the ones I use the most at the top of the brush selector menu (**Fig.01**).

I usually start with an A4 landscape page and rough out about six to eight shapes in two rows (**Fig.02**). I try to make each thumbnail

different, but sometimes find that once the first few shapes are created, an idea starts to form and this stops the flow of new ideas. It's difficult to move past the urge to do variations on a single design, but it's a good idea to try. Some ideas will be terrible, but it's important to work through as many as you can. It's just as useful to show ideas that don't work as ones that do. Bad designs also make the good ideas stand out. If a co-worker comes to look at your progress, it's much better to have a page of rough scribbles than only a few detailed ones. The AD will be able to see your thought process and let you know if you are heading in the right direction. It's a starting point and if the direction changes, you haven't wasted your valuable time and can quickly amend the roughs.

> IT'S GOOD TO USE A FEW SIMPLE COLORS TO HINT AT DECALS, GLASS AND ARTIFICIAL LIGHT SOURCES

When working in a games studio, it's common for leads and ADs to be watching your progress from their own desks over the network. It's handy to add little notes to reinforce what you are thinking so your working drawings are not misinterpreted early on. You could save your initial work locally of course, but leads often ask for you to work on the server for this reason. So, it's quicker to scribble a few notes as you go, or even paste an image to show what textures you are thinking of rather than painting it.

DAY ONE: 1:30PM TO 5:00PM – THUMBNAILS: SECOND STAGE

Once you feel you have some good ideas down and the lead is happy for you to continue, you can add some detail and better define the shapes and surfaces.

A method I use a lot when I'm painting digitally is to first break the object into readable chunks of light and dark values; light being the main chunk or section of an object and dark being

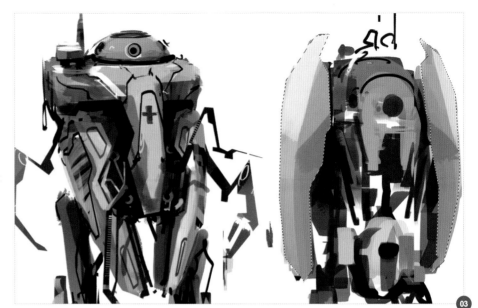

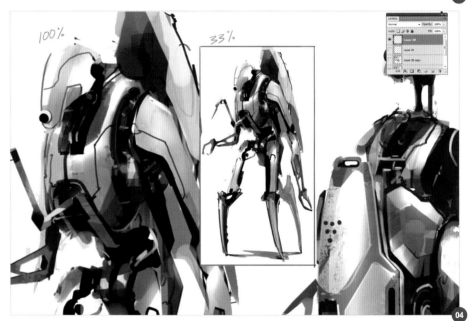

the recessed area in between (**Fig.03**). I do this by using the Polygonal Lasso tool (L) to mask an area. Using a large flat brush I then lay in some basic values, similar to that of a base 3D model with global lighting. I then invert the selection using Shift + Control + I and block in the darker areas. At this stage I'm working at 33% zoom.

Fig.04 shows a comparison between 100% and 33%. I find it easier this way to keep an eye on how the design is reading as an object from a distance, and to determine how the light and dark areas contrast with each other. Any closer than this and the detail is largely pointless as thumbnails are often only viewed

all at once on a screen or printed onto an A4 page. No one is going to be zooming in to look at detail at this point. Thumbnails are about the basic design.

Once the basic shapes are defined, I can then suggest detail with quick lines and break up the panels with joins and creases. It's good to use a few simple colors to hint at decals, glass and artificial light sources. I then lay in shadows with a large flat brush using complete black at 100% opacity. If you don't press too hard, you will achieve a nice shadow effect with single strokes. The standard Round Flat brush does a good job for this, but I find that textured brushes such as Chalk do just as well.

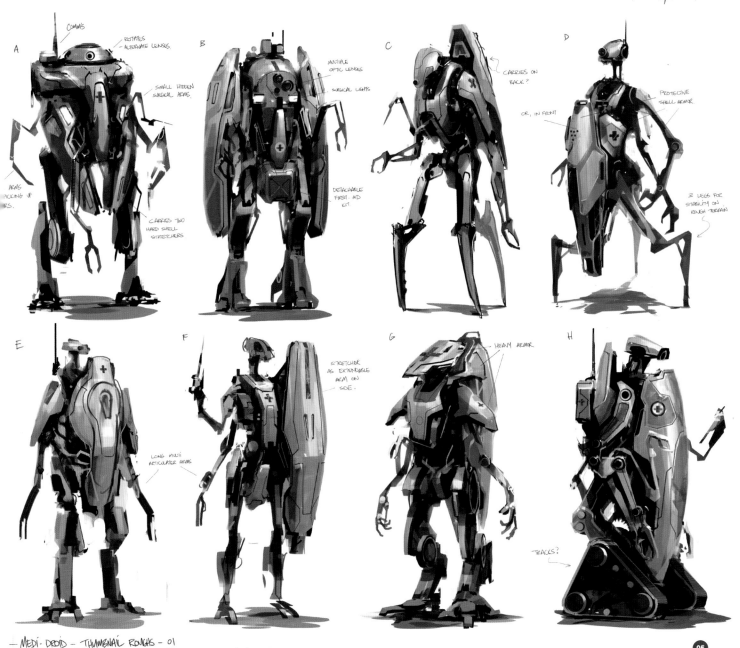

— MEDI-DROID - THUMBNAIL ROUGHS - 01

05

To add highlights I like to start with a flattened layer. Select all (Ctrl +A), then Copy Merge (Shift + Ctrl + C), then Paste (Ctrl + V). I do this because I use the Dodge Tool for highlights and I like it to affect all of the layers.

Using an airbrush with the range set to Mid-tones, I drop in some quick down light. I then change the range to Highlights and use a smaller brush to pick out high contrast areas. I like to add extreme light right next to shadow areas, which emulates a trick that light plays on the eye. If the objects are looking too washed out here, I create an adjustment layer set to Selective Color. I then set the colors to whites

in the menu and slide up the black until the balance is right, maybe introducing a little bit of yellow as well.

To finish off it's always good to add some notes if you haven't done so already and label the thumbnails with letters or numbers. This makes it easier for the AD to let you know which ones are preferable (**Fig.05**).

DAY TWO: 9:00AM TO 10:30AM - FINALIZE DESIGN CHOICE
By this point the AD will have looked over your roughs and hopefully made a selection;

either one particular design with possible amendments or a combination of thumbnails. For example, he might like the top of A, with the bottom of D and the arms of E. For the purpose of this exercise, D was chosen as a suitable rough to work up.

DAY TWO: 10:30AM ONWARDS – FRONT AND BACK ¾ RENDERS
The first thing I do when working up a thumbnail into a final front and back ¾ view is roughly plan out both views beside each other. I find it's important to do this early on as it helps to determine if the back works well with the

49

front in its present state. It also allows me to see if I've missed anything in the front view that should be visible. I try to make the front/back perspective as straight on as possible to make it easier to do the orthographic views later.

The fastest way to do this is to simply copy the thumbnail and flip it horizontally. Then, by dropping the brightness and contrast to black, it's easier to imagine that you are looking at the object from the back (much like a silhouette), as there are no details to fool you otherwise.

> ❝ IT'S AT THIS STAGE
> THAT I BASICALLY
> CLEAN UP ALL OF
> THE SHAPES AND
> START TO MAKE
> SENSE OF HOW THE
> PARTS FIT TOGETHER ❞

By running lines across from key points on the thumbnail drawing, you can determine where things are placed on the back view. I also do a quick render of the medical droid with the stretcher down and the soldier inside being operated on. This gives me a good idea of what parts I need to add in order for this design to function (**Fig.06**).

The next task is to paint in the front view using the same method as described earlier in the thumbnail section, but taking more care to render surfaces a bit more smoothly. It's at this stage that I basically clean up all of the shapes and start to make sense of how the parts fit together. I often use the Elliptical Marquee tool (M) as a mask tool for arcs and circles. The thinner lines are created using the stroke function, as shown in **Fig.07**. I use Transform Selection to make the mask bigger or smaller, and also the Modify/Expand and Contract function for irregular shapes that don't transform that well.

Using the shortcuts I've mentioned so far (selecting with the Lasso, blocking in value, inverting selection, blocking in value), rinse and repeat! I work my way down the image, cleaning everything up and solving any issues I find (**Fig.08**).

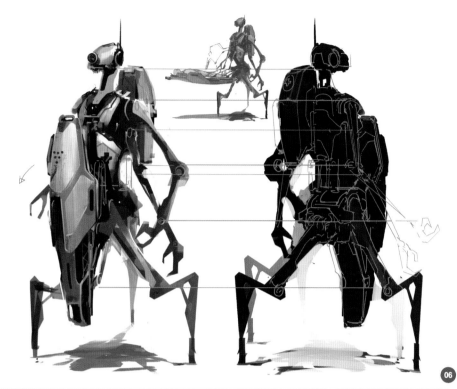

06

07

08

I do the same with the back view, constantly running guide lines across to see if everything matches up (**Fig.09**).

Shadows are created using a large flat brush as stated earlier. This time I use the Lasso tool to more accurately select the areas (**Fig.10**).

> *Quick Tip :* It's good practice to keep sections of detail on separate layers. That way it's easy to select specific parts, and add lighting or make changes later on (**Fig.11**).

It is then time for another clean-up pass and to add more detail lines and joins, making sure all of the surfaces are the right color and all of the points match up from front to back (**Fig.12**). I find that a good way to achieve crease lines is to take a flat brush and turn off Other Dynamics in the brush presets. You can then hold down Shift while you are drawing a line and just keep clicking from point to point. I use this a lot.

SOMETIMES IT'S A GOOD IDEA TO ADD SAMPLES OF THE TEXTURE REFERENCES YOU'VE USED IN BOXES TO THE SIDE OF YOUR RENDERS

I finish the front and back renders by adding some metal and grunge textures using a Multiply layer, and paint in scratches, dents and decals. Finally I flatten the layers and use the Dodge tool to add highlights, like I stated earlier. A drop shadow is created by making a Load Selection of the robot and using Transform Selection > Distort to change the perspective to ground level. A simple gray fade and it's done (**Fig.13**).

Sometimes it's a good idea to add samples of the texture references you've used in boxes to the side of your renders. This is to make sure that the modelers know exactly what type of materials you would like to use for each surface. Even if you render the object beautifully, it can still be misconstrued as another texture.

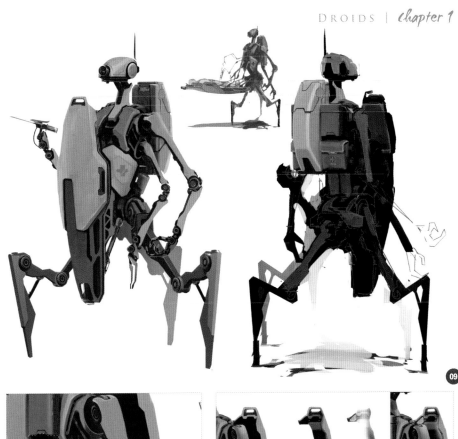

09

10

11

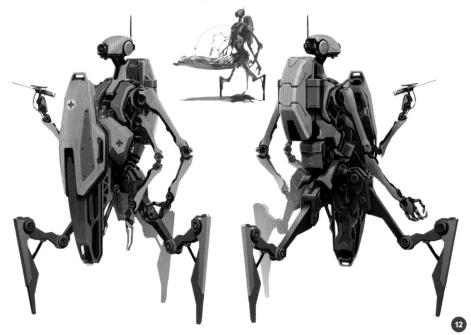

12

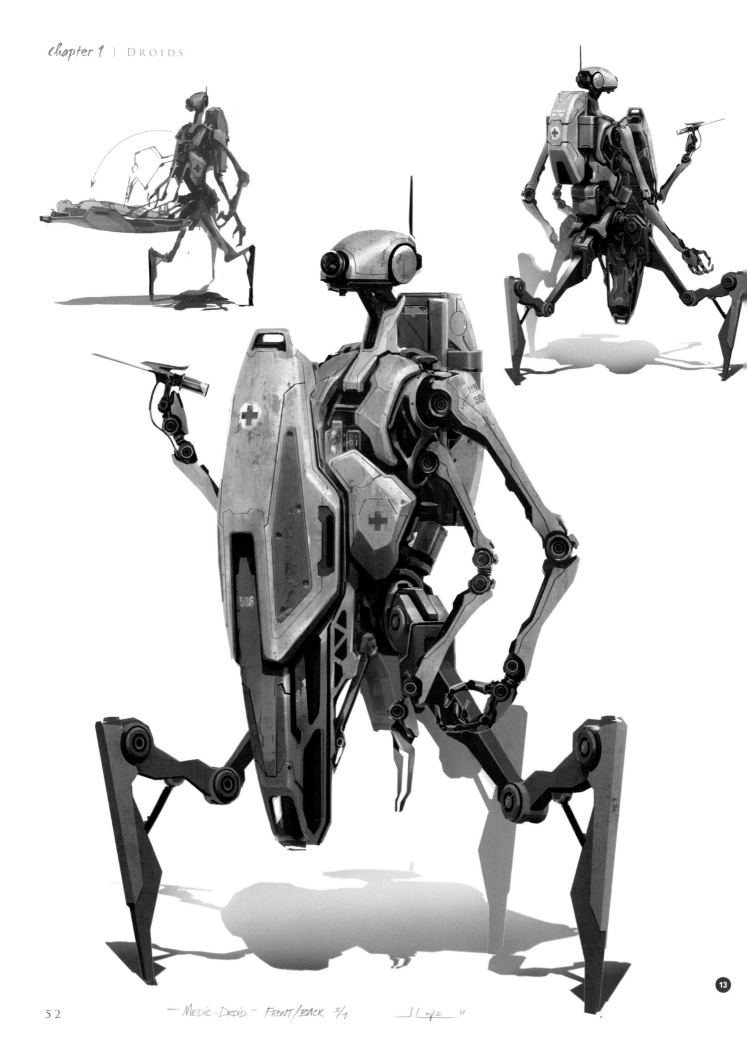

MEDIC-DROID - FRONT/BACK 5/9 J Love 11

13

DAY THREE: 9:00AM ONWARDS – ORTHOGRAPHIC VIEWS

Orthographic sheets are where all your hard work will pay off. If you have designed your object well, then this stage should hopefully be a walk in the park.

I start off by placing the front ¾ render onto the page and dropping the opacity right down. I then drop in some guide lines at key points, similar to when I was doing the back ¾ view. Rough lines are used initially to get an idea of where sections sit and how the model translates into a front view. I imagine the model turning slowly in order to get an idea of how the shapes appear when facing straight on to the viewer. Basically the side planes will become thinner and the front planes wider. You can even select some of the larger shapes from the ¾ view, drag them across and widen them slightly as something to start from (**Fig.14**).

When I'm rendering the ¾ views, I keep in mind that it would be handy to have some of the arms and legs close to the correct plane for orthographic use. This way I can simply paste them in and draw over them. The arms are bent in places so I straighten them out by moving the pivot point in Transform mode so I can rotate the arm from the right spot (**Fig.15**).

It's important to show the arms straight and have the legs side-on so that the modeler can use them to model from properly. Movable sections that cover the object, such as the stretcher and the arms, should be removed and drawn separately so that detail can be added behind them (**Fig.16**).

To get an idea about whether the front half is correct, mirror the image and make sure everything looks good before continuing. I've found that when doing orthos in the past, everything looks good until I mirror it, and it always seems to have a chunk missing out of the middle, especially with faces (**Fig.17**).

Once I have everything laid out, it's time to drop in the final line work. This is simply a matter of being more precise with lines and

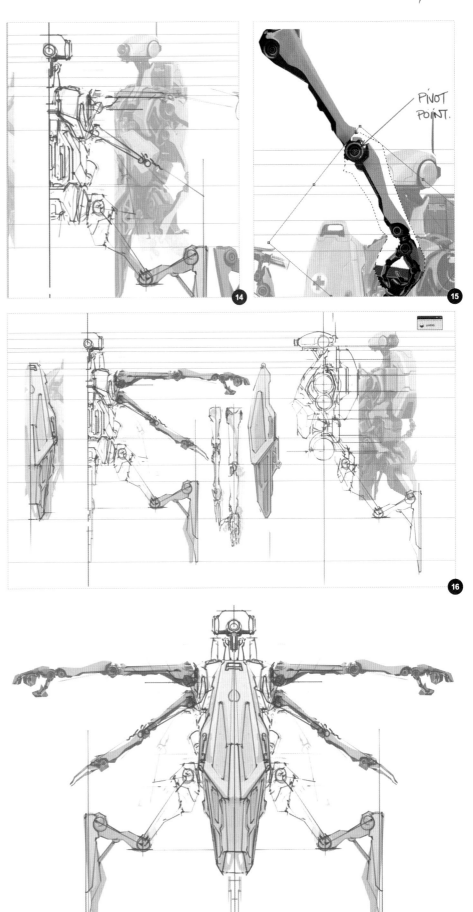

making certain that all points match up in all of the views as best as I can (**Fig.18**). It's not crucial to get everything spot on, as the 3D artists are usually very good and can fill in the gaps. Although it's nice to get it close!

Doing the side view, it's a good idea to have it as close to the front view as possible so you can easily eyeball back and forth to see where things should be going. It would take too long to make this an exact match, but as long as it's close, the modelers will love you for it (**Fig.19**).

If the arms and legs are the same on both sides, it's not always necessary to draw them twice. So I've left them off the back view to save space on the page for other sections. As you can see in **Fig.20,** I've simply drawn over a shape from the back ¾ render and will just drag it across and manipulate it if necessary. The more views you do, the more problems you'll start to find, so it's a continual process of moving lines around to make everything work.

Once I've finished the line work, I make sure that there are no gaps in the outer perimeter by drawing a single thick line around the whole drawing (**Fig.21**). The reason for doing this is so that I can then use the Magic Wand tool (W) to select the empty white space around the droid. Once this is selected, I then invert the selection using Shift + Ctrl + I, create a new Multiply layer and fill it with a light gray. I then lock the gray layer and paint in some darker areas using the Lasso tool. Finally, I use

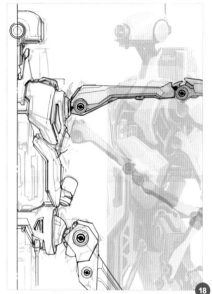

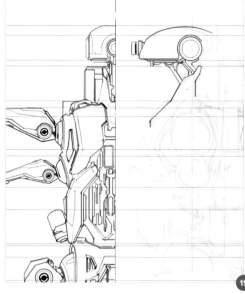

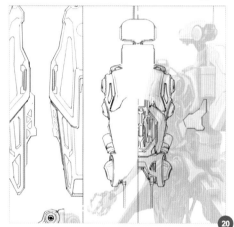

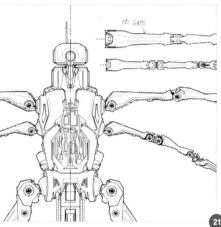

the Dodge tool to add a small amount of light for curved surfaces, label the views "Front", "Back", "Side", etc., and it's done. It's also a good idea to add a human figure for scale reference (**Fig.22**).

If you have time, sometimes it's nice to do a quick painting of the object in its proposed environment. This will help sell the idea and also be a good addition to your portfolio (**Fig.23**)!

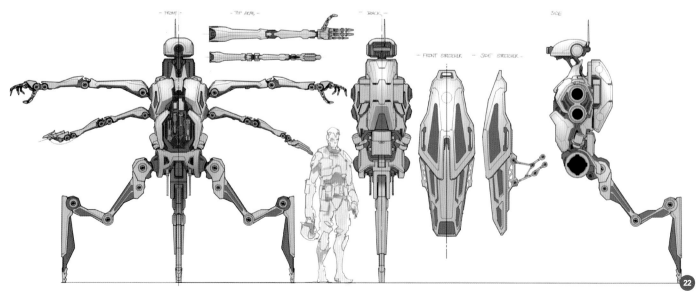

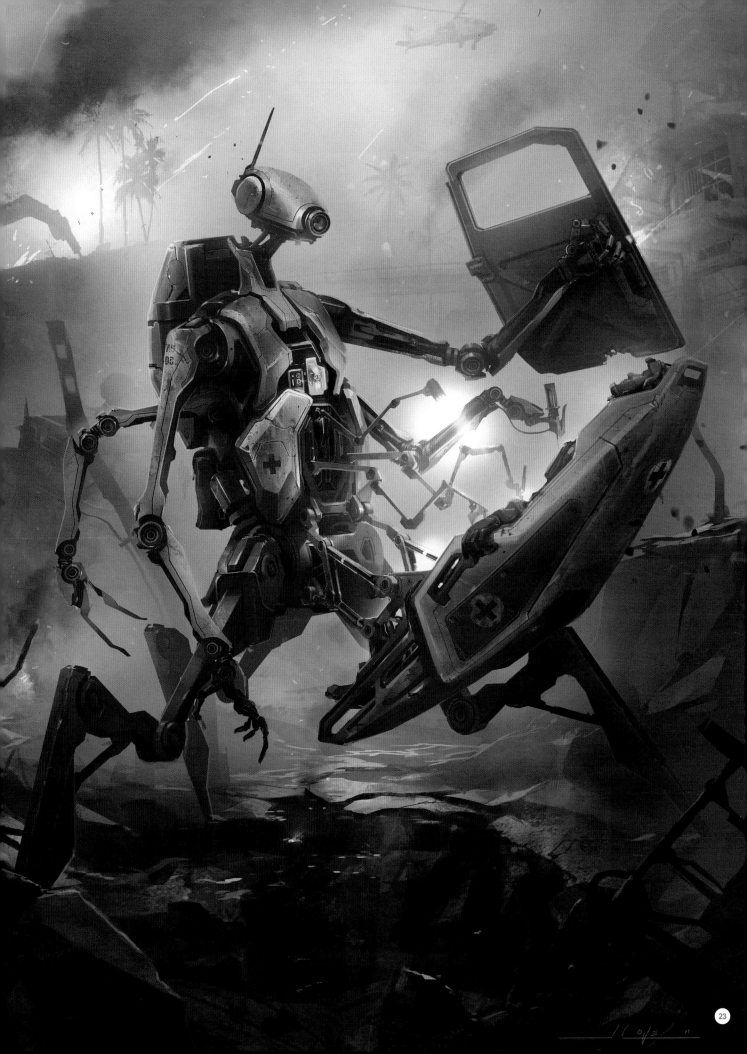

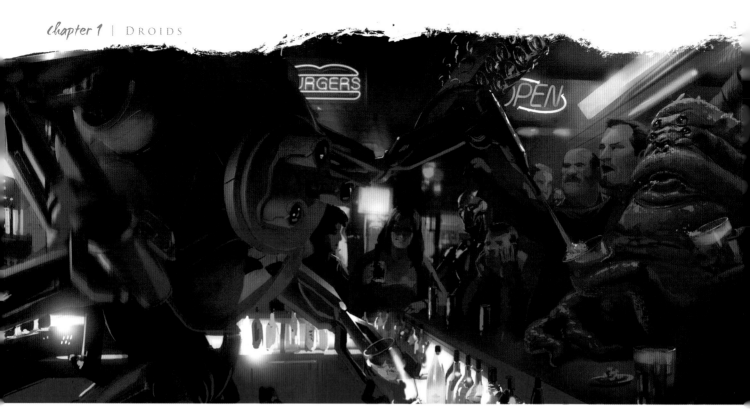

BARTENDER DROID
BY IGNACIO BAZAN LAZCANO

INTRODUCTION

This image was a great challenge to think about. When I got asked to create it my first thought was to focus on the design and draw something simple, but finally, as I nearly always do, I ended up making things much more complicated so that my work has an added value. I believe that in order to produce a more desired idea, it is necessary to be a perfectionist.

THE IDEA

I really like to wander along the streets of Buenos Aires at night with my friends, stopping for a while at any one of the numerous bars or pubs that are open all through the night. I like to enjoy a beer or a drink whilst watching a football match on the TV, or just talk to people who enjoy the never-ending journey as much as I do. From Mondays to Saturdays this cosmopolitan city offers a wide variety of places where Argentine people or visitors from abroad can choose how and where to have fun.

Looking for inspiration and references, I visited several places decorated in a modern or classical style. I also visited British and Irish

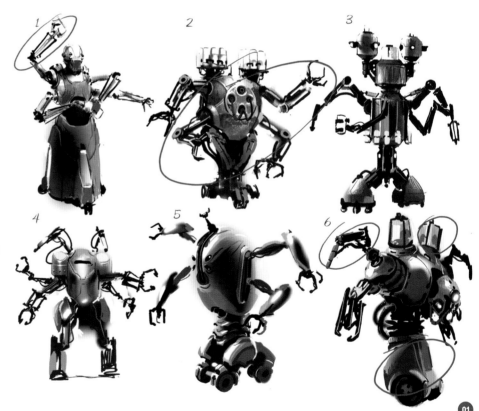

pubs where foreigners often meet with fellow lovers of beer and good football.

The first thing I did was to draw several thumbnails and sketches, to have options

available by the time I needed to start the final design (**Fig.01**). I always say that the most fun thing to do is to draw anything that comes into your mind, without any limitations. This is the way you have to work in the film and video

game industries to be creative. To encourage this creativity I start with thumbnails and sketches.

The best thing to do when choosing a single design from several concepts is to meet up with the art director, the lead artist or lead designer to select the parts that they like best from each design. That way you can link them together in a final concept.

> ## " THE MORE INFORMATION WE GIVE TO 3D ARTISTS, THE MORE ACCURATE THE FINAL MODEL WILL BE "

THE DESIGN

I decided that the best way to show a robot bar tender was in its work environment. I chose a retro 80's style, drawing a lot of influence from *Star Wars*, which is one of my favorite movies for its designs.

When working professionally in the video game industry you need to make a schematic or technical drawing of your design. This technical guide is useful for 3D artists when modeling the character.

Quick Tip: The easiest way to make a schematic is based on the ¾ view, which means we can project the guide lines in order to step to the next view. It's like moving the plan of a house to be able to see all sides of it.

The most important views are the ¾ view of the front and back. If we want, we can add the profile view and detailed plans of the areas that perform some specific functions. The more information we give to 3D artists, the more accurate the final model will be (**Fig.02**).

To understand how to make a schematic better, I made an example with simple geometric shapes (**Fig.03**).

To obtain a perfectly presented idea I tend to add a color design along with the schematic;

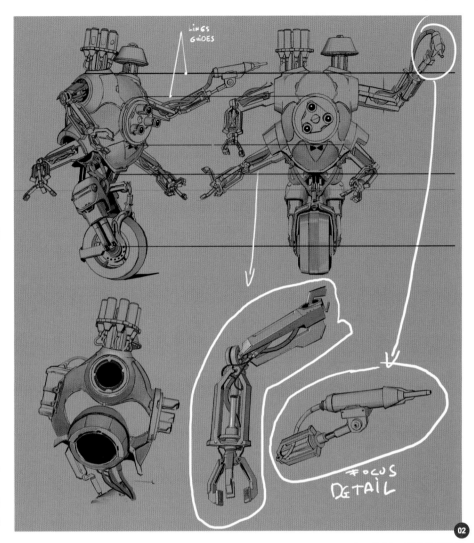

02

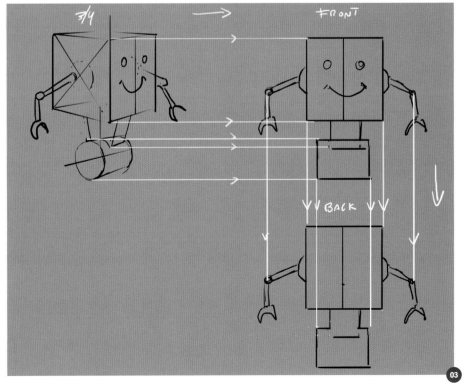

03

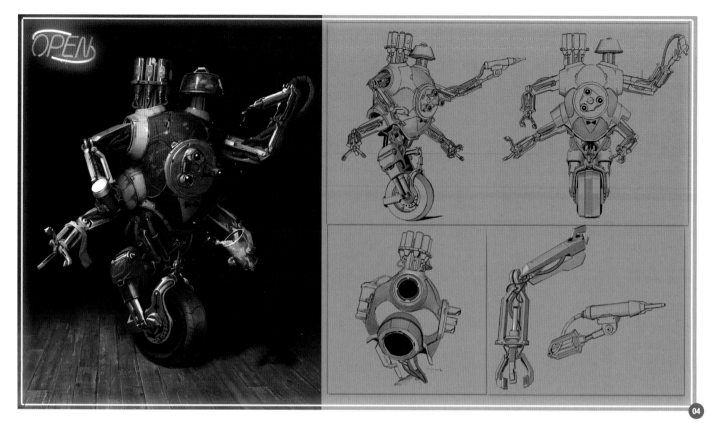

this is a more professional and aesthetic way to display your designs (**Fig.04**).

THE ILLUSTRATION

Previously I said that the first stage was the concept, the second stage was the final approved design and the last stage is marketing materials or the finished artwork. Almost all video game studies work this way. The final illustration will show the method of creating this style and how the design is applicable for all other project designs.

> ## WHAT I NEEDED WAS A SCENE WHERE I COULD FEEL AS IF I WERE PART OF THE IMAGE, AS IF I WERE STUCK IN THE SCENE

To begin the illustration I made a couple of sketches. This was to see which the best option was to see how a bartender works. In **Fig.05** are some examples of this.

I found the first sketch very symmetrical and front on without much action. The second option seemed perhaps a bit more dynamic,

but I still did not like it. What I needed was a scene where I could feel as if I were part of the image, as if I were stuck in the scene. So I went with the last option. I really like pictures that have photographic effects like films do, or make me feel as if I were interacting within the scene.

Once I knew which scene I was using, I began to add detail to the sketch on a new layer; I enlarged the image and began to polish it completely (**Fig.06**).

The next step was to set the background color; this is the base to add colors to each element

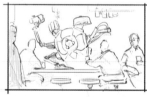

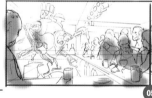

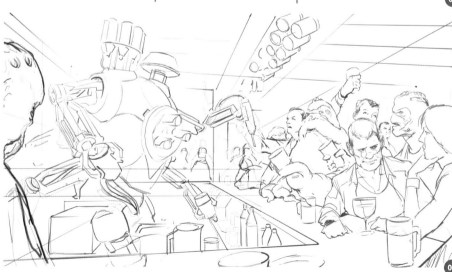

of the drawing. In this case I went for red, which influenced all of the other colors.

When a drawing is very complex I usually define volumes in black and white or, in this case, using the base color. I found that drawing the robot was very difficult. That is why I detailed volumes in a single color first, so that afterwards it would be easier for me to add final details (**Fig.07**).

To accurately define geometric objects, in this case the bar and walls, I used the Magic Wand tool towards the vanishing point. I painted with a mask to create a well-defined and neat edge. You should always use a vanishing point as a guide to give a perfect finish to all your surfaces and flat edges (**Fig.08**).

> ❝ TO WORK
> PROFESSIONALLY,
> YOU DON'T NEED
> TO BE AN EXPERT IN
> DIGITAL ART. AS YOU
> CAN SEE, ALMOST
> EVERYTHING I HAVE
> EXPLAINED CAN BE
> DONE WITH A SIMPLE
> BRUSH TOOL, MASKS
> AND A FEW LAYERS ❞

COLOR

Once I have defined the basic plans of a drawing I start with color, creating a new layer in Normal mode, and from there I begin using a brush at 70 to 100% opacity.

When painting a scene like this I guide myself by using the lights that are in my picture. In this case there was an orange light in the top right and a blue light coming from the bar in the bottom left. The blue light was going to have an effect on the robot's base, since it was coming from below, and at the same time it would touch the top of the face and hands of the people leaning on the bar (**Fig.09**).

As I always say: paint the light to show the shape of the individual elements in the scene. If this isn't considered carefully the image will look wrong.

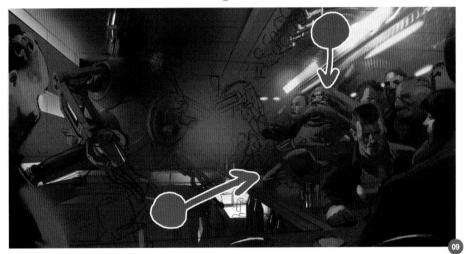

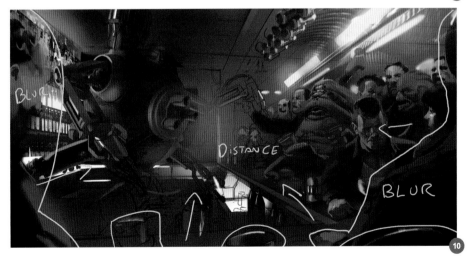

To achieve a photographic effect while giving depth to the picture I placed objects further back and out of focus. This creates the illusion of being inside the action, as if we, the viewer, are taking the photo (**Fig.10**).

CONCLUSION

To work professionally, you don't need to be an expert in digital art. As you can see, almost everything I have explained can be done with a simple brush tool, masks and a few layers. The important thing is to have a good foundation of traditional drawing and a lot of patience. I spent two weeks just thinking about the idea behind this image before I was ready to draw it.

Always keep in mind the way in which you will present your image. Making sure it's different from other art will give you the opportunity to get noticed.

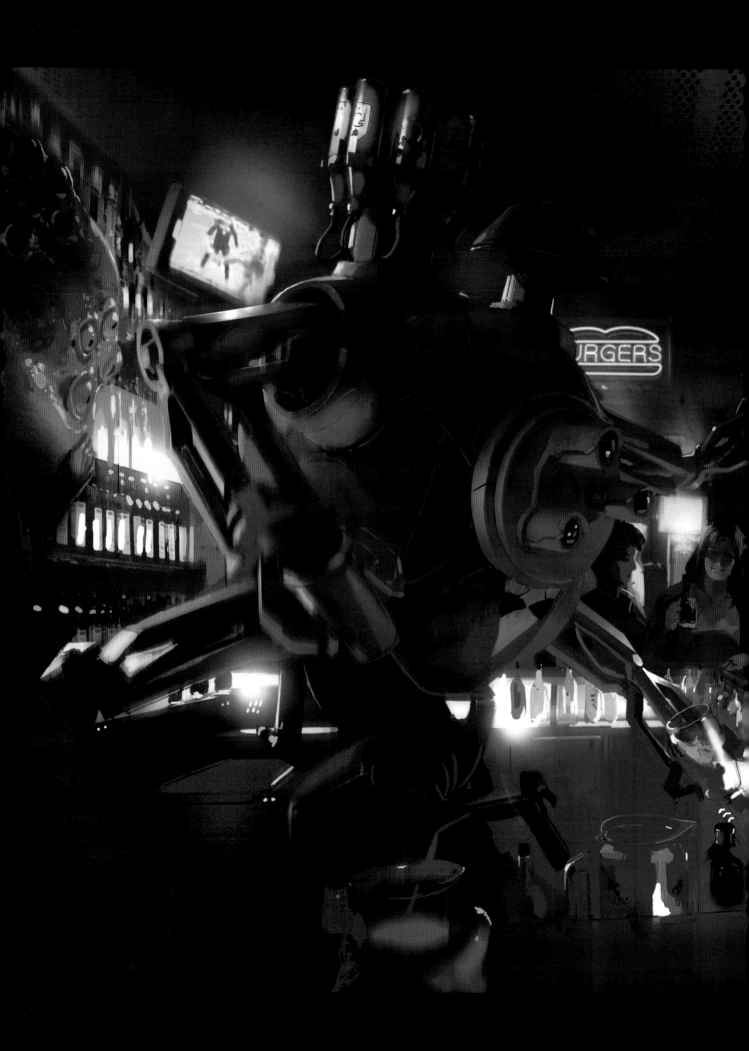

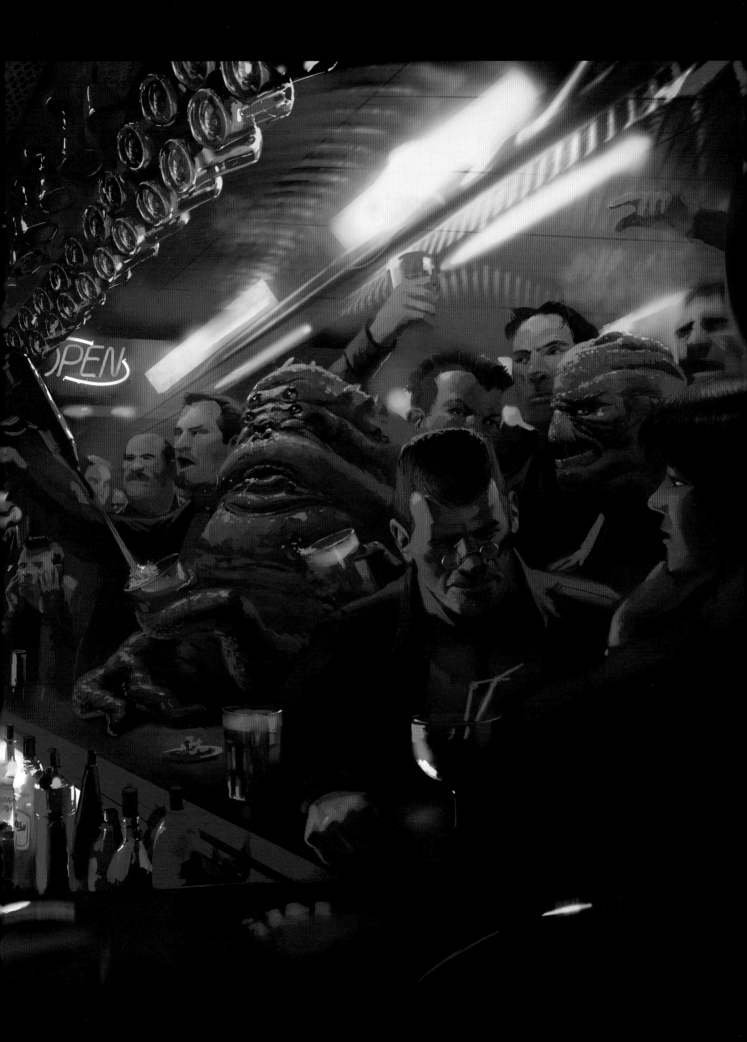

DEMOLITION DROID
BY JUSTIN ALBERS

THUMBNAILS

I thoroughly enjoyed working on this tutorial
and was pleased with how it turned out! I'd
like to show my overall working method for
completing these pieces in Photoshop, as well
as communicate a little of my thought/design
process.

Since the main purpose of a demolition droid
is to destroy things (hopefully in a planned and
organized way), I started out creating a few
thumbnails that demonstrate this objective. I
wanted it to read as a droid and not as a mech
or battlesuit.

The droid would need to be durable, small and
somewhat stealthy, maybe able to fly/hover, or
maybe be built to roll over all types of different
terrain. Perhaps the droid could be equipped
with tank treads or multiple sets of wheels. In
the end I decided a design that hovered was
best as this meant the droid could go anywhere
and wasn't limited by terrain or blockades,
making it very versatile in combat.

The design needed to be durable enough to
take a few hits and still function, so I chose
thumbnail B in **Fig.01** as it seemed the most

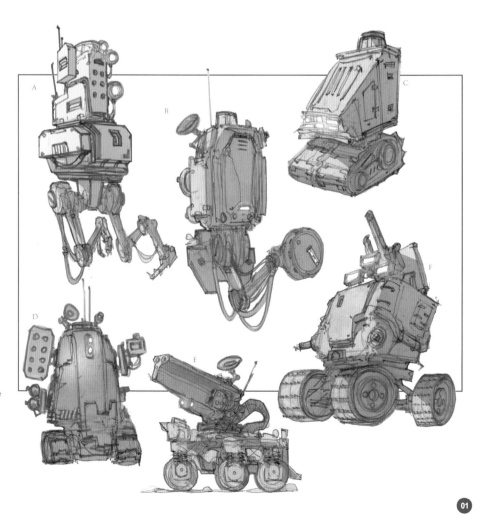

suitable. The main body was a sturdy case that held small explosives operated by a small arm. This arm could place the explosives strategically to maximize the bombs' potential to destroy a structure or vehicle. To aid in the placement of these explosives, a cutting torch was added to slice through metal bulkheads and doors. Lastly, missile launchers were added so the droid could defend itself or remove obstacles.

ILLUSTRATION

Next, I started planning my illustration (**Fig.02**). I wanted to show the droid in an exciting scene so I decided to paint a squad of demolition units powering forward, carrying explosives ready to be planted. I also wanted to show its missile launchers deployed and firing (indicating that there are enemy units ahead of it). I felt this model of droid would be particularly effective as a squad hitting multiple targets at once, striking quickly before the enemy can regain ground.

I started drawing out some quick compositions based on this squad mentality until I arrived at the one I was happy with. From there I created a rough drawing of the scene and blocked in my basic shapes. I created an extremely rough proxy model of the piece in Google SketchUp, just to get some rough perspective lines in there, as well as a 3D feel. I tilted the droid to give it some force and some dramatic appeal, and then added in a few more rough perspective lines to help me do an accurate underdrawing.

I frequently flipped the image and kept an eye on my Navigator window to be sure the piece read well when small in size. Now that I was somewhat satisfied with the overall design, I started to indicate my lighting and values. I wanted the front droid to be dark against a background of fog and explosions (**Fig.03**).

COLOR

Next, I concentrated on picking a color palette (**Fig.04**). I wanted the piece to be mostly warm, indicating explosions and fire around the squad of droids, but I also wanted to add smoke from the burning targets to bring in some cooler

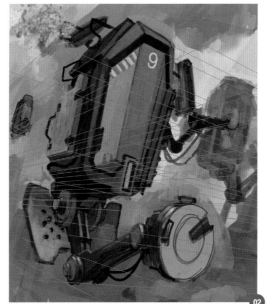

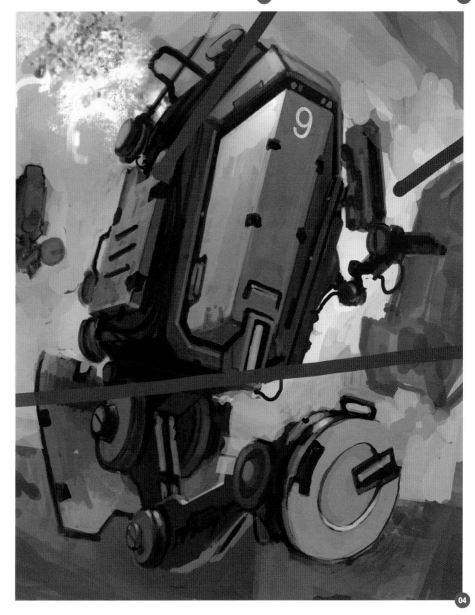

hues. To add more action I eventually wanted some enemy fire crossing (indicated by the red lines) over and behind the main droid to give the piece a little more depth.

I then went on to refine the design, color and lighting. I will usually concentrate on both defining the design and continuing the actual painting at this point. I looked at many military references for color and decided my battle would take place out in some oil fields of a desert or plains. The main body of the droid would be a brown/tan color so that it blended in with this particular environment (**Fig.05**).

> ## A FRIEND OF MINE SUGGESTED THAT THE MAIN DROID NEEDED SOME SMALL DETAIL ADDED TO MAKE IT REALLY STAND OUT AND GIVE IT CHARACTER

I toned down the saturation of the entire painting a bit because I felt that the color was getting a little too bright and vivid for a war scene (**Fig.06**).

Fig.07 shows how I continued to tighten up the piece, defining my edges on the main droid as well as the other robots and structures in the background. I wanted the ground to be on fire to give a very warzone-like feel, which would allow me to add some light from beneath to make the droids stand out from the background. I also fixed a few perspective issues here and there as I saw them.

A friend of mine suggested that the main droid needed some small detail added to make it really stand out and give it character (warning signs, ID numbers, logos, etc). I came up with a logo for a fictional military group, as well as caution symbols and danger signs to put around the engines (**Fig.08**). For some scale reference I added in some handlebars on a few of the panels. Extra scratches, grime, texture overlays, dirt around the edges, and some blast marks were also added to push the droid's battle-worn appearance (**Fig.09**).

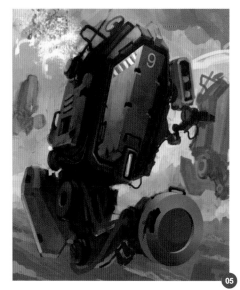

05

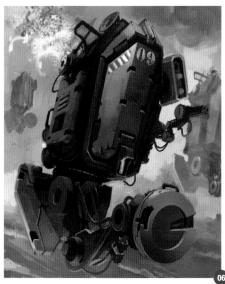

06

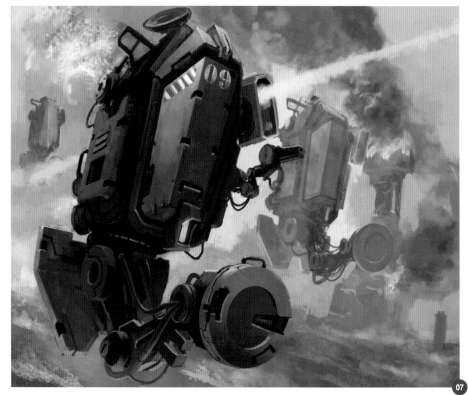

07

08

09

I made a few last minute lighting tweaks, cleaned up some of the edges on the main droid, added detail and texture to it, and brought the enemy fire beams back into the piece (**Fig.10**). With that I felt like the picture accurately illustrated the basic idea of what a demolition droid does – blows stuff up! – and I called it done.

When the design and illustration were complete I created some technical drawings by projecting details from the original design. This ensures that all the main features are in the correct place and that everything is proportionate (**Fig.11**)

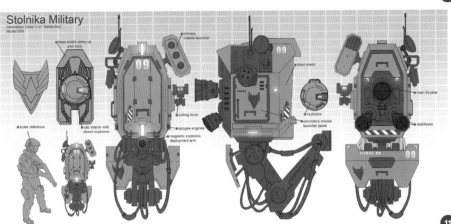

Stolnika Military
Demolition Droid 'Y-31 "Battle Box"
Model 009

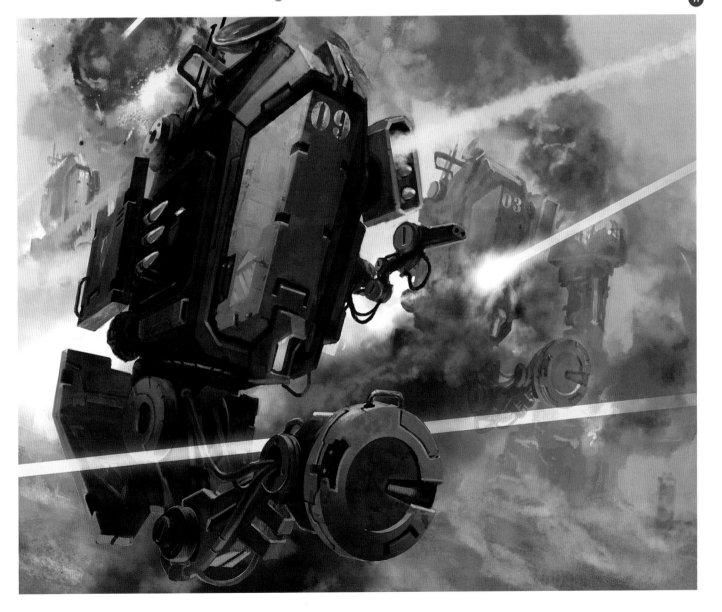

P L E A S U R E D R O I D
BY CARLOS CABRERA

INTRODUCTION

Stressed? Does your back feel tight? Do your arms hurt after long hours of painting? Well suffer no more, simply ask one of our latest i-pleasure 2000 robots for a free back rub (relaxing music included) and we guarantee you will feel in your twenties again!

IDEAS

All projects need to start with an idea and in this case the idea is a pleasure droid. First of all we have to sketch some ideas on our canvas. You can see mine in **Fig.01**. I started by sketching some simple ideas for things I thought this droid should have. I chose a massage robot so I added a vibrating massage device, as I thought it was more futuristic than two hands.

On the back of my sketch you can see a big C-type battery, which I thought added a little humor to the design. Whilst still thinking about the humor aspect I decided that the robot needed a face so I chose a Japanese style and sketched a weird, crazy, painted face! On the sides of the legs I added a medical kit and in the middle of the chest, a panel similar to one you would see on common soda machines, so

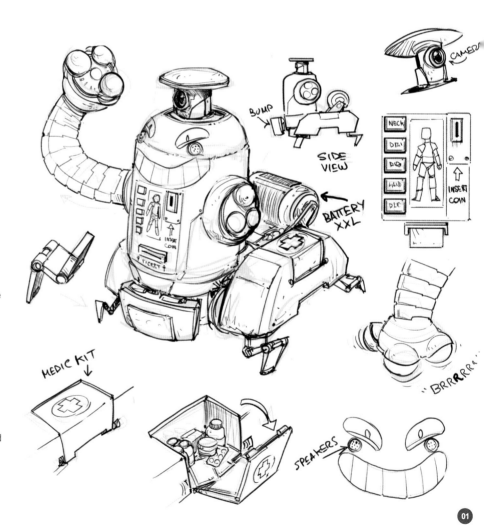

01

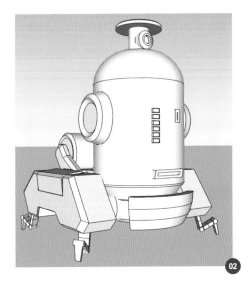

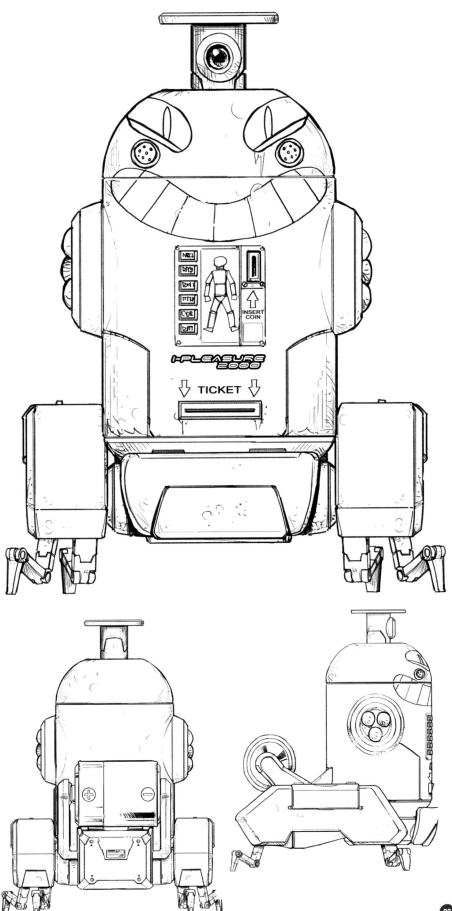

people can insert a coin and select the part of the body that needs treatment.

PROFILES

This step is very important in the production of any illustration. This is because if you create a detailed profile of your design it can be used by a 3D artist, or be used to help you maintain the same look throughout any further images you paint of the character. However, I wouldn't usually do this for a simple one-off illustration, but in this case I will show you how to do it as if you were creating the image for a client.

I would suggest using a 3D program to create a simple base (Google SketchUp is ideal for this and free). Once you have created a model it will be a lot easier to create the profile images. You can see my rough 3D model in **Fig.02**. I then exported the different views I wanted to create into Photoshop.

When creating these profile images you only need to use line art. In the past I have painted all the different views, but several video game companies told me that was not necessary and they always used a simple line drawing. This means that you can forget about things like light and shadows at this stage. You can see the images I created using my 3D model as a base in **Fig.03**.

COLOR ILLUSTRATION

I started the illustration phase with another rough sketch. I did this very quickly, using fast and loose strokes because I didn't want to think

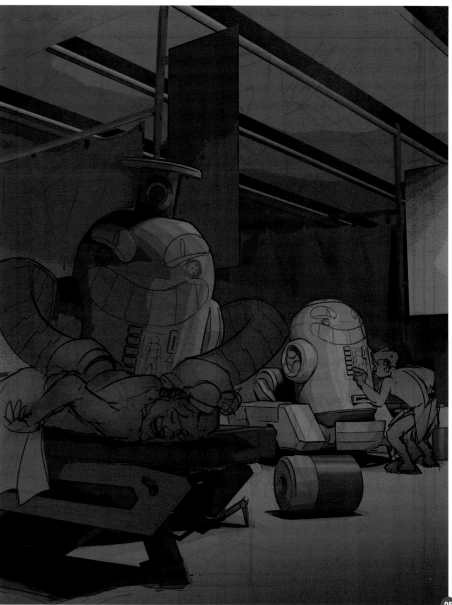

too much about the illustration; I just wanted to get my idea onto the canvas (**Fig.04**).

> *Quick Tip* : When starting an illustration, try to work fast and loosely. It can end up being counterproductive to spend time refining a detailed sketch that hinders the development of different ideas.

The next step was to try to make more sense of the loose sketch. I did this by using a variety of grays to paint in the volume and define shape and depth (**Fig.05**). I wasn't sure about the lighting at this point, but it was a good start. All of the elements seemed to work and I was happy with the composition. This is because the sketching phase was approached without any limitations or forced ideas. I thought that an empty robot battery on the floor would be a great way to show how cheap this Japanese massage house is.

Now it was time to add a simple base color, as you can see in **Fig.06**. In this case I picked a brownish color for the entire painting to accentuate the poor hygiene of this establishment. The blue letters add a cold contrast that works perfectly in the background. Also the city behind is a good source of light to the scene. But still, at this point I felt like the lighting wasn't right and you will see later in the process that I decided to change it quite a lot.

In **Fig.07** you can see how I started to add more color to our secondary robot and client.

You don't have to worry about detail in these early stages, so work loosely over the painting, making sure you are happy with the base painting as it will be harder to change things later in the process.

I then moved on and started to paint the foreground robot. To do this I picked a warm palette, like the red for the droid's head and a violet color for his hands. As I said before, you can fix anything you're not happy with later or try different colors. Sometimes it is better to think of this as a loose process rather than as if you are trying to create an illustration. In **Fig.08** you can see the rough palette I settled on. I changed the perspective of the front robot at this point as well, but wasn't sure if the change was too drastic. The face of the guy on the bed was important as well as he needed to demonstrate how good the massage was.

In **Fig.09** you can see that I moved on to add the face to the front robot, and also some lights to the panel and his hands. For the hands I chose a green color because I have a similar device at home that uses this color, but I wasn't sure how well it worked. As with everything that I have mentioned so far, I knew I could change things later if I wanted to.

The foreground of the illustration was starting to work well so I decided to turn my attention to the background. To do this I used lots of photo references and textures to create a densely populated area. Once I had done that I could adjust the images and paint over them to make them look integrated into the painting (**Fig.10**).

From this point I continued to develop the painting and turned my attention to the floor and the curtains in the background. When these were done it seemed to calm down the bright green on the droid's hands, which helped improve the image. Although the image was progressing, the focus was still to work on creating a solid base rather than focusing on the details too much. To do this I tried to use larger brushes and long strokes (**Fig.11**).

In **Fig.12** you can see the complete color scheme with almost everything painted to the

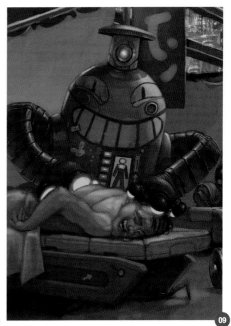

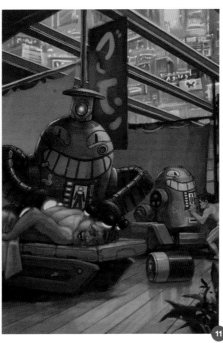

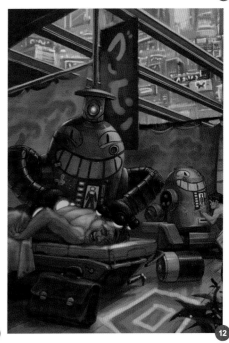

same extent. I added a couple of objects to the scene to make it look more interesting, like the carpet on the floor and a briefcase alongside one of the clients.

Up until now I had been adding color to places however I wanted, but now I had to start thinking about how I wanted the final image to look. One thing that stood out immediately to me was that the violet and the green on the droid's hands were too strong to work together. The idea behind choosing those colors was to attract the viewers' attention, but they attracted too much attention at this point. There were also other faults like the perspective and the overall lighting, which I found a little dull.

It was at this point that I thought it would be good to change the image to a night-time scene. As this was supposed to be a cheap massage house, I thought it would look seedier at night. It also meant that the glowing city in the background and the lights on the robot would stand out.

In **Fig.13** you will see how I changed the color of the lights in the robot's hand to a turquoise as I felt that it worked better in the scene. I also added more detail to the face of the client, always considering the effect of the light source on his face. As another comedy effect I added the puddle of drool on the table. You will also see that I changed the lights on the robot's chest panel to yellow, which again worked better and eliminated the green from the scene.

To add more interest to the scene I added more items and detail to the floor (**Fig.14**). This was to accentuate how dirty this massage parlor really is. As I was changing the image to a night scene I had to add a couple of lights to the ceiling, which means there are some strong highlights on the floor. As my goal at this point was to make the scene look rough and cheap, I added some graffiti to the body of the droids and added some signs to the background that showed that you could get a discounted massage (**Fig.15**).

I then used a dark military green gradient fill over the top of the whole image, from the top

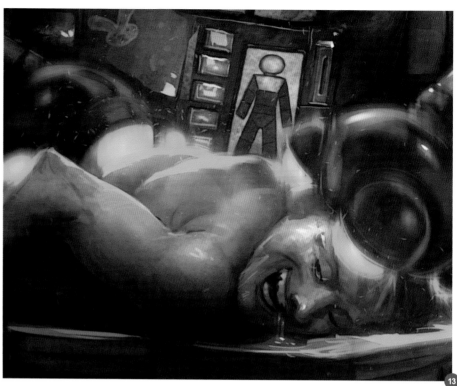

of the canvas, and set the layer to Overlay mode. This was to further show that it was a night scene. If you do this to your own image remember to use a gradient as a standard fill over the whole image will look strange. By doing this and tweaking the results it was fairly easy to show that it is a night-time scene.

The final stages are really fun. You can use colors already in the image to add detail to different areas quite quickly. I wanted to make the environment look even cheaper and I did this by adding a spark to the droid, making it look as if it was breaking. I also added some

fog to change the entire atmosphere and make it look like people had been smoking in the area. I did this by using a photo of cigarette smoke, which I added in Screen mode. To make sure the effect wasn't too strong I decreased the opacity of the smoke so it looked more believable.

Well that wraps up the whole process! Remember, you can always improve or add modifications to your pleasure robots; maybe you could even make small ones for foot massages or toenail treatment! See you soon – I'm off for a massage!

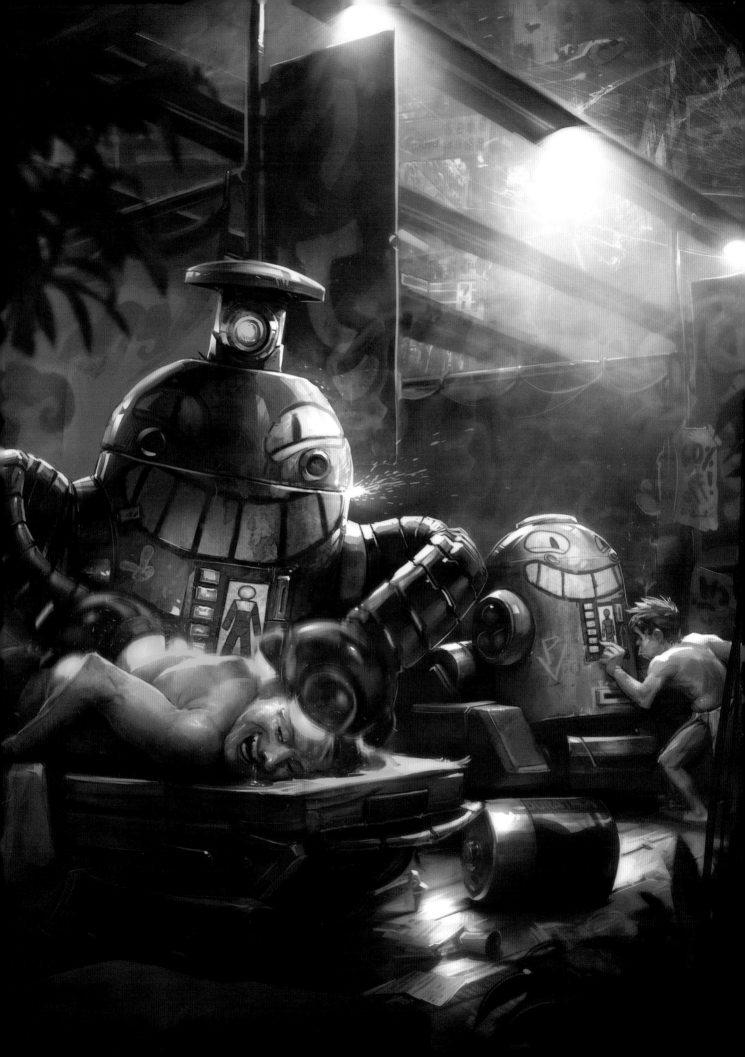

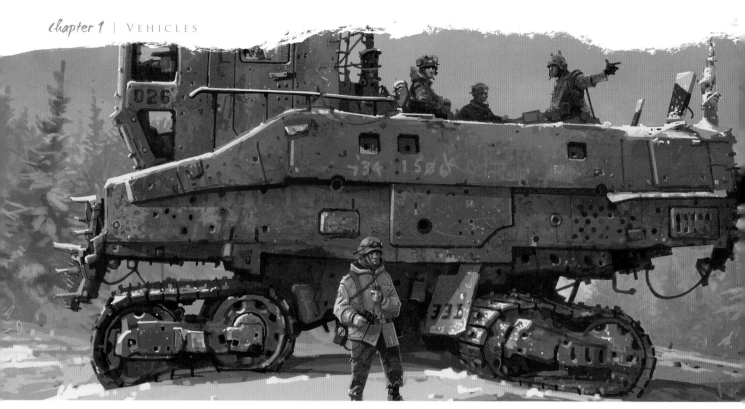

QUAD TRACK
BY IAN MCQUE

INTRODUCTION

While this tutorial is ostensibly for a book showcasing digital painting techniques, I hope that it will show how traditional media can still play an important part in creating a digital painting. For all the advances in painting software and input methods, for me there's nothing that beats the immediacy and fluency of gesture that a pencil or pen on paper provides. While I will sometimes start a painting from scratch in Photoshop, I tend to find that the most reliable way to create a successful image starts with a pencil and a blank sheet of paper.

CONCEPT SKETCHES

Having been asked to create a set of vehicle tutorials for this book I've decided to approach the task as I would a brief in my job as a concept artist for video games. As always, my initial response is to take out my sketchbook and pens and just start doodling. The first 20 minutes or so of these "warm-ups" serve a variety of purposes, including warming up your sketching muscles, helping get you "in the zone" and allowing you to get the most obvious and clichéd thoughts on paper before you begin really exploring your designs.

In these first sketches I'm trying to think of a way to tie the four vehicle types together, to give them a sense of cohesiveness. I decide that a good way to tackle this would be to have one main carrier-type vehicle, or "ark", which houses the other types of vehicle; a walker robot or "mech"; a flying scout vehicle and a "quad track" troop carrier. These initial doodles show how I'm looking for a series of interesting shapes above all else. I'm not worried about

too much detail at this stage. After a while I begin to see designs emerging that I like, so I start working up those more solidly. Firstly I want to tackle the troop carrier (**Fig.01 – 03**).

Because this vehicle features quite a lot of ellipses in the wheels/tracks etc., I decide to construct a sketch model in 3ds Max. I don't spend a great deal of time on this model and just throw together some fairly basic boxes to

SPOTTER

02

GUNS

MODULAR:
APC,
MEDIC/
MECHANIC/
BREAKDOWN,
FIRETRUCK?

GUN
SLOTS

03

indicate the shapes. This is really just to serve as a perspective guide when I come to work up the painting in Photoshop (**Fig.04**).

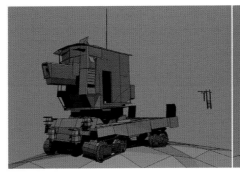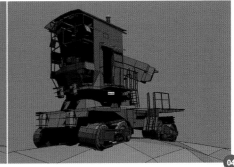

When I'm happy the model has all the detail I'll need, I play about with various views of the vehicle before settling on one I like, taking a screengrab via the Print Screen button. Opening up a new image in Photoshop, I paste the screengrab onto a new layer (Ctrl + V). So now I have the basis for my troop carrier concept in place I want to create two layers that will let me draw my line art, using the screengrab of the sketch model as a guide. I add a blank layer (**Fig.05**), and another I call "trace layer". I use the Paint Bucket tool to fill the first layer with a white color, then set the opacity to 50% so the sketch model image shows through as a drawing guide (**Fig.06**).

Now the layers are in place I can start sketching. Choosing a hard square brush and picking a fairly neutral dark color, I begin drawing on the trace layer, making fairly loose marks, following the perspective of the sketch model image but otherwise trying not to be too labored. I try to do this as quickly as possible as I want to keep the line art looking as fresh and gestural as those initial sketches.

COLOR

Once the line drawing is finished, I can start adding color and texture. I add a new layer and set it to Multiply, naming it "color". I have in mind a winter camouflage paint scheme for the vehicle, so I decide on a mid-gray as the color key. This is a very traditional way of painting, very much akin to how you'd start an oil or acrylic painting on canvas. This under-painting will help to keep the palette unified as the image progresses (**Fig.07**).

I use the Paint Bucket tool to fill the color layer, then pick a slightly darker tone than the under-painting to begin blocking in the form and texture of the vehicle (**Fig.08**).

Next I choose a dry media brush (something like soft oil pastel). I tend to use this brush a lot at this stage as it gives me a nice sparkly surface reminiscent of weathered metal

(**Fig.09**). I continue this texturing process, following the line art, but not too slavishly. I'm working pretty rapidly here, not spending too much time on any one area, but seeking to work up the whole surface at the same time. I find this instills a sense of movement in the painting that will keep the viewer interested. After all, if you've laboured over a painting, chances are the end result will look laborious!

Throughout this stage, and indeed throughout the whole painting, I'm using the same limited set of tools and keyboard shortcuts; B for the brush, I for the color picker and + to decrease and increase the brush size.

This is an iterative process – I'm not looking to paint a finished surface at this point. What I'm doing here is trying to achieve a busy and interesting texture. This usually means working and reworking the same area a number of times. I never worry about painting over an area I'd previously felt happy with – the idea is not to become too attached to anything at this point. Try to let the painting do what it wants to do and go where it wants to go. The paintings of mine that I find the most successful are those that I've allowed to develop in their own way. Being open to chance and happy accidents will open up opportunities for more interesting visuals than if you'd stuck to a rigid plan from the off.

Of course it's helped that I modeled the basic form of the vehicle and created a line art guide over that so this isn't totally freeform – the design and perspective are already taken care of so I don't have to worry about that as I work up the image. I can follow the line drawing safe in the knowledge that I've a solid base on which to work.

As I follow the line art I'm looking for edges and seams where I can add weathering details very rapidly, such as paint chips, rust spots, stains from fuel spills, etc. While I'm adding these random, almost abstract splotches I try to place complimentary colors next to each other. These are the colors opposite each other on the color wheel (color theory is possibly the most important aspect of painting. I'd advise reading

09

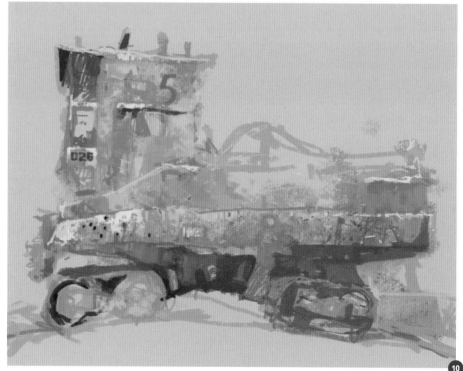

10

up on this as much as you can!). If I have a patch of orange I'll place an area of blue next to it. What this does is make the colors vibrate a little in response to each other, making for a little extra surface sparkle and adding interest. If I turn off the line art on the trace layer it's possible to view the texture pass at this stage and see just how abstract this layer is (**Fig.10**).

I could spend a lot longer adding texture here, but I think it's looking pretty OK, so after sketching in some loose background elements for context, I move on to the detail pass.

Since I'm going to be painting over the line art (which is still visible under the color layer) I reduce the line art layer opacity to about 50%.

This is so it'll be less intrusive as I work on the detail layer (**Fig.11**).

I like to use a square brush for the detailing pass, so after choosing a Hard Square at 8 pixels, I make a start (**Fig.12**).

At this stage I'm careful not to simply re-draw the line art that already exists; I'm just using it as a guide in order to start giving form and weight to the texture pass I did previously. So, again trying not to focus on one area for too long, I begin adding details such as panel edges, rivets, doors, handles – all the sorts of things you'd expect to find on a vehicle of this type. It's important to note that while I do this the brush opacity and flow are set to around 75% and 50% respectively; this is so that the color on the texture layer underneath shows through slightly, creating a mix of the two. If I hadn't done this the detail layer would be rather flat and lifeless.

Once again, I'm not following the line art too strictly. I let it guide and inform me as to what decisions to make – what to add, what to leave out, where to invent something new entirely such as hatches, exhausts, antennae, etc. Throughout this process I always keep an eye on my second monitor where I have my reference images.

Like the texturing previously, I continue with the detailing until I'm satisfied the vehicle is looking interesting and, well, cool! I'm now ready to move on to what I call the "shadow pass", but first I duplicate the detail and color layers so that I have them as insurance in case of mess-ups. I then merge these duplicate layers together (Ctrl + E). Next I duplicate this merged layer and name it "shadow" (**Fig.13**). I don't want this to be a Multiply layer, so I go into the layers dialogue and change it to Normal.

What I'm going to do now is create the "in shadow" version of the image, so I call up the Hue/Saturation dialogue (Ctrl + U), check the Colorize box, and adjust the Hue/Saturation/ Lightness sliders until I have a shadow color I'm happy with – in this case, a dark blue. I may change the color of this layer later, but for now

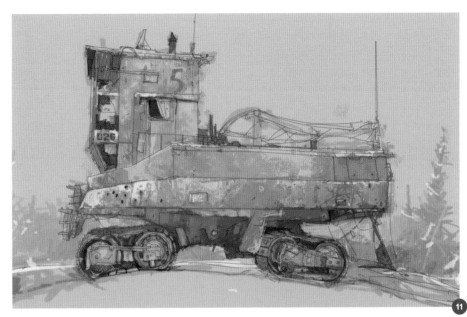

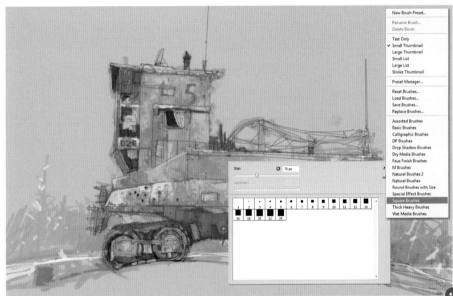

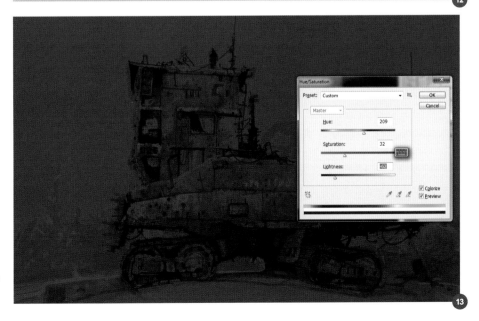

this is good enough for my purpose. I change the layer opacity to around 80% so more of the color layer shows through. Now I'm ready to begin cutting away the shadow layer to reveal the areas that will be fully lit. This is how I "model" the form of the object, almost painting in the light.

> **I'M A HUGE FAN OF THE LASSO TOOL AND USE IT IN ALL OF MY PAINTINGS. IT ENABLES THE CREATION OF FANTASTICALLY CRISP AND STRAIGHT EDGES THAT WOULD OTHERWISE BE IMPOSSIBLE TO ACHIEVE WITH A BRUSH ALONE**

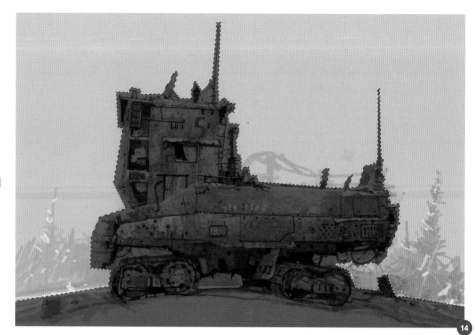

I start by selecting the Lasso tool (L) which, when used in conjunction with the Alt key, enables me to draw around the areas I wish to delete. I loosely select the background and sky area, then press the Delete key (**Fig.14**).

I want the vehicle to be lit from above and to the left, so I continue selecting and deleting, revealing the lit areas and leaving other areas in shade. I'm a huge fan of the Lasso tool and use it in all of my paintings. It enables the creation of fantastically crisp and straight edges that would otherwise be impossible to achieve with a brush alone. I also enjoy the chance to focus on carving out the form of an object using negative shapes like this (**Fig.15**).

OK, when I'm happy with the shadow pass and the form of the vehicle is taking shape I switch my attention to the background (**Fig.16**). To do this, I duplicate the vehicle and the foreground so I can paint behind them freely. Again, I merge the shadow and color layers, change the layer setting from Multiply to Normal and duplicate the layer again. Using the Lasso + Alt key technique once again, I select the area around the vehicle, deleting the selection as before. I continue around the vehicle, deleting as I go (**Fig.17**).

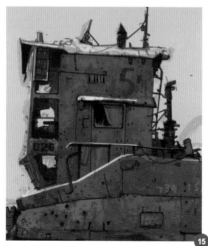

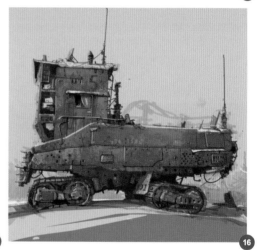

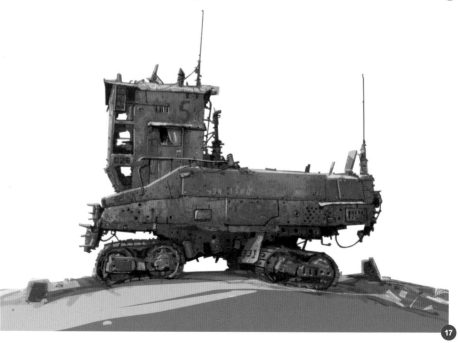

Once this is done, I select the layer beneath this and begin blocking in the snowy landscape background, keeping it quite loose and impressionistic (**Fig.18**). When I'm happy with how the painting's looking at this point, I'll take a break from it.

Quick Tip: It's always a good idea (time permitting) to take a break from a painting and come back to it with a fresh pair of eyes later.

On coming back to the image I'm relatively happy with what I see. I flip it horizontally (Image > Image Rotation > Flip Canvas Horizontal) to check the composition for any right or left bias that might need to be corrected, but again it seems to be OK. I'm thinking the vehicle could benefit from having a few human characters on or around it. This will impart a sense of scale and also makes it easier for the viewer to picture themselves in the scene – an important factor in selling a fantasy picture as a believable reality.

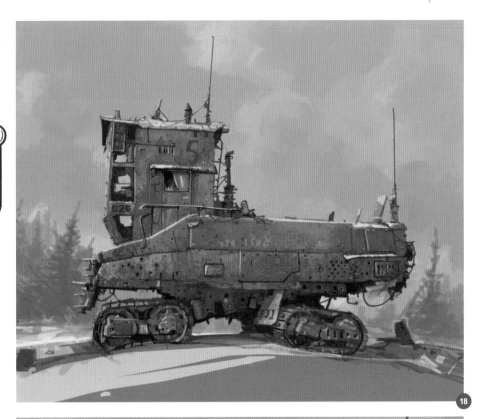

> **I'M RELYING A GREAT DEAL ON MEMORIES OF FIELD TRIPS WHERE I SKETCH FARM MACHINERY, FISHING BOATS, TRACTORS AND THE LIKE**

I add a new layer and call it "figures", select a square brush and start loosely sketching in a couple of figures (**Fig.19**). It should be clear at this point that some experience of drawing landscapes and figures is essential to create a successful and convincing painting, even if it is based around a sci-fi/fantasy theme. I'd recommend always carrying a sketchpad and pen around with you. Try to go sketching outdoors as much as possible and draw figures when you can.

It might appear that I'm making up a lot of the details on this vehicle as I'm going along, but I'm relying a great deal on memories of field trips where I sketch farm machinery, fishing boats, tractors and the like – anything that I

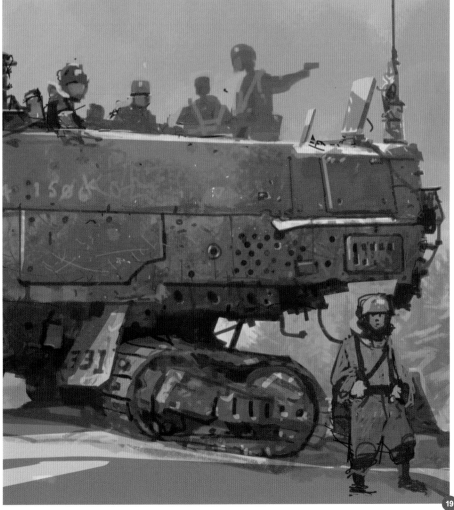

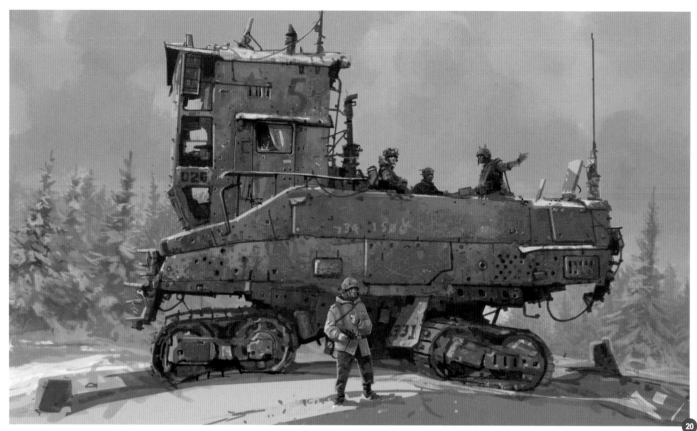

20

think will lend an air of believability when I'm painting back in the studio. Of course, you can always take photos to use as reference too, but I always think that actually sitting in front of the subject to make a drawing helps cement it in your mind. I like to think I'm building up a store of mental references I can access at any point.

So, once the figures are painted in (**Fig.20**), I'll sit back and take stock of the image. If you have the space it's good to step back from your monitor to view the painting from a distance – you can sometimes get caught up in details and intricacies that make you lose sight of the "big picture". Standing back lets you assess the image as a whole.

I'm happy with the image at this point, so to finish off I'll make a final detail pass, tightening up here and there, pushing highlights and shadows to make everything as solid as possible, and adding a dusting of snow to help the vehicle sit in its environment (**Fig.21**).

The painting is pretty much what I'd call finished now. A couple of finishing touches I usually add is to push the image through a

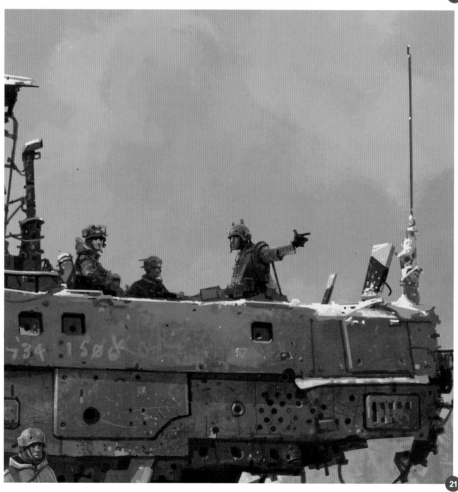

21

couple of variations just to see what effect it has. This can really lift the painting, unifying the palette and making it more cohesive. I do this by first merging the layers I've been working on (I name this "troop carrier") and then duplicating it. I go to the Image drop down menu and select Adjustments > Variations (**Fig.22**). I'm presented with a selection of palette variants.

I want to warm up the painting slightly, so I choose the more red option, followed by a more yellow option and click OK (**Fig.23**). I'm looking for a subtle warming of the palette here so I reduce the opacity of this layer to around 40%, allowing the original colors to show through slightly. I then merge this layer down and proceed to the final step, which is to sharpen the image slightly. I find this adds a little sparkle and a kick that I wouldn't be able to achieve by painting alone.

In the Filter drop down menu I go to Sharpen > Smart Sharpen (**Fig.24**). With both the Advanced and More Accurate boxes checked, I adjust the Amount and Radius sliders until I'm happy with what I see. I really like how this pushes the contrast between areas of color and line. It pays to be a little cautious with this step as it's easy to overdo the level of contrast. Depending on the size of the image, I find between 150-200% Amount and 1.5-2.0 px Radius usually works for me.

So there you have it; a finished painting!

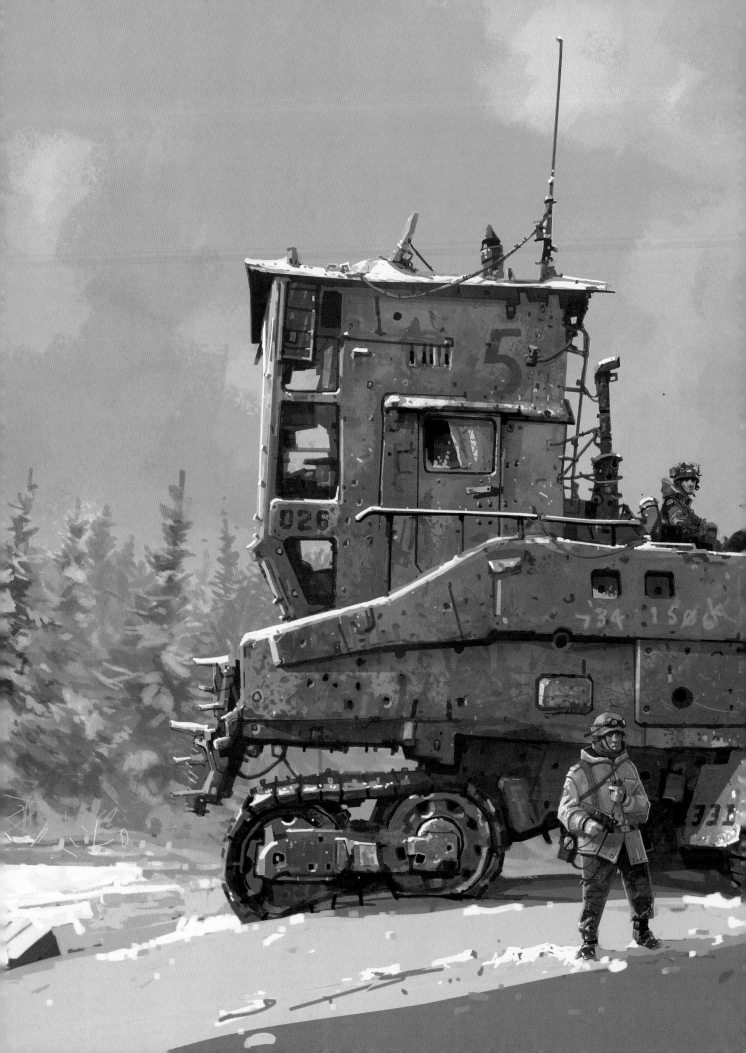

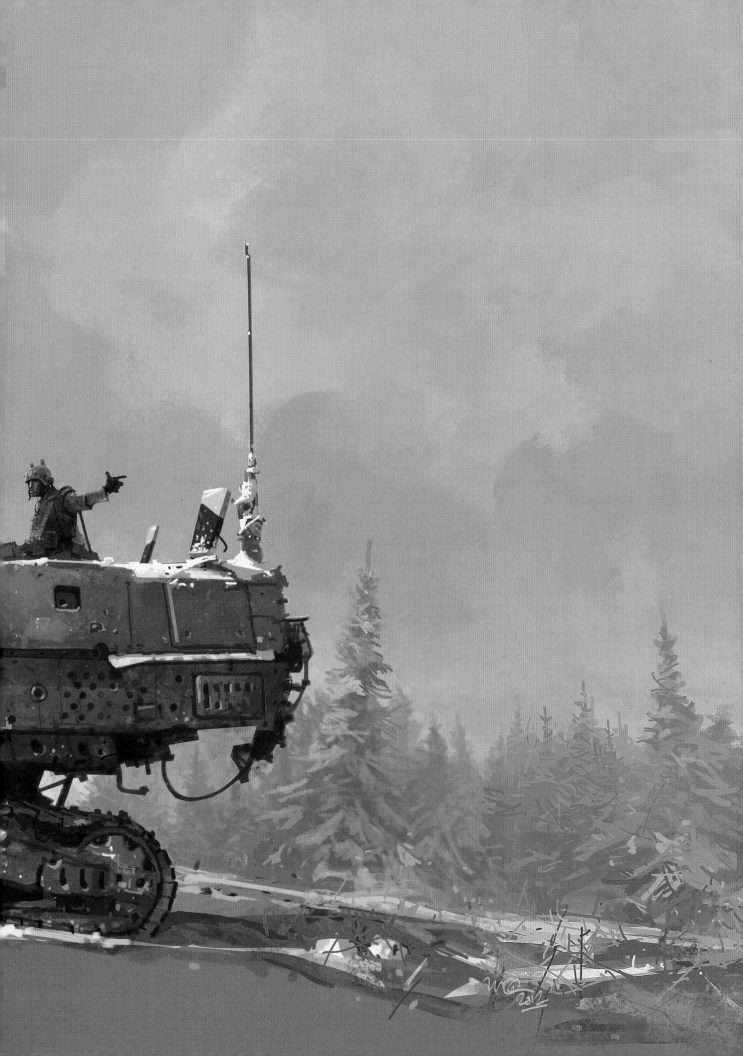

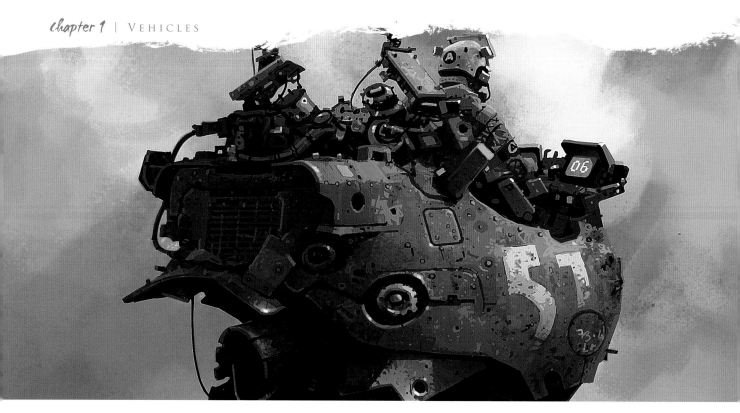

SCOUT FLYER
BY IAN MCQUE

CONCEPT SKETCHES

When starting a new painting, I'll usually put together a reference board; a page containing images relating to the piece I'm about to do. These images can be photographs I've taken myself while out and about, or pictures I've found on the internet (Google image search is your friend!). I might not use everything I place on the ref board, but the point of it is that it saves me having to hunt around my reference folders for that particular cool little engine detail – I have them all here at hand. I keep this file open on my second monitor, which is just to the left of the one on which I paint. This way I can keep both in my line of sight.

COLOR AND DETAILS

As part of the group of four vehicles, I want to include a small, one-seater scout flyer. I set about my usual sketching process, producing many loose sketches until I hit upon a design I like (**Fig.01**). I scan this drawing and open it in Photoshop, naming the layer "line art". I follow this with the color and detail stages mentioned previously in the previous tutorial (**Fig.02**).

Then referring back to the reference board, I look at how I can improve upon the design.

01

02

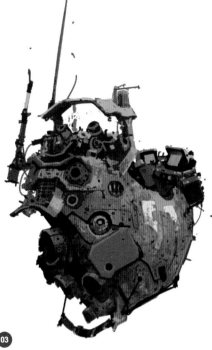

03

05

I'm thinking something that shares some of the structure of the fork lift truck reference I've gathered might be in order, so I add another layer and start sketching some stronger, bolder shapes (**Fig.03**).

I'm really still doodling at this point, making marks, leaving them if they help the design, deleting them if they don't. Above all, I'm staying pretty loose and gestural here, looking for lines that help the design flow. I never really try to add parts that make sense technically, I'm just adding things that hopefully appear at home on the craft itself. This is where the ref board is really helpful; if I see a space on the vehicle that I'm not quite sure what to do with I merely hunt around the ref imagery until I find something that fits. In a way this is a lot like the "kit bashing" you might do with plastic model kits, only in two dimensions (**Fig.04**).

I press Ctrl + T to call up the image transform "handles", modifying them until I have a shorter and wider-looking craft, pressing Enter when I'm happy. It's still a little flat so I decide to transform the ship a bit more. Going to the Edit > Transform drop down, I select Perspective. Pulling down the handle at the top right gives the craft the effect of receding into space, lessening the flatness that was apparent previously (**Fig.05**).

I should say a few words about this "suck it and see" approach, which doesn't always come across well in a tutorial! This tends to be the basis of a lot of my work – it's rare that a painting will just work seamlessly. In fact, in most paintings I'll reach a point where I'm not happy at all with how the image is turning out! However, I know that if I persevere I'll move

past this point and reach a situation where I'm happy. This is the hardest part of any creative endeavor – having faith in your ability and not giving up when something isn't going according to plan. As I said, this is a difficult notion to get across in a tutorial like this, but it's nonetheless very important. There is no magic button or filter, or even a guarantee that a particular process will work every time. I have folders on my computer full of paintings that haven't worked out. They're not failures as such; indeed I often go back to them at some point in the future and see a way to make them work that wasn't apparent before. So my advice would be don't give up!

Back to the scout flyer, and now that I'm much happier with the overall design I can return to the detailing pass, working to bring out the new

> THE HARDEST PART OF ANY CREATIVE ENDEAVOR – HAVING FAITH IN YOUR ABILITY AND NOT GIVING UP WHEN SOMETHING ISN'T GOING ACCORDING TO PLAN

As I'm adding these details I find I'm not really happy with the overall shape of the ship, so I decide to try to improve it using Image Transform. After merging the detail layer down

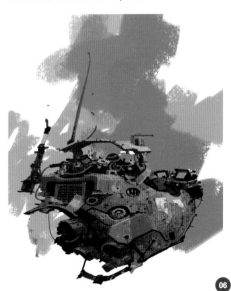

06

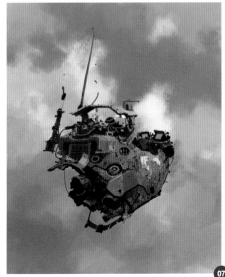

07

squatter, meaner characteristics. Switching
my attention to the background, I add a new
layer under the layer the flyer is sitting on and I
start blocking in a rough sky using my favorite
soft oil pastel from the Dry Media brush set,
as it will give me a ragged edged cloud effect.
Again I'm looking for something impressionistic
here rather than a literal rendering of clouds
(**Fig.06**). I also choose colors that will
compliment the oranges and yellows of the
ship, so a blue and purple palette works well
(**Fig.07**).

I feel the color of the ship is looking a little too
strong and saturated, so I call up the Hue/
Saturation dialogue (Ctrl + U). I only want to
change the color of the fuselage so I choose
red from the color drop down (**Fig.08**). I adjust
the Hue and Saturation sliders until I have a
color I'm happy with.

Now it's time to add shadow to the ship, so I
duplicate the ship layer and, once again using
the Hue/Saturation controls, colorize this layer,
making it a cool, dark blue/violet (**Fig.09**). I
imagine the light is coming from above and to
the right, and begin deleting sections of the
shadow layer using a combination of the Lasso
(L) and Eraser (E) tools, allowing the lit layer
underneath to show through (**Fig.10**).

I'm still open to revising the design even at this
stage and I'm thinking the arch section on top
of the ship is a little too fiddly. It's also denying
me the chance to show the pilot sitting in the
cockpit. Using the Lasso tool to crop precisely
around this area, I delete it.

Adding another layer, I take a square brush
and begin sketching in the pilot and any other
technical items that help the composition,
merging this layer down when I'm happy with
the result. Flipping the canvas horizontally to
look for inconsistencies at this point (Image >
Image Rotation > Flip Canvas Horizontally) I
correct anything that looks unconvincing, and
add a few highlights and shadows (**Fig.11**).

Flipping the ship back to the correct orientation,
I zoom in and begin the final detailing pass,
generally tightening up the surface (**Fig.12**).

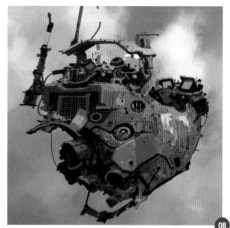

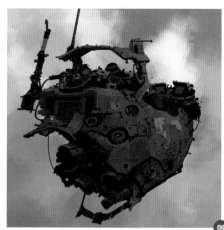

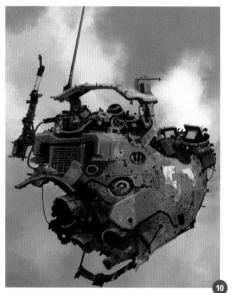

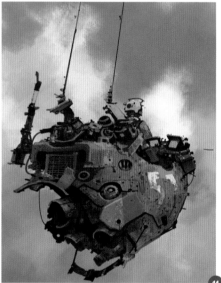

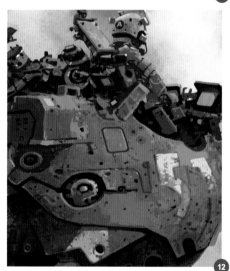

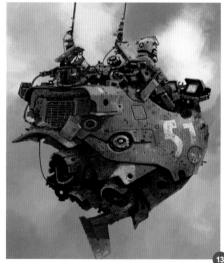

When this is complete the painting is nearing
its final stages (**Fig.13**). I'd like to unify the
palette a little, warming it up at the same
time, so after merging the ship and the sky
background together, I duplicate this merged
layer and go to Image > Adjustments >

Variations and choose the More Red filter. After
this is applied I reduce the opacity of this layer
to around 25% as I'm looking for a very subtle
warming of the image. To finish the painting
and give it a little extra crispness I apply a
Smart Sharpen filter.

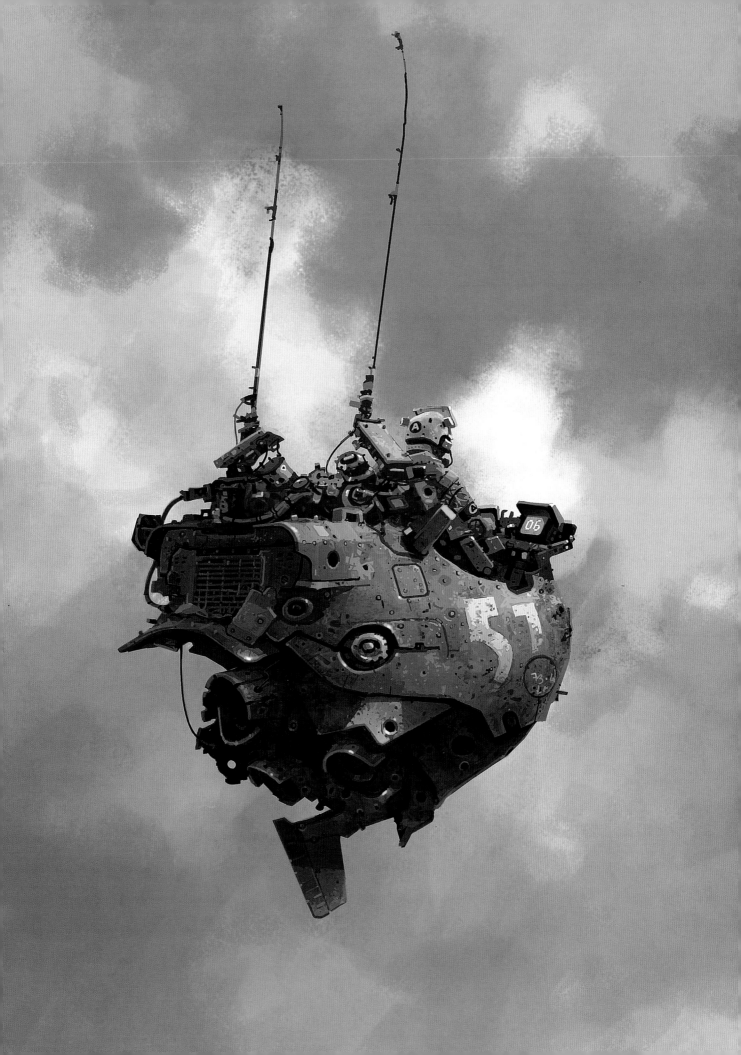

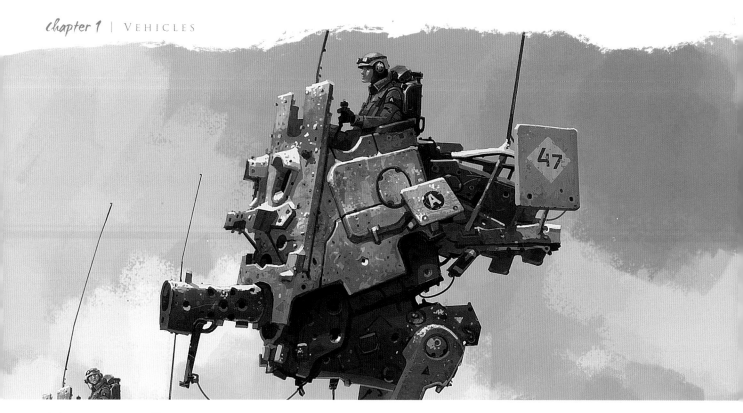

M O B I L E G U N N E R
BY IAN MCQUE

C O N C E P T S K E T C H E S

The third vehicle in this series is to be a mobile gun platform, taking on the characteristics of a typical mecha. Once again I produce dozens of sketches exploring variations on this theme (**Fig.01**), eventually settling on a two-legged walker-type machine, with a cockpit for a couple of crew members. As before, I create a line art layer onto which I paste the scanned sketch. Once this is in place I can add another layer, which I set to Multiply and name "color" (**Fig.02**).

C O L O R

Continuing the winter theme, I choose a cool blue as the under-painting color, flooding the layer using the Paint Bucket tool (G). Again, picking my favorite soft oil pastel brush from the Dry Media brush set, I start blocking in the main body of the vehicle. I do this loosely, not worrying about going out of the lines of the line art (**Fig.03**). Next I add another layer and name it "detail" so I can begin to refine the structure using a small, square brush (**Fig.04**).

With this stage of the detailing complete I duplicate the detail and color layers, then merge them together (**Fig.05**). Using the still

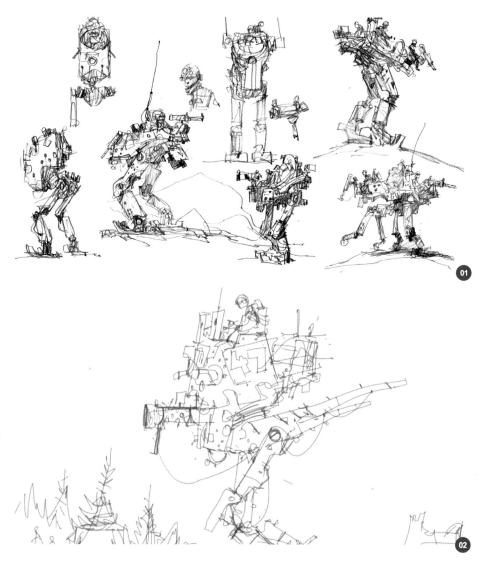

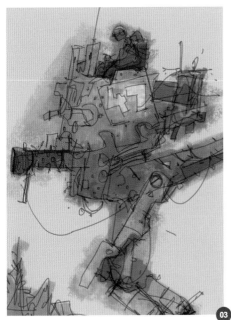

03

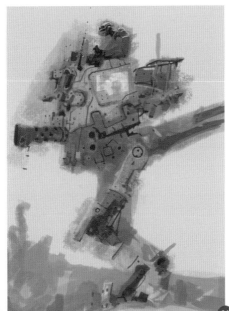

04

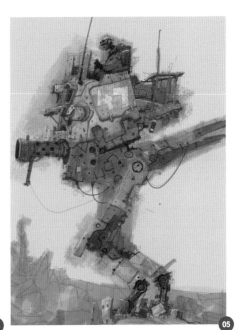

05

visible line art layer as a guide, I take the Lasso tool (L) and in conjunction with the Alt key, begin cropping the vehicle out of the background, at the same time defining its crisp outline (**Fig.06**).

> " I LOOK THROUGH MY FOLDER OF VARIOUS PHOTOS OF WINTER LANDSCAPES I'VE TAKEN, CHOOSING ONE THAT MATCHES THE MOOD I'M LOOKING FOR "

I now change the layer's setting from Multiply to Normal and duplicate the layer, ready to start the shadow pass. I name this layer "shadow" and call up the Hue/Saturation dialogue (Ctrl + U), adjusting the Lightness and Saturation sliders until the vehicle looks as if it's in darkness. Again using the Lasso tool with the Alt key, I delete the areas I want to be in sunlight (**Fig.07**).

BACKGROUND

Moving my attention to the background I make the color layer visible and start blocking in a loose landscape behind the vehicle. There's no real trick to what I'm doing here; I look through my folder of various photos of winter landscapes I've taken, choosing one that

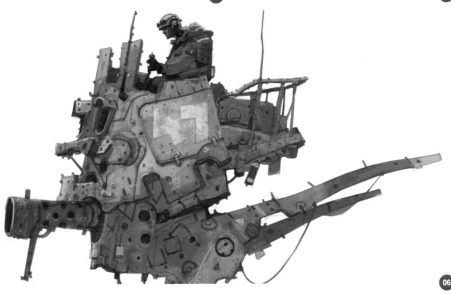

06

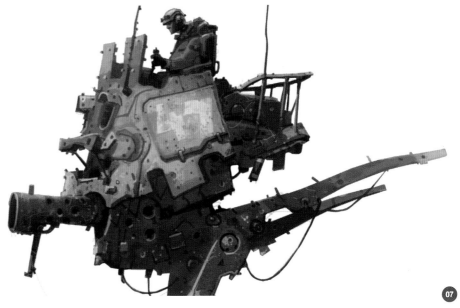

07

matches the mood I'm looking for. Then it's a simple matter of copying it and modifying the shapes as I go to strengthen the composition. At the same time I try not to get bogged down in details – the vehicle should remain the focus of the painting (**Fig.08**).

Quick Tip: I'd recommend looking at books on traditional landscape painting techniques to pick up tips on just how much detail you need to include in your paintings, but perhaps, just as importantly, how much you can afford to leave out!

When I reach a point I'm happy with it's time to stand back and assess the painting as a whole (**Fig.09**). The cockpit/turret is still looking a little flat to my eyes, so I spend some time deepening shadows and popping out highlights (**Fig.10**). I continue this process across the whole vehicle, refining as I go and adding a layering of snow here and there, helping to sit the mech in its environment (**Fig.11**).

I could probably say the painting is finished at this point, but I'm thinking it could benefit from

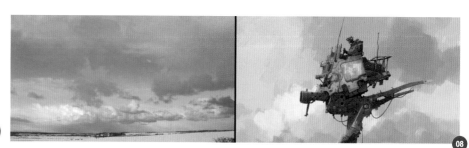

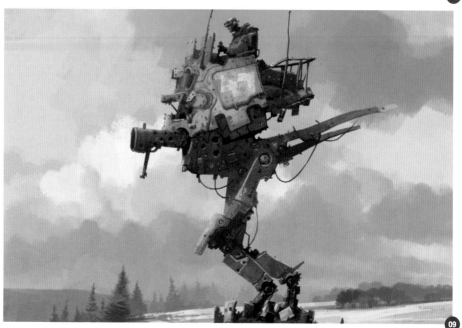

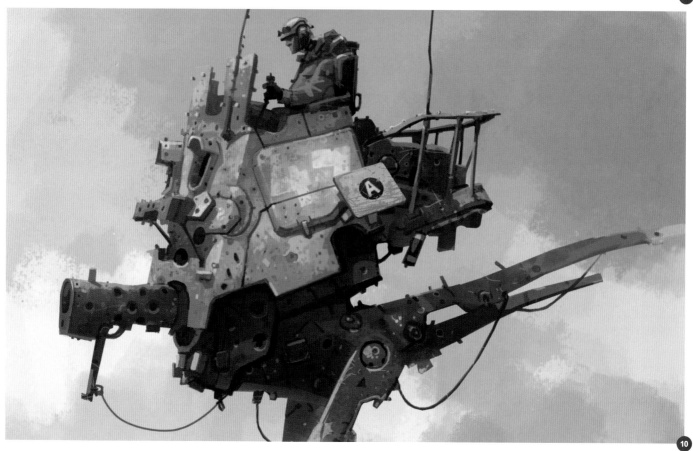

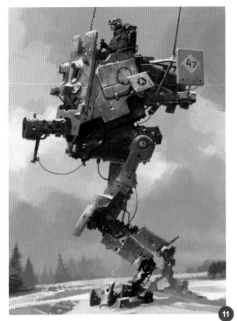

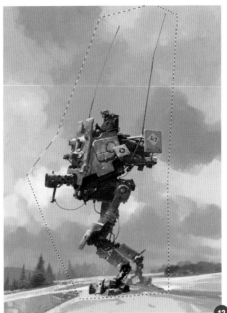

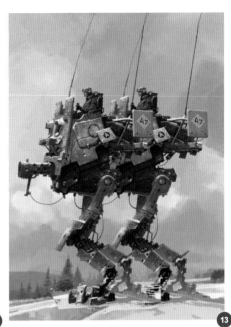

some extra depth, perhaps by adding another walker mech a little way in the distance. To do this I draw a selection marquee around the vehicle using the Lasso tool (**Fig.12**). I then duplicate the selection by pressing Ctrl + C, then I paste it onto its own layer using Ctrl + V, naming the layer "duplicate" (**Fig.13**). This vehicle needs to look as if it's behind the other so I drag its layer down until it sits underneath the main vehicle in the layer stack.

> WE STILL HAVE TWO IDENTICAL-LOOKING WALKERS AT THE MOMENT, SO I FOCUS ON THE SMALLER OF THE TWO, MAKING ALTERATIONS SO THAT THEY LOOK LIKE UNIQUE VEHICLES

I open the Transform dialogue with Ctrl + T and scale the duplicate vehicle to approximately half the size of the other walker, holding down the Shift key while dragging the top right transform handle to constrain its proportions (**Fig.14**). I press Enter when I'm happy it looks a good distance beyond the foremost vehicle. We still have two identical-looking walkers at the moment, so I focus on the smaller of the two, making alterations so that they look

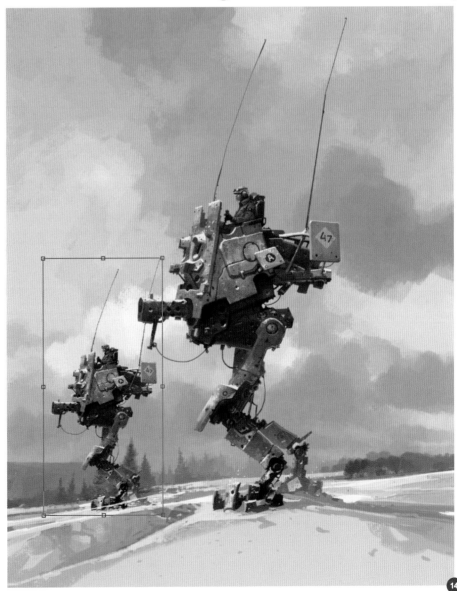

like unique vehicles; leg positions, numbers on panels, positions of the pilot's head, etc (**Fig.15**).

To emphasis the distance between the two vehicles I want to introduce a little aerial perspective (the fogging and graying out of an object as it recedes into the distance). I do this by first reducing the opacity on the smaller vehicle's layer by about 15%, then calling up the Hue/Saturation dialogue (Ctrl + U) and reducing the saturation until the vehicle appears to recede.

> ## I'M LOOKING TO INTRODUCE THE EFFECT OF A GROUND HAZE, OR A MISTING OF ICE CRYSTALS

To force this recession even further I add a new layer in between the vehicle layers and call it "fog". I'm looking to introduce the effect of a ground haze, or a misting of ice crystals. To do this I choose the Lasso tool once again and draw a selection sitting on the ground plane where the distant walker stands. I then select the Fill tool (G, or Shift + G to toggle from the

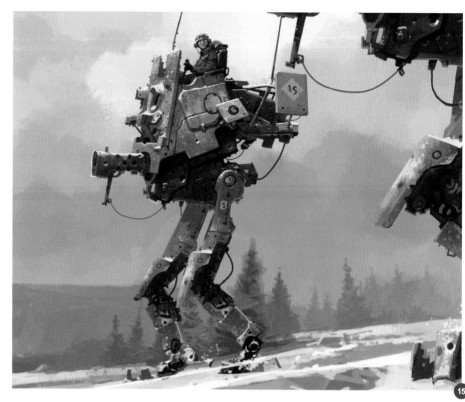

Paint Bucket), making sure that the Fill setting is Foreground Color to Transparent. Then I click and drag the Fill tool from the bottom of the marquee upwards to give the impression of a mist hugging the ground. I may do this several times until I'm happy I've achieved the effect I'm looking for (hiding the marquee

selection or "marching ants" while doing this is advisable. Press Ctrl + H to do this) (**Fig.16**).

The painting is very near to completion; all that remains is to flatten the layers together, then add that crisp sparkle using Filter > Sharpen > Smart Sharpen.

BATTLE ARK
BY IAN McQUE

CONCEPT SKETCHES

For the final painting in this series I'm aiming
to give some context to the previous three
crafts, perhaps showing one or more of them
alongside the "Ark" that houses them.

After the usual round of pencil sketching I
settle on a design and then create a series of
thumbnail compositional sketches (**Fig.01**).
There are a lot of potentially tricky perspectives
in the proposed painting, so I decide to create
a sketch model in 3ds Max; nothing too
detailed, just a fairly basic representation of the
design that I'll use as a guide when drawing up
the line art.

I pose the model in the scene, duplicating it
a few times to reproduce the compositional
thumbnail as closely as possible. I take a
screengrab of this and paste it into a new layer
in Photoshop. On my second monitor I open up
a reference board I created previously, which
contains a selection of detail and mood shots
that will inform the painting. I then add a new
layer, naming it "line art" and proceed to draw
in the main elements of the composition using
the screengrab of the sketch model as a guide
(**Fig.02**).

01

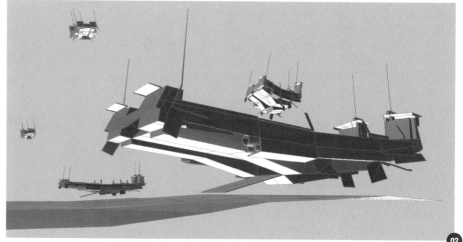

02

03

04

Drawing something very linear such as this is made a lot easier if you use the Shift key in conjunction with the Brush tool. Hold down Shift while marking where you wish one end of a line to start, lift the pen off the tablet and mark where you'd like the line to end and there you have it: a crisp, straight line. This method is useful for things like railings, antennae, rigging, etc. I find I use it all the time (**Fig.03**).

COLOR

When the line art is complete I turn off the background layer and add another one, naming it "color" and setting it to Multiply (**Fig.04**). As in the previous tutorials I set about blocking in the color and texture, checking my reference board for guidance all the while. I'm thinking a dusk setting would be interesting so I use the Paint Bucket tool (G) to flood the layer with a bluish purple color as my under-painting. Choosing a slightly darker tone than this, I start to block in the ships (**Fig.05**). As before I follow the line art loosely, not really looking to describe form at this stage, just enjoying making a patchwork of color and texture.

When I'm happy with this I move on to the finer detailing, so I add a new layer and reduce the line art layer opacity to around 30%. Then, once again using the just visible line art as a guide, I add details and build up the structure of the ship (**Fig.06**).

05

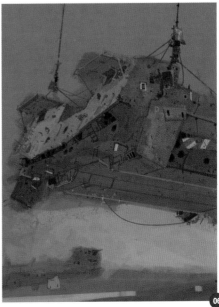

06

I duplicate the detail and color layers, merging the duplicates together in preparation for cropping the outline of the ships. Using the Lasso tool with the Alt key, I progress around the ship outlines, cropping as I go (**Fig.07**).

Once this is done and I have a crisp, sharp-edged collection of ships, I'm ready to begin the shadow pass. As before I duplicate the ship layer, renaming it "shadow", then call up the Hue/Saturation dialogue (Ctrl + U), reducing the Lightness and Saturation until I have an "in-shadow" version of the craft. Picking the Lasso tool again I resume cropping, but this time deleting from the shadow layer to allow the lit portions of the ships to show through (**Fig.08**).

To tie in with the near-dusk setting I'm going for, much of the body of the ships will be in shadow and the strongest source of light will be emanating from the interior of the main foreground ship, illuminating the exit ramp and the ground beneath. To achieve this I'll be using the same gradient fill method I employed for the mist in the Mobile Gunner tutorial. I created a new layer and named it "light", making sure this layer is between the shadow and color layers.

Selecting the trusty Lasso tool once again, I proceed to draw a selection that covers the area any light spilling out from the belly of the ship would follow (**Fig.09**). Choosing the Gradient Fill tool (G) and setting it to Foreground to Transparent, I choose a suitable color for the light; in this case a very pale lemon, which should read well against the bluish/violet tone of much of the painting.

To better see what I'm doing I hide the "marching ants" marquee selection (Ctrl + H) and also make the original color layer visible again. Now it's simply a case of dragging the Fill tool into the selected area until I'm satisfied with the lighting effect (**Fig.10**). It helps if the opacity on the Fill tool is quite low. I usually have it set to around 36%. This is so you can build up the cone of light in subtle increments.

After what have been quite precise parts of the process I decide to switch my attention

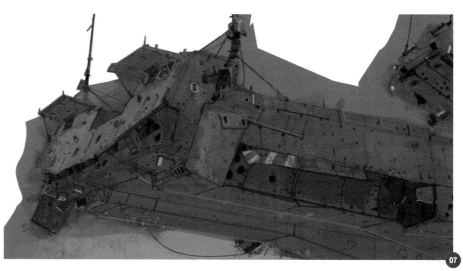

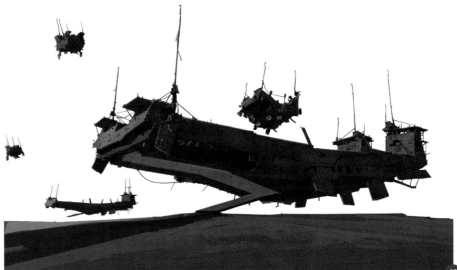

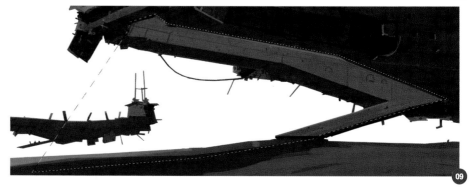

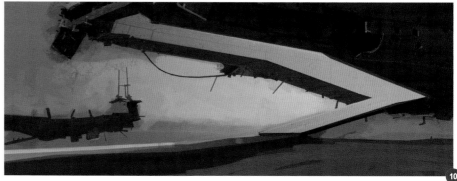

to the sky and background, partly because it needs to be done, but also because it provides an opportunity to be loose and painterly. It's good to mix up approaches like this as it helps add life to the image. Once again I eyeball my reference board (the dusk idea came from walking to my studio just after sunset and being bowled over by the quality of the sky; I snapped a couple of shots with my phone and they form the basis of my reference). Selecting the color layer I start loosely laying in the cloud formations, always trying to relate them to the form of the ships.

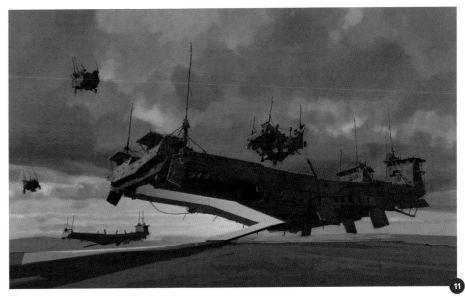

> **I'M NOT ONE FOR WORKING ON MANY DIFFERENT LAYERS AT ONCE – I FIND IT BECOMES DIFFICULT TO TRACK WHERE THINGS ARE AND CAN LEAD TO SLUGGISH PERFORMANCE TOO**

While far from complete, the painting is fairly fleshed out at this point. All the components are in place, so I step back to appraise what I have so far (**Fig.11**). While I'm quite happy with what I see, I think the fuselage of the ships could benefit from being lit in certain areas, helping the structure to read better. I add a new layer to the top of the stack and name it "lights2". Using the same gradient fill technique as before, I make my way around the main ship, adding lights here and there. This is very much a process of trial and error, deleting additions that don't quite work and leaving others that do (**Fig.12**).

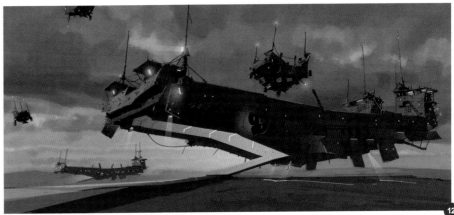

I duplicate all the ship and light layers, and merge them into one. I'm not one for working on many different layers at once – I find it becomes difficult to track where things are and can lead to sluggish performance too. Also, I like to paint in as traditional a manner as possible and having relatively few layers feels more true to this approach.

I now start the final detail pass where the painting comes together. It's at this point

that I can start to "freestyle" a little, adding shapes to build on the basic forms I've already created and pushing the design in various directions. I use an amalgam of the tools I've used throughout these tutorials; basic square brushes, dry media brushes, Lasso tool/Alt key cropping, gradient fills, etc.

To add a sense of continuity, context and scale, I drag the vehicle from the earlier quad track

painting onto a new layer, modifying its scale, color and lighting until it looks at home in this scene (**Fig.13**).

I take another last look around the painting, tightening up the contrasts here and there, adding some subtle atmospherics around the spotlights to give the impression of a slight fog and giving the sky a final once-over (**Fig.14**). And then it is finished.

MOUNTAIN CITADEL
BY CHASE TOOLE

CONCEPT

This mountain citadel is a place of refuge for the citizens of this cold outpost town. It also serves as a directional beacon that travelers can use to gain their bearings if stuck in a snowstorm, or as a warning for approaching attackers.

The approach I wanted to take was much like a desert oasis, except with snow. I envisioned a bright city in the midst of large, snowy mountains and a clear night sky. Temperature plays into the concept because I wanted the warm city to draw in the viewer. This made the color palette very easy to decide on because torchlight is usually orange and snowy landscapes at night tend to be blue (or what we perceive to be blue). The composition is also fairly simple. It has a focal point that the viewer has to travel to and a surrounding environment that they have to traverse to get there.

When I started this piece I knew from the brief I was given it had to include three things: a citadel, a town and mountains. With that in mind I knew I could keep the composition and concept simple so I could focus on the color and light.

I started by blocking in a rough composition in color. I knew that I wanted the camera angle fairly low so that it would feel like you were a traveler looking up towards the citadel (**Fig.01**). I kept the block-in very loose, using a large round textured brush so that I could add the shapes very quickly and also have a little bit of texture and noise to add some interest.

ADDING COLOR

The way I thought about color and value at this point was kind of like a black hole; everything radiates inwards toward the focal point. All my warms were centralized and all the darkest values were basically pointing towards the focus. I painted the image while it was still small because I find it much easier to work on the whole composition when I'm not zoomed in.

After I was satisfied with the rough comp, I started refining the shapes and edges (**Fig.02**). When the shapes started reading at a distance I then started working in some more textures and colors. At this stage I kept to two to three layers: one working layer, one merged layer and a layer with my original color rough (for

reference). When I was unsure about what I was painting on my working layer, I just turned it on and off to see if it helped or hindered the image (I use this technique a lot throughout my painting process!).

> ## I REALLY WANTED THE LUMINESCENCE OF THE CITY TO SPILL OVER INTO THE SURROUNDING ENVIRONMENT

Flipping your canvas can be a life and time saver. I didn't realize how grayed out my painting was getting until I flipped it. I really wanted the luminescence of the city to spill over into the surrounding environment, so I bumped up the contrast by intensifying the city lights and darkening the mountains (**Fig.03**). However once I had done this I realized I had slightly overdone it, so I added a Multiply layer and masked out some of the parts that I wanted to remain lighter (**Fig.04**).

To create the trees and rocks I used a regular round brush and sometimes the Lasso tool if I wanted a really sharp edge on things like the buildings (**Fig.05**). Most of the time I tried to work with more textured brushes, but because the scene is at night most of the texture wouldn't be visible. To counter this I tried to bring out the texture more in areas that were lit.

02

03

04

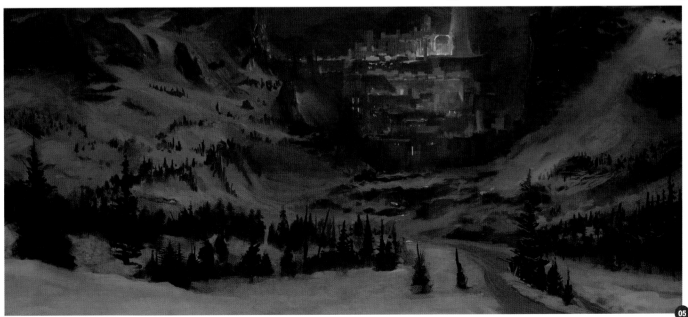

05

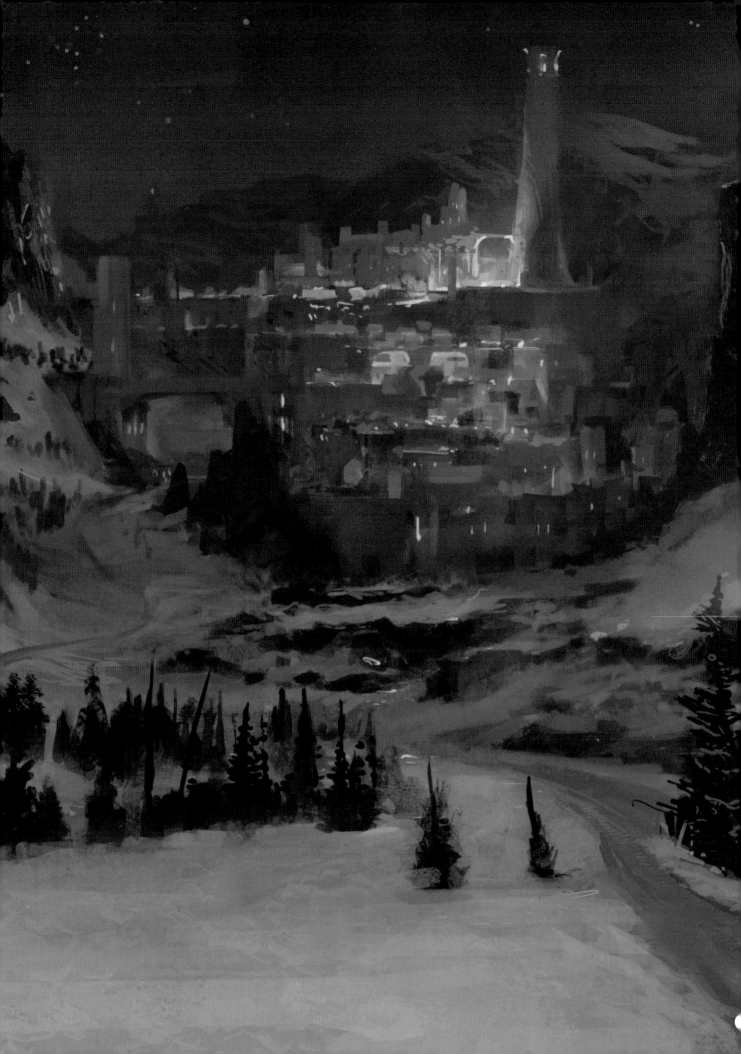

At this point I was still working out the design of the city and the immediate area around it, so you may notice that quite a few changes take place in **Fig.06 – 07**.

Being that I'm Canadian I have a lifetime of experience in the snow and can remember how different snow feels and looks. I can even remember how it reflects light differently, so when I try to apply this kind of stuff to my paintings it adds another level of enjoyment. If you are less familiar with the subject in your paintings I would recommend gathering as many references as possible.

> ## THE EDGES OF AN ILLUSTRATION SHOULD ALWAYS PUSH THE VIEWER AND NOT PULL THEM

One of the things I really wanted to paint was snow weighing down the pine branches and dead, leaning trees that have toppled over under the weight of the snow (**Fig.08**).

At this point I was getting ready to start finishing the painting, so I looked for faults or areas that I didn't think worked, like dead spaces, or contrasting elements that pulled too much. The bottom left didn't seem to be doing anything so I thought it might be good to have some directional elements to support the eyes' movement (**Fig.09**).

I can't quite remember where or who I heard it from, but someone once told me that the edges of an illustration should always push the viewer and not pull them. To reinforce that rule I strengthened the values closer to the edges to add a kind of vignette.

The final touches are usually slight color adjustments, but I also adjusted the contrast a bit around the focus just to try and match what I had originally envisioned (**Fig.10**). I added a bit of glow to the city to try and sell the mood a little bit more, and then called it a day. Overall I'm fairly happy with the outcome; the mood is close to what I wanted and the concept is what it needs to be.

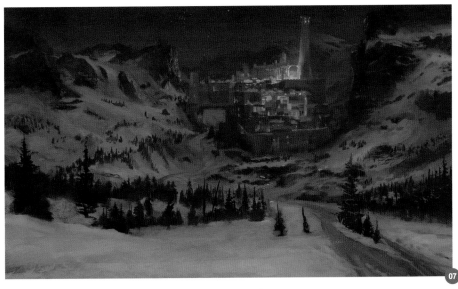
07

08

09

10

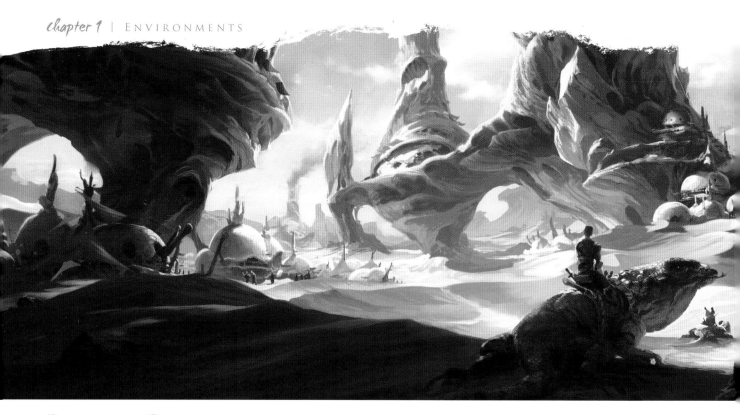

DESERT CITADEL
BY TUOMAS KORPI

INTRODUCTION

Hi, I'm Tuomas, a production designer, matte painter and illustrator from Finland. I currently work in an animation and illustration studio called Piñata, doing production design and concept art for varying projects. The work we do is mostly in the field of advertising, but we also work with a number of game companies, directors, and animation and production studios.

When I read tutorials or go to art lectures, I find the ones where they talk you through the thinking process behind the painting the most interesting. Being able to see the process in a step-by-step manner can also be educational, but what I find most interesting is reading why an artist made a certain visual choice or design decision. Why the artist adds one thing and leaves something else out is always interesting to know and helps with your own decisions.

In this tutorial I will try to describe the thought process I employ when working on an environment painting, and will also tell you a little bit about my workflow. I try to focus on the design and conceptual aspects of the painting first, and then describe my painting process.

01

02

THE DESIGN

Of course, every new painting starts with some general overall idea or a concept for the painting. In this case the rough guidelines and framework had already been provided. The image should be a desert environment set in a medieval/fantasy period. It should also include a settlement reflecting the habitat, and a citadel with a burning beacon at the top. The brief was quite simple, yet very broad, so right from the beginning there were a lot of ideas going through my mind.

I usually begin by breaking an environment down into core visual elements and then trying to find logical answers to any questions there

might be. What kind of color palette reflects the nature of the environment? What are the living conditions like – harsh or mild? Is the culture limited by their surroundings or do they control their habitat? To me this part is like solving a simple puzzle. The key is to find the visual solution that emphasizes the design, mood or impression you want to communicate.

WANDERING THE DESERT

From the start I knew there were going to be some challenges with the design and composition, since the desert is pretty much defined as an open, vast, horizontal space. Grand open spaces tend not to make for the most interesting compositions! I also wanted to avoid clichés like a Tatooine-style *Star Wars* city, as well as keep away from the all-too-familiar nomadic huts and tents.

> IT'S ALWAYS IMPORTANT TO BORROW ELEMENTS FROM THE REAL WORLD TO MAKE THE DESIGN AND ENVIRONMENT FEEL NATURAL, AND GIVE THE VIEWER SOMETHING FAMILIAR TO RELATE TO

I wanted to give the desert a surreal and alien feel, but at the same time keep it relatively natural looking. While sketching the first ideas, I came up with huge rock formations that defied the laws of gravity (**Fig.01**).

I was quite free-handed with the formations, but decided to keep the feel and texture close to what you would see on the walls of rocks found in the Arizona desert. It's always important to borrow elements from the real world to make the design and environment feel natural, and give the viewer something familiar to relate to. The same applies to everything from the cultural detail to the creatures and habitat of our imaginary desert world.

There is an evolutionary process behind each civilization and culture on Earth, and

by studying their architecture, traditions and history you can get a great sense of reality in your painting, even if it's an imaginary world you're painting. Viewers immediately recognize certain visual concepts and link them to certain cultures.

The strategy I employ is to simply find a familiar cultural basis, and then modify and revise it to the point where the viewer's imagination starts to subconsciously create reason for the elements in the picture. You are telling small stories and showing hundreds of years of history without actually having to paint it!

If you think about Middle Eastern, African and nomadic cultures; they always seem to live in harmony with their habitat. I think this is because the resources in the desert are limited, but also because they have to travel long distances for resources and really respect their hostile environment to make a living there. To keep the painting natural and believable I didn't want to paint a huge amount of human-built structures in the middle of a desert for no

apparent reason, because they wouldn't have the resources or materials to do that.

I felt inspired by the ancient rock houses and temples of Jordan and Tunis, and took this idea a bit further to create huge citadels and cities carved from solid rock. I wanted some variation to the houses to imply some sort of social hierarchy and decided to add smaller houses in the open desert.

Even though there is some variation in the architecture, I didn't want to use precise geometrical forms, but keep the feeling of the architecture really primitive and hand-made – organic even (**Fig.02 – 03**). This would further emphasize the time period and create a feeling that people are really living in harmony with their desert habitat.

EXPLORING THE COMPOSITION

When I have the rough framework for a painting and environment figured out, I start exploring the composition through small

thumbnail size ink sketches. I try to keep them very quick and rough, and usually spend only a minute on each one. If I already have one strong concept for the image in my head, I might want to explore to see if I can take it a bit further. What I'm looking for is a composition, view or camera angle that maximizes the information I want to communicate, and nails the feeling I want the viewer to have.

My main principle when working on the composition, and for the whole painting process in general, is to keep true to the original sketch and concept. If it's not working at thumbnail size, it's definitely not going to work when bigger!

With this painting I explored aerial views and different rock structures, but felt the buildings and cultural elements of the image were left too small. I also wanted it to feel as if you were arriving into a city complex and discovering it for the first time. The main challenge here was finding a nice balance for the rock formations and avoiding making the composition too crowded by having too many elements in the image (**Fig.04 – 05**).

> ❝ DEPTH IS BUILT
> THROUGH LOGICAL ❞
> TRANSITION,
> VARIATION OR
> REPETITION OF
> ELEMENTS FROM THE
> NEAREST POINT IN
> THE IMAGE FRAME
> TO THE FURTHEST
> POINT IN THE
> DISTANCE

An amazing book full of great advice about composition is called *Framed Ink: Drawing and Composition for Visual Storytellers* by Marcos Mateu-Mestre. Another great read is *Dream Worlds: Production Design for Animation* by the amazingly talented Disney production designer Hans Bacher. His blog is also worth visiting to learn more about composition.

Of course, there are a ton of things that make a strong environment or landscape painting, but

05

for me it relies very much on the simplicity of the form, depth and flow; three little and quite abstract words.

By form I mean that the silhouette of each element in your image should be simple enough to read without the values or color.

Depth is built through logical transition, variation or repetition of elements from the nearest point in the image frame to the furthest point in the distance. This can be, for example, a color shift from warm colors to colder tones, a change in the contrast or a repetition of objects of the same scale that get smaller as they disappear into the distance.

The flow is what brings the form and depth together in a way that's interesting and easy to look at! Balanced composition is important, but especially with landscapes and environments as you want to build an interesting path in the image for the eye to follow. The eye shouldn't escape straight to the horizon or go directly out of the corner of the image. In my opinion there should be an easy starting point where the eye

06

can start wandering around the image, like a sharp contrast, a vivid color or an odd form – something that catches your attention first.

From there you can build different paths that intersect key focal points of the image. It's easy to experiment with different possibilities if you start your painting process very lightly with rough sketches. You can see the thumbnail I chose to develop in **Fig.06.**

I also wanted a nice balance between the bright, well-lit areas of the image and the shadows, to emphasize the feeling of a burning hot desert sun. The sun was placed so that it fits the composition nicely, but also so the light follows the form of each shape nice and clearly. I also introduced some reflected light from the ground to give the shadow areas more visual information, and to add some hot, red tones to my image.

The dunes, buildings, small flags and sunshades were a great way to tell the viewer about the distance and scale of objects, and how they relate to each other. Repetition of elements improves the sense of depth and also gives the image a nice flow. You can see how I applied the depth in the color in **Fig.07**. You can also see how I designed the silhouette and shape of everything in **Fig.08**, and the flow of the image in **Fig.09**.

"REPETITION OF ELEMENTS IMPROVES" THE SENSE OF DEPTH AND ALSO GIVES THE IMAGE A NICE FLOW

Even though I personally like to explore the composition quickly with inks, I also try to imagine the colors and values in my head while I draw! With this desert painting I thought for a while about whether I wanted the lighting and color palette to be based on an evening or daytime lighting scenario, but I chose to go with the latter. I felt it would emphasize the living conditions in the desert environment much better, and give me a nice shift from the warm tones to the cooler and more desaturated colors towards the horizon.

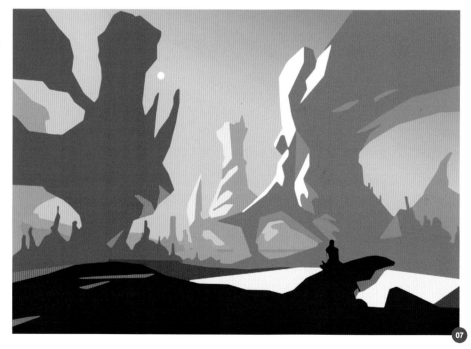

07

PAINTING

When I'm painting digitally I usually follow the same workflow, more or less. The basis of my workflow is, as I said earlier, staying true to my original concept and trying to improve the painting in each step I take.

I like to think there's a certain hierarchy of elements in every image, and you can't really change the order of how a viewer is going to read your image. In order they will look at the shape or silhouette, the perspective, the values and the colors. This is quite a practical way of viewing things because you won't be able to fix major flaws in the values in the image with colors. Or if you haven't focused on creating a strong sense of depth and perspective first, the values probably won't fix the problems.

Of course there are exceptions to this, like if I was doing a speed painting, or sketch, etc. I don't paint these kinds of images quite as methodically, but I do still try to think of the image in layers of hierarchies, where each element dominates and controls the other.

> **Quick Tip:** My tip for a beginner artist is to keep doing small practices every once in a while, employing these basic elements in order. Explore how you can build depth in your image with values, how you can keep your silhouettes readable, etc. Do small experiments with complete paintings and don't get stuck doing one thing for too long!

REFINING THE SKETCH

After I feel I have a strong thumbnail sketch for an image, I scan it into my computer, scale it up and start doing a more refined line art version of it (**Fig.10**). Sometimes I like to do this step traditionally by up-sizing the sketch and printing it on A4 paper. I then grab some extremely thin animation paper and start refining the sketch with inks.

At this point I refine the perspective in the image. I also design any buildings, creatures, etc., that I might want to add. I don't have to be too precise with everything, but good line art helps to speed up the painting process. When

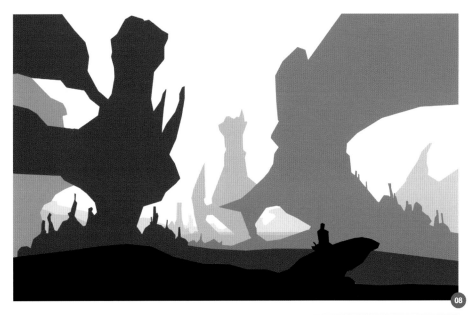

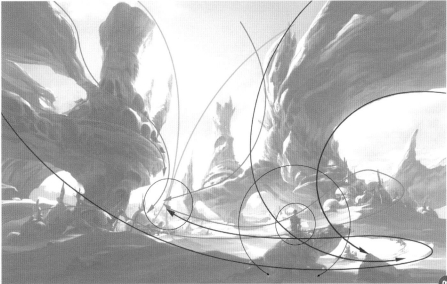

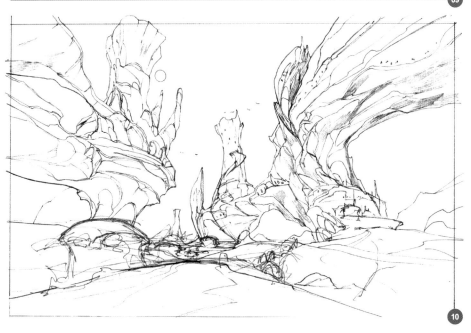

the line art is ready I scan it to my computer, open it in Photoshop and use it as the top layer in Multiply blending mode. This way it's easy to paint on the layers underneath and just click the line art on and off.

VALUE AND LIGHTING STUDIES

With the line art created it's easy to just start painting the image, almost like a coloring book. With the more complex images where there are a lot things happening, it's good to explore the lighting and values a bit before starting with the colors. I try to keep this value study more as reference for later, but it also works nicely as a basis for your color palette in the next step (**Fig.11**).

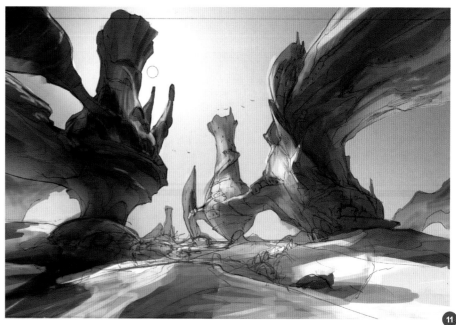

11

> ## YOU SHOULDN'T FEEL TOO TIED DOWN TO THE VALUES YOU ADD AT THIS POINT AS THEY'RE JUST A REFERENCE FOR YOU TO FOLLOW

The reason I paint the values separately is that it's easy to get carried away with things like reflected light, bright colors, etc., while you paint. This way you always have a reference as to how you would like the image to look. It's much easier to start with a simple grayscale painting and then move on to colors later.

I make sure I carefully study the direction of the light and silhouettes, to ensure that the contrast between the light and shadow areas is correct, and that there is good contrast between the foreground and background elements.

You shouldn't feel too tied down to the values you add at this point as they're just a reference for you to follow. If you want to change them later you can do.

When working on this stage of an image I try to work on the painting zoomed out, in a small thumbnail size. Again, the overall impression is the most important thing and all the little details come later.

12

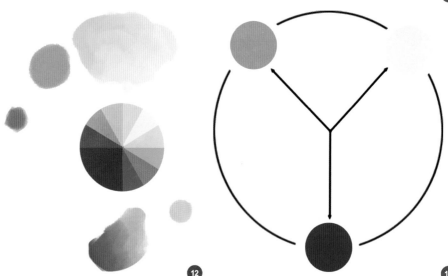

13

COLOR PALETTE

The black and white values were ready now so it was time to move on to the colors. I had a pretty clear idea at this stage where I was heading with my colors. I knew the time of day, direction of the light and had a clear line art for the objects in my image. I still continued working zoomed out and with really big brushes, trying to find the overall balance for my color palette.

I usually start with a simple color contrast, complementary colors or a simple color harmony and start to build my palette from there. For this image I chose the complementary colors of blue and warm yellow, and continued to increase my cold and warm

contrast by adding in tones of purple and yellow, which are also complementary colors (**Fig.12 – 13**). I also added a hint of red and green here and there to disrupt the balance a bit, so the palette didn't look too uniform.

It helps me to keep my color palette in Photoshop set to HSB (Hue/Saturation/Brightness) so I can keep track of the brightness and hue separately, and watch my saturation during the whole painting process.

I use adjustment layers and tools like Color Balance, Channel Mixer, Selective Color and different blending modes as much as I can. Using this approach truly justifies creating the image digitally rather than traditionally!

I check my value study regularly to make sure there is a clear distinction between light and shadow, and the lighting setup is natural. I try to improve the sense of depth with logical transformations in color areas (**Fig.14**). I use the Gradient tool a lot to make a lot of big, overall changes. Sometimes I bring back my value study and mix it in with blending modes like Soft light or Overlay to get some definition back (**Fig.15**).

It's all quite fast and chaotic, but there's always a clear goal. There are just so many ways to get to the desired result. I usually already know how the image should look at this point, but it doesn't hurt to explore a bit and check if you can improve the image even further. I don't worry about spending too much time here because this is the stage that pretty much defines what the final painting is going to look like. If all goes well I should have a small, thumbnail sized version of the painting that looks almost exactly like the final painting.

This process is extremely convenient when working for clients, because you can give them a very clear idea of the direction you are heading, without putting too much effort into painting and detailing everything. You also have the line art ready, so the client can already comment on the design and content of your painting, and you can do the necessary changes without having to backtrack.

PAINTING AND REFINING

At this point I had the base of my painting created, but I still had about 80% of the actual painting to do. I started to focus on the detailing, rendering everything out nicely and basically just continuing to define each element further. When adding detail I like to keep the buttons of my Wacom pen set to Alt (shortcut for Color picker in Photoshop) and X (changes between foreground and background colors) as this speeds up my painting process. I can pick colors straight from my color sketch and keep two different colors active at the same time! I try to follow my rough color palette while I paint, but also try to establish each of the different materials. I also like to mix photographs and textures into my painting

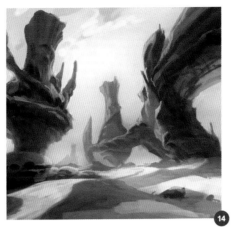

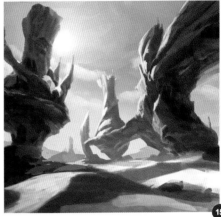

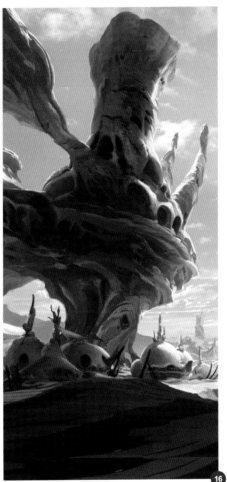

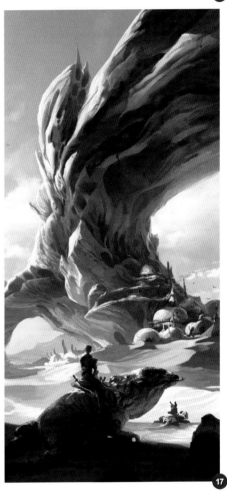

to get a sense of detail quickly, but I usually always filter them with Median (Filter > Noise > Median) and paint over them to get rid of the overly sharp feel. This part is also about creating and building little stories into your image, and that's the most fun part of the process for me (**Fig.16 – 17**).

This kind of painting workflow would work quite well in a professional studio where other artist will start using parts of your painting as

a backdrop or reference for lighting or color palettes before your image is finished. If I need to complete a certain part of the painting first, to be used as a matte element in an animation for instance, I can paint that part of the image first and it doesn't hurt the rest of the painting because the palette and composition isn't going to change much.

Thank you for your time and hope you found something useful here!

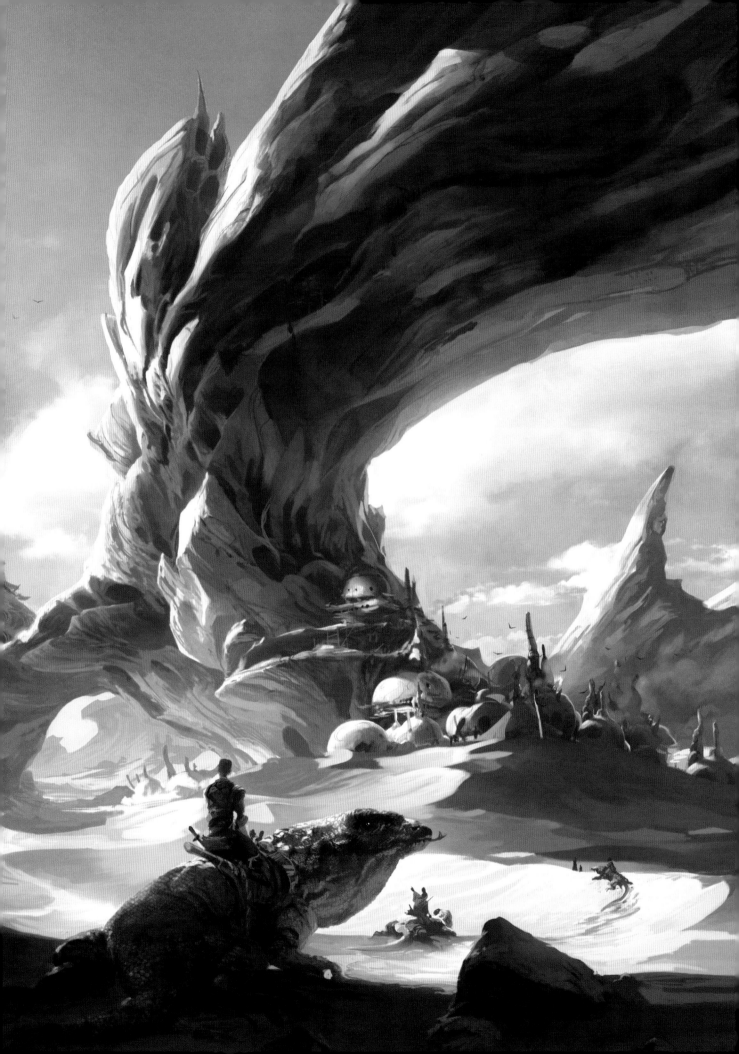

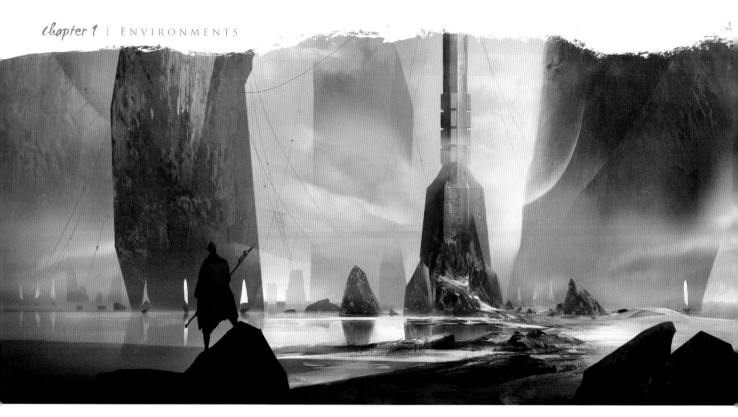

COASTAL REEF CITADEL
BY LEVI HOPKINS

INTRODUCTION

In this tutorial I was tasked with creating a coastal encampment in a fantasy setting. Some of the more specific tasks were to create a beacon, high walls, and some town elements. I immediately began gathering reference for this project. My reference gathering involved finding images specifically related to coastal elements, along with a wide variety of random abstract pieces. With a library of images to work from I begin to form various ideas that I'd like to capture in the piece.

REMOVING THE DREADED WHITE CANVAS

In the beginning it's very abstract thinking; sometimes it's just a single descriptive word or a type of mood. Once I feel satisfied with my research prior to starting a piece I begin moving forward with the actual painting.

To start this piece I begin with just some simple brush strokes and overlays to get rid of the absolute fear I have when starting with a blank white canvas. Starting with a white canvas feels incredibly daunting, so I always block in some colors or values quickly to help get my mind moving forward (**Fig.01**).

01

DEVELOPING THE IMAGE

Even though I have a basic palette down at this point, I don't completely lock myself into it at such an early stage of the painting. Another step I do here is to lay down some basic brush strokes indicating the ground surface dropping back into perspective. I know I want my horizon line lower so I can eventually have a very vertical beacon.

Next I start blocking in some large masses for potential rock formations. At some point I want to add architecture high up on the rocks so this is a bit of pre-planning. I add some indications of texture on these giant shapes to portray rock formations (**Fig.02**).

The textures are done with a bit of photo overlay combined with custom shapes. After

I've laid in some basic shapes, I quickly block in the general area and shape of the beacon (**Fig.03**). I keep the beacon incredibly loose to start with; just a few brush strokes to indicate a basic idea.

The reason I start very loose is that I don't want to jump in and design the beacon immediately, before I've decided on the composition, placement, scale and other features in the scene. In this step I also knock out the large shape in the middle of the canvas because it is overpowering the beacon, and start to detail the ground surface.

> " IT'S INCREDIBLY HARD TO MOVE FORWARD ON A PIECE WHEN IT'S JUST NOT SENDING YOU THE RIGHT VIBES. IT BASICALLY BECOMES AN EPIC BATTLE TO FINISH A PIECE YOU PROBABLY SHOULD HAVE JUST THROWN AWAY "

At this point in the painting I'm feeling confident about the general direction of the piece. If I was not happy with it, even though it's still early, I'd go ahead and start from scratch. It's incredibly hard to move forward on a piece when it's just not sending you the right vibes. It basically becomes an epic battle to finish a piece you probably should have just thrown away.

So now that I've come to terms with my own sanity, I block a few more details into the beacon. I want the beacon to remain monumental with just some basic edge definitions (**Fig.04**). I also decide on the light direction in the piece, indicating it on the beacon, the ground surface and the huge rock. Looking at the piece at this point I decide the composition is super unbalanced. The way I remedy this issue is by simply blocking in some larger rock masses to the right of the beacon. I'm keeping the rocks very stylized, with some hard edges, due to my personal preference (**Fig.05**).

Now the piece looks a bit flat with basically just a mid-ground component. To push the depth more I include a large rock in the background that falls within the flow of the rock right in front of it. I keep this rock completely hazed out and at a low contrast to imply a further distance from the viewer (**Fig.06**).

To push the depth even more I increase the contrast in the foreground and add some smaller rock elements. I've also tried to portray the foreground in a large shadowed area. I push a cool color in the foreground to contrast with the warm light that's being cast through the piece.

> I'M NOT TOO KEEN ON RENDERING OUT PIECES TO HELL AND BACK AND ENJOY MOMENTS WHERE A SIMPLE SHAPE CAN INDICATE AN ENTIRE SUBJECT

Stepping back from the piece I decide to add a scale indicator in the foreground – a little dude (**Fig.07**). As in most of my pieces, I have an addiction to adding silly little dudes wandering through the piece. In my mind it tells a story more than just staring at a beacon and some rocks. I like to think of the moment this character comes into view of the scene and takes it all in.

06

I also add some simple scale elements in the mid-ground (with about two brush strokes), to indicate small ships with sails. I'm not too keen on rendering out pieces to hell and back and enjoy moments where a simple shape can indicate an entire subject.

Now that the piece has a clear division between the foreground, mid-ground and background, I start to add more detail. I also flip my canvas, which I've been doing throughout the whole painting process, just to try and get a fresh perspective on the piece. Once again, I

07

indicate some very basic shapes on top of the rocks where I'd like some structures to be built (**Fig.08**).

I do this in the same way as I blocked in the beacon, by starting with just a few shapes to judge the basic feel and placement prior to any heavy detailing, which will save you a lot of time. These simple shapes have been created with a Marquee tool and some color sampling from the rocks they are placed on.

To continue this piece at this point I go into full-on detailing mode! I jump all around the canvas, hitting elements in the foreground, blocking in some of the architecture on the rocks, and throwing in a lot of atmosphere and clouds (**Fig.09**). I do a lot of brush strokes and adjust their perspective to give the impression that the clouds are moving through the piece towards the background. A lot of the texture on the rocks is created by simply layering custom shapes.

Finally, the last step is to do some basic color tweaks and contrast adjustments. These are all done through adjustment layers, where I can delete the parts that I don't like. This stage can really be an endless abyss, leaving you to second guess a variety of choices you've made (**Fig.10 – 11**). I find it best to just be very decisive here otherwise I can see myself changing this into a night scene, disco party, or whatever else I stumble upon with adjustment layers. Eventually I'm decisive enough to say that I'm happy with the piece and call it finished.

ARCTIC CITADEL
BY DENNIS CHAN

INTRODUCTION

This illustration was based on a short brief, but I was pretty free to interpret it however I liked. The brief told me that I had to paint a fantasy environment featuring a citadel and surrounding settlements, and that it should be based in the Arctic. I like adding a story when painting concepts. I often find it hard to paint an environment concept without adding some sort of character to add some narrative to the piece.

I wanted the illustration to feel alive and almost look like I had taken a screen capture from a movie. Before I started working on it I knew that this illustration would require some effort, and that I would probably change it a couple of times. I honestly didn't have a clear vision of what my final image would look like when I started it, but I did have a good idea about the mood that I wanted to achieve.

When I first got the brief I started right away by doing some quick and rough sketches in my sketchbook. I put the assignment to the side for a couple of days, then went back to my sketchbook to see if I was still hooked on my rough ideas, with fresh eyes. I find that this is the only way I can be critical of my work.

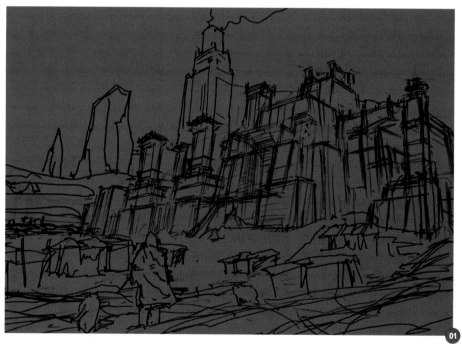

GETTING STARTED

The next step was to get started in Photoshop. I began with a simple and quick line drawing of the whole scene (**Fig.01**). It's a rough sketch and I was basically just trying to mark out what I had imagined with the support of my sketches. What I was trying to do is to figure out the composition, scale and proportions. At this point I was not concerned about the details

or trying to refine precise design elements. I kept the line drawing on a separate layer so I could easily paint beneath it and turn it on and off when I needed it.

I decided early on that the main light source would come from the left because I wanted to highlight the character and the castle, as they were the main focus of the painting (**Fig.02**).

FOUNDATION

The next step was to continue to develop the under-painting and to start to add some texture. When looking for reference images for textures I look for images that match my chosen color palette, and that contain features and shapes that will add more interest to the painting. I also look for references at this point to help me further understand the texture of the different parts of the painting. I then try to use

> " I ALWAYS HAVE A COLLECTION OF RELEVANT PHOTO REFERENCES ON MY SECOND MONITOR. I USUALLY SEARCH FOR THESE ON GOOGLE, BUT I ALSO HAVE A LIBRARY OF PHOTOS I'VE TAKEN "

colors taken from my texture references to start to block in some color under my line drawing. The idea at this point is to build a foundation to work on (**Fig.03**).

At the moment my image was a bit dark in value and the contrast was too subtle, but it was good enough for me to start working on as I intended to work from dark to light. I used Curves and adjustment layers to increase the colors and contrast before I got stuck into painting.

I added some animals to the scene to add more narrative to the painting, and to make it look like a populated area rather than just an empty village. I also added some lights inside the tents to show that there were people inside them and that this was an active and social area. At this stage I predominantly work with mid-tones, though I do paint elements in the foreground with a darker value just to separate important elements and show depth (**Fig.04**).

REFERENCES

As I mentioned before, I always have a collection of relevant photo references on my second monitor. I usually search for these on Google, but I also have a library of photos I've

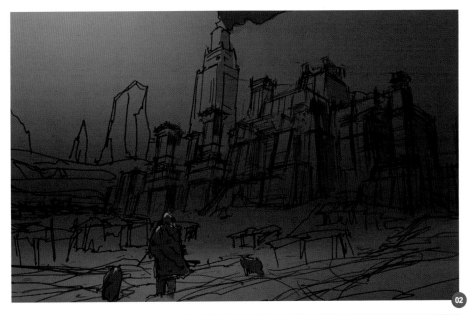

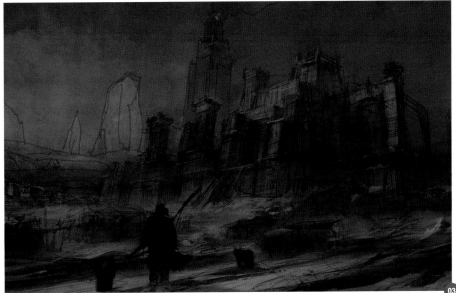

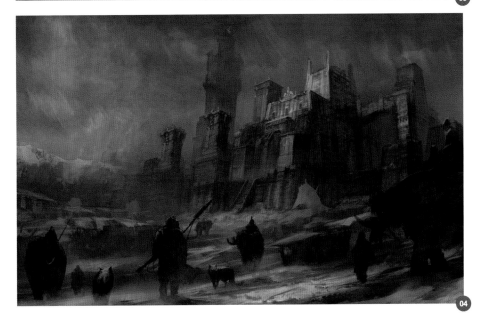

taken on my field trips and travels. I find using photo references very important. I rarely find photo references that exactly match my needs, which makes studying and having a good understanding of your subject matter extremely important.

PAINTING AND ADDING PHOTO TEXTURES

As you can see in **Fig.05**, a great amount of painting has taken place. This step is a big jump from the foundation painting that I mentioned previously, but the process was quite simple as it was simply a case of picking colors and applying them to the painting.

In this stage of the painting I started to work more with the values and contrast. I knew at the beginning that I wanted the light source to come from the left, but now that was more established and this helped me to think more about the way the lighting should look and what should be in light and shadow.

Because the camera angle was slightly raised and looked down on large parts of the environment, almost everything facing upwards would be lit by the moonlight. When I work on a busy illustration with lots of elements, the image can easily become noisy, so I intended to fake the highlights and how the light affects the elements so it focuses on the main elements of the image. To achieve this I made sure the lightest area were around the main characters and on the front of the citadel.

I also added some mountains to the background to further demonstrate depth. To add these I used a photo of some snow-capped mountains and set it to Overlay layer mode with very low opacity. This meant that I could then paint over this area to achieve the desired painterly effect.

I also made some changes to the citadel. I was inspired by Gothic architecture, and basically copied and pasted part of a church image into the painting to add some texture, which saves a lot of time. Once these editions were made I had to again add the correct lighting to the updated area. The best way to do this is to

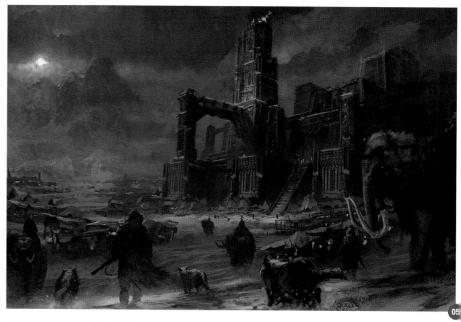

IMAGE FROM WWW.CGTEXTURES.COM

SOFT BRUSH

SOFT BRUSH WITH TEXTURE

imagine yourself in the scene and the lighting effect that you would see.

I also added a rusty texture over the whole painting and set it to Softlight at 15% opacity. Since the rusty texture was pretty much red, I had to desaturate it to make it match the tone of the painting. The reason I do this is because it helps to get rid of the digital look and adds texture to the canvas, which can be interpreted in different ways. I find most of my textures on **www.cgtextures.com** (**Fig.06**).

The last thing I do at this stage of a painting is copy the whole image and open it on a new canvas, then decrease the size of the painting to 60%. Then I copy back the decreased image

to the original file and scale it back up to 100% again. I use the Unsharp mask under Filters and move around the sliders until I am happy with the result. I pretty much go by instinct and I do it differently each time. Again, the reason I do this is to lose the digital look. As a painting progresses it can look a little flat, but by doing this some of the pixels will blend together and it makes it look like your image was painted with dry paint. Even once I have done this I will continue to define edges and make further adjustments.

TEXTURED SOFT BRUSH

At this point I felt that the image lacked depth and atmosphere, as well as contrast, so I pushed back the background with some

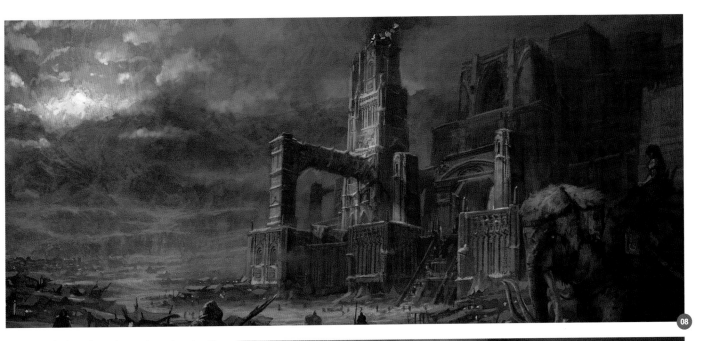

atmospheric dept. I used a costume brush with a texture applied, set to 10% opacity, to do this (**Fig.07**). With this brush I could desaturate and reduce the contrast in the areas that I wanted to push further into the background. Using a textured soft brush helps you avoid making your image look flat. The texture leaves surfaces with subtle value differences, which helps to mimic the affect of atmospheric depth.

FIND BALANCE

I wasn't happy with the citadel so I scaled up parts of it so it took up more space. I did this because I felt the castle was too small in proportion to the rest of the painting and needed to be balanced (**Fig.08**).

FINALIZING

In my opinion, the last part of any painting is the most hideous part. I basically run through the whole painting, stepping away, observing, making corrections, removing, balancing color, defining edges and so on (**Fig.09**).

On a separate layer I added some snow particles in the air to depict a sense of motion. I also felt it supported the mood I was going for. Again, I added more brush strokes here and there until I was happy with everything.

The last things I did was to the merge the painting to a new layer and use the Unsharp mask to sharpen the edges a little bit (**Fig.10**).

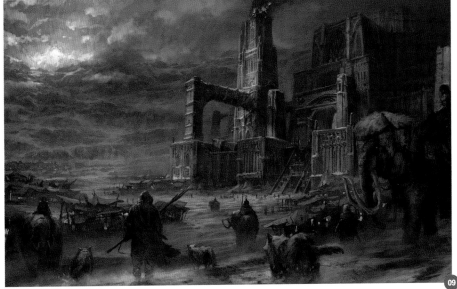

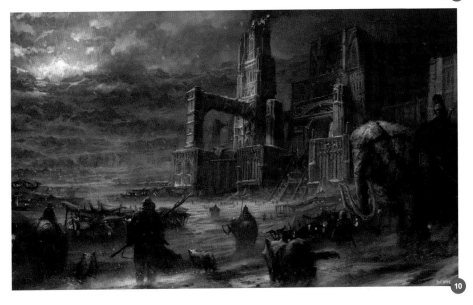

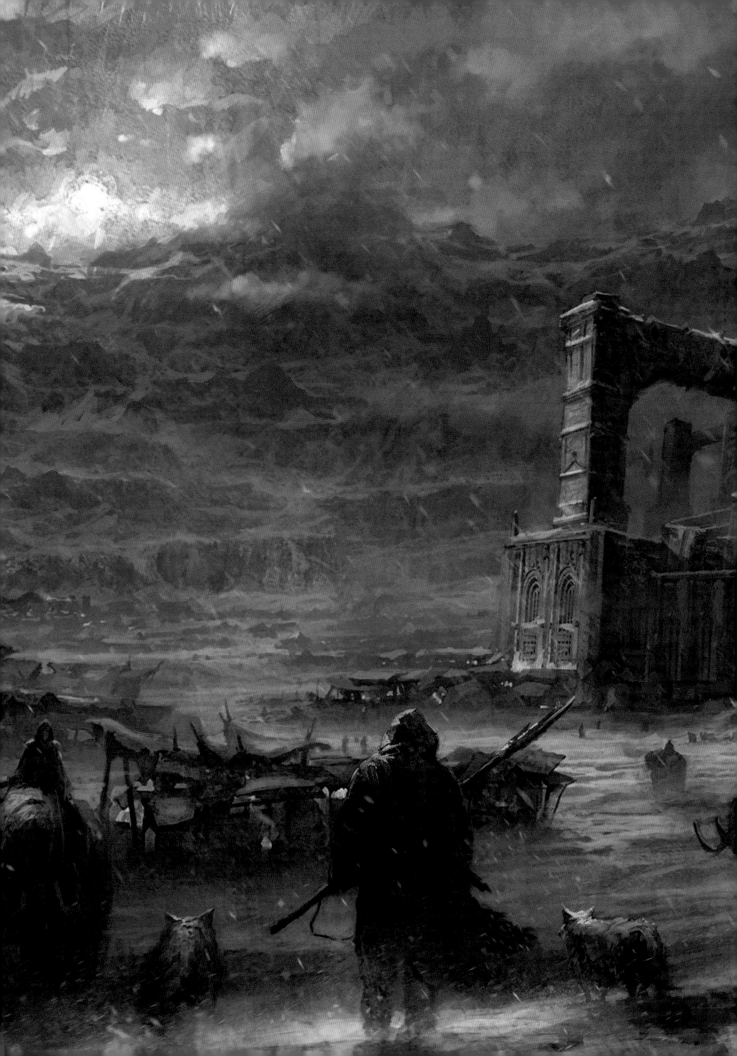

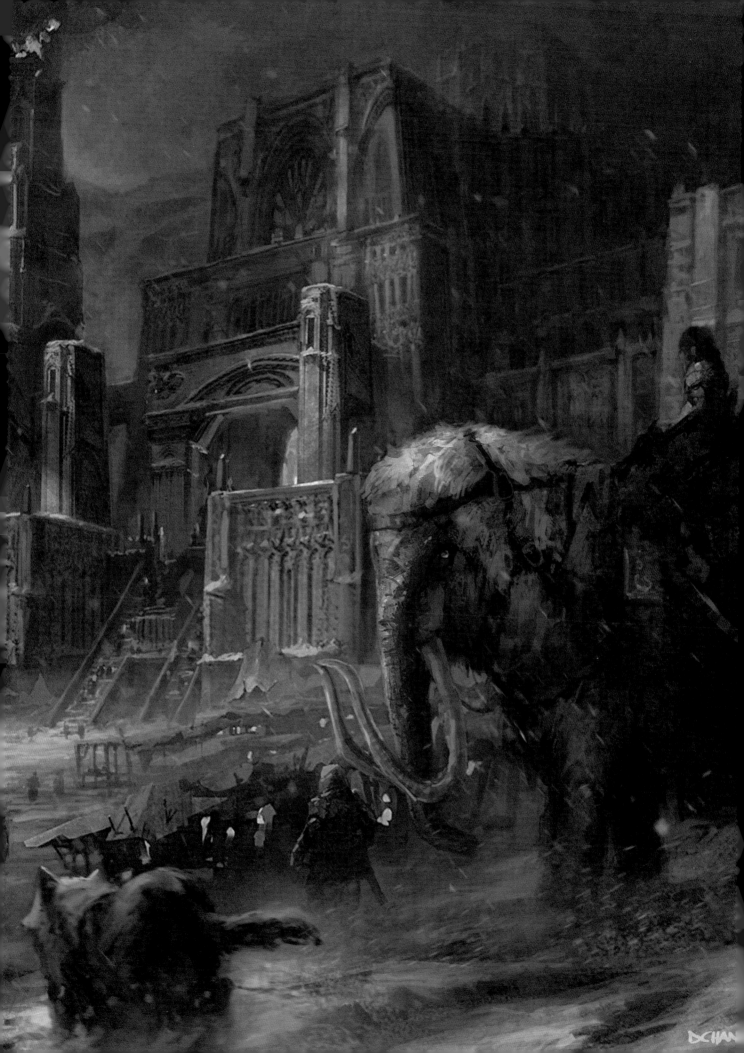

chapter 2 | STYLES

Artistic styles can be subtle and unique to individual artists. However, they can also be obvious and internationally recognized, and in this section we will be looking at three of the more mainstream ones: pin-up art, comic art and manga. Each of these has their own huge audience that continues to grow and thrive, boosted by the influence of the movie and game industries, which increasingly draw on their heritage for inspiration. The beauty of creating art in a specific style is that there are rules you can apply and techniques that can be used to make your work instantly recognizable, and fit neatly into one of these categories.

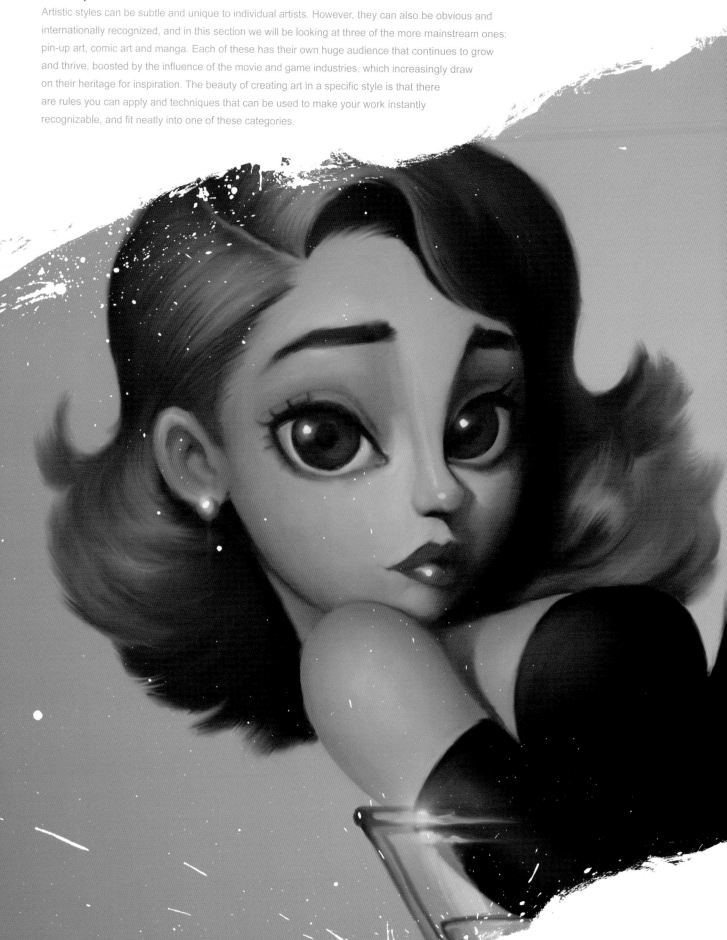

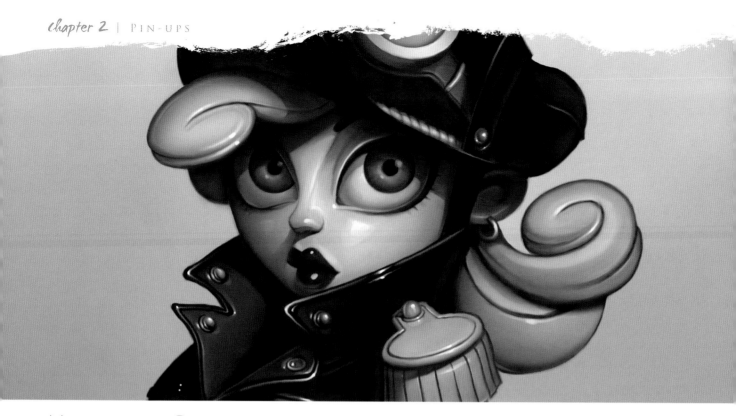

MILITARY GIRL
BY SERGE BIRAULT

INTRODUCTION

For this image I will try a style that's different from my usual one. I want to do a cute cartoon pin-up, with very simple shapes. Bambi (her name) will be the character for this entire section. This chapter will be a military pin-up.

INFLUENCES

Here's a list of the artists who inspired me for this project:

- **Osamu Tezuka**: The father of manga. He used to say he was not a good designer, but I think he was wrong. He had the capacity to create great characters with very simple shapes. He provided a very good influence when creating the face I wanted for Bambi, and was a great help when deciding on the proportions.

- **The Fleischer Studios**: They created Betty Boop, perhaps the most popular pin-up of all time. I'll try to emulate her beautiful legs.

- **The Walt Disney Studios – in particular Lee Clark:** He did a lot of sketches of Mickey Mouse's hands (you can easily find these sketches on the internet).

- **Bawidamann (www.bawidamann.com)**: A very good pin-up artist who created a lot of military girls. This was a useful reference to have for the uniform.

THE SKETCH

Usually I don't spend much time on sketches. I do a very fast doodle to see if the composition, curves and shapes are good (**Fig.01**).

COLORS AND LIGHTS

For a vintage-looking picture I will need sepia tones (**Fig.02**). I can't work directly with these colors as it is too time-consuming, so I do this by making adjustments at the end. I want to do an exterior scene so I choose a blue background, like a big, blue sky. This blue will be my ambient light so it will influence all the tones of my picture. There will be a lot

of reflective materials (vinyl/plastic/metal) in this scene. I like to show these with square reflections. It's not very logical because it's an exterior scene, but I'm not trying to be realistic – I just want it to look cool!

AIRBRUSH TECHNIQUES

I do 95% of my pictures with the Soft Round brush. I used to say I was a Hajime Sorayama disciple. When I was young I used a real airbrush and tried to emulate his style. I'm just trying to do the same things with software now. It's far easier, but at the same time the digital airbrush is a bit too clean for me.

There are only two points to manage with digital airbrushes: the size of the brush and its opacity (**Fig.03**). Don't forget that the more opaque part is the center of the circle of your brush. Try to do good gradients in a single stroke if you can. If your gradient seems to be unclean, try using a bigger bush. Working with 100% opacity is difficult so you'll probably need to lower the opacity of your brush. I often use my brush with less than 10% opacity and do a lot of strokes. I find that radial gradients are usually much more effective than linear ones.

If you want more details on the airbrush techniques, take a look at Hubert de Lartigue's website (**www.hubertdelartigue.com/**). He is a French airbrush master.

THE HEAD

Big eyes a cute nose and small lips, like the work of Tezuka. I only do simple and curvy shapes. I don't have a lot of flesh tones to do, but I want a kind of plastic look to her, as if Bambi is a toy or a vinyl figure. So her skin has to be more reflective than normal. The reflections are made with pure white and I add a little bit of blue in the shadow. I begin with a hard brush and I blend the tones with an airbrush. Finally I add some red on her nose and her eyes (**Fig.04**).

VINYL/PLASTIC/RUBBER

All her clothes are done in the same way. I begin with the darkest color and add brighter colors (a very bright blue) little by little on new layers (**Fig.05**). Don't be afraid to create a

lot of layers and merge them when you are satisfied. Use the airbrush with a low opacity for reflections or simply lower the opacity of the layer (**Fig.06**). Don't try to be too realistic; you're not a 3D render engine. Good looking is far more important than logical. You can easily find references of vinyl/plastic/rubber reflections. A very simple example is car paint.

> ## MY TANK LOOKS LIKE A 2CV, AN OLD FRENCH CAR WITH A VERY FUNNY BODY

THE LEGS

The stockings are very simple. The base color is a bright brown. I simply use the Burn tool on the edge, with a soft round brush of course, and a low opacity again. The reflective parts are on another layer and are white. I just decrease the opacity of this layer. The shadows are on another layer too and are black. I just decrease the opacity of this layer too (**Fig.07**).

THE TANK

I'm not very interested in military stuff. My tank looks like a 2CV, an old French car with a very funny body and chromium plated headlights and bumper. It's very simple and the reflections are not complicated either, so I don't spend a lot of time on it. The only funny part are the headlights. I try to be organized. Every part has its own layer. Selection tools are very useful for these kind of geometric parts (**Fig.08**).

BACKGROUND

Once again, I try to not lose too much time on this step (**Fig.09**). I add smoke and fire in order to hide the low levels of detail behind Bambi. Painting sand is very boring and time-consuming. Hopefully the surface is small. I use only three colors. I sometimes copy and paste some parts and paint over them.

ADJUSTMENTS

Adjustments are magic. You can change the colors, hue, luminosity or contrast. If all the different parts of your pictures are on separated layers, it will be easier (**Fig.10**). This time, I only create a color type layer and add the sepia tone (about 25% opacity).

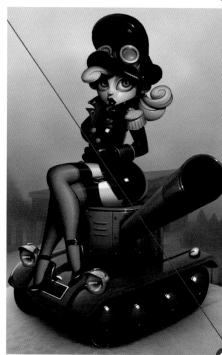

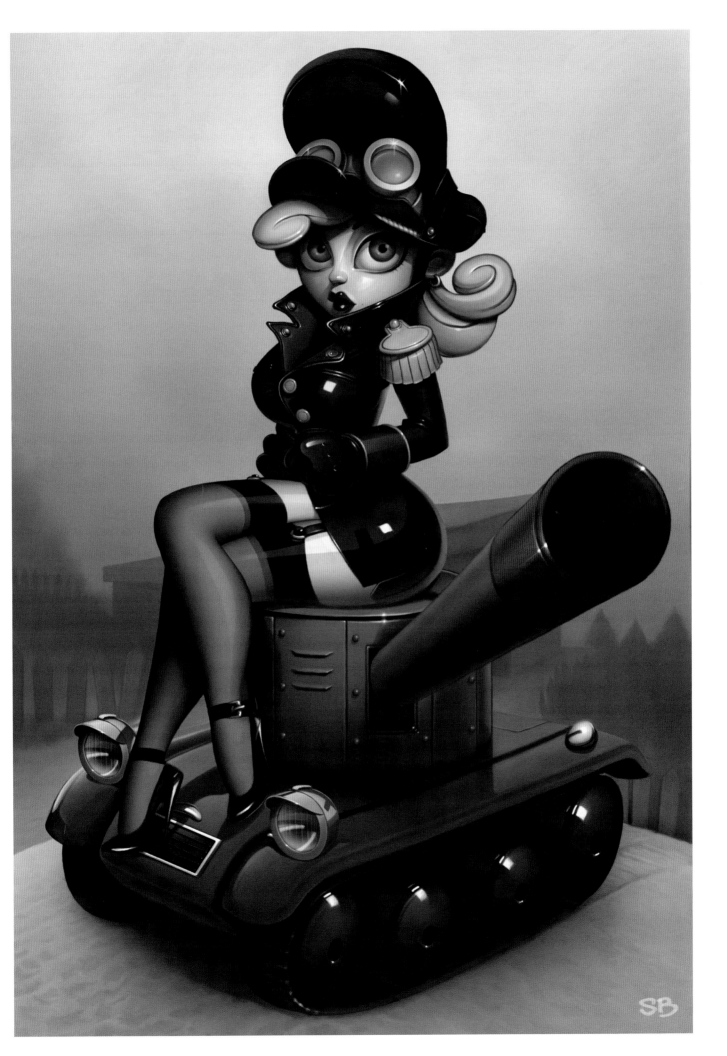

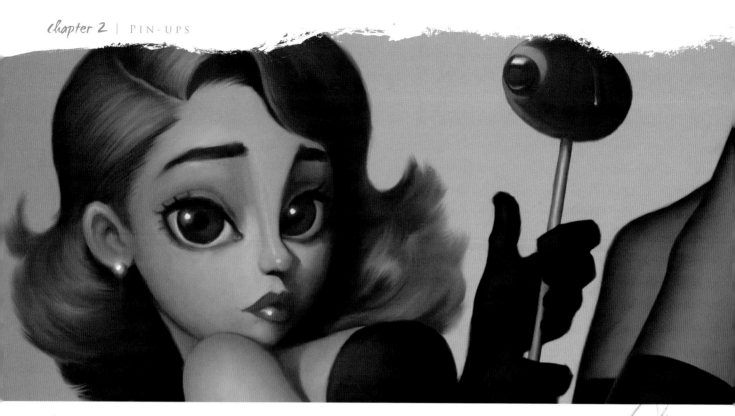

CLASSIC GIRL
BY SERGE BIRAULT

INTRODUCTION

A girl in a Martini glass – a classic in pin-up painting! In order to keep to this vintage/old school idea, I will try to emulate (a little bit) an oil painting. So I have to mix the cartoony style of Bambi with a classical way of rendering.

INFLUENCES

Here are the artists who inspired me this time:

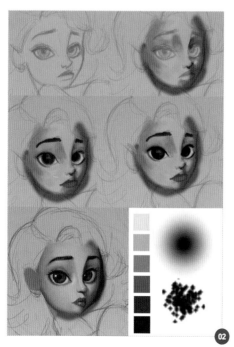

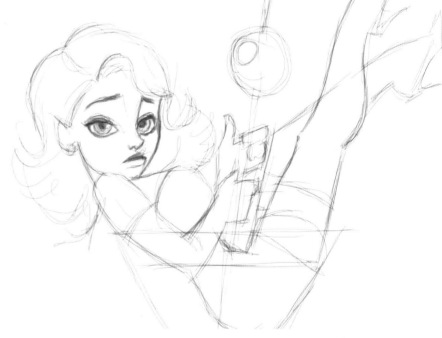

• **Gil Elvgren**: He was, is and always will be the best pin-up painter. This time I will try to give Bambi an oil painting-like look. The tones that Elvgren used will have a great influence too.

• **Cartoon pin-ups**: There are a lot of 2D/3D artists who do this kind of character, such as Andy Hickinbottom, Matt Dixon, David Dunstan and Rebeca Puebla. Take a look at their work; it could be very useful.

THE SKETCH

As usual, I don't spend a lot of time on my sketch. The composition will be quite simple. I will probably do some changes, especially to her face (**Fig.01**).

COLORS AND LIGHTS

The light will come from the top left of the picture. I will try to emulate interior lighting, like a photo studio. In order to make it look like an Elvgren painting I will avoid shiny skin

by keeping the contrasts low. The tones that Elvgren used are very interesting: a lot of red in his dark colors, especially on the skin, and a yellow base for the light tones. You will see that my palette is very simple and logical.

THE LOW OPACITY TECHNIQUE

In order to have an oil painting-like render I will try to avoid heavy use of the airbrush or soft round brushes this time. I never create custom brushes; I try to use the basic ones that come with Photoshop. They usually do the job. The only unusual brushes I like are the Ditlev brushes which are available to download for free if you search for them. A lot of digital artists use these brushes. Ditlev have done a really great job!

> ## SHE LOOKED A LITTLE LIKE A VINYL TOY. HER SKIN WAS VERY PLASTIC AND REFLECTIVE

The problem is always the same: how do you blend colors and paint good gradients? There are a lot of possibilities, but I think using very low opacity brushes (between 0 and 20%) is a simple and perhaps the most efficient way. Airbrushes with low opacity would make the image too clean so let's try to create a more painting-like look.

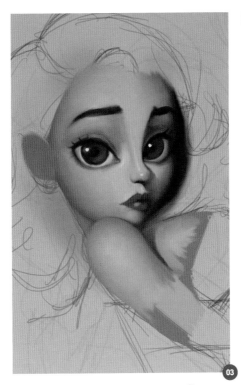

THE FACE AND THE SKIN

I will change the face of Bambi a little bit. The last time, she looked a little like a vinyl toy. Her skin was very plastic and reflective. This time, I want her to look like a classic pin-up. I begin with a middle tone, a yellow/orange on a layer. I create another layer for the darkest tones (brown/red). Then, on separate layers, I paint the gradient by using a lot of strokes with low opacity brushes. I do cheat a little bit and sometimes use a couple of airbrushes, again with low opacity (**Fig.02 – 04**).

The eyes and the lips are on separate layers. I merge all the layers only when I'm happy with the result. I use the same technique for all the flesh tones in the picture.

THE STOCKINGS

Elvgren had an amazing technique for painting stockings. I am going to try to emulate it. The darkest color is a very dark brown and the lightest is the flesh basic tone. It's quite logical, but he also used to add red tones between the two. So I do the same (**Fig.05**).

Never do gradients that contain only two colors. Try to do it with at least three! Once again I add a lot of layers and merge them when I'm satisfied with the result. I do, however, keep two layers separate, one for each leg.

THE HAIR

The hair is probably the most time-consuming part of this picture. I use two very small Ditlev brushes (with low opacity again). For the end of the hair I use the same brushes, but I also use the eraser (low opacity again). The haircut is, of course, very much inspired by several pieces by Elvgren (**Fig.06**).

> **YOU CAN FIND A LOT OF REFERENCES ON THE INTERNET ABOUT PAINTING GLASS, BUT THE ONLY RULE IS TO DO LOGICAL GRADIENTS**

THE GLASS

Glass can be difficult, but there is a simple way to paint it. First create a Multiply layer over the other layers. Then use pure black and basic round brushes with a low opacity.

You can find a lot of references on the internet about painting glass, but the only rule is to do logical gradients. For the reflective parts use a very light color, but not a pure white. You can also use the airbrush to add little touches on the brightest parts (**Fig.07 – 08**).

The background and details can be seen in **Fig.09 – 10**. I do some minor changes to the background colors and some of the missing parts of the composition. There is nothing difficult here. The olive is very simple and you can use the technique we used for the glass for the reflection and the drop.

MINOR CHANGES

I change the shape of the leg and do some adjustments on the light and the contrast. It's very useful to have each part on different layers (skin, hair, stockings, dress, etc.,) so you can do your adjustments without changing the whole picture.

HEAVY METAL GIRL
BY SERGE BIRAULT

INTRODUCTION

I was a teenager is the 80s. It was a very strange decade, especially for music. I listened (and sometimes still listen) to a lot of heavy metal. Metal bands were linked to very kitsch artwork, full of chrome, lighting and blonde girls in leather (now you know where my love for reflective surfaces comes from). I tried to emulate this style with my heavy metal Bambi.

INFLUENCES

Here's a list of the artists who inspired me:

• **Doro Pesch and Warlock**: She is my principal influence for this picture. She was (and still is) the Queen of Heavy Metal. You can find a lot of photo references of how she looked in the 80s. If you look at the final image you will see that Bambi's haircut is a poor copy of Doro's.

• **Jason Edminston**: My friend Jason is an incredibly traditional illustrator. He has done a lot of pictures that are influenced by old metal bands.

• **Didier Crisse**: He is a famous French illustrator who has made a whole lot of

comic books. His style influenced the look and also the colors I have used.

• **Hajime Sorayama**: Always my favorite influence. The great master of chrome and leather.

THE SKETCH

As usual I don't spend a lot of time on the

sketch (**Fig.01**). The composition is very simple and the pose is very classic and kitsch. Exactly what I need!

COLORS AND LIGHTS

This is the most important part of the picture. The colors are very simple because my palette is very logical. This time I use a different technique. I usually create a lot of layers and

I try to separate all the different parts, but sometimes it's easier to work on a single layer and choose your tones carefully. It's kind of like doing a colored sketch and it's very useful (**Fig.02**).

I then cut and paste the character into a new file and clean her up with the Soft Round brush with very low opacity. Don't forget to work in a big file format. I then create a simple background with some quick gradients (**Fig.03**).

> # SHE LOOKS LIKE A SIMPLE CARTOON, BUT THE RETRO LIGHTING FROM THE ENVIRONMENT CREATES INTERESTING VOLUMES

PAINTING TECHNIQUES
In my original color sketch I created my entire color palette. Because of this I don't have to work with so many low opacity brushes. I create the whole image with the Standard brush, with the opacity set between 50 and 100%. I sometimes clean the gradients with the Soft Round brush, but on this occasion the image is more painterly and doesn't require the use of many soft brushes.

THE HEAD
Bambi's face is quite simple. She looks like a simple cartoon, but the retro lighting from the environment creates interesting volumes. I change her expression a bit during the process (**Fig.04**). I copy the flesh tones that I have already created in my sketch and use them to make sure that there is enough contrast in the skin. I add a blue/cyan retro highlight in areas. For the first time you can easily see my brush strokes. Once I have done this I've finished the skin tones of the image.

The hair is not too complicated. I add a little bit of orange between the darkest and brightest tones to emulate the transparency of the hair, which would be present with this kind of lighting (**Fig.05**).

THE LEATHER AND METALLIC PARTS

I begin by concentrating on the darkest area, which is a very dark brown. I add brighter colors little by little, on new layers. Then I add the retro blue light (**Fig.06**). Leather is less reflective than vinyl or rubber so the contrast has to look soft. The metallic parts are done with very few colors. I create a lot of Sorayama-like halos to add to the kitsch effect (**Fig.07**).

> ## CHROME IS A VERY SPECIAL METAL. IT LOOKS LIKE A MIRROR SO IT REFLECTS ITS ENTIRE ENVIRONMENT. YOU HAVE TO KEEP IN MIND THAT THE OBJECT HAS ITS OWN VOLUME AND SHAPE

THE GUITAR

I try to find the most emblematic guitar of the 80s heavy metal scene and I settle on the flying V model. In the beginning I thought a red guitar was a good idea, but I've decided to go with chrome as I think it will be more interesting to do (**Fig.08**).

Chrome is a very special metal. It looks like a mirror so it reflects its entire environment. You have to keep in mind that the object has its own volume and shape. The most difficult part is to find the correct gradient to use. In reality the guitar would not reflect the floor and it would probably only reflect the sky, which is a kind of brown/red color. I choose to cheat a little bit as I often do. I do all the parts on different layers and merge them all when I'm satisfied.

BACKGROUND

I try not to spend too much time on this step. I only add the shine, the lightning and a few reflections on the floor.

ADJUSTMENTS

In order to give it an 80s appearance I remove a bit of the blue color everywhere in the picture. Then I just do some corrections to the contrast and it's done.

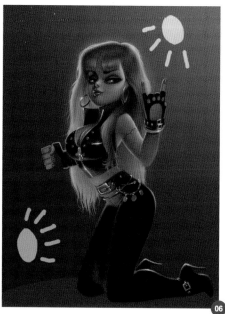

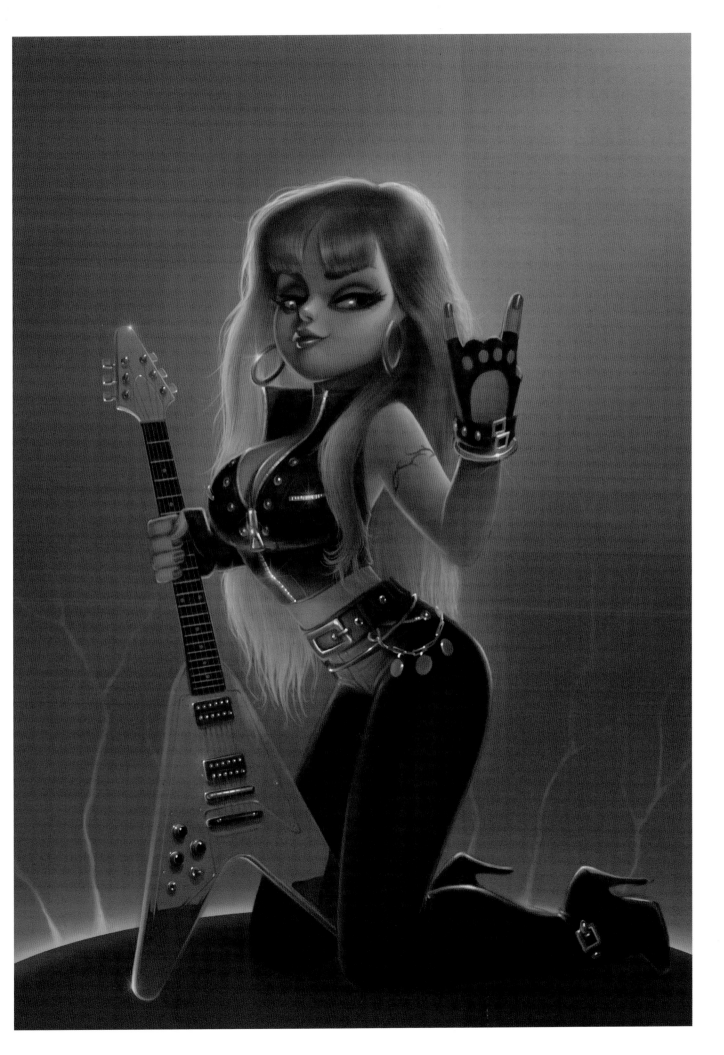

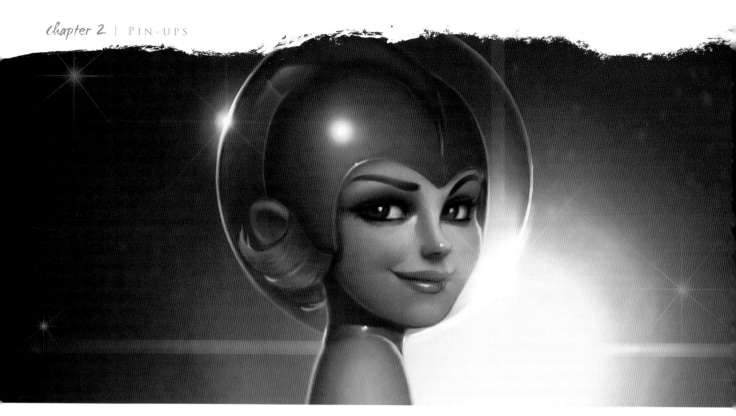

SCI-FI GIRL
BY SERGE BIRAULT

INTRODUCTION

I'm not very familiar with science fiction, but I am going to give it a go in this tutorial. I hate painting spaceships and ray guns and things like that, but I love old fashioned sci-fi movies so I will try to use that as my inspiration.

INFLUENCES

As with the other tutorials I will start with a list of who or what inspired me for this image:

- **Sci-fi illustrators:** I looked at the work of old school sci-fi illustrators like Frank R. Paul or Pete Elson.

- **Siudmak:** He's probably one of the most famous sci-fi book cover painters. The main influence I took from him was his use of very saturated tones.

- *Amazing Stories* **magazine:** Old issues have incredibly kitsch, sci-fi covers.

- **Hajime Sorayama:** As usual!

THE SKETCH

The sketch is very simple (**Fig.01**). It is a girl and a rocket. Although it's basic, it's a classic

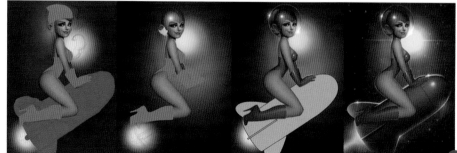

pose for a pin-up that has been used by a lot of painters. You often see military pin-up girls sitting on bombs and that is the type of style I would like to mimic.

I always work on big files, at least A4/A3 format at 300 dpi. Always keep your sketch on a separate layer and don't hesitate to create a lot of layers around it if you need to. I used to create roughly 200 – 300 layers for a simple picture. If you don't have a very powerful computer, merge them when you're satisfied.

COLORS AND LIGHTS

I really don't know how to start. I have any ideas for the colors and the lighting, so I change my mind often (even more often than usual). As you can see, I start with cold tones and I add saturation little by little (**Fig.02 – 03**). My global light starts in white and then later becomes yellow. It's very easy to make changes with Photoshop. Don't forget you've got the right and ability to try a lot of different things. You don't have to work in a linear way. If you come across a similar problem, the best thing to do is test some variations out and see what you do and don't like.

As usual I'm working with very low opacity brush strokes. I only use the Soft Round brush (airbrush) for this picture, with the opacity set between 50 and 100%.

THE HEAD

Bambi's face is different in every picture I do. This time she is less cartoony than usual. I try different proportions and skin tones. Once again I don't work in a logical way as I think it is good to not know where your painting is going. I add details like the helmet, which I make bubble-like with very strong (and false and incorrect) reflections. I don't try to create a realistic result, but instead try to get the old-school look I am aiming for (**Fig.04**).

THE FLESH TONES

The gradient I use for the flesh tones is very classical in appearance (**Fig.05**). I add a little bit of red between the darkest tones and the middle tones. This is very similar to the technique used by Elvgren.

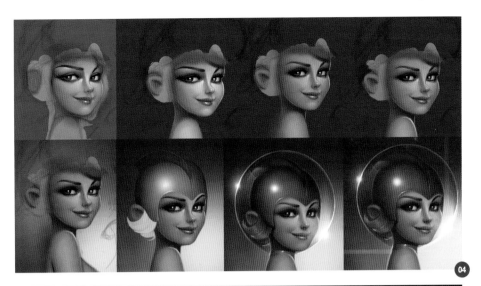
04

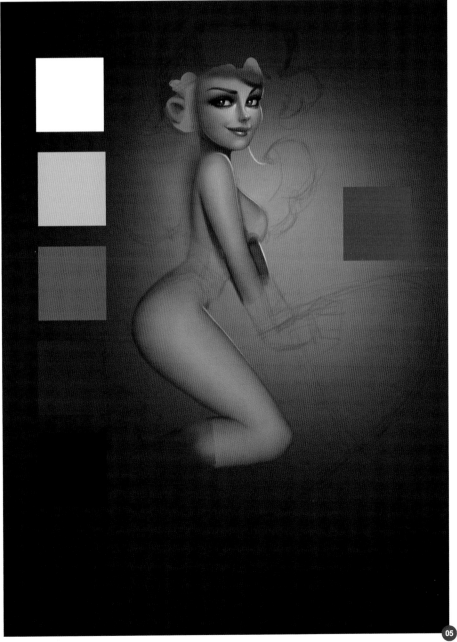
05

143

THE OUTFIT

I want the outfit to look a bit like rubber
(**Fig.06**). It's not a very difficult material to
paint. You have to paint a logical gradient
and then add some strong but small white
reflections. There's a very easy way to paint
reflections like this. Create a new layer and
paint the shape of the reflection with a hard
brush with the opacity at 100%. Once you have
done this decrease the opacity of the layer.
If your gradients are good, it will work. Quite
simple isn't it?

> ## THE MORE TIME YOU SPEND ON YOUR PICTURE, THE MORE PRECISE AND DETAILED IT WILL BE

THE ROCKET

When you have to paint geometric shapes
don't try to paint them, use vectors. You can
work with vectors in Photoshop, but there is
other software that works better. I use Flash,
but you could also use Illustrator. I simply just
take a screenshot of my picture then paste
it into Flash. I paint the shape with Vector
tools and then export it as an AI file. I can
then import the shape into Photoshop where
it becomes easier to paint over the shape
(**Fig.07**).

THE STARS AND HALO

I want to add a kitsch halo to this picture. To
create it I duplicate a simple line again and
again, changing the opacity and the size of it
every time. When I've done this I am able to
change the angle and create the desired effect.
I also add a bit of noise in the background with
a standard brush (**Fig.08**).

ADJUSTMENTS

As I made a lot of changes to the colors and
the lights along the way, I don't have to do a
lot of adjustments (**Fig.09**). Once I have it is
finished.

The four pictures of Bambi are simpler than my
usual work, but the only difference is time. The
more time you spend on your picture, the more
precise and detailed it will be.

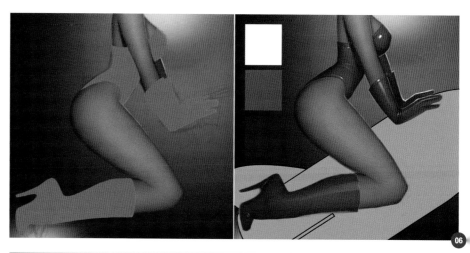

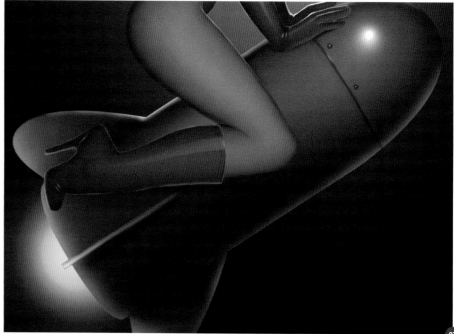

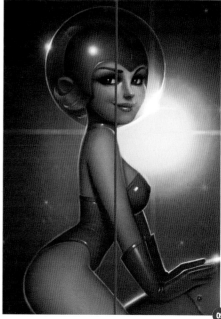

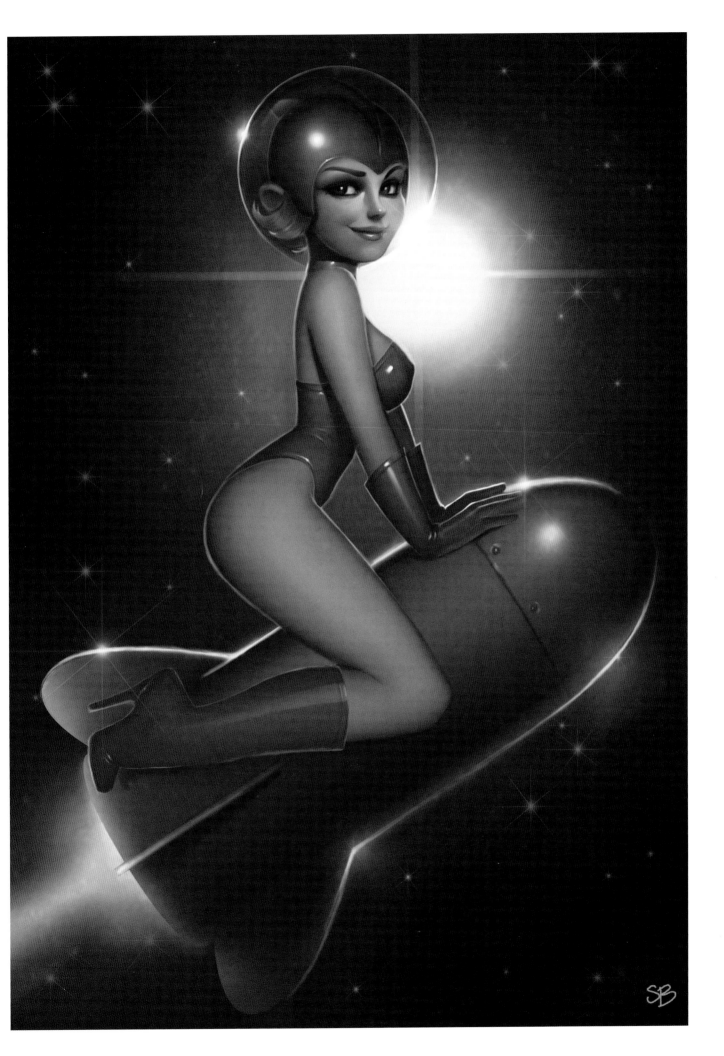

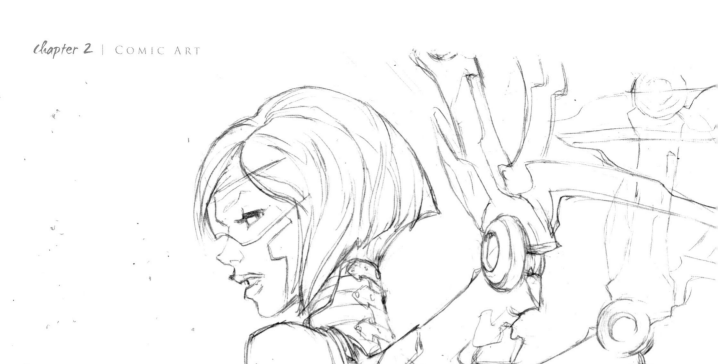

SKETCHING
BY DAVID NAKAYAMA

CONCEPT

When designing a superhero from scratch, I try to keep two essential guidelines in mind. Firstly, the costume must communicate everything the viewer needs to know about the character and his/her special abilities at a glance and secondly, it needs to feel iconic. Superheroes, after all, are super. They've got god-like abilities and tend to embody some big concept or another (be it an elemental force, animal savagery, patriotism, death, etc.,) so the clothes really must convey the notion of being bigger-than-life.

In the case of Tech Angel here, I've created an interesting thematic mash-up by combining techy shapes and hard-energy holography with angelic wings and an all-white palette. For me, this hits exactly the right notes for a superheroine: sleek and sexy, but also very strong and appropriately geared for combat. I leave the shoulders, upper chest, and face bare to help draw the focus upward, which will help later during the coloring phase.

For any comic page, editors expect to see and sign off on layouts before an artist commits to final pencils. With a cover, you'll often provide

several options and the editor will either choose a favorite or provide notes for a second go-around. Layouts should be simple gestural drawings around 2-3 inches tall, and the idea is to communicate pose and a general story – and that's it. Shading and detail would be a waste of time at this point and detract from the primary goal (**Fig.01**).

I'm treating this cover like a #1 issue, and because we're meeting this character for the first time, a portrait type of composition makes the most sense. I try out various ideas exploring warrior and angel poses and, ultimately, my editor and I settle on #2. It's a sexy side/back shot, which will definitely help attract eyeballs on a crowded comic stand,

and we get a nice close-up look at distinctive costume details like her wings and sword. An intense light source (from heaven or a *Tron*-like computer environment perhaps?) fills out the background.

Incidentally, note that on each of these layouts I've taken into account where the logo will go. Never forget about the logo – treat it like part of the composition.

> ## DRAWING A CURVY FEMALE OR RIPPED MALE IT'S ALMOST IMPOSSIBLE TO GET ALL THE NUANCES RIGHT WITHOUT SOME REAL LIFE EXAMPLES TO DRAW FROM

In the past, I used to begin each full-sized penciled piece by projecting the layout onto a blank page taped to the wall. Now that seems like a waste of time and overly-precious as well. Try to avoid crutches like these. Rather, begin with loosely-drawn lines focusing only on recapturing the proportions and energy of the original layout. I look back and forth between sketch and full-sized image constantly to make sure the bouncy, organic quality remains intact. At some point during the process, I decide that the sword has better balance as a dual-

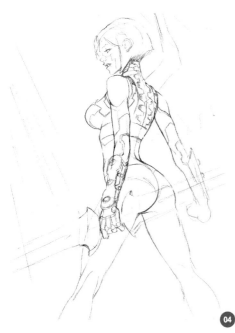

04

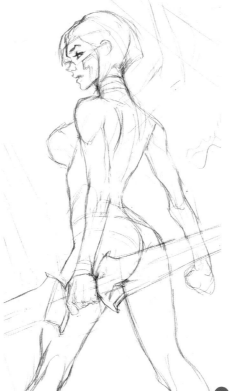

02

blade, and I spend some time figuring out a convincing pose for her hand (**Fig.02**).

Do I use references for the pose of the body? Absolutely! When drawing a curvy female or ripped male it's almost impossible to get all the nuances right without some real life examples to draw from. I spent years worrying that this was somehow "cheating" and I'm here to tell you: get over it. Study anatomy carefully and begin each drawing on your own. When it's time to add details, use references to aid you. I have a large collection of photos categorized by viewing angle (front-on, profile, back, etc.,) and with a combination of these on my drawing table, I have the information I need to refine the character's form.

Taking your Sketching into Photoshop

But I'm far from finished. Stepping back from the art, I see that I've made some significant errors in my proportions. This can happen sometimes when you're drawing at a large scale; because the top of the paper's tilted down and away from you, it's easy to overcompensate and draw things near the top

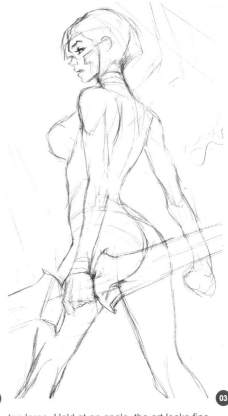

03

too large. Held at an angle, the art looks fine, but seen straight-on, it's warped. And that's what's happened here; the head's too large and the neck is too long, especially given the low-angle we've got on this character (**Fig.03**). So I scan the image and bring it into Photoshop where I can easily transform the scaling and adjust the head. At the same time, I use Liquify to push a few other things, like her shoulder, into a more naturalistic position.

Another helpful trick at this point is to flip your canvas horizontally or likewise, hold your drawing up to a mirror. Mistakes tend to jump out like sore thumbs when the image is viewed this way, and you should do it often. In Photoshop, I've mapped the flip command to the F5 key as an action, and this greatly speeds up the process.

I make one last adjustment to the basic pose by pulling her right leg outward a bit, and then I'm ready to start on her outfit. It might be tempting to add costuming details before this stage, but I wouldn't recommend it. Make absolutely sure that your pose is sound before continuing, or you may have to redo work later (**Fig.04**).

Using my original front-view design as inspiration, I begin to apply similar shapes to the character's back. I'm designing as I go, but am also informed by two useful rules of thumb: firstly that costume elements work best when they reflect and flow with the shape of the underlying anatomy and secondly, it helps to establish a visual "language" and stick to it. In this case, my design vocabulary consists of triangles, half-hexagons, and the occasional circle – all geometric forms, in other words. Organic lines would probably feel out of place on this tech-based character.

More surface details. I continue to use the hexagon motif established earlier as I render the sword and leggings. Recently I've noticed that the hexagon – and particularly hexagon mesh patterns – has become an all too common visual shorthand for the sci-fi genre. I'm deliberately using the shape in a different way here, because I think the standard mesh thing's pretty played-out. If I use a texture overlay during the color phase, I'll definitely go with a different pattern (**Fig.05**).

> *Quick Tip:* It helps to juxtapose areas of dense detail next to areas that are more sparse. This gives the eye a "breather", so to speak, as it moves around the form. It also helps me focus the viewer's attention where I want it (which, in this case, is her shapely behind).

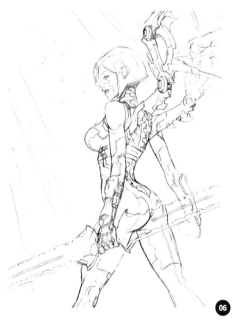

05

All this time, I've been debating whether to interpret Tech Angel's wings as metal or hard light, and you can tell from the sketch that I originally had feather-like shapes in mind (**Fig.06**). Well, at this point, I commit to complex, machine-like forms made of hard light, sort of combining the best of both worlds. I feel like the sword and wings are shaping up to be her coolest, most unique assets, and I want to put a literal spotlight on them. I complete the right leg and arm, but try to leave the line weight and level of detail a little lighter here to help sell the idea that they're further back in space. If you look at the left vs. right wing, you'll notice that I pulled the same trick there. This really helps complete the illusion that one object is closer than the another.

All that remains is the face and head. Fortunately, I hit the expression just about right in the sketch phase, and all I really have to do at this point is tighten up the hair and some of the finer details. But because they're so critical, let's discuss faces for a moment. For female

06

characters, the important thing to remember is that less is more. Even a single unnecessary line can age your character 10 years. This means that you have to nail the lines you do put down (**Fig.07**).

Another thing to keep in mind is that facial expression is one of only two key tools you've got (the other being body language) in communicating a character's state of mind, personality and intent. In this case, the story is about strength and, to a lesser extent, sex appeal. She looks back at the viewer as if to say, "Don't mess with me", but you could just as easily read it as, "Hey, eyes up here, buddy." So there's a little built-in viewer interaction and that's absolutely vital if you want to engage people. Other strategies for this might include a visual gag, pop culture reference, or just a metric ton of detail – in each case, you're asking the viewer to bring something to the table and to invest some thought in your art, and ultimately, that's what makes a cover memorable.

LINE WORK
BY DAVID NAKAYAMA

INKING

During the inking process my goal is to translate everything I set down in the pencil phase, making everything that was loose into rock-solid, confident, final marks! Inking is an under-appreciated art form that requires a very steady hand, a lot of interpretation (especially if you're working over another artist's work) and, traditionally, the mastery of several tricky-to-use tools (brushes, nib pens, templates etc.,) all without the use of an Undo button. On most comic pages, you'll be called on to fill large areas of black, feather/crosshatch/blend them into white and outline everything else. Here, because the theme is focused around stark whiteness, we'll simply focus on the outline process, which is an art in and of itself.

This character we're inking is defined by two themes: technology and angelic perfection. Both suggest a clean, ultra-precise style and that's why we're staying clear of heavy black shadows, loads of hatch marks and splatter. Rather, our job here is to provide as tight a framework as possible for the color process to come. My tools of choice for this are Faber-Castell PITT pens, which are simple, straightforward markers and the perfect tool

01

for laying down lines of even-width quickly. In the past, I've tried various tech pens and other markers, and none of them are as easy to use and maintain as these – give them a shot.

I like to work thickest to thinnest, so I start by establishing all the heaviest lines first with size M and F pens. Note that I'm not simply outlining the entire form like you'd see in a coloring book. A uniform stroke tends to flatten and posterize things, so in this case we'll be better served by mixing up the line weight

and acknowledging the strong light source. Areas closest to the light receive no ink at this point, whereas the areas in shadow or further away from the light get the heaviest marks. Ultimately, this treatment will help sell the illusion of light and shadow, even though we're only dealing with outlines (**Fig.01**).

Now it's time to start rendering the interior, so I shift to the thinnest pen I've got: size XS. The general idea is to contrast thick and thin lines to give the character weight and interest. Thick

lines are covered at this point, so we need to stay thin and light on all this fine detail.

I begin working my way up the form, mostly freehand. When I get to a long straight or curved line, it's helpful to use a ruler or French curve, and when I encounter a precise circle or oval, like the details on her boots, I break out the templates. This is actually very important, especially on a tech-themed piece like this. Sure, it takes more time to rule things out precisely, but you'll never get those tight curves right without a template, so buy several sizes and use them religiously. Your work will look a lot more professional, I promise (**Fig.02**).

> THE WINGS REQUIRE PLENTY OF TEMPLATE WORK, BUT THE RESULTS ARE WORTH IT: THEY LOOK SUITABLY SMOOTH AND MACHINE-LIKE

Think very carefully about what each line is doing as you ink, and as you interpret the sketchy pencil lines, consider adding and subtracting detail wherever appropriate to enhance the form (**Fig.03**).

On the leg pattern (A) for example, I decide to use two thin lines instead of just one to give the shape a bit of a lip. And on the center seam (B), I intentionally break the line in a few places to indicate that the groove is subtle and too shallow to cast a deep shadow. I continue this process until I have something like this (**Fig.04**).

In the final pass, the wings require plenty of template work, but the results are worth it: they look suitably smooth and machine-like (**Fig.05**).

And that's pretty much it. Basic inking is complete, but there are still a few steps to

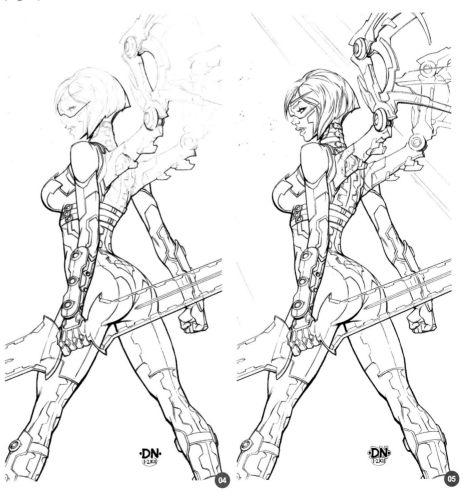

go before we're ready to color. For starters, I carefully eliminate all traces of pencil from the page using a Magic Rub eraser. And had I royally screwed up at some point, this would be the time to fix mistakes. Artists use all kinds of products for this purpose, but I like to use Pro White (an opaque, water-based paint) over problem areas and re-ink when it's dry. Fortunately, there are no screw-ups this time, so I scan the image at full size and 300dpi.

> ## DON'T GO TOO CRAZY HOWEVER; THE LINES WILL ACTUALLY BECOME BLOATED AND FUZZY IF YOU OVERDO IT

Now in Photoshop, my first order of business is to eliminate any dirt or stray marks added during the scanning process. I use the Eraser tool to quickly remove various dots and smudges (**Fig.06**).

Next, I adjust the Levels. First, pull the white arrow in until almost all of the light gray pencil marks disappear. Next, pull in the black arrow until the ink lines look sufficiently tight and solid – don't go too crazy however; the lines will actually become bloated and fuzzy if you overdo it. Lastly, slide the gray arrow until things look balanced, e.g., black lines are black and white areas are white (**Fig.07**).

Adjusting the Levels handles about 95% of the clean-up process, but you'll still need to go in by hand and get whatever's left. If a pencil line was particularly dark, it might still be around at this point, but a quick Dodge pass will clear that right up. Set the Dodge tool to Highlights with Exposure at around 80%. Zoom-in and brush out whatever pencil residue remains (**Fig.08**).

And there you have it. Now we're ready to color! (**Fig.09**).

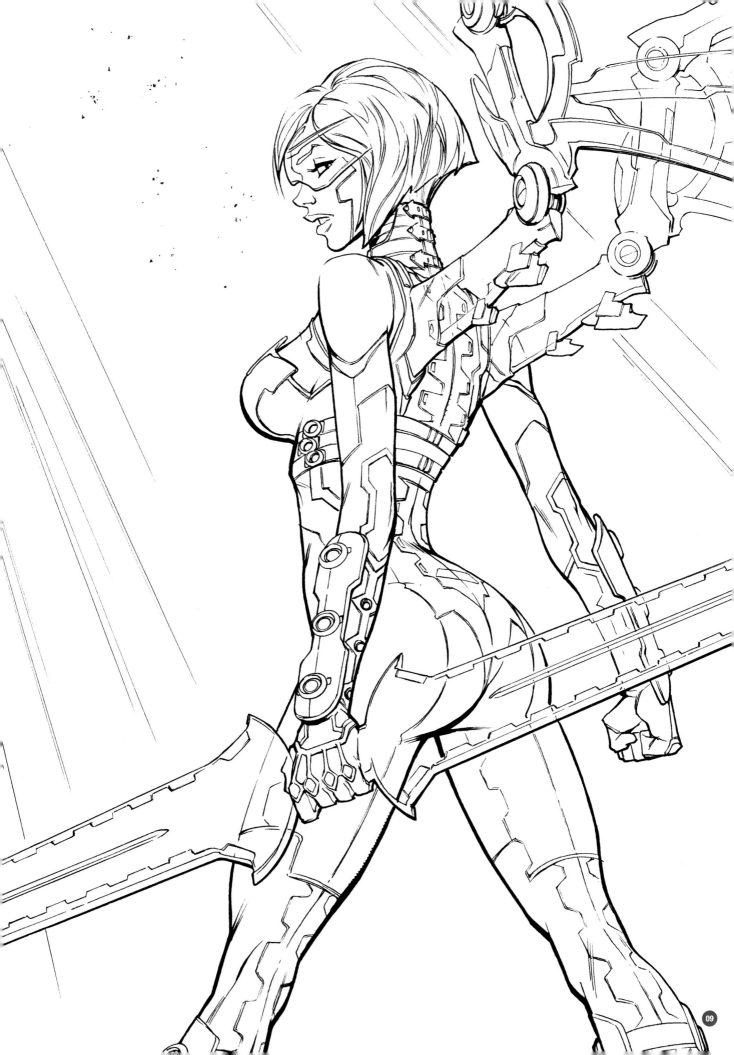

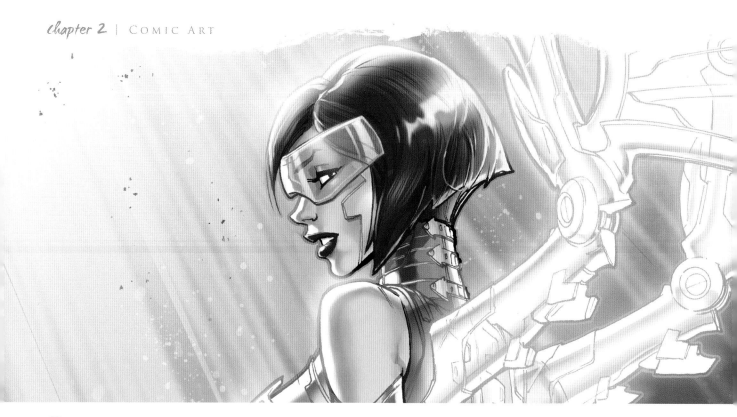

COLORING
BY DAVID NAKAYAMA

PREPARING TO COLOR

Before we get started for real on the painting portion of this cover, it's important to first set up a couple of layering tricks that'll make the job a lot easier. For starters, I anticipate that we'll be changing the color of the line art quite a bit, so for easy adjustment it's important to get all of the black into its own layer. To accomplish this, simply copy and paste the black and white artwork into a new channel. Next, click the channel to select all the lines. Lastly, use Edit and Fill (with black) to move all that information onto a new, transparent layer. This method is way more precise than using the Magic Wand tool, and by moving the line art to its own layer, you'll be able to adjust it with ease (**Fig.01**).

Next make your background layer white and then we're ready to move onto the next step. Now let's start laying in some flat colors. First, fill the background with any color you like (**Fig.02**). Next, under the new line art layer, use the Lasso tool to select the whole figure and fill it with a contrasting color (i.e., different value and hue). Afterwards, continue to break the figure and background into smaller and smaller sub-divisions, using a different contrasting color each time.

Note: The actual hues don't matter – we're simply trying to create a grid of easily selectable shapes that we'll use over and over throughout the painting process.

As you go, test your various shades with the Magic Wand selection tool (with Tolerance set to 20 or so) to make sure it can tell the difference between them. It's also useful at this stage to group together all materials of the same type. That way, it's easy to select and paint all the areas representing a certain material at once, saving you repeated trips to the Color Picker.

With flats now complete, the image has been mapped with a patchwork of selectable regions, making it easy to click on something and paint only that item without spilling over onto its neighbors.

Now, make a duplicate of this layer. Use the original specifically for selections and use the copy as your actual paint layer. Again, this will allow you to easily paint all of one material and then move on to other ones in turn (**Fig.03**).

PAINTING

Now I begin the actual painting, starting with broad tonal choices that'll help set the mood I'm looking for (**Fig.04**). First order of business is to bring the flat colors closer in line to the palette I want to use in this piece (basically black and white with a couple of color accents). Also, crucially, I establish a very general light source in the background as a road map for all the lighting choices to follow. And because the sword and wings are meant to be translucent "hard light" objects, I lighten the value of their line art to 50%. Tinting like this is often called a color hold or a knockout. On a piece like this, we'll be using the technique extensively.

Using my selection layer to focus on various areas of the costume, I begin a light and shadow pass with a loose sketchy brush (**Fig.05**). I'm just trying to find the boundaries between light and dark, and convincingly wrap shadows around the anatomy. Referring to actual human references comes in handy once again. Eventually, I've roughed-in the

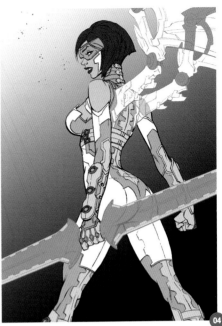
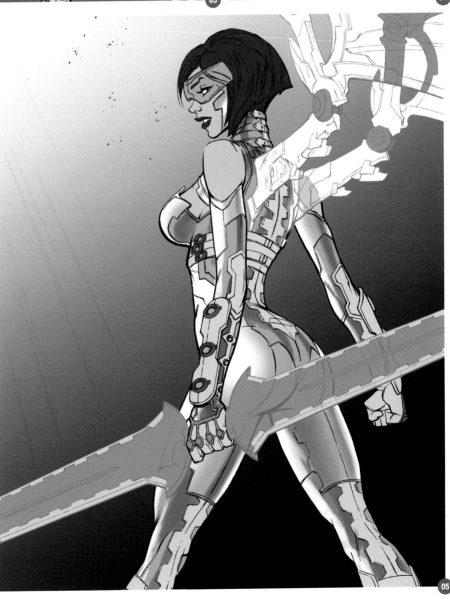

entire figure, and it's time to start tightening
up (**Fig.06**). A soft round brush at 50% opacity
and the Smudge tool help me blend and refine
the original marks. To strengthen the contrast
between light and dark, I adjust the Levels
sliders and refine individual details with Dodge
and Burn tools, again with a soft round brush.

Quick Tip : Open a duplicate
window of your work space by selecting
Window > Arrange > New Window for (file).
As you're painting close-up in the main
window, you can keep an eye on how these
small changes are affecting the overall
read of the piece in the other, zoomed-out
window, and in real-time to boot. It's easy to
get caught up in details and to waste time
rendering things that don't ultimately work.
Using the two-windows approach helps
to cut down on that. Some artists use the
Navigator feature for the same purpose, but
I find it simpler to work this way.

When I feel like I've roughed in all the basic
shadows on the body, I turn my attention
toward other, more loosely-defined areas
(**Fig.07**). In particular, it's time to consider
the color treatment of the line art. Right now,
everything's solid black and for me, that looks
too flat. So working just as I did during the
inking process, I treat each line according to its
context within the overall lighting scheme. Near
the light and the line is tinted a light color or
even erased; away from the light and the line is
allowed to remain dark.

Next, I address the light source with a
rendering of directional rays (created with a
custom brush and warped into perspective).
For the background, I decide that some
vaguely-defined ruin shapes would help round
out the composition, so I grab a few photos
off the internet, manipulate them heavily,
and finally drop them into a new layer set to
Pin Light at around 16% (**Fig.08**). A subtle
suggestion is all I need; anything more will
distract from the figure, which is where I want
to focus the viewer's attention. Lastly, I add
an orange outline around the entire figure, to
further emphasize its shape and to pop it off
the background.

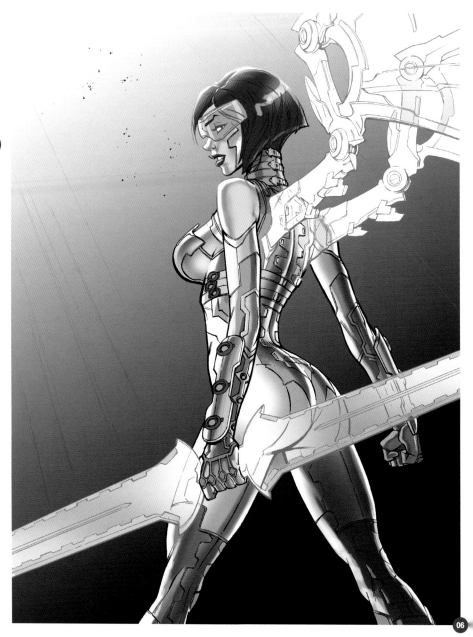

06

07

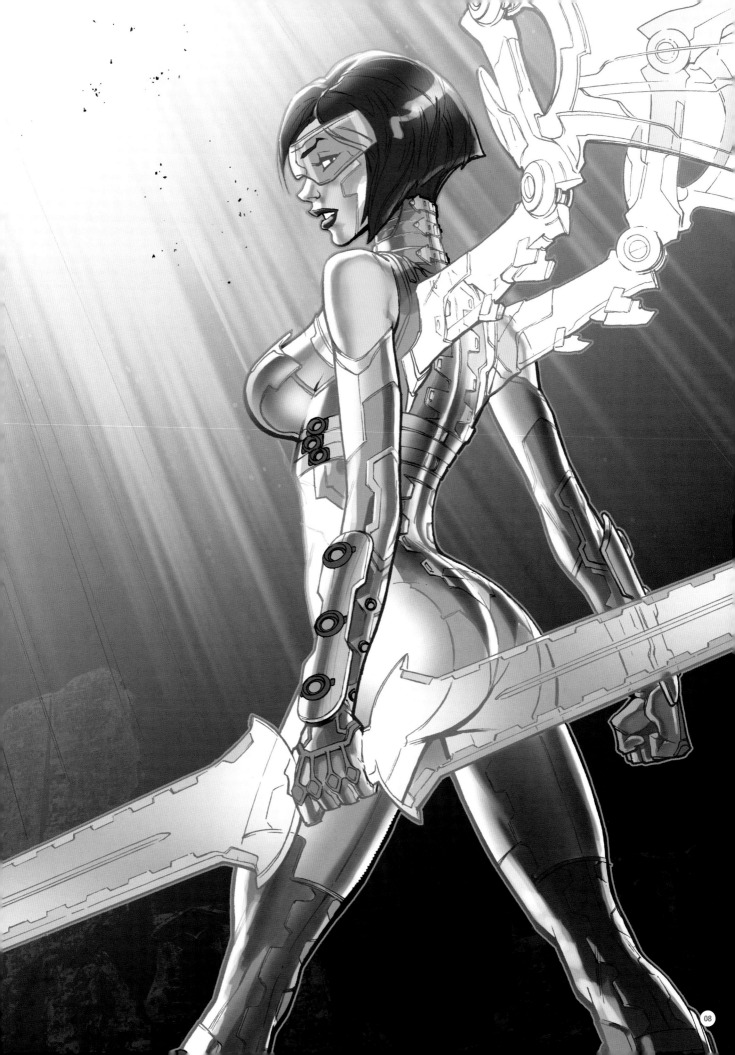

09

10

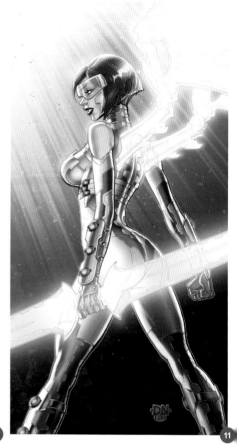

11

Most of the main compositional elements have been addressed at this point, so it's back to the figure rendering (**Fig.09**). I notice that my light and dark contrast looks pretty weak, so I focus on the shadow edges, exaggerating them with dark paint, additional Burn and further Levels adjustments. I also notice that the various regions of her costume are blending together, so I make final decisions about which elements will be light or dark and level accordingly.

I've left a few lighting bells and whistles to the end, and it's finally time to finish those off. I add orange glows to some of her costume details, a splatter texture in the background and a heavy glow on the "hard light" objects, using white paint on a new layer set to Screen mode at around 75% (**Fig.10**).

I'm essentially done with the painting process at this point, so I stop to see if anything's missing. Though I like the simple black and white look in theory, I feel like the character's full-color highlights are standing out too much in practice. So to improve color unity, I add a new purple tint layer set to Soft Light

mode at around 21% (**Fig.11**). This adds just enough saturation to pull the background and foreground together.

My editor suggests that I take this one step further, by tinting the glowing objects orange. I play around with various solutions, but eventually get the effect I want by turning my glow layers into two identical orange tint layers, one set to Overlay at 44% and the

other to Screen at 79%. Turns out that he's right on the money: with orange and purple distributed throughout the image, there's plenty of connective tissue to hold it together as one unified image (**Fig.12**).

And what comic cover would be complete without its logo and trade dress? I grab some free fonts off the internet and whip up a logo that matches the vibe of the character (**Fig.13**).

12

13

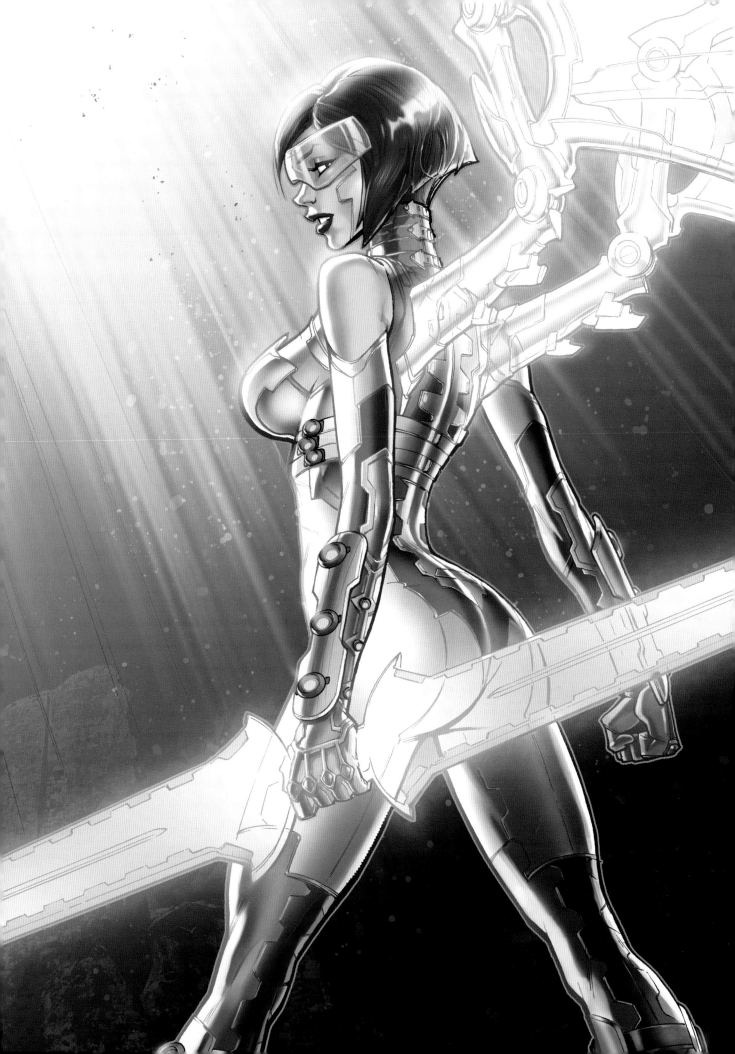

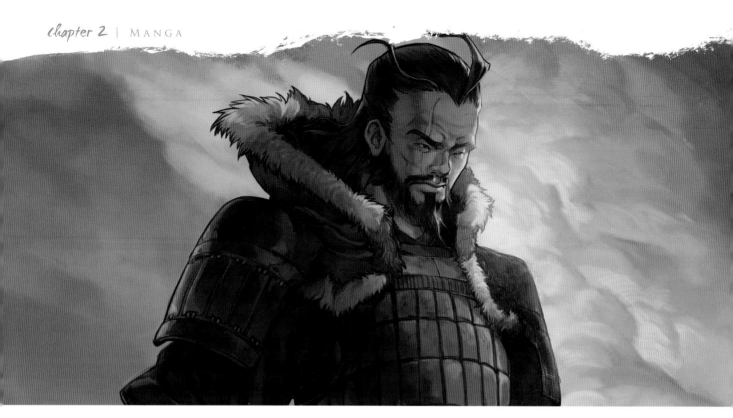

GHENGIS KHAN
BY PATIPAT ASAVASENA

INTRODUCTION

My name is Patipat Asavasena and I'm a freelance artist living in Bangkok, Thailand. I'm really influenced by Japanese manga. You can visit my website **www.asuka111.net** to see my work in full. In this tutorial I'll show you the process I used to create my image of Genghis Khan in a manga style.

I believe manga is a brilliant way to draw characters in a simple format, with more of a cartoon-like quality to them. Most of the manga art books out there have already explained the best technique for drawing a really good manga figure. However I still recommend that you learn the fundamental skills such as anatomy, realistic drawing and tonal value. If you don't have a solid foundation to your image it cannot be improved. There's no shortcut, so keep practicing and be patient!

DESIGNING THE CHARACTER

To do a manga illustration you should do some research before you start. It's really easy to find some good resources on the internet. I love to look at reference books about the subject too. After I'd done this I was able to create a digital

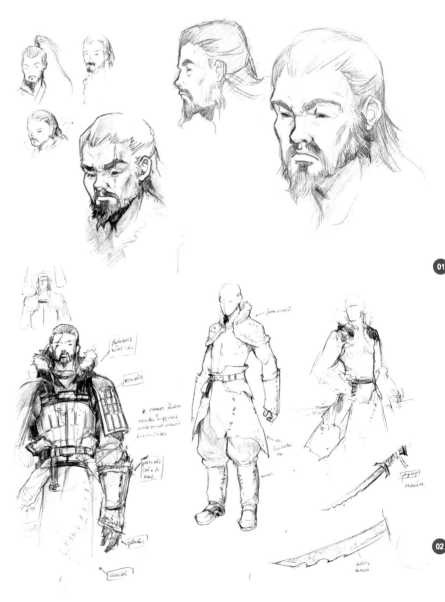

01

02

scrapbook from resources and information I found, and I used it as a reference sheet for my design (**Fig.01 – 02**).

Now and again I love to work on impulse. I like to use my own inspiration, or you could call it an improvisational method. Unfortunately I cannot do this when I'm working with a client as it may not meet their personal expectations. This is why I need to come up with a rough idea beforehand that the client is happy with. Only then can I move on to the next stage.

PLANNING THE COMPOSITION

Once I've worked out the rough idea, I have to think about the composition of the different elements in the image, like the characters, backgrounds and props. I also have to think about design fundamentals, such as the value contrast and focal point. I try to come up with a simple design, because it gives a clear idea and readability of the image to the audience.

To design the composition for this image I used a small thumbnail sketch to visualize my idea. I imagined the overall canvas and then quickly sketched it out on paper. I took me roughly five minutes to create each sketch. I was able to take a break and come back to develop some of my favorite sketches further until I came up with a great idea (**Fig.03**).

REFINE THE THUMBNAIL

You can see that I chose the thumbnail sketch I liked the best. I turned it into a digital format using Photoshop. I enlarged the thumbnail to fit it to my canvas size (A4, 300 dpi). Still keeping it as a rough sketch, I started to refine it. The digital medium is great for editing! I like tweaking color, scaling and transforming layers and color overlaying. If I save multiple versions then the client has lots of options to choose from (**Fig.04**).

ROUGH SKETCH

I then decreased the thumbnail layer's opacity and created a new layer on top. I developed the image into a more defined sketch for inking by drawing on the top layer. It's a bit like tracing on a light table (**Fig.05**).

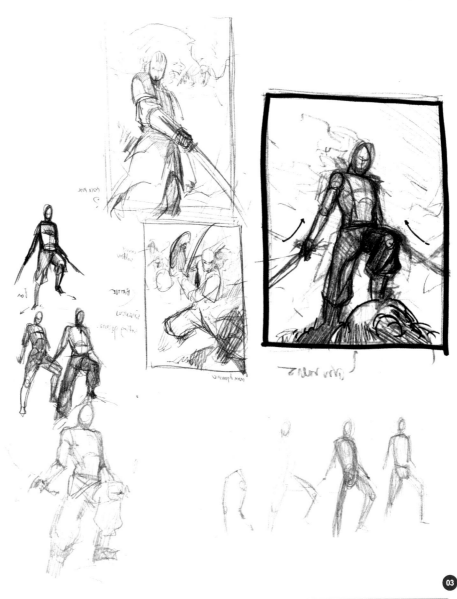

03

REFINED THUMBNAIL

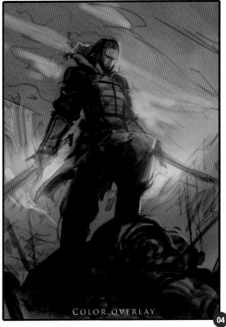

COLOR OVERLAY

04

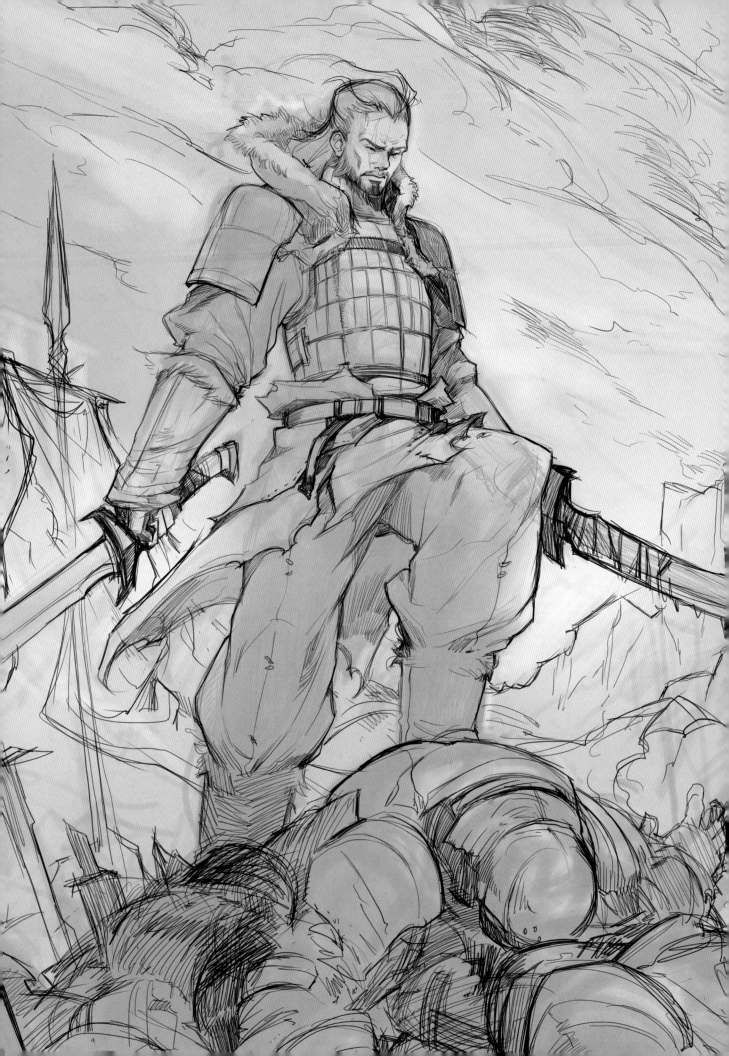

INKING

I would highly recommend using a pressure sensitive brush. I used the default Hard Round brush (10-15 pixels in size) to do the inking. You may have noticed that I used various line weights to give depth to the image. I also did some hatching to create the tonal shading effect and texture (**Fig.06**).

> " WITH REFERENCE PHOTOS I FIND IT HELPS TO PUT THEM ON A SECONDARY MONITOR OR A NOTICE BOARD SO I CAN KEEP REFERRING TO THEM AS I PAINT "

CANVAS PREPARATION

Next I created the layers for a character in the foreground, a flag in the mid-ground and the mountain and sky in the background. I used the Lasso tool and Fill command to fill the area of each layer with a color, making sure each layer had different tonal values to give the image a sense of depth. I arranged the lower value (the darker area) in the foreground and higher value (lighter area) in the background. This developed a backlighting effect and brought a more dramatic mood to the image. Then I used a soft brush to overlay the simple color on each layer to match the thumbnail (**Fig.07 – 08**).

Quick Tip: Turn on Preserve Layer Transparency to make sure that you can only paint on the opaque area of that layer.

PAINTING THE BACKGROUND

Now I could start to work on the background layer. I found some good reference images from my own personal photos, but I didn't just copy and paste them into my canvas. With reference photos I find it helps to put them on a secondary monitor or a notice board so I can keep referring to them as I paint.

I didn't worry about the flag and mountain layer as much because they only had a small area in the canvas. I tried to maintain a good tonal

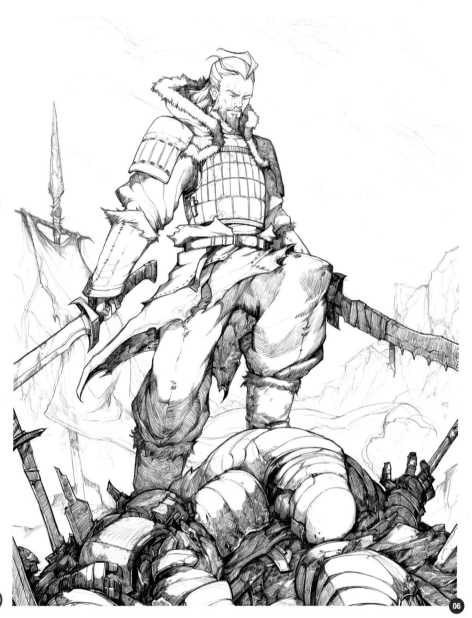

value throughout and kept slightly less contrast between these layers. Both had a higher contrast than the character in the foreground to make sure they looked separate and to show depth. When I'm painting a new image like this I zoom out to see the whole thing and compare it to the thumbnail. This allows me to make sure I haven't developed the image in a different direction to how I had previously planned.

> " THIS IS A NON-DESTRUCTIVE METHOD OF EDITING AN IMAGE AND ALLOWS YOU TO COME BACK TO IT LATER AND CHANGE OR REMOVE SOME OF THE ADJUSTMENTS "

PAINTING THE CHARACTER

Again I tried to match the overall image to the thumbnail as I painted, but also had some flexibility to change or add some extra details. For example, I changed some parts of the character's costume color to a slightly bluer hue. I also added some minor detail to the armor so it looked slightly damaged (**Fig.09 – 12**).

TOUCH-UP

At this point I created some adjustment layers so I could do some fine-tuning (e.g., Curves, Brightness and Contrast, Color Balance, etc.). This is a non-destructive method of editing an image and allows you to come back to it later and change or remove some of the adjustments. You can see this in **Fig.13**.

SUMMARY

Finally, my version of the great Genghis Khan in a manga style was finished! This took me about 10 to 13 hours (**Fig.14**). I hope this tutorial has provided you with some inspirational ideas or helpful information. I encourage you to create your own masterpiece.

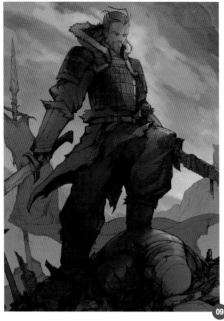

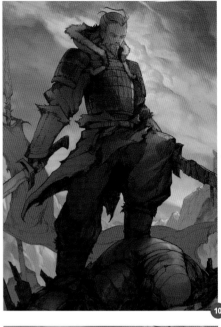

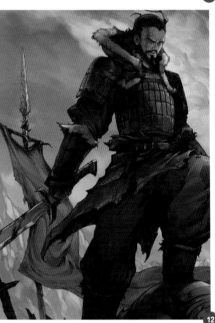

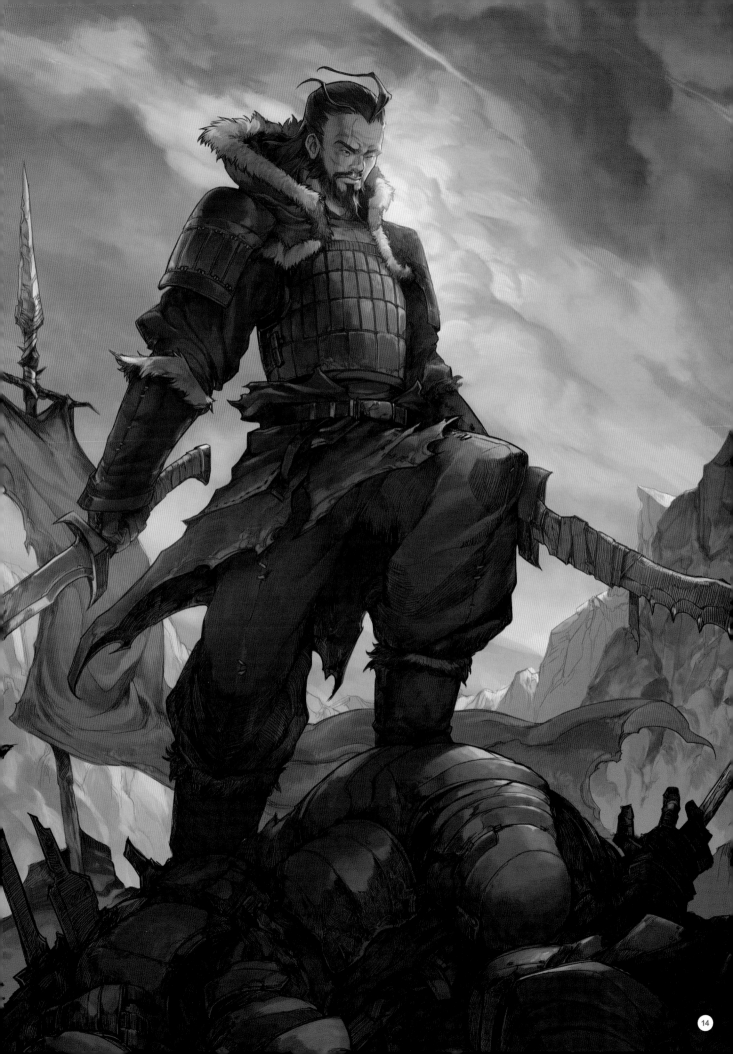

JOAN OF ARC
BY PATIPAT ASAVASENA

INTRODUCTION

In this tutorial I will start by looking more closely at how to draw something in a manga style, before moving on to explain how I created my manga version of Joan of Arc.

THE HUMAN SKULL

When it comes to manga, anatomy is, of course, very important so I begin by drawing an accurate human skull. It is really helpful if you can find a real skull or one that you can use as a reference when drawing. If you can't get one, you can always search for multiple references on the internet.

By studying the skull you will realize that it can be broken into two larger parts: the skull and the jaw bone. You can see in **Fig.01 – 02** how these larger shapes can be adjusted and simplified to create a manga-style head shape.

This whole process can be simplified further to make our process more practical and systematic. You can see how you can create the head using simple shapes in **Fig.03**.

When you are drawing you should always consider volume, unless the character is going

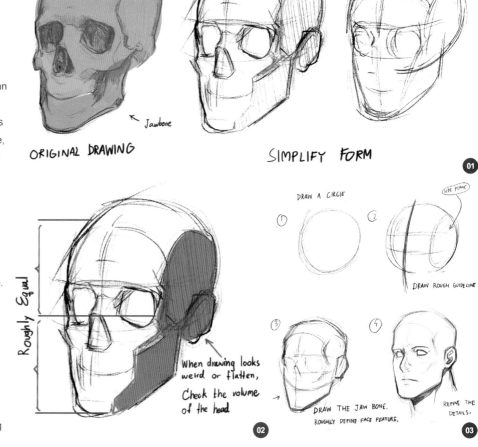

ORIGINAL DRAWING

SIMPLIFY FORM

← SKULL

← Jawbone

01

Roughly Equal

When drawing looks weird or flatten, Check the volume of the head

DRAW A CIRCLE

① ②

SIDE PLANE

DRAW ROUGH GUIDELINE

③ ④

DRAW THE JAW BONE. ROUGHLY DEFINE FACE FEATURE.

REFINE THE DETAILS.

02 **03**

to be colored or painted in a flat way. Check your character sketch to see if the forms look good by flipping the image horizontally. You may find that there is quite a big difference when you do this to the image and that you spot quite a few little errors. If you draw on the paper you can flip your drawing by turning your paper over and holding it up against a window so you can see your line work through the paper. To flip the image in Photoshop use Image > Image Rotation > Flip Canvas Horizontal (**Fig.04**).

VARY THE CHARACTER

A useful technique that can be used to create multiple styles of faces is to adjust the shape of the jaw bone and other features, as you can see in **Fig.05**. You can find inspiration to help you do this by observing real people around you, or by drawing people in life drawing classes or anywhere else you can practice.

That's all the advice I can give you about drawing a face in a manga style. It sounds simple, but it takes a lot of time to become efficient at using this process.

Quick Tip: I recommend that you draw from life as often as you can and study the human figure as it will really help you create good characters. Once you have a good understanding of how to draw anatomy you can apply it to a lot of different styles and techniques.

START WITH A CONCEPT

I always start every concept by gathering references and other information. When I have got an idea of what I would like to do, I start designing the character by creating a set of thumbnail designs. It is useful to get extra information about your subject matter as it will help add story to your image.

In this case I found out that Joan of Arc was a French heroine who claimed that she received direction from God in her role as a French military commander fighting against the English. This made me think of keywords like "religious messenger" or "holy knight" (**Fig.06 – 07**).

ORIGINAL

FLIP CHECK

FINE TUNING MINOR DETAIL, FIX THE OFFSET.

04

05

06

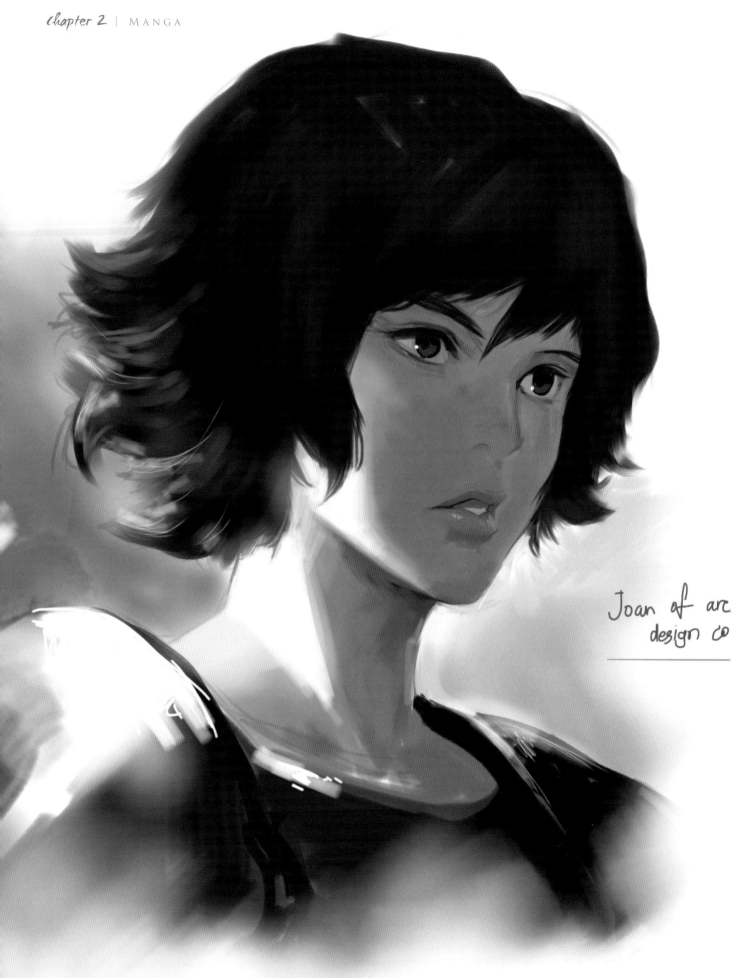

Joan of arc
design co

COMPOSITION DESIGN

I chose a symmetrical composition to express
the religious theme, as this is common in that
kind of art. To continue the religious theme I
used colors that are also common like red, gold
and white. You often see these colors in the
images that hang in churches and cathedrals.
In the background I intended to show part of
a glowing character, which was supposed to
symbolize God leading the way (**Fig.08**).

In the case of this character I also got
inspiration from Milla Jovovich, who played
Joan of Arc in the movie *The Messenger*.

> BY SWAPPING
> BETWEEN A
> PAINTBRUSH AND
> THE ERASER TOOL
> YOU CAN ACHIEVE
> SOFT BLENDING
> QUITE QUICKLY

COLORING TECHNIQUE

I chose a different coloring technique to last
time; it's similar to painting in watercolor. By
adding layers of paint in Multiply mode I simply
increased the tonal value of the desired areas.
When I use this technique I don't create a
Layer mask, which means some color will
expand outside the edge of my sketch, but this
doesn't have to be a bad thing. Little things like
this will make an image look less digital and
more like a traditional painting (**Fig.09**).

By swapping between a paintbrush and the
Eraser tool you can achieve soft blending
quite quickly. This can be done using three simple
steps (**Fig.10 – 11**).

- Create a new layer to paint on
- Apply the shade and color with a hard
 round brush
- Change to a soft eraser and delete the
 sharp edges as required

ARMOR AND METALLIC ITEMS

For the armor, I used a technique where I
used the Lasso tool and gradient fills to quickly
create shading with soft blends on hard, mainly

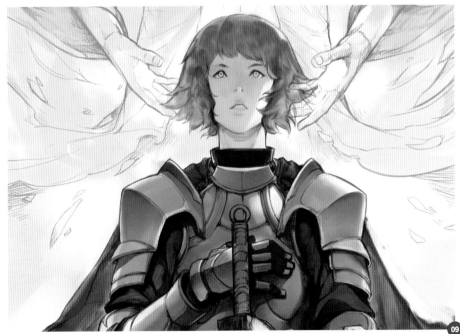

flat surfaces. This technique will leave you with a very clean-looking metal effect, which will need to be painted over with a textured brush to make it look more believable. I also like to change the color hue from time to time when doing this as it provides some natural variation (**Fig.12**).

This technique can again be explained in four simple steps:

- Lasso selects the desired area
- Use the Gradient tool to fill the area using a mid-range opacity
- Continue to the next area – you don't need to deselect
- Paint over the areas that should still be selected to add some texture.

GOD LIGHT

The God-like character was in the background and I didn't want him to compete with the main character too much. I kept the overall tonal value gray, but also put some white area around the hands so it contrasted with the Joan's face (**Fig.13**).

There were some details and a little bit of hue variation even in the white light. If I had painted it a pure white color then the picture would have looked very dull, so I used complimentary color (light blue) combined with the light yellow and pure white. By using this method my painting stayed rich-looking and felt naturally illuminated.

MINOR DETAIL

After I had finished building up the shade with a Multiply layer, I flattened all the layers and painted on a new layer on the top using a normal round brush and some textured brushes. I then continued to add minor details and clean up messy areas until I was satisfied with the overall image. I also did some minor adjustments using Curves and Color Balance.

FINAL THOUGHTS

That's it for Joan of Arc. It was fun to use so many techniques on one image, and I hope that these techniques prove to be helpful to you too. Now it's time to create your own (**Fig.14**).

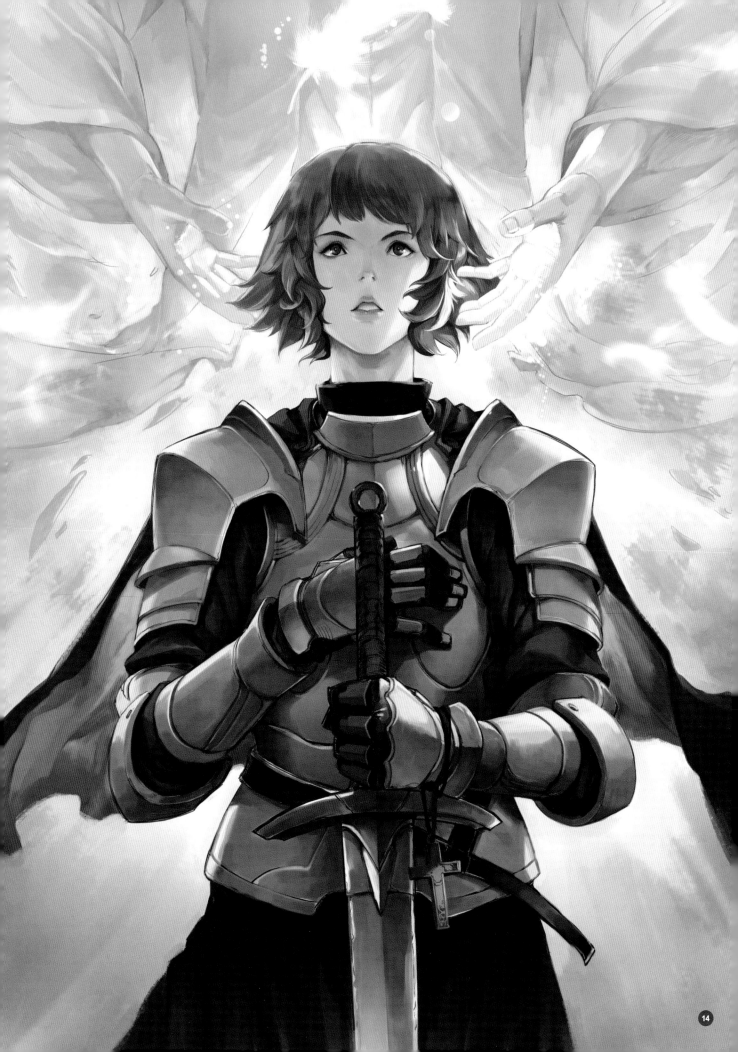

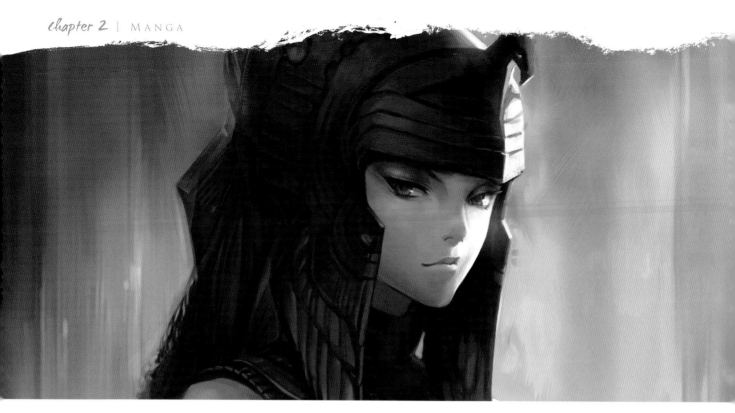

CLEOPATRA
BY PATIPAT ASAVASENA

INTRODUCTION

For this tutorial I was presented with the task of painting the charming and beautiful Queen of Egypt, Cleopatra, in a manga style. I will use a painterly approach for this painting, whilst trying to achieve the look of oil paints. I set myself this challenge, although I knew it might create some unexpected results and would definitely take more time than usual.

IDEA AND CONCEPT

Although I didn't spend time working on sketches or thinking about the composition like I did in my other tutorials, I did have to think about what direction I wanted to take the image in before I get started. If I don't set myself a specific goal, I sometimes continue to paint without really getting anywhere. So to start with I had a good think about the concept.

I wanted to illustrate Cleopatra and capture how attractive she was in a portrait painting. I thought hard about her posture, silhouette and the lighting scheme. I spent quite a lot of time thinking before I started in Photoshop.

PREPARING THE CANVAS

To begin with I started to randomly paint onto

an A4 canvas at 300 dpi with some brushes. This process helped me to warm up and made me think about interesting textures. When I was happy to get started I used a large round brush to sketch the character and color scheme (**Fig.01 – 02**). I used some photo references to help inspire her costume. Finally I used a small

round brush to refine the detail, add the eyes and paint some rim light (**Fig.03**).

ADDING COLOR AND LIGHT

I added a saturated orange for the light in the background and saturated dark red on the

character to create a subsurface scattering effect (**Fig.04**). If you hold your hand up to the light you will see a good example of this effect, and without it skin doesn't look believable.

I added a HSV adjustment layer with zero saturation on the top layer. This is so I could quickly check the tonal value of the image. I could quickly hide or unhide it to swap between color and grayscale without having to convert the entire canvas to grayscale mode (**Fig.05**).

> " I WANTED TO MAKE HER CLOTHING SEE-THROUGH AT FIRST, BUT I CHANGED MY MIND AT THIS POINT AND DECIDED TO DO SOMETHING A LITTLE MORE CONSERVATIVE "

Refining

The next step was to paint over Cleopatra's headdress and arm to refine the detail and volume. I also added a complimentary color (grayish blue) to the reflection of the headdress (**Fig.06**). I wanted to make her clothing see-through at first, but I changed my mind at this point and decided to do something a little more conservative.

Changing the Pose

After adding a rough background I just realized that the composition had too much empty space, so I decided to change the character's pose to support it (**Fig.07**). To do this I created a new layer and sketched a left arm and painted it. After doing this I flipped the canvas a few times and noticed some errors in anatomy. To fix these I used the Lasso and the Free Transform tools to select, copy, resize and move them into the correct place. This method only works when you are correcting minor errors. If you come across a major error you will need to repaint the incorrect part.

Blending with the Mixing Brush

The next step was to use the Mixing Brush tool with the Flat Bristle brush to quickly blend the

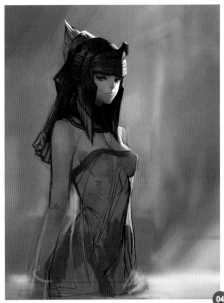

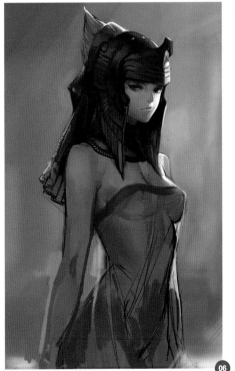

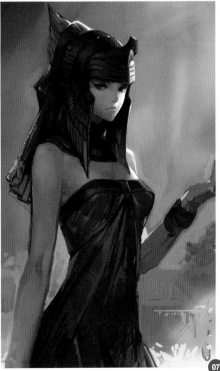

skin and cloth. I didn't want the brush to feel too smudgy so I set the Wetness to around 30-50%. This feature is only available in Photoshop CS5 or higher, but you can combine various brushes to achieve the same effect in older versions (**Fig.08**).

ENLARGE THE CANVAS

When the overall image became clear I enlarged the canvas to 11 x 15 inches in size. The result of this was that the image looked blurry, so I continued to refine the detail even more, especially at the focal points like the face and hands. This method helps to create more contrast between the blurry area and the focal area (**Fig.09**).

DETAILS

I find it quite a lot of fun to work on the detail. I kept panning around the image and spotting details and refining them. The face was the most time-consuming area for obvious reasons. I added a red/orange gradient to a Multiply layer over her face to mimic the look of make-up. One I had done that I used a fine brush to paint further detail, such as eyelashes, eyelid and highlights, into a Normal layer. At this point I was happy with the character and could turn my focus to the background (**Fig.10**).

THE BACKGROUND

I used oil pastels and a soft airbrush to paint randomly into the background until I created an interesting texture (**Fig.11**). I then added some cracks, edges and glyphs to make it look like there was an Egyptian stone wall in the background. As for the foliage, I used a mixing brush with the Small Real Bristle to quickly paint them. I also added the butterfly to the image to add a mystical feeling (**Fig.12**). At this point it felt like the image was done, so I left it for a while and planned to look at it again later with fresh eyes. When I did look at it again I was dissatisfied.

REVISION

I think the problem that bothered me was that the image lacked a sense of depth. I felt that the fuzzy, unrefined background that I had in an earlier stage looked better. Because of this I had to repaint the wall area again with a soft-

edged brush, and add a few lighter tones in the background. Finally when I had done this the image felt done (**Fig.13**)!

FINAL THOUGHT

Using an improvised approach is about settling on a direction and going with it. The good thing about this is that you work instinctively, which sometimes causes unexpected results. The downside is that you have to deal with the unexpected problems too. I used to have to

scrap a lot of my work because of this. If you do employ this technique make sure you occasionally save your work, because if anything goes wrong you can always rollback to a previous version so you don't need to start from a blank canvas again.

Personally I like to clearly plan everything before I actually get started because I don't like facing frustrating problems that waste my time later in the process.

chapter 3 | TECHNIQUES

The techniques you use to create an illustration will most likely alternate depending on what it is you are painting and the environment in which you are working. For this reason, having an arsenal of different methods and processes is a priceless asset for professionals and also those aspiring to break into the industry. Throughout this book you will be provided with numerous approaches to help you improve your own work, but in this section the artists will focus on more specific techniques to help add another string to your bow, including custom brushes, adding narrative to your illustrations and how to go about painting textures and reflective materials.

* Please note, that the Goldilocks and Repunzel tutorials by Simon Domic Brewer have been created using Painter.

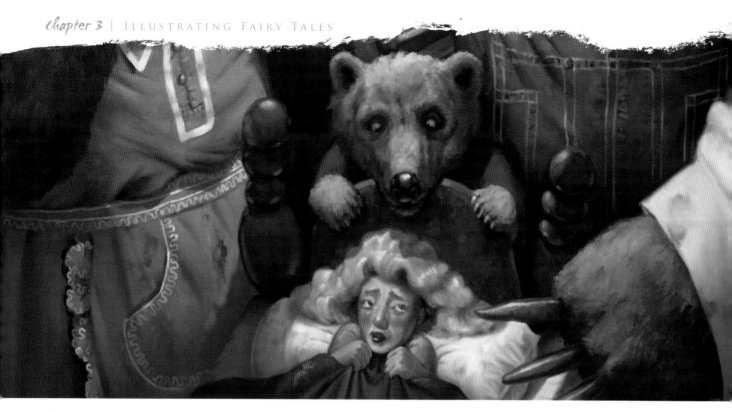

GOLDILOCKS
BY SIMON DOMINIC BREWER

INTRODUCTION

The story of *Goldilocks and the Three Bears* has its origins in the nineteenth century when it was recounted as a much darker story than the family-friendly, modern version. Early telling had a foul-mouthed old woman as the protagonist, and even a fox, and it was only later that Goldilocks put in an appearance as a presentable young girl.

In this tutorial I've chosen to depict a key scene from the modern story whilst retaining some of the overtures of menace from the original. Goldilocks is very much a tale of threes – three bears, three bowls of porridge, three chairs and three beds – and whilst it's possible to include all these in a single image, in order to tell the story it's not really necessary. What I'm going to do is use selected elements and prioritize their positioning in order to make it clear what fairy tale I'm illustrating. Beyond that, I want the scene to speak to even those viewers who are unfamiliar with the story (if any exist) and communicate the situation and back-story at a glance. The scene will have hints at comedy, but hopefully will also retain some of the claustrophobic, intimidating imagery present in the early incarnations.

BRUSH SETUP

The first step is to sort out which brushes I'm going to use. I'll only be using two – one for putting down paint and one for softening and blending. For painting I use an Artists' Oil variant with pressure-dependant opacity and medium grain. Grain is important because it interacts with the paper texture to give a more traditional look (**Fig.01**). I give it high levels of Viscosity, Clumpiness and Wetness and medium Blend. The result is a brush that applies thick paint at firmer pen pressures and almost none at all at lower pressures, therefore functioning like a blender. When I want to

blend larger areas I use a brush with almost identical settings to my main painting brush, except I set the amount of paint to 0% and Blend to between 50% and 100%. This won't give a perfectly smooth blend and is ideal for conveying a more painterly appearance.

DEFINING THE ELEMENTS

If I was working for a client I'd produce a selection of rough concept sketches at this point for them to browse and decide which one to go forward with. However, since I've already worked out in my head what elements I want to include I produce only one concept sketch. The

concept stage can be deceptive in that it's very quick to execute yet arguably, together with the final sketch, it's the most important part of the process. This is because the fundamentals of the image are laid down here; the rest is just technical work. I've decided to depict a scene in which Goldilocks is discovered sleeping in Baby Bear's bed (**Fig.02**).

> ## I'VE ALSO DECIDED TO DISPENSE WITH ACCURATE PERSPECTIVE AND GO FOR A SKEWED, NIGHTMARISH LOOK

So what do I want to include? Well, obviously I want Goldilocks and the three bears in there as a starter. Then we need to remember we're telling a story, so it's no good just having these characters standing there; we want them to show us what's going on through their appearance, pose and expression. So we'll have Goldilocks cowering in Baby Bear's bed whilst Father Bear roars at her to get out. Mother Bear is a bit worried by the whole situation and Baby Bear is just inquisitive, wondering who this strange creature is and why she's in his bed.

I've also decided to dispense with accurate perspective and go for a skewed, nightmarish look. Normally that's not a good idea, but because this is a fairy tale, and I want to give the impression of confinement with a hint of claustrophobia, I think it will work OK. The thing to remember if you decide to go down this route is to make it obvious you're not going for a traditional perspective otherwise people will just think you're not very good at it!

In the background we have a table with three bowls on it and, again, this is an integral part of the story. Through the window we can see a forest at sunset. I'll explain more about the various elements and their placement as we progress through the tutorial.

PALETTE CREATION

This is a good time to get my palette ready. In the Mixer I make a series of brush strokes and

dabs to represent the key colors I'll be using. I concentrate on the colors for fur, skin and wood, which will comprise the base palette for the image. I will be using other colors too, but I like to work as much as possible from a basic color scheme. In order to get a palette of swatches I use Create Color Set from Mixer to transfer my colors to a Color Set. I then close the Mixer as I won't need it any more (**Fig.03**).

ROUGH SKETCH

Having worked out the composition in the concept I'm ready to get started with the main image. First I create the canvas. I don't need to go full sized just yet so I work with a canvas of about a quarter of the final dimensions – 700 x 967 pixels. It's important my aspect ratio is accurate as later I'll be resizing this canvas upwards for the main painting stages.

On this small canvas I sketch a very rough outline of my characters and environment (**Fig.04**). Sometimes it's necessary to create a detailed and polished sketch at this stage,

especially where realistic characters need to be portrayed, but in this case I want more of a spontaneous feel, and as long as my bears don't end up looking like dogs it should be OK! To make doubly sure of the last bit I loosely reference a couple of bear photos from Google.

COLOR SKETCH

Selecting colors from the Color Set where possible, and still working at a small size, I quickly block colors on top of the sketch. The purpose of this step is three-fold. First, I want to see all the elements that will be present in the final image. They might only be splodges of paint now, but I need this sketch to show me how everything fits together. Second, I want to define my lighting. Because of the intentionally skewed perspective on this piece I'm not using the lamp as a definitive light source and instead I'm working with another "virtual" light source closer to the viewer and slightly behind the characters. It's still important, however, that lighting is broadly consistent all over the scene (**Fig.05**).

Finally, it's a good idea to get an indication as early as possible as to whether your image is going to work, taking into account composition, form, lighting and color. It's easy to make fundamental changes at this stage, or even start all over again, whereas the longer you leave it, the more time-consuming and disruptive changes become.

UPSIZING

I'm happy with the overall feel of the piece so it's time to upsize. Upsizing should be done after you've got the basics sorted, but before you started to add detail, because if you add detail before you upsize it will result in pixilation and fuzziness. In this case I resize up to a height of 4500 and because my aspect ratio is already accurate, Painter sets my width automatically to 3257 (**Fig.06**). Now this is larger than the final image I will be delivering and that's because I like to work big and reduce later as I find it's easier to add fine detail this way. I also set the resolution to 300 pixels per inch (PPI). This is standard for printed publications.

> " I'VE GOT HER EYEING FATHER BEAR'S MONSTROUS CLAW, WHICH IS A LITTLE TOO CLOSE FOR COMFORT "

STARTING ON THE DETAIL

Zooming in to 100% I begin detailing the focus of the image – Goldilocks's face. I use the Artists' Oils brush for all of the painting and most of the blending, but when it comes to areas I want very smooth, such as her cheeks, I use the Blending brush sparingly. Goldilocks is looking understandably apprehensive, having just been woken to find herself surrounded by bears. Because Father Bear is standing over her, yelling at her that she needs to leave, that's where I've directed her gaze (**Fig.07**). Or, more accurately, I've got her eyeing Father Bear's monstrous claw, which is a little too close for comfort. It's very important when telling a story to not only have the individuals acting in character, but interacting in an

immediately understandable manner. So whilst the scene itself is clearly impossible the viewer can suspend disbelief and, for a moment, be a part of the situation.

PAINTING CREASES IN HEAVY MATERIAL

Goldilocks is pulling the blanket up to her chin so the creases in the material need to reflect this. I make heavier use of the Blending brush when painting the blanket in order to denote a thick material (**Fig.08**). The creases in the material are sharper close to where it is pinched by her fists and gradually get softer as they blend into the main body of the blanket. When blending, it's important to dab and tease the paint rather than smear it, because smearing leads to a stringy, contoured outcome rather than a painterly blend. During the blending process it's often a good idea to add higher saturation paint at intervals in order to stop the blended colors becoming too muddy.

DEALING WITH LARGER AREAS

For larger areas, such as the blanket and Father Bear's alarming dungarees, I initially zoom out, and only once I've got the general feel right do I zoom back in to 100%. For zooming and panning in Painter 12 I always use the Navigator for its speed and ease of use (**Fig.09**). Sometimes I'll use colors that aren't in my Color Set. There's no science involved here, I just pick the ones that look right and don't jar with my color scheme. For picking non-Color Set colors I always use the Temporal Color palette, which I'll come onto later.

CLAWS!

One handy method of making dark objects look like they're actually dark-colored instead of in shadow is to add specular highlights. I paint Father Bear's claws in low value (dark) oranges and yellows, and then add a single specular highlight line along each one (**Fig.10**).

CHARACTERIZING VIA FUR

Each bear's fur needs to be painted slightly differently in order to add character. Baby Bear's fur is neat and cropped short, much like a teddy bear, whereas Father Bear's fur is longer and somewhat shaggy (**Fig.11**). I've added a pink tint to Mother Bear's fur because whilst female bears don't tend to be pink they aren't immediately identifiable as feminine either, and I want her to look very much like a mother bear and not just a male bear in drag. That would make for a very different story, I guess.

PAINTING FUR

In terms of rendering fur I first paint short strokes over my base painting, frequently varying the color by choosing from the Color Set or picking directly from the canvas. I don't press too hard otherwise the effect would be too gritty. The second step is to go over the fur areas with the blender. However, it's very important not to blend too much otherwise the resultant effect will be fuzzy and appear overtly digital. Whatever area I'm painting I always bear (sorry for the bad joke) in mind my light source so that all objects in my scene are lit consistently. Here we can see that Father Bear's prodigious upper jaw casts a shadow over his tongue, giving the impression of solidity and depth (**Fig.12**).

USING A LAYER AS AN AID

If you're as bad at drawing freehand ellipses as I am then it's good to have a digital aid handy. With the Ellipse tool I draw an ellipse for the light shade, angle it using the Transform tool then drop it onto the canvas (**Fig.13**). I won't be sticking strictly to the elliptical outline because I don't want the result to be too clinical for this particular image, but all the same I find a guide very helpful in getting the overall sweep of the shape.

In terms of the story I add the lamp because I've always found that artificial illumination inside a house has an ominous effect when it's still light outside. Maybe it's just me, but I think it adds a hint of menace to the scene.

BEARS ARE NO GOOD AT DIY

In the real world bears don't live in houses. That much is clear, but if they did I suspect they'd be terrible at DIY and this would result in a number of defects around the place. In **Fig.14** we can see damp creeping across the walls and ceiling from the corner of the room, as if it is a result of faulty guttering that Father Bear has neglected due to the enormous size of his paws (begging the question how he manages to eat porridge with a spoon, but that's another matter). So essentially the message is that giving a bit of thought to

the environment and the back-story can add authenticity to a piece, even one that depicts a scene that could never occur in real life.

UNDERSTANDING YOUR ENVIRONMENT

Out of the window we can see the forest, which is consistent with the Goldilocks story. The sun looks to be setting, as evidenced by the pink-tinged clouds, and this helps explain Goldilocks's readiness to sleep. The time shown on the clock backs up the impression of late evening. I add a few subtle reflections on the glass otherwise it would look like the

window frames are empty. The reflections also help intensify the claustrophobic atmosphere of the scene (**Fig.15**).

DETAILS OF THE STORY

We need to pay particular attention to what's on the table, as this is an integral part of the story. If you remember from your younger days, Goldilocks finds three bowls of porridge. The first she tries is too hot, the second too cold and the third – the smallest – is just right. Whilst this variation in temperature is not easily explicable visibly, that's the story and it can be represented here via a subtle steaming effect on Father Bear's porridge, which remains uneaten. Next to the big bowl is Mother Bear's portion, which is cold and therefore has no steam. Closest to the viewer is Baby Bear's bowl, which is empty. Goldilocks is apparently a messy eater as evidence of her scoffing is all over the tablecloth. To add content to our story I've also made the size of the chairs agree with the bowl sizes (**Fig.16**).

FEMALE BEARS

Mother Bear is a real beauty, with claw varnish and lippy to match her dress. Again, these little touches in a fantasy setting help give the impression of a female animal that in real life would not be easy to distinguish from its male counterpart. With Mother Bear's dress, apron and bracelet there can be little doubt what her role is in the family (**Fig.17**).

PAINTERLY SHADOWS

One method of painting shadows is to use a Darken or Multiply layer of medium opacity, which is dropped to the canvas after the shadow areas have been painted. This is a quick method and results in perfectly satisfactory results, but if I have the time I like to paint shadows using the traditional method of picking each color and painting straight onto the main canvas (**Fig.18**).

As an example, the white embroidered areas of Mother Bear's dress are affected by the same creases and therefore the same shadowing pattern as the pink material. In order to paint the white embroidery I start off with a high value, mid-saturation pink for direct lighting

and, in the shadowed areas, I match the line of the crease to the embroidery and paint that particular bit with a lower saturation, and lower value color of the same hue. The Temporal Color palette is very useful for this sort of work; it is very quick to access and appears right where you're working. I use Edit > Preferences > Customize Keys to assign the Temporal Color palette to the / key for easy toggling.

REMOVING HARD EDGES

As the penultimate step I use the Blending brush to smooth any hard edges left in my image. I use dabs and short strokes so that I don't overly blend objects and the final effect is more like a strong anti-alias than blending. I find that doing this produces more cohesion in the final image and prevents sharp boundaries from irritating the viewer (**Fig.19**).

A FRESH PERSPECTIVE

At this point I leave the image for a couple of

days then return to it to see if anything else needs doing. If deadlines allow it's often good to put a bit of distance time-wise between yourself and your image, because after you've worked 10 or 20 hours on the same piece you can end up becoming too familiar with it. You could say it's like failing to see the wood for the trees.

Immediately I notice that Goldilocks appears to not have any shoulders. Clearly this situation needs to be remedied so I give her a pair of shoulders hunched up to her ears (**Fig.20**).

All that remains now is to make some subtle adjustments to the image intensity in order to bring out the colors and I think it's done. Once I'm happy with the image I save a downsized copy of the image to fit the specifications, which in this case are 2480 x 3425 pixels. Thanks for reading and I hope you enjoyed the tutorial (**Fig.21**).

RAPUNZEL
BY SIMON DOMINIC BREWER

INTRODUCTION

In this tutorial I'll be illustrating a scene from the fairy tale *Rapunzel*. Like most fairy tales, *Rapunzel* has been retold in several variants over the decades. In one version the old enchantress is replaced by an ogress and in another the prince gets up to some un-princely behavior in the tower. For this illustration however, I'll be depicting the scene where the prince finds out how to scale the tower in which Rapunzel is imprisoned. For many an evening since he first discovered the tower he's secretly listened to Rapunzel singing and this particular evening he happens to catch the old woman paying her a visit. He hides in the bushes and watches as Rapunzel wraps her hair around a hook on the window ledge, then lowers her braid so that the old woman can climb up.

COLOR SCHEME

First I set up my color scheme. I want the atmosphere to be bleak, to convey the concept of imprisonment and isolation. I'm also thinking of a moonlit scene, so I've decided to use a very limited triadic complement of colors. This basically means three colors that roughly form an equatorial triangle on the color wheel. I choose cyan, purple and a yellow-green.

For each of the three colors I dab a range of values from dark to light onto the Mixer palette. When I'm done I choose the Create Color Set From Mixer option, which gives me a set of 256 swatches in the Color Set palette. I delete some of these so I'm left with a representative sample of a manageable size. For the rest of the painting process I will mostly work from the Color Set palette (**Fig.01**).

CONCEPT THUMBS

Very quickly I paint some small, rough concept thumbnails. These thumbs aren't meant to show detail, but they should give a general idea of the composition and value distribution (where the lights and darks will appear). I decide to go with the layout depicting the larger, central tower with the prince kneeling in the corner (**Fig.02**).

ROUGH SKETCH

I create a small canvas at 700 x 967 pixels, which represents the same aspect ratio as my final image will be. This will serve as a base for my rough sketch and rough color work. When it comes time to add the details I'll resize up to my working dimensions. Sometimes when the subject matter is complex or you're working for a client with a strict specification, it's a good idea to spend time on a detailed sketch. In this instance, however, a quick value study is all that's needed.

Although there's still no detail at this stage I scribble in my main elements: the tower, Rapunzel at the window, the enchantress and the prince. It's crucial to remember at all times that we're telling a story, so what's happening needs to be as clear as possible. The prince is secreted in the dark underbrush, suggesting he's watching proceedings whilst keeping a low profile. I position Rapunzel very close to the top of the canvas to give the impression that she's isolated in the tower, a long way from the ground and too far up to jump. By having the old woman at the bottom of the tower and over to the left I create a path from her to the prince, then to Rapunzel. Later I'll enhance this path using tonal shading on the tower, in particular with Rapunzel's golden braid (**Fig.03**).

ADDING COLOR

I add color to the whole image at an early stage in order to minimise surprises later on. Working directly onto the canvas I use the Artists' Oils brush to dab on the paint, picking my colors from the Color Set panel. I don't pay much attention to the color's hue (e.g., green, purple) and instead concentrate on the value, ensuring that it broadly matches the value I put down in my rough sketch.

Of course, when painting generally it's often essential to pay close attention to hue and saturation as well as value, but value tends to make or break a picture and in this particular instance I'm emphasizing that theme to produce a very value-oriented result. In other words, as long as your lights and darks are in the right place, your picture should work on a technical level.

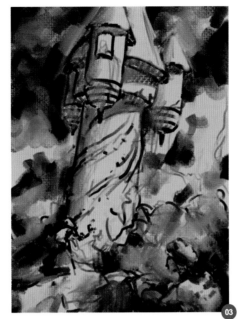
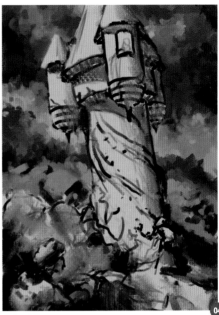

If we were trying to accurately represent a scene lit by moonlight we would be working with far fewer hues and almost entirely in the low value range. However, as this is a fairy story we can allow ourselves some leeway. From this point on I will occasionally flip the image horizontally. This gives the eye a fresh perspective and helps identify problems early on (**Fig.04**).

RESIZE UP

The next step is to resize to my working size: 3257 x 4500 pixels. My working size is larger than the specified dimensions for the final image because it means I can add fine detail without resorting to unfeasibly small brushes (**Fig.05**).

ROUGH DETAIL

There's no right or wrong way to approach adding detail in terms of which part to do first. Sometimes I start with the main character and sometimes I'll flit at random from one part of the image to another. This time I'm going to work from the top of the image down, just for variation.

I zoom in to 50% and with a 20-30 pixel Artists' Oils brush, start blocking in the detail. At every stage we must bear in mind the story we're telling without losing sight of the technical aspect as both go hand in hand. Here I'm depicting the tower as old and decrepit; not quite derelict, but certainly in need of some TLC (**Fig.06**). A few cracks in the brickwork

combined with creeping tendrils of vegetation do the trick. I pick frequently from the Color Set palette, concentrating on value as I mentioned earlier. This gives the brickwork a pleasingly mottled effect, thereby communicating age and weathering.

MAKING THE TOWER "POP"

The tower is comprised of the same basic hues as the sky so we need to use value to distinguish them – to make the tower "pop". I do this by applying deep darks to the tower's shadow and bright highlights on the moon-lit side.

The sky, by contrast, is composed of a narrower value range spanning medium darks to medium lights. What I also do is juxtapose light and dark areas of tower and sky, so that on the upper left I balance the shadowed edge of the far spire with an area of light sky, and on the right I do the reverse.

> **Quick Tip:** One useful tip to painting shadows is to try and dab a little reflected light into the shadow areas. This helps give the impression of added solidity. Here, I add a little reflected light onto the shadowed areas of the tower, balancing them as required with deeper darks (**Fig.07**).

RAPUNZEL

To paint Rapunzel I zoom in 100% and reduce the size of my Artists' Oils brush to around 7 pixels. The fact that our primary light source is located above and to the right causes a small problem when rendering Rapunzel, as strict adherence to our lighting model would mean that most of her face and torso would be in shadow. The solution is simple: I cheat and paint her face with an up-lighting effect so as to better emphasise the form of her face and hair.

I frequently stress the importance of consistent lighting throughout an image and for good reason, but on occasion it's perfectly acceptable and even desirable to cheat a little, as long as the affected area is not too extensive. This might take the form of an

enhanced intensity of reflected light, an ad-hoc increase of value in a localized shadow area (maybe accompanied by a hue change) or a spotlight effect, as seen here. The ultimate test of course is, does it look good? If it does, it's OK. If not, you need to paint over it and try again.

As far as Rapunzel herself goes, I've left her expression neutral and largely undefined, for two reasons. Firstly, in the final image she will appear quite small and a detailed facial expression would either be lost or appear too fussy or contrived. Secondly, and more importantly, the story does not call for any overt expression of emotion for her in this situation. Rapunzel is resigned to her captivity and whilst she's likely in a glum mood there's no requirement for her to be shouting or crying or expressing any other emotion that would be obvious on such a small character (**Fig.08**).

STONEWORK

The tower is an ancient edifice constructed from roughly-hewn stone. The best way to show this is to "suggest" the stonework rather than explicitly paint each block as if it's a 3D render. In some areas I paint the staggered pattern reminiscent of stone buildings, yet other areas I leave bare, textured only by the color variations. Not only does this help to avoid an overpowering texture effect, it gives the impression of age and the viewer can imagine the tower being worn down by the elements over many years (**Fig.09**).

VEGETATION

In order to make the creeping vines stand out I color them mainly green, with a bit of blue thrown in for the shadows. I stress the age of the tower by scribbling in some grimy streaks running down the stone from beneath the roof tiles (**Fig.10**).

STORMY CLOUDS

I've already painted the rough outline of my clouds and now comes the time to smooth them a bit. For this I use a duplicate of my Artists' Oils painting brush, except I set the Amount of paint to 0 and reduce Blend a little. When combined with the paper texture this creates a nice, textured transition. A good rule for blending is to not go too far. Exactly what constitutes "too far" comes with experience, but a guideline is that if two colors differ a great deal in hue or value then leave them un-blended.

So here, I blend the cloud bodies but leave the contrasting colors of the edges (the billows) relatively sharp, with maybe just a dab here and there to soften some of the rough edges. This method of selective blending ensures you don't get the dreaded digital painting effect where everything is smoothed to within an inch of its life and one object blurs into the next (**Fig.11**).

REMOVING THE HARD EDGES

Sometimes the Artists' Oils brush creates hard-edged strokes that appear discordant with a painterly image. To fix this problem I use my Artists' Oils blending brush and tease the sharp edges. In **Fig.12** you can see I have smoothed the edges of the mountains a little more than the foreground elements in order to give the image more depth and to help ensure the background doesn't overpower the foreground.

PAINTING VEGETATION

To help enhance the feeling of depth I include some bushes in the middle distance. For foliage that is some way from the viewer it's often not desirable to try and render each leaf and each branch. The way I've painted these bushes is to first block in a general, dark shape using a larger brush and then, with a smaller brush, paint negative space into the dark foliage shape. This gives the impression that the sky is showing through clumps of leaves and branches. I color pick regularly from the juxtaposed areas of sky on the canvas to achieve the effect of the sky continuing behind the bush (**Fig.13**).

ROCKS NEEDN'T BE BORING

In order to demonstrate the remote location of the tower I include some jagged rocks in amongst the bushes and weeds. It's easy, if you're not careful, to allow your rocks to appear boring and lifeless. To counter this I balance the desaturated colors of the rock with splashes of higher contrast hues, such as blue and purple. I add some moss and creeping vegetation so the rocks don't appear too sterile and I also vary the shape of each rock so that no two appear identical (**Fig.14**).

DON'T FORGET YOUR STORY

If you bear in mind the tale you want to tell, you'll find that even relatively late on in the process you can make subtle tweaks to communicate the back story to your viewer. In this case the brush strokes in the lower left

resemble a little path. Being that any tower would normally have some sort of access route I decide to embellish this area with edging stones and a couple of flat stone slabs.

LEANING TOWER

During the painting process I sometimes zoom out and flip the image horizontally to get an idea of how the whole thing is progressing. What I've just noticed is that the tower is leaning too far to the right, even accounting for the slightly skewed camera angle. To be truthful I should have spotted this earlier but still, it's no big deal.

One option to correct this is to use the Transform tool to rotate the canvas to the left, then use Edit > Transform > Commit Transform to retain the transformation. The problem with this is that the default canvas color will be visible along some of the edges. So what I do

is select the entire image using Ctrl/Cmd + A, copy it (Ctrl/Cmd + C) and paste it (Ctrl/Cmd + V) as a new layer. I remove the selection with Ctrl/Cmd + D and use the Transform tool to rotate the layer and then commit it. Lastly, I drop the layer to the canvas. This has the advantage that the original image shows through at the edges, making it much easier to blend the changes in.

OLD WOMAN

I depict the old woman as ugly and vaguely hunched because whilst she is clearly not a very likeable character (having imprisoned Rapunzel in the tower in the first place), she doesn't come across as being actively evil. An old crone with blood dripping from her fangs would have been fun to draw, though would have been overkill for this particular story (**Fig.15**).

FOCUSING ON KEY ELEMENTS

Central to the Rapunzel story is her long, braided hair. It could be argued that Rapunzel's hair plays more of a role in the story that any other character, herself included, because take away the hair and you take away the element around which the whole tale revolves. For this reason I decide to indulge in a bit of experimental artwork (experimental for me, anyway) and highlight Rapunzel's hair braid in vibrant corn-yellow. I could do this by repainting the whole thing, but I don't fancy dealing with all those braids again so I create a Colorize layer and paint onto that. When I'm finished I set the layer opacity to around 75%, otherwise it would be too garish, and drop it to the canvas (**Fig.16**).

THE PRINCE

We have a bit of a dilemma here. On one hand, the prince is a very important character in the story, yet on the other he's hiding in the shadows. In other words, if we draw too much attention to him it will work against the premise of secrecy, but if we understate him excessively he'll be lost in the foliage and the viewer won't see him. I deal with this by firstly painting his clothes in distinct yet not overly bright colors. I add a little trim to his jacket and princely

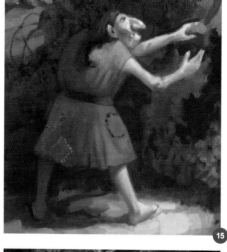

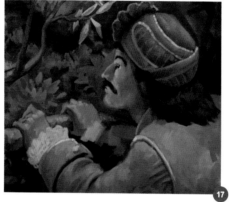

headgear whilst ensuring there's nothing too flashy to immediately draw the eye. In terms of lighting I again emphasize the reflected light from the scene to define his features. Because he's in the shadows our main light source does not affect him directly, so we don't have any sharp light/dark transitions to grab attention (**Fig.17**).

FINAL DETAILS

When I'm happy and the image is almost done I check it at 100% zoom and add some tighter detail where appropriate. For example, I use a small brush to accentuate the cracks in the stonework and the mortar in between individual blocks (**Fig.18 – 19**).

AOB

The final step is my Any Other Business stage. I leave the image for a couple of days then come back to it and see if anything leaps out as needing to be changed or finalized. I'm happy with the detail, but now I come to think about it, the enchantress is looking too much like a tramp. Therefore I give her a fetching witch's hat to make sure the viewer knows who she is. I add a few more details too, such as a moon peeking out from behind the clouds and three crows flying off to roost. I resize the image down to my final dimensions (2480 x 3425 pixels), increase the contrast a touch and call it done. That concludes this tutorial. I hope you've found it useful!

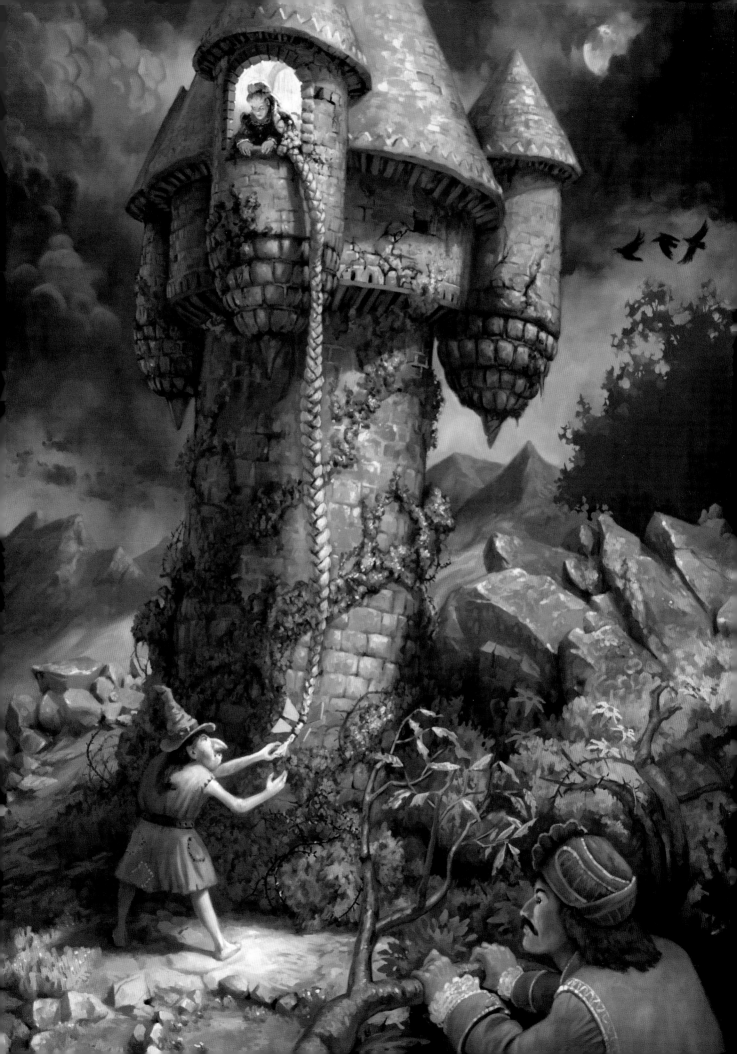

THREE LITTLE PIGS
BY BLAZ PORENTA

INTRODUCTION

I have always wondered how it would look if I were to portray children's fairy tales in a different way, and change those cute and cuddly characters into gritty and realistic ones. I decided that I would take this approach and apply it to the story of the *Three Little Pigs* and the wolf, but with a little twist.

THE IDEA

When creating a new painting, from either an existing story or completely original one, I always try to implement something to lure the viewer in and make them think. In this particular case I decided to play with an idea that I had. Who is the real bad guy in this story? To convince the audience to feel sorry for the wolf, the pigs couldn't look friendly or cute at all! So I chose to portray them as three big, fat, redneck hogs who were dirty and nasty in all kinds of ways. Because I didn't want to forget the well-known characteristics that set them apart from each other, I also decided to give the pig with the straw house a pitchfork, portray the pig with the wooden house as a lumberjack and have the third and smartest pig as a bricklayer, placed at the very front of the image.

Now that the main idea was set it was time to lay down a sketch. When working on a piece I usually start painting with scattered brush strokes, waiting for elements to pop out and tell me how to move on. Since I already knew where I wanted to go with this image, I started with rough line art instead and continued from there. This didn't mean that the final painting would end up looking exactly the same as the sketch, but with the characters designed the painting process would be much quicker (**Fig.01**).

Painting realistically requires lots of observation and an understanding of what you are painting. If you are painting something for the hundredth time it is likely that you will have a clear image of the subject in your head already. If you haven't painted something many times, I highly recommend using some photo references. With the internet and digital cameras in every home finding references shouldn't be a problem. Gather as many photos as you can and study them carefully, rather than just copying them. Often different photos have different light sources, perspectives and color warmth. All that can result in a painting that looks like a bad collage, no matter how well rendered it is.

> I WAS GOING FOR A MODERN HORROR MOVIE POSTER-LIKE PAINTING, SO I WANTED A GREENISH MONOCHROMATIC RANGE WITH SOME AREAS POPPING OUT

GRAYSCALE

Going back to my painting process, it was time to create a grayscale scheme, searching for the right tone values in the image. Important areas that should attract the most attention, such as the hogs' faces and their silhouettes, needed to pop out immediately, therefore creating vivid contrasts around them was a must. Other less important areas could blend together or be hidden in the shadows at the back. At this stage I also started playing with textures and some custom brushes to get an idea of what kind of result I was striving for (**Fig.02**).

ADDING COLOR

When I was happy with the tone values I quickly threw some colors over it. Usually I use the Color and Overlay layer modes here. The Color layer mode is for choosing the main colors whilst the Overlay layer mode is for accenting them and making them vivid so they contrast with other areas of the image (**Fig.03**).

The colors that you use will define the overall mood so it's important to choose ones that will enhance your ideas. I was going for a modern

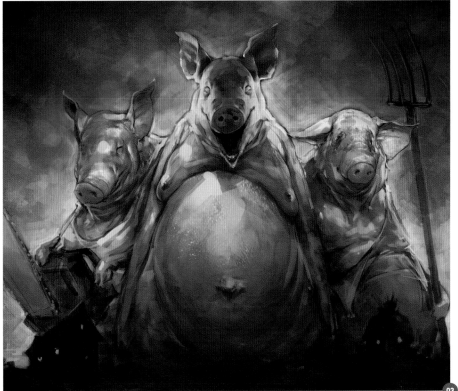

horror movie poster-like painting, so I wanted a greenish monochromatic range with some areas popping out. For these areas I used warmer hues such as red and light orange.

REFINING THE IMAGE

This is the polishing stage of the painting process. Once again if you are not doing something for the hundredth time there is nothing wrong with using a photo reference. It will help you recreate the small details that make the difference between something looking just OK and something looking authentic and believable. Study the wrinkles

and textures and observe how different materials reflect light. This is probably the stage that takes the most time, but it is also the most fun (**Fig.04**).

I never limit myself to the base sketch. It is something that is good to start with, but I always look for upgrades and to make changes that will make the final piece better. At the beginning I was thinking of placing the wolf's skin in front of the hogs, but I found it too straight forward. I decided to go with a more subtle approach and made the wolf the mortar between the stones. What is not seen and can be left to the viewer's imagination is always more powerful than serving everything up on a plate (**Fig.05**).

Another important thing to do was drop some more ideas into the painting to help distinguish the pigs from one another, making them diverse and hinting at their professions (**Fig.06 – 08**).

Since the pig with the straw house should be the least smart, I portrayed him in a goofy way, with pimples all over his face and mucus coming out of his nostrils. The one with the wooden house is a lumberjack with a trucker's hat. I made him look unshaven and gave him strong fangs that look a bit like a mustache. Last, but not least, is the smartest and most confident pig with his big smile, chipped fang and black spots to make him stand out from the rest.

I also started working on the background, adding a pine forest and grain fields behind them to distinguish the characters even more. I also did a little more to define the pitchfork and chainsaw, and added flies around their heads and a fast food chain tattoo as a hidden Easter egg on one of the hogs. This is not added as advertising, but is a hint of their bizarre nature and suggests they are cannibals (**Fig.09**).

The final stage was to add some finishing touches. I looked at what stuck out too much and how to tie up all the elements in the painting to make it work as a whole. This usually requires some color adjustments with

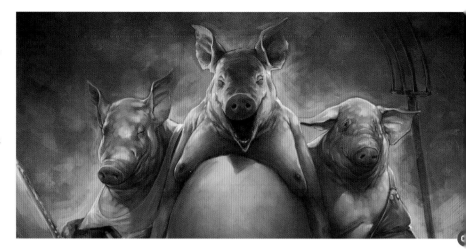

Curves and means applying grainy textures all over the image. Be careful not to overdo it, which can easily happen. Think of textures as another brush stroke, only place them where they are needed and don't cover mistakes or try to replace parts of the image. Textures are there to help define the materials; otherwise they should be invisible to the eye (**Fig.10**).

I hope you learned something from this tutorial and enjoyed reading it as much as I enjoyed painting those three "little" pigs.

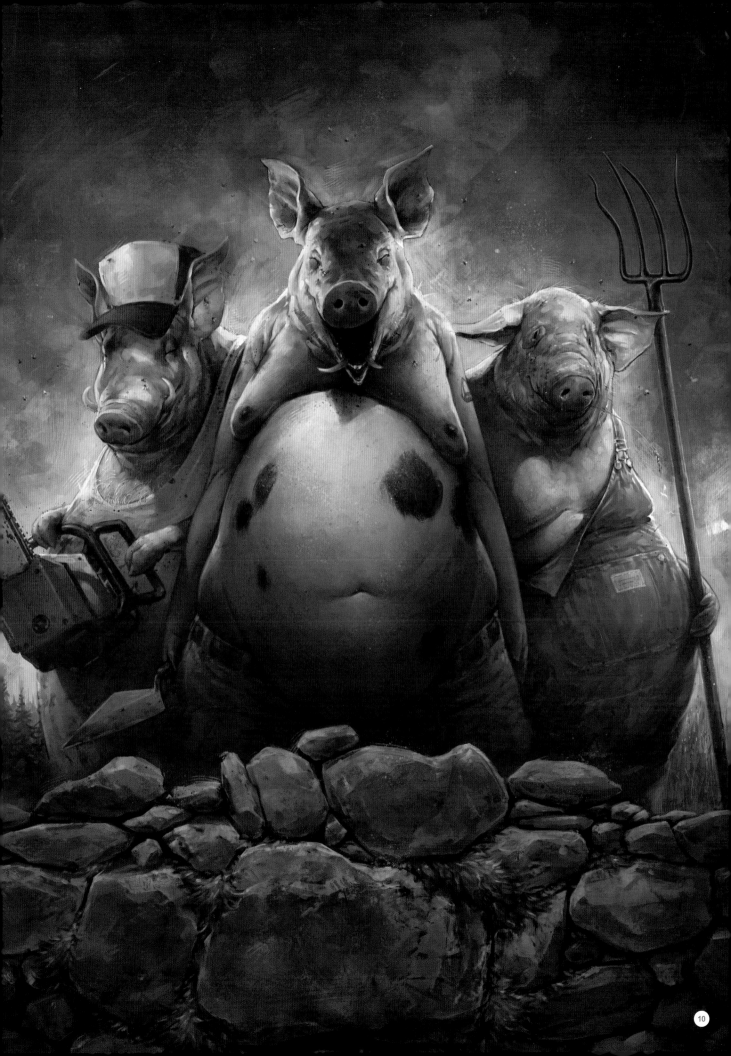

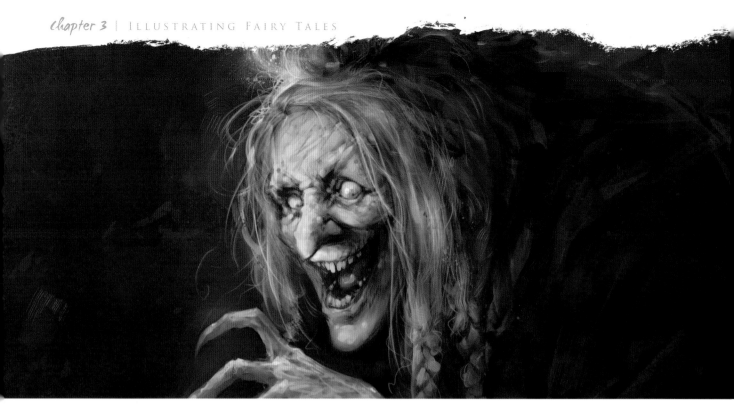

HANSEL AND GRETEL
BY BLAZ PORENTA

INTRODUCTION

To be honest, to begin with I struggled with this image, especially in its early stages. I couldn't decide which part of the story to portray and what would work well with the darker, sinister twist. I had loads of different ideas, like a burning gingerbread house or Gretel pushing the old woman into the fire, then suddenly my final idea came to me! It is this final idea that I will explain in this tutorial.

After dismissing the first idea of a burning house, I did a sketch of a witch walking little Hansel to his end with a ghost-like Gretel high in the background of the image (**Fig.01**). As with the Three Little Pigs tutorial, I started this painting with a line art, creating a rough composition of our main three characters. No other elements were sketched at this point as I was imagining a completely black background with one main light source coming from the left, that being a fire in front of them (**Fig.02**).

It is sort of a chiaroscuro style of painting, which is similar to the way old masters like Caravaggio and Rembrandt painted. As I usually do, I started with a really quick grayscale image to establish basic tone values

01

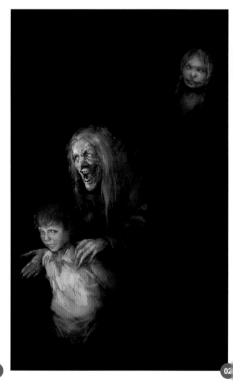

02

and contrasts. I added none of the fine detail at this point. Although I was originally happy with the composition of the line art, I started noticing some flaws as the image developed. The black in the background was too strong and the characters were almost randomly all over the place. It was time to make some changes.

To counter the faults I had found I moved Gretel more to the left and added an arch of light behind her to hint that they are in some sort of room. I also painted in some reds in the lower left corner to show that this is where the fire is and to hint at warmth in the image (**Fig.03**).

When painting over a grayscale image I usually use Color and Overlay layer modes in Photoshop. I use Color mode to add colors and Overlay to pop out contrasts and make colors more vivid. Although I was mainly working with warm colors here, I never forgot to drop some colder hues in as well. By dropping in these cooler hues you make the oranges and reds next to them look more alive. Also by using contrasting warmths you can add to the story of an image. As I mentioned before, I wanted Gretel to look almost like a ghost as she was preparing to push the witch into the fire.

> ## HANSEL'S BODY POSTURE IS TELLING US HE IS SURPRISED AND TERRIFIED BY THE GRIN ON THE WITCH'S FACE, WHILE GRETEL LOOKS ALMOST TOO CALM AND IS FACING AWAY FROM THE POTENTIAL DANGER

Although the image was progressing overall, I wasn't particularly happy with it. The composition was weak, mainly because all three characters were facing the same direction, leading the viewer's eye out of the image instead of making it circle around the painting. Because this wasn't working I decided to try a completely new composition and portray another part of the story with it. I decided to paint the moment where the children met the old lady for the first time so I could capture their response and uncertainty. Hansel's body posture is telling us he is surprised and terrified by the grin on the witch's face, while Gretel looks almost too calm and is facing away from the potential danger, leading us into the painting (**Fig.04**).

Now that I was satisfied I could move on to details and defining the characters, their outfits and a final color scheme (**Fig.05**). This is another dangerous stage of painting where you can easily get stuck in one part of the image, which often means that the painting won't work as a whole. Work systematically and be patient.

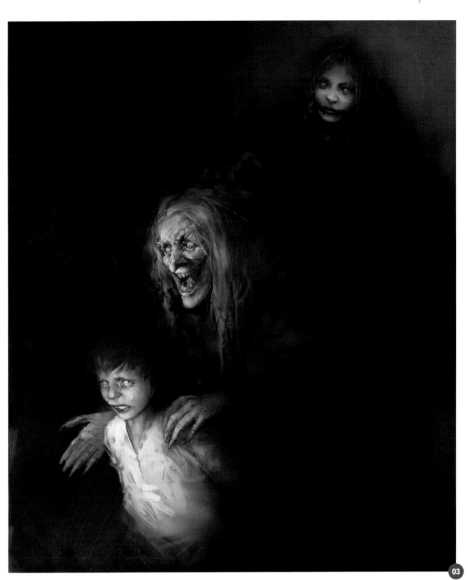

03

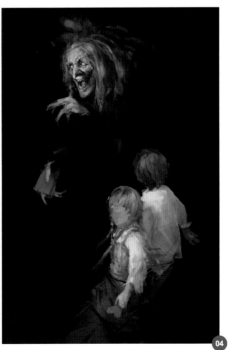

04

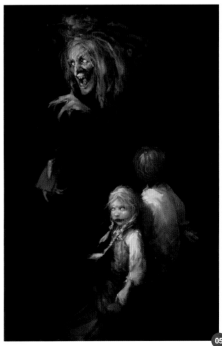

05

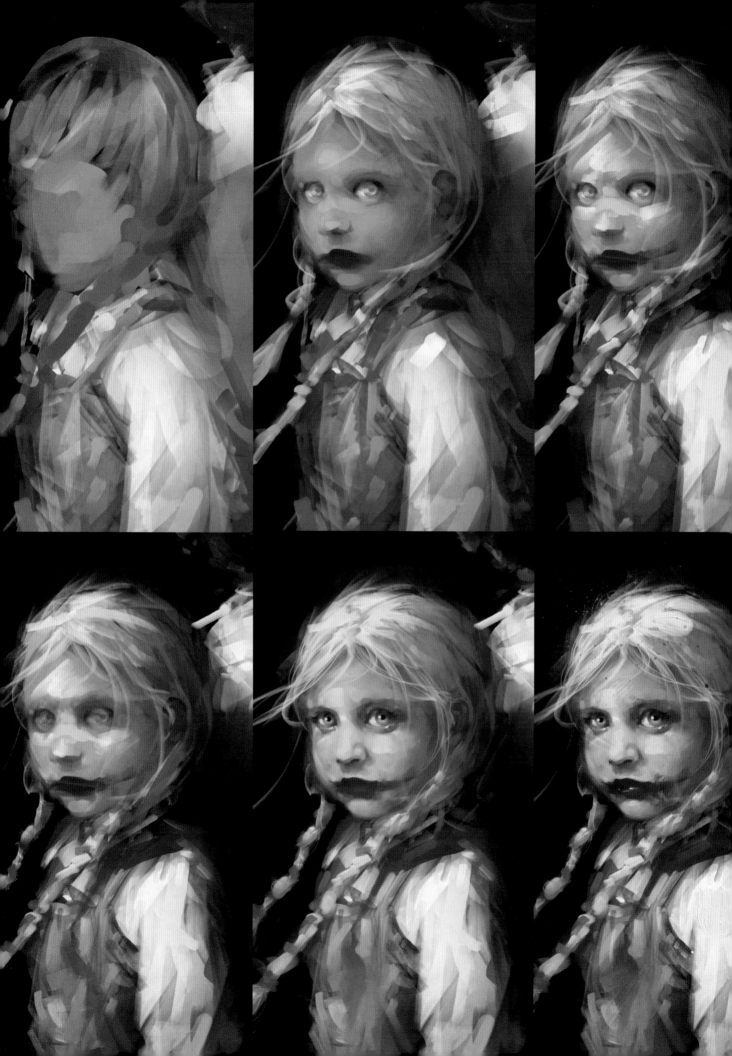

You will get to paint eyelashes and all those reflections eventually. Create the basic forms and figure out all the light sources. Always check the full size image and don't work on close-ups for too long. Once that is complete you can move on to the detail (**Fig.06**).

> ❝ 'THERE IS NO 100% BLACK OR WHITE IN NATURE' AND THE SAME SHOULD BE APPLIED TO PAINTINGS, OTHERWISE IT WILL LOOK OVER-BURNED ❞

In my next step I widened the canvas a bit as I felt the characters looked a little trapped, and painted borders with loose and rough brush strokes to suggest there is something more behind the frame. I also put another yellow/orange layer in Overlay mode on top of the image, which is a simple but effective way of creating warm tones and uniting the main light source color (**Fig.07**). If there is too much white in the painting the Overlay mode won't give you the result you are looking for. If that is the case, darken the painting a bit. As my art teacher said, "There is no 100% black or white in nature" and the same should be applied to paintings, otherwise it will look over-burned.

Although I planned to leave the background dark and almost black, I realized that with the hint of a wall behind the witch I didn't only get a better depth perception, but could also cast her shadow and get another composition element to play with (**Fig.08**).

The biscuits in the old lady's hand were replaced with a skull jar full of sweets, which adds a hint of danger and a really sinister twist to the witch. I also gave the girl a biscuit that looks like a bleeding heart, which could just be a cookie filled with strawberry jam. I also made it look like she has blood dripping from it and her mouth, which points forward to the horrible act she has to commit to survive (**Fig.09**).

In my final step I started tightened everything up with details where they needed to be

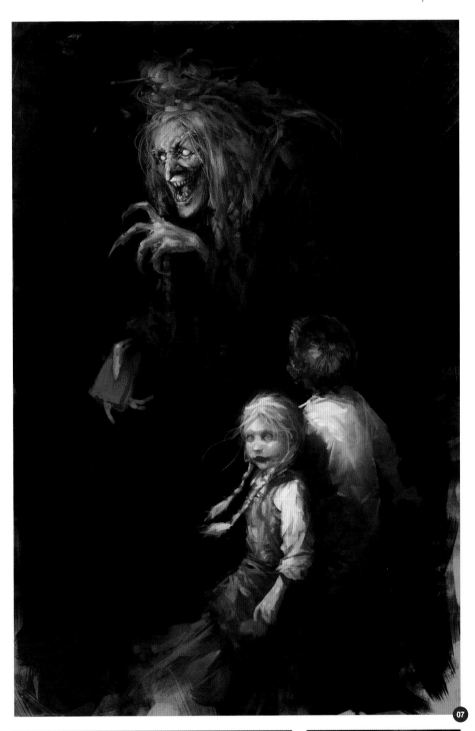

197

applied. I added highlights to pop things out from the background and placed some textures to add more life to the painting (**Fig.10**).

I need to confess I got carried away with the witch's face in these final stages, so much so

that she ended up looking like she was wearing a mask (**Fig.11 – 13**). This demonstrates the importance of what I said before: always look at your paintings from a distance. The details are the least important element in the painting if the painting doesn't work well as a whole.

I hope you enjoyed looking at my images as much as I enjoyed painting them. A big thanks goes to the 3DTotal team for the awesome opportunity to work on this well-known story and for giving me the freedom to develop my own interpretation.

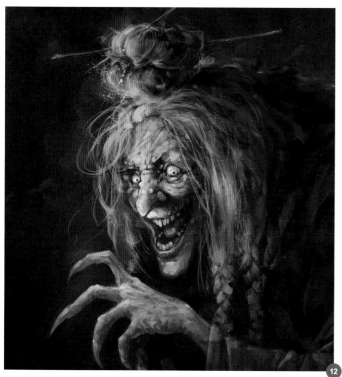

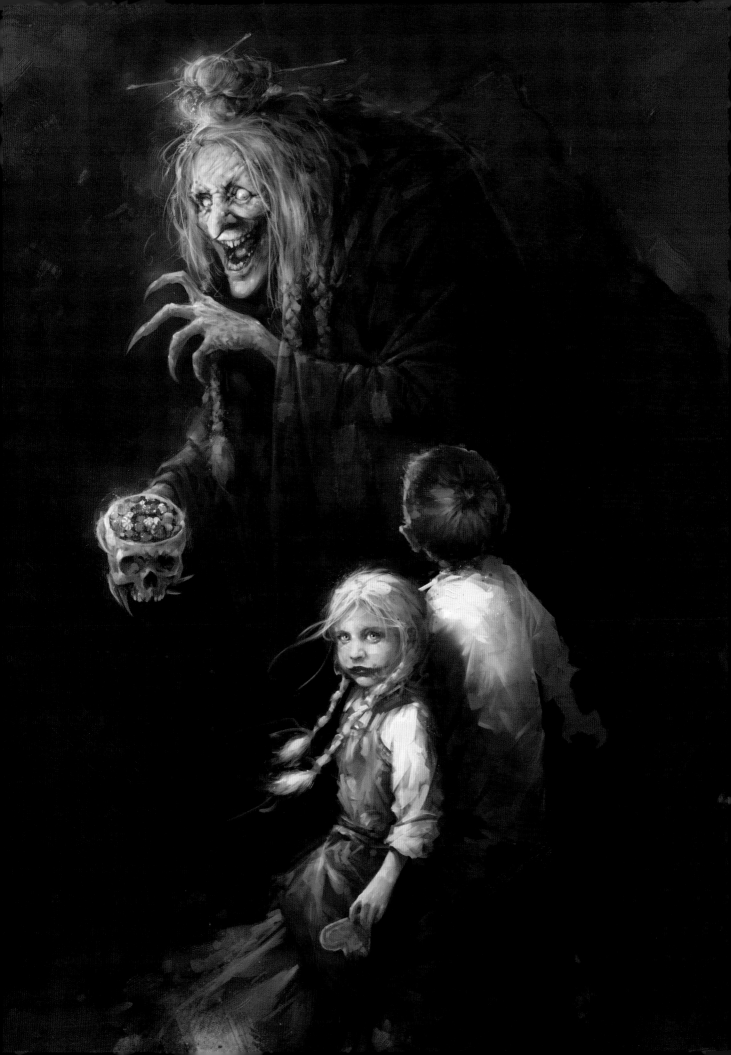

EGYPTIAN SCI-FI SCENE
BY CHASE STONE

INTRODUCTION

The goal of this tutorial is to show an explorer discovering something alien in an Egyptian tomb. I'm going to show you how I went about painting it and, more specifically, how custom brushes and patterns helped speed things up.

SKETCHING

I started out by loosely getting my idea down with a rough sketch. For the alien artifact, I decided to go with an obelisk inspired by *2001*, but with some glowing alien writing scribbled on it. I went through a couple of variations before I came up with something I liked, ending

up with a worm's eye perspective and a couple of different light sources, with a teal/yellow color scheme. Ideally you want to do all of the experimenting at this stage because if you do it later on (like I usually do) you might end up frustrated (**Fig.01**).

Once the sketch was looking promising I worked out a perspective grid and refined it, defining the structure of the wall and staircase (**Fig.02**). Since I knew I would be applying patterns and textures to these surfaces, I tried to get my values as accurate as possible,

working out shadows and atmospheric perspective. It makes things easier later on.

MAKING A REPEATING PATTERN

OK, so I had my blank wall, the perspective was good and the values were more or less down. Now I needed to brick it up. The problem is nobody wants to manually paint a million bricks. Fortunately, Photoshop can help out with that. But first, I needed to make a repeating brick pattern.

Let's say you have a photo or drawing of some bricks, but it doesn't tile very well, for example. The first thing you have to do is open that photo or drawing in a square Photoshop document. If it's a photo, white out everything except the outline of the bricks; you don't want to deal with the photographic texture in between, as you can see in Square 1 of **Fig.03**. Also, for copyright purposes, make sure it's a photo that you took personally. Enlarge the canvas (not the image) and make it three times its original size so that you have some room to play around in, and then duplicate your pattern to another layer (we'll call this Square 2). Drag Square 2 over to the right, so that side C of Square 1 is adjacent to side A of Square 2. Now adjust Square 2 (and only Square 2) to blend with Square 1.

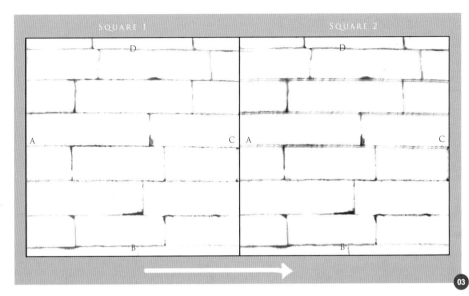

> THE KEY TO USING PATTERNS AND BRUSHES IS GOING BACK AND APPLYING YOUR HAND TO THEM; OTHERWISE THEY WILL LOOK TILED AND COMPUTERIZED

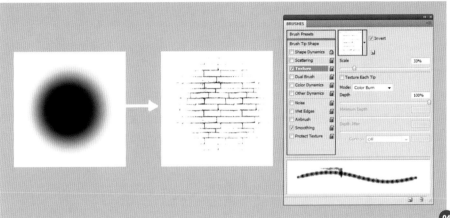

The blue lines in Fig.03 represent the changes I made, which, because we're only dealing with lines here, were very subtle. When it's a good transition, move Square 2 back over Square 1 and merge down. Now repeat this process, but instead of moving the duplicate to the side, move it up so that side B of Square 2 meets side D of Square 1. Once these fit well, bring the duplicate back over Square 1, merge the

layers and bam! You've got a repeating pattern. I apologize for making that sound way more complicated than it is.

Now go to Edit > Define Pattern. Once it is defined as a pattern, turn the image into a texture that can be applied to a brush. Next, get a really big, soft default brush. Open up the Brush palette and enabled the texture.

Selecting the brick pattern, put Depth all the way up, and adjusted the scale appropriately (**Fig.04**). This allows us to essentially paint the pattern onto the image; just make sure its on its own layer though, as it is in box A in **Fig.05**.

Now, go to Edit > Transform > Perspective, and warp the pattern until it matches the perspective of your piece, as you can see

201

in box B of Fig.05. You'll have to do this separately for surfaces with different vanishing points. Then – and this is important – paint over it, as in box C in Fig.05. The key to using patterns and brushes is going back and applying your hand to them; otherwise they will look tiled and computerized. This whole process should take probably less than ten minutes and is way better than painting all those bricks one by one.

There are some things that I still had to paint though. The statue was just straight-up painting with the Chalk brush, and went through a couple of variations (**Fig.06**). B looked weird somehow, so I gave him a staff, which seemed more fitting for an Egyptian guardian statue.

MAKING THE ALIEN WRITING

Ideally, I wanted the writing on the obelisk to look like there was some rhyme and reason to it, but not look like any kind of human alphabet. Instead of just straight up drawing out the pattern, I created a couple of very simple custom brushes to lay down the groundwork. These were literally just straight lines that I defined as brushes, and enabled Scattering on.

First, I laid down a couple of the vertical lines on their own layer (**Fig.07**). Then I did the same with the Slanted brush on another layer, which I then duplicated and flipped so it made diagonals going in the other direction. What this gave me was a pretty random collection of lines that were also semi-symmetrical. Next, I merged those layers and cleaned it up by connecting some lines and erasing others. To make things a bit more organized, I confined the pattern within an overall symmetrical shape.

I brought the pattern into my piece as a solid teal shape and just like the bricks, used the Perspective tool to map it into place. Then I just had to erase from it, leaving some parts brighter than others, to create a pulsating, shimmering look (**Fig.08**).

Those walls still looked a little flat, so I created a sort of dimple brush to add a little variety

06

07

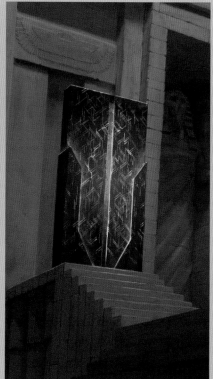

08

to the surface (**Fig.09**). Again, I enabled Scattering and also enable a little Angle Jitter. I did a few strokes on a new layer, and this generated a random collection of dimple shapes, which I then lowered to about 10% opacity. I wanted this to be very subtle; the goal was simply to add some variety to the surface.

> **"LAST, BUT NOT LEAST, I HAD TO PUT IN MY INTREPID EXPLORER. I WANTED SO BAD TO GIVE HIM A FEDORA, BUT TO AVOID THIS BECOMING INDIANA JONES FAN ART, I WENT WITH A MIDDLE EASTERN-STYLE HEAD WRAP"**

To create a dusty atmosphere, I used the same process, but with a textured brush I created from a photo of a canvas (**Fig.10**). Again, the word here was subtlety. The texture gave the surface a little bit of visual variety that pulled things together.

Finally, using the same process as the bricks, I laid down a hieroglyphic pattern on the wall. I used perspective to warp it, and then thoroughly erased it from the layer. This was a pattern that could easily become really distracting, so I made sure to bump it down (**Fig.11**).

And last, but not least, I had to put in my intrepid explorer. I wanted so bad to give him a fedora, but to avoid this becoming Indiana Jones fan art, I went with a Middle Eastern-style head wrap, which is cool in its own way. Like the statues, this was just straight up painting with the Chalk brush (**Fig.12**)

You can download the custom brush (ABR) files to accompany this tutorial from: **www.3dtotalpublishing.com**. These brushes have been created using Photoshop CS3.

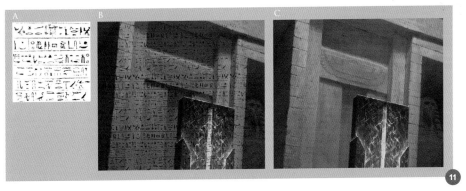
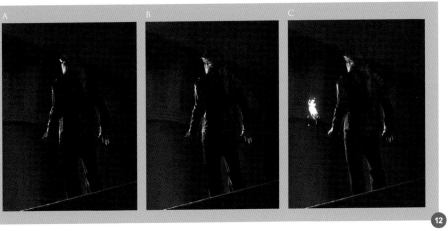

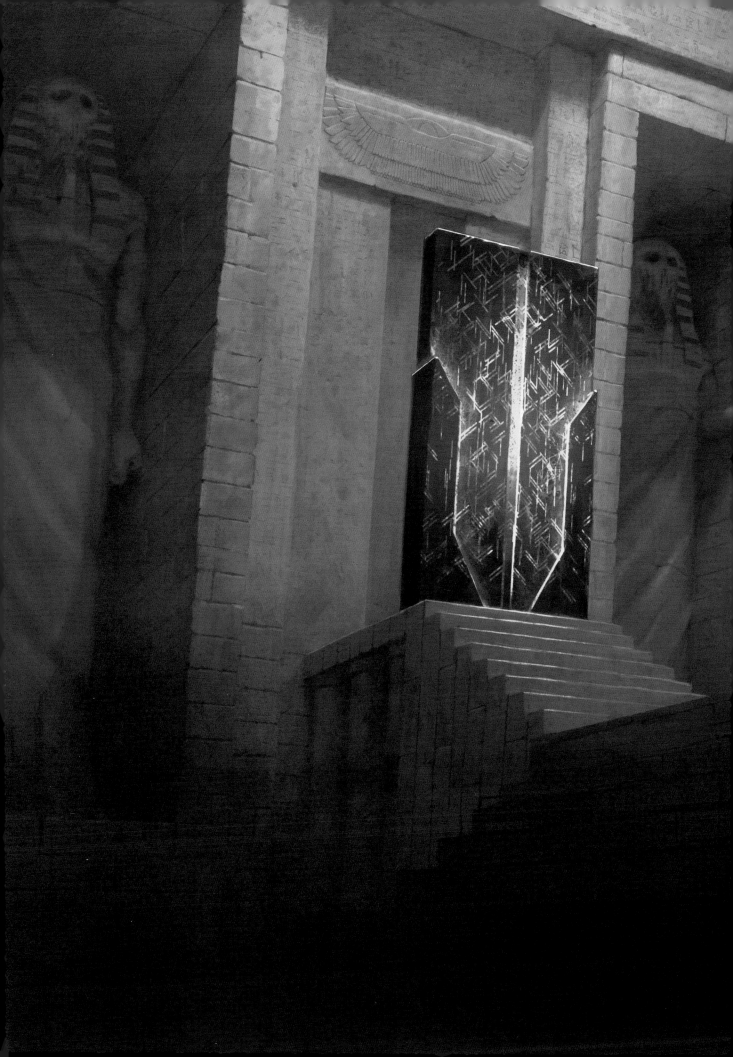

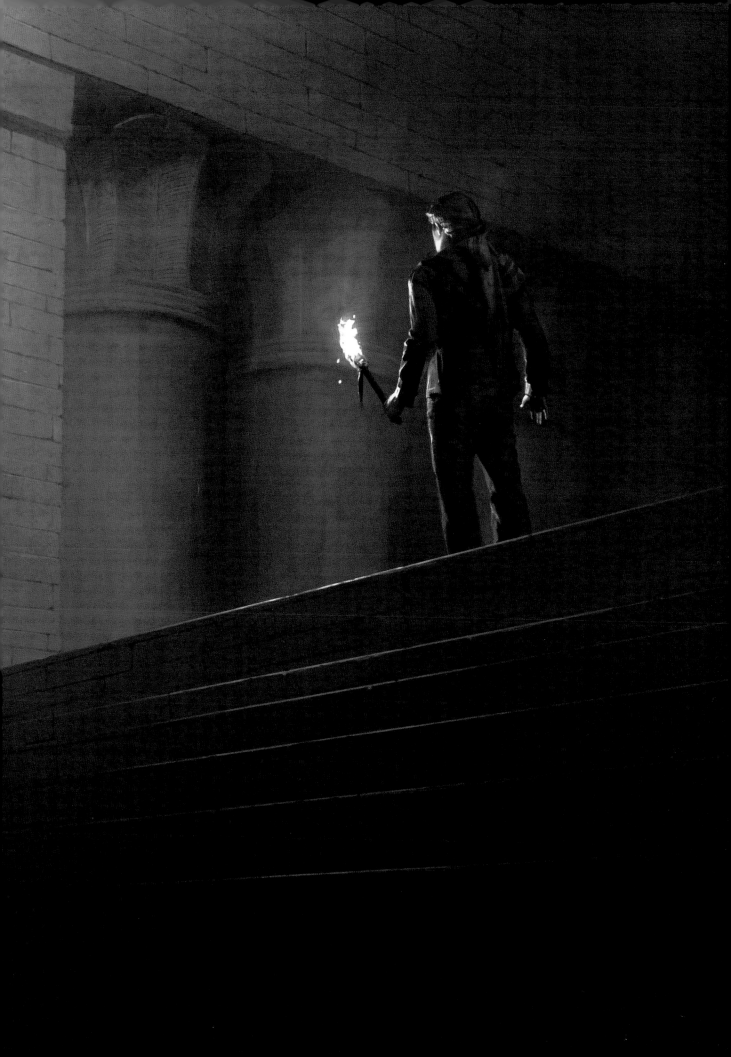

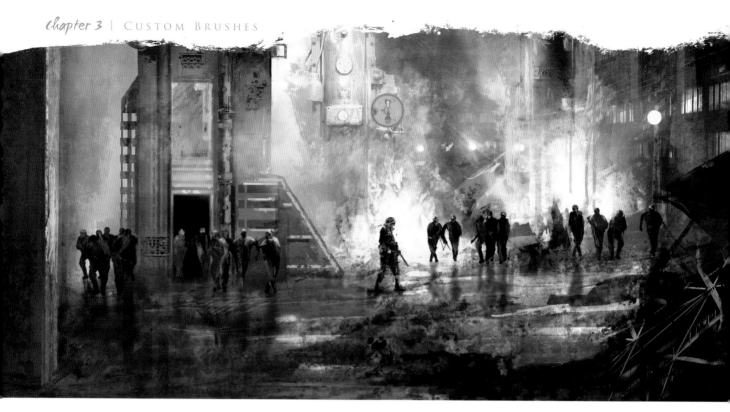

NIGHT-TIME BATTLE
BY RICHARD TILBURY

INTRODUCTION

The theme of this tutorial revolves around some kind of conflict within a city environment, but with a science fiction slant. In this instance it will focus on a lone soldier isolated from his unit, hiding in the foreground from an approaching search party of enemy troops.

The principal aim of the exercise is to create an array of custom brushes that will help add a certain dynamic to the painting, helping to create some of the details and shape some of the forms. Custom-made brushes can add a textural realism to your paintings and be used to not only paint designated shapes, but also to add variation to surfaces and the canvas in general. They can be used for specific tasks such as depicting clouds, smoke or, in many cases, simply to add a more random quality to your brush strokes. Coupled with this, they can prove to be an efficient way of repeating a motif/texture and hence streamline your workflow.

Each time you create a new brush they can be saved into a library or your "virtual studio" if you prefer, and then used in the future for similar tasks.

During this tutorial I will aim to show how custom brushes can be tailor-made for specific tasks and hopefully provide a glimpse into their value as a painting aid.

BLOCKING IN

Before creating any custom brushes I blocked in the rough composition and established a preliminary color palette. As this scene will evoke a battle between opposing factions it made sense to include fire and smoke, which is typified by most war-torn environments.

Fig.01 shows the initial blocking in with a street stretching away, flanked by a wall on the right and a series of pillars on the left. I chose a warm color scheme to reflect the fire that would eventually illuminate the scene. These shapes were blocked in using some of the Standard Hard Round and Chalk brushes, with Dual Brush enabled within the Brushes palette.

In **Fig.02** you can see the brush settings with Dual Brush enabled. By using a single brush, such as one of the default Chalk brushes, you

can vary the strokes and brush marks by just
changing the secondary brush in this section.
I often do this during the initial stages to help
generate randomness across the canvas.

CREATING A CUSTOM BRUSH

Now that there was a provisional composition
in place I could get on with creating a new
brush used to paint something quite specific,
like an approaching group of men. As these
were going to be in the distance, almost in pure
silhouette, it would be useful to have a brush
that gave me the freedom to quickly add in
extra figures at any point.

To save time and avoid having to manually
create them I scanned through the library
of photos freely available from 3DTotal. I
found two suitable references which I used
as my starting point (**Fig.03**). I created an
approximate selection area around the men
marked with arrows and then pasted them into
a new file. I then re-scaled them before turning
them into a silhouette using pure black.

To create a custom brush from these, make
a selection area around them and then go to
Edit > Define Brush Preset and name your new
brush. To see your new brush, select the Brush
tool and then click on the small thumbnail
along the top menu to gain access to the Brush
Preset Picker. Scroll down to the bottom and
you should see your new brush (**Fig.04**).

In order to refine and further customize your
brush, toggle the Brushes palette on by clicking
on the small menu icon in the upper right. This
will open a dialogue box similar to that shown.
It is here that you can modify your brush and
control how it is applied, but in the case of this
particular brush there was little to alter.

Notice that the Spacing is ramped up to 199%
in order to separate the brush marks, thus
breaking up the characters into discernible
shapes whilst applying a single stroke.

Fig.05 shows the resulting mark if this is turned
down to 1%, which is often the default setting,
so be sure to make this your first port of call.

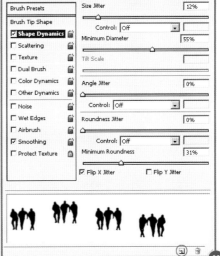

No need to alter the Angle as I wanted the
characters to remain upright at all times and
the same applies to the Flip Y tick box, which
would turn them on their heads!

The next group of important settings are Shape
Dynamics, where you can alter how the brush

marks vary with each stroke. The settings for
this brush can be seen in **Fig.06**. Angle and
Roundness are switched off as these would
affect the upright stance of the characters. Size
Jitter alters the size at which the marks vary
in each brush stroke, with Minimum Diameter
affecting the extent. These have been enabled

to ensure that the sizes of the characters are not exact with each stroke.

In **Fig.07** you can see five separate strokes, each using a different variation of settings. The bottom row is the saved custom brush. The one above has had the Spacing reduced to around 72%, but maintains the same Shape Dynamics. The top two strokes have the Size Jitter at 100%, but with the lower one using a Minimum Diameter around 50% and the upper around 0%.

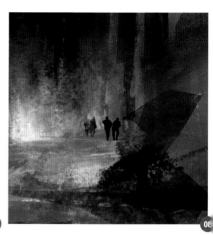

> ## THE BRUSH WILL NOT CREATE A PERFECT GROUP OF CHARACTERS AND, AS WITH ANY TOOL, REQUIRES SOME CONTROL

Obviously the brush will not create a perfect group of characters and, as with any tool, requires some control, but with careful editing and some erasing it will provide a good starting point. Once you have modified the settings to your liking it is important that you save your brush otherwise these alterations will be lost. You can do this by clicking on the small icon ringed in red at the bottom right of the Brushes palette in Fig.06.

This new customized brush will now appear at the base of your brush presets. Alternatively you could save the brush from within here by clicking on the same icon. I started off moderately and just added a few characters to begin with as I was not sure how many to include at this point (**Fig.08**).

The next brush I made was used to paint debris and rubble strewn across the street. **Fig.09** shows the brush (bottom row) and how the marks vary with a stroke (top row) once the settings have been modified. The middle row shows the brush "stamped" four times using the mouse, which shows the varied nature of the individual marks once the settings have been tweaked, as seen in **Fig.10**. The Dual brush used is a general spatter brush, but any textured brush will do a similar job. You can

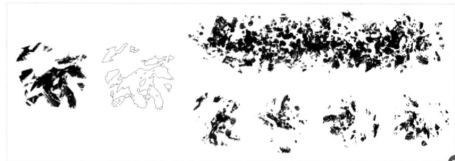

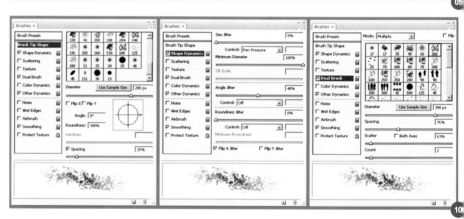

see the effects of this brush in **Fig.11** and how it can quickly produce a random scattering of marks.

I decided at this point that the composition and perspective were not working, and so I extended the canvas vertically. I also created a new brush to paint windows onto the buildings, which you can see in the upper left area. This is a very simple brush that comprises of twelve small squares divided into six groups of two (**Fig.12**).

> BY ALTERING THE
> SPACING YOU CAN
> CREATE DIFFERENT
> ARRAYS OF
> WINDOWS AND VARY
> THE LOOK OF THE
> SKYSCRAPERS

The only setting that really needs altering is the Spacing, which you can see in **Fig.13**, and which ensures that the windows don't overlap with each stroke. If this was turned down to 1% it would result in two unbroken lines running parallel.

I then used this same brush to portray the two high-rise buildings in the background, as shown in **Fig.14**. By altering the Spacing you can create different arrays of windows and vary the look of the skyscrapers.

To add some extra variation I made a new brush, which can be seen in **Fig.15**. It started from the previous brush, which I used to paint a slightly broken line by playing with the Spacing. I then used a textured eraser to mould this into a random pattern of small dots, which you can see bottom left next to the brush. Under Brush Tip Shape I set the Spacing to 100% and then the only other thing I modified was the Flip X/Y Jitter under Shape Dynamics, which just rotates the brush during each stroke.

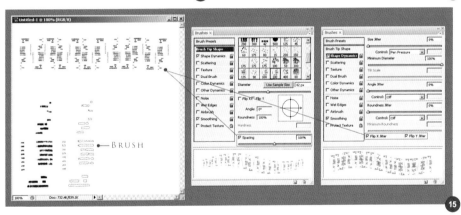

You can see the results of this brush in the upper right of **Fig.16** where I have painted in some windows on the side of the skyscraper. I also added more windows along the right part of the street, making the doorway look larger.

I have had some provisional smoke painted
in, which was evident in Fig.12, but as this is a
key feature of the scene I decided to create a
custom brush expressly for this purpose.

Fig.17 shows the brush and the resulting
stroke once the Shape Dynamics/Spacing have
been altered. The way to create a brush similar
to this is to use a photo as a base and then use
a soft eraser to form a soft edge around the
selection area. Once saved out this becomes
a brush with an apparent hard edge, but when
used it still retains the soft edge of the photo
(top). I then used this brush to add in some
smoke rising above the left building, as seen
in **Fig.18**.

The last and final brush I created was similar
to the window brushes and was used to add
some detail on a large spaceship hovering
above the city. It was made up of a few random
lines and dots, and had the Spacing altered to
form a consistent pattern. I also checked the X
and Y Jitter under the Shape Dynamics. This
ensured that with each stroke the marks are
rotated to break up the symmetry, as shown by
the lower brush stroke in the left box (**Fig.19**).
You can see the result of using this brush in
Fig.20.

This concludes this tutorial, which has focused
on the more important brushes that were
created specifically for this scene and showed
how useful these can be to digital painting.
I have deliberately avoided a step-by-step
guide to the painting process as this tutorial is
primarily about the brushes, but despite this
I have tried to outline some of the key stages
involved along the way.

You can download the custom brush
(ABR) files to accompany this tutorial from:
www.3dtotalpublishing.com. These brushes
have been created using Photoshop CS3.

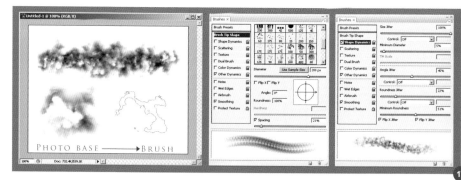

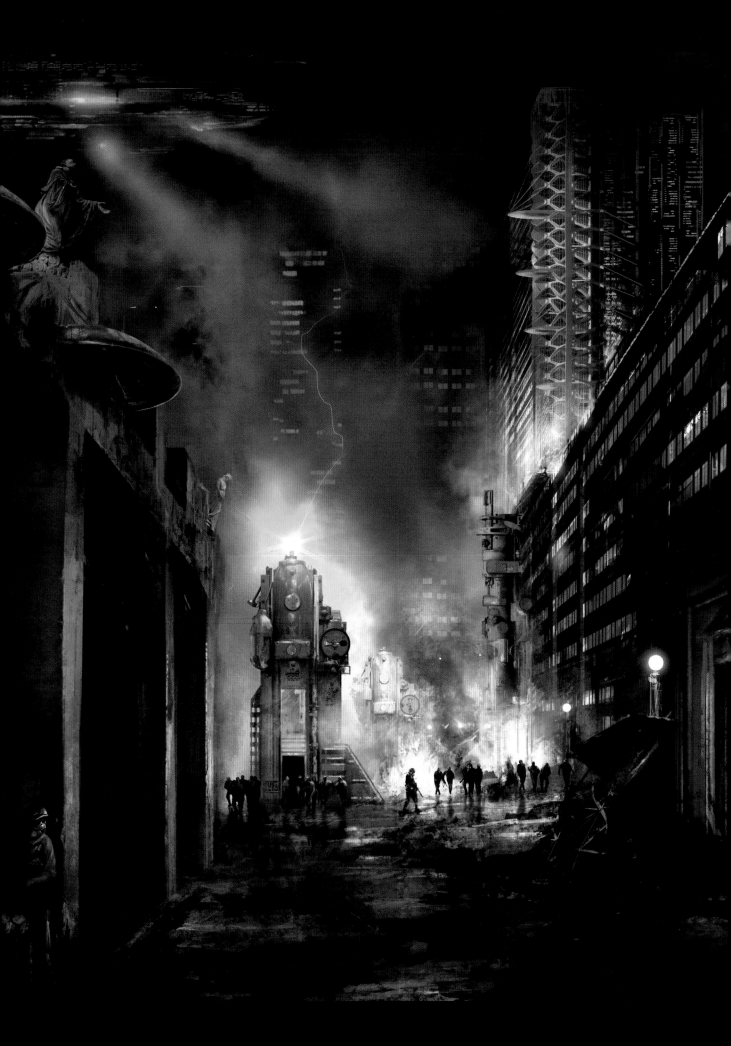

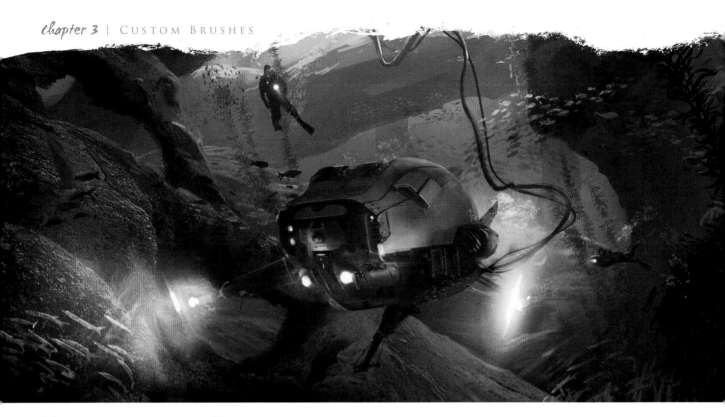

UNDERWATER ENVIRONMENT
BY IOAN DUMITRESCU

CONCEPT

Hi guys, in this tutorial I will take you through
the steps I took when making an underwater
environment with the help of some custom
brushes that I'll explain how to create along
the way. When I created this image I woke up
early in the morning and already had a pretty
clear idea of how I wanted the final image to
look. My first steps usually differ from image to
image, but as this was the first drawing of the
day I did a quick loose line drawing to establish
a rough composition (**Fig.01**).

I knew I wanted the underwater scene to have
a remote control unit, a couple of divers and a
main ship on the surface. They would be diving
into a cool environment surrounded by all kinds
of weird rock formations.

ADDING VALUES

The next step was adding values. I chose to
do it directly in color as there wouldn't be much
color in a piece such as this anyway. The blues
and greens of the water would be all over
almost the whole image. For the submersible
I chose a simple white and yellow scheme. I
still wasn't sure about the rock formations, but
I knew I wanted some cool shapes that I could

have fish swimming around, and have all sorts
of vegetation and corals hanging and growing
from (**Fig.02**).

REFINING

Once I had the basic color scheme and values
settled, I removed the line drawing and started
to refine my shapes. I really wanted to avoid
overworking this image, as water scenes do

02

tend to blur out and lose a lot of detail. The noise, sediments and lack of light all affect how much you can see (**Fig.03**).

I added in a picture of a seaside shore I took this summer and start painting over it so I could have a foreground element that set the submersible in place, and gave depth to the other rock structures. I picked up a textured brush and tried to emulate a dirty, full-of-spots kinda look, and added a bit of contrast between the heavy shapes and thin ones. I then started to flesh out the sub (**Fig.04**). Because of the rocks I was planning and the organic shapes around them, I added lights to the sub so it can see ahead as it goes deeper, and a camera in the middle to record its journey (**Fig.05**).

> " I TOOK A SHORT
> WALK DOWN
> MEMORY LANE AND
> REMEMBERED ALL
> THE DISCOVERY
> PROGRAMS I HAD
> SEEN "

I then refined the rocks in the mid-ground and foreground to keep the image heading in the right direction. I added a bit more of the same photo texture to the mid-ground rock formations and another hole in the left foreground structure, just to give it even more depth and contrast.

CREATING OUR BRUSHES

At this point the environment was pretty much done so it was time to add some life and a bit more dynamic movement to the scene with the help of our good friend: the custom brush. I'm not a big fan of creating my own brushes, although I do have a couple that I like to use regularly. For this piece, first things first, I needed a fish brush that could emulate fish swimming around.

I opened a new file and started drawing different kinds of fish. I took a short walk down memory lane and remembered all the Discovery programs I had seen, and picked out a few formations that could work in this scene. First I drew some fish that weren't going

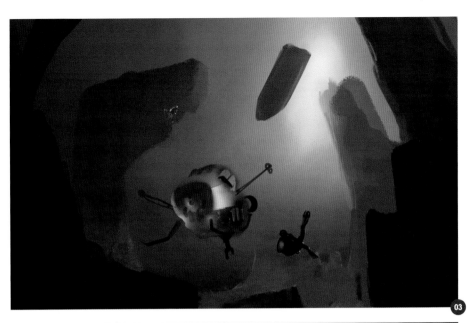

anywhere soon – they were just lying back and admiring the view (**Fig.06**). Next were the fish that swim around in a hurry – huge packs of fish swimming like crazy around rocks and coral (**Fig.07**). Finally I knew I wanted a type of mackerel-like fish and a thinner fish that would look good when I painted them in a big row in huge numbers (**Fig.08**). I tried to vary the size and shapes of the fish so that even if they were tiled there would still be a difference (you can download the JPG files for my brushes at the end of this tutorial).

I then took each layer individually, went to Edit > Define New Brush Preset, opened up my brush menu and started playing with the settings. I knew I wanted to change the Scattering, Shape Dynamics and maybe Color Dynamics settings. I changed Shape Dynamics so rotation would follow the direction I painted. I also changed Size Jitter to a higher value, around 60. I wanted the fish to keep tight together in a mass, like they do in real life, so I lowered the Scatter amount and increased the count a little more to achieve this effect.

Custom brushes are all about fiddling and trial and error until they fit your needs. Especially with the ones that are trying to replicate something from real life! When you're happy with a brush and its settings, you can go ahead and right-click on the Brush menu and go to New Brush Preset. That creates a new brush from your modified one and also keeps the rough version in case you want to modify it later.

Now it was time to populate (**Fig.09 – 10**). I knew I wanted the fish to go around the rock columns and near rocks, like they were hiding from the sub. But I also wanted some to be

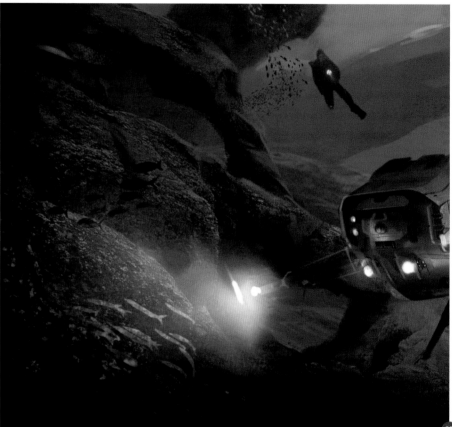

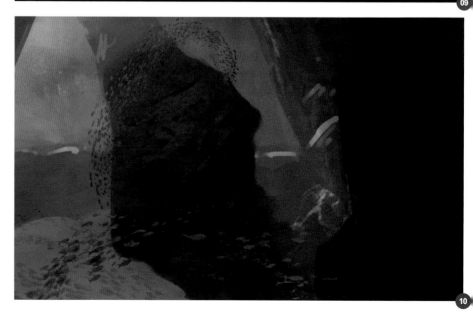

surprised by it so I put them into the light as a secondary focal point. I just locked the transparent pixels in the layer menu (Ctrl + click works as well) and started painting over them to give them a bit of shine and texture, trying to treat them as a group. Now the image was coming alive!

I knew that beside these I wanted some underwater vegetation that would be a good ground for fish to play or hide in. So it was time to draw the kelps and seaweed that was going to be growing on to the rocks.

I followed the same process to create this kelp and seaweed custom brush. I opened a new file and started a few kelp leaves on a new layer. After some experiments I noticed that if I drew too many leaves the tiling was becoming more obvious, so I narrowed it down to only a few. I then made the brush and started playing with its dynamics, changing Size Jitter to 60, Angle Jitter to direction, adding a small amount of Scatter and a big count, and making a little color dynamic change to the Hue and Brightness Jitter. I actually created two versions of this brush so I could have a bit more variety in the environment (**Fig.11 – 12**).

Next I started adding a few columns of kelp rising to the surface. I tried not to put them in a straight line so it looks more natural, like they are floating and their roots are keeping them on the rock. I also erased some parts out and painted some new leaves in where it seemed too boring, but nothing big. The brushes did their job well.

I also punctured the right foreground just to get a glimpse at the coral in the background. I then focused a little on the divers, refining their edges and silhouettes, and then added a cable that powers the sub from the mother ship. The ship was looking a bit small so I enlarged it and made a trail behind its main propellers. The right foreground rock looked a little too clean so I added a few pieces of coral using my shaky hand (**Fig.13**).

So everything was pretty much in place at this point. Just one thing was missing: the bubbles

from the divers, sub and random fish. I went into my brush files and painted some rough spots to mimic bubbles, and then went back into Photoshop. With a few adjustments in the Scatter and Shape dynamics I added some bubbles to the scene.

Now all that was left were the final tweaks, adding a little more light hitting the fish and some color dodge on the top of the water where the sun is hitting right next to the mother ship. I also added a Noise filter for some subtle texture and it was done (**Fig.14**)!

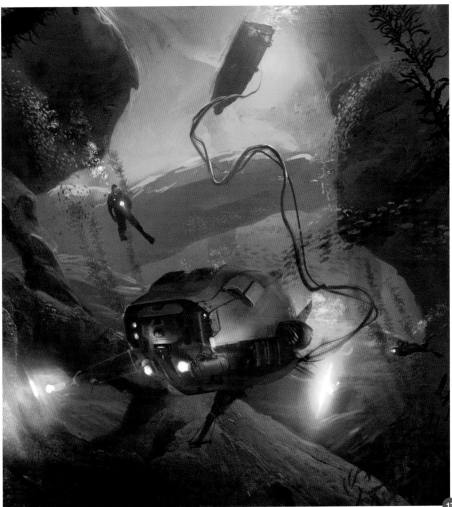

I hope you guys enjoyed this underwater environment. Of course, the way I create the custom brushes doesn't have to be your way. For other projects I may do it differently, but for this they did their job pretty well.

You can download the custom brush (JPG) files to accompany this tutorial from: **www.3dtotalpublishing. com**. These brushes have been created using Photoshop CS3.

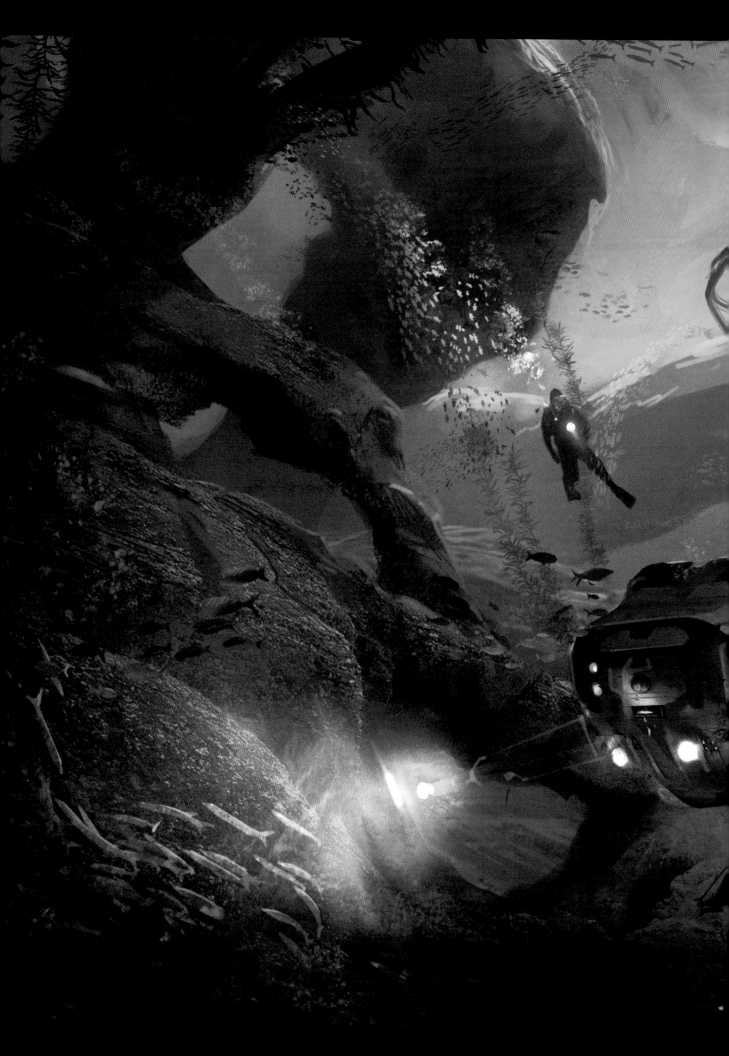

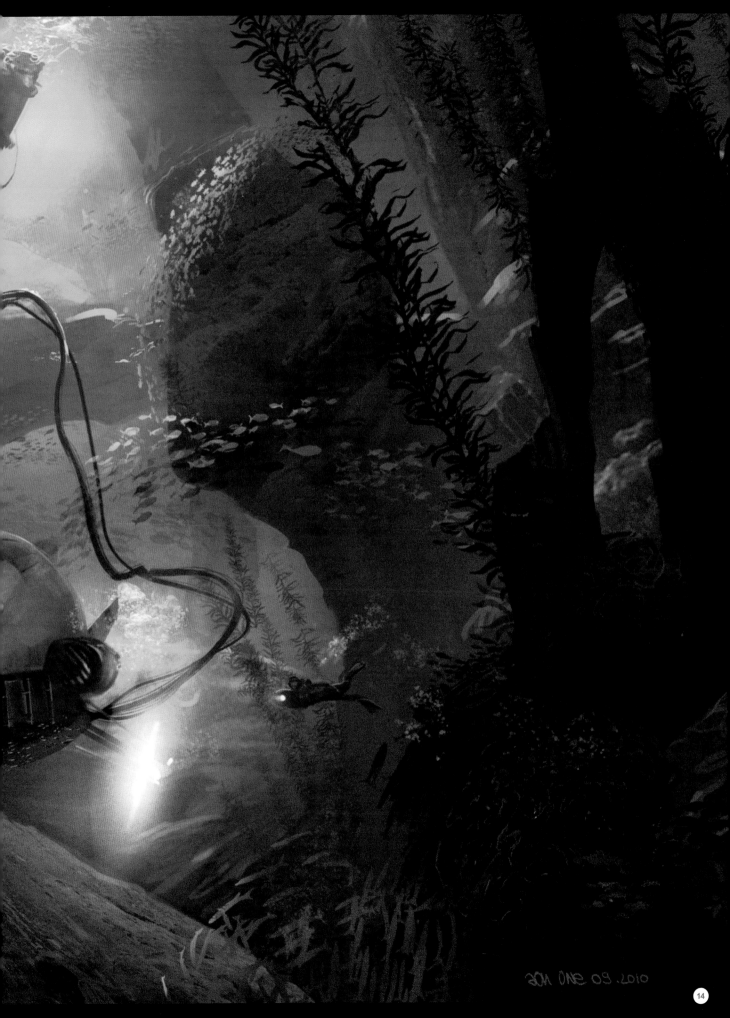

son One 09.2010

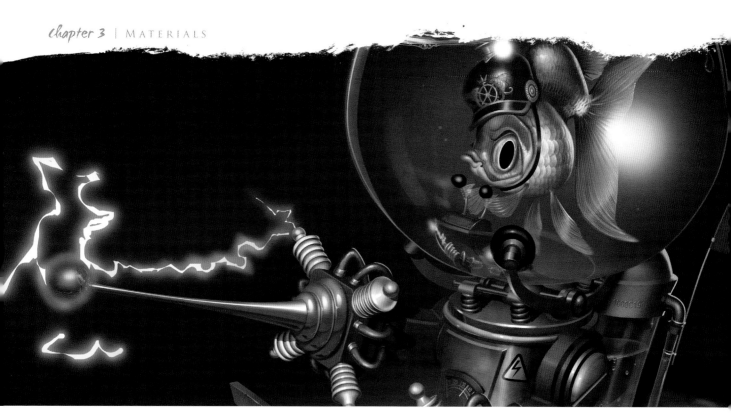

TACKLING TEXTURES AND REFLECTIONS
BY LOOPYDAVE

INTRODUCTION

Inspired by my love of retro gadgets and my own inner psychotic goldfish, this has been a concept sketch sitting both in the back of my mind and on my pin board for a number of years now. I also thought it would be perfect for a tutorial on my process; how I paint textures, calculate reflections and yes, deal with annoying cats.

SKETCH AND SCAN

I always start my creative process with pencil and paper, and usually do a number of drawings to fully flesh-out my ideas before painting. Once I have cleaned up my final sketch, I scan it in quite large (400-500 dpi); in this case the layout worked out to be around 8000 pixels wide. I've learnt the hard way that it's easy to scale down an image later if you want, but scaling up your finished art can present image quality problems. I was unhappy with the goldfish design at this stage, but as I planned to paint the robot first I decided to go ahead anyway and redraw him later.

Because much of the illustration is of a mechanical nature I wanted the edges quite crisp, so I trimmed my sketch using the Vector

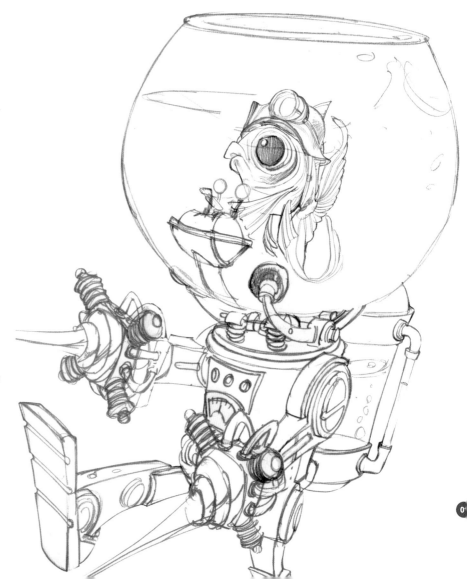

...ool, Eraser and Delete key. This gave me a nice shape to select later when I wanted it (**Fig.01**).

BACKGROUNDS

Metals, liquids and glass have a high interaction with their environment (through reflections, transparency, etc.,) so it's really important to establish both the lighting and the background before painting anything else. In this case I kept it very simple as my Catchaser 3000 was already full of a lot of busy details. At this stage I may place something to indicate where I want my light sources. Sometimes I paint a sphere with specular indicators or place some dots or arrows. In this particular case I quickly blocked in the object's shadow on a separate layer (**Fig.02**).

> **I MADE THE METALS ECHO THE GOLDFISH COLORS TO MAKE THE ROBOT AND FISH FEEL MORE LIKE A SINGLE UNIT**

COLOR ROUGH

Next I changed the layer settings of the sketch from Normal to Multiply, set the transparency levels to 50% and then created another layer under it on which to do a quick color mock-up. Here I can solve any potential color issues, roughly work out shading and shadows from my designated light sources, and make sure it all gels harmoniously with my background (**Fig.03**).

I generally like to use a limited color palette, then contrast it with some kind of opposite colored lighting. In this case I made the metals echo the goldfish colors to make the robot and fish feel more like a single unit. I usually have a strong idea of how I want my image to look, so this stage tends to be quick and easy.

FORM

Next I set about creating the robot's form. Using my rough color study and light source indicator as a guide, and still retaining my sketch as a layer on top (so I could toggle it on or off), I created new layers and started

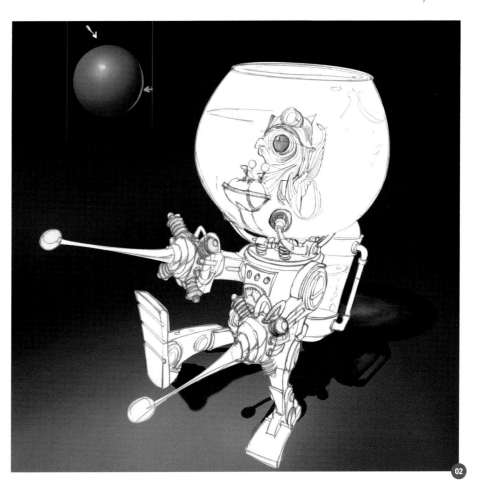

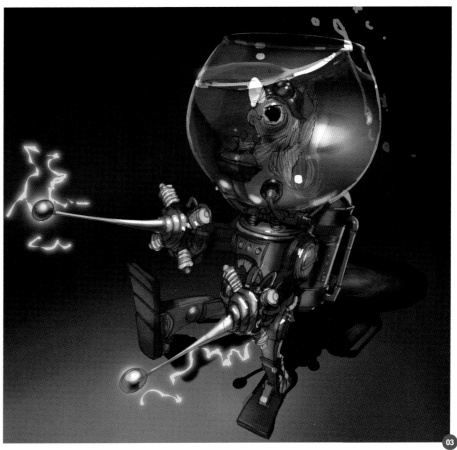

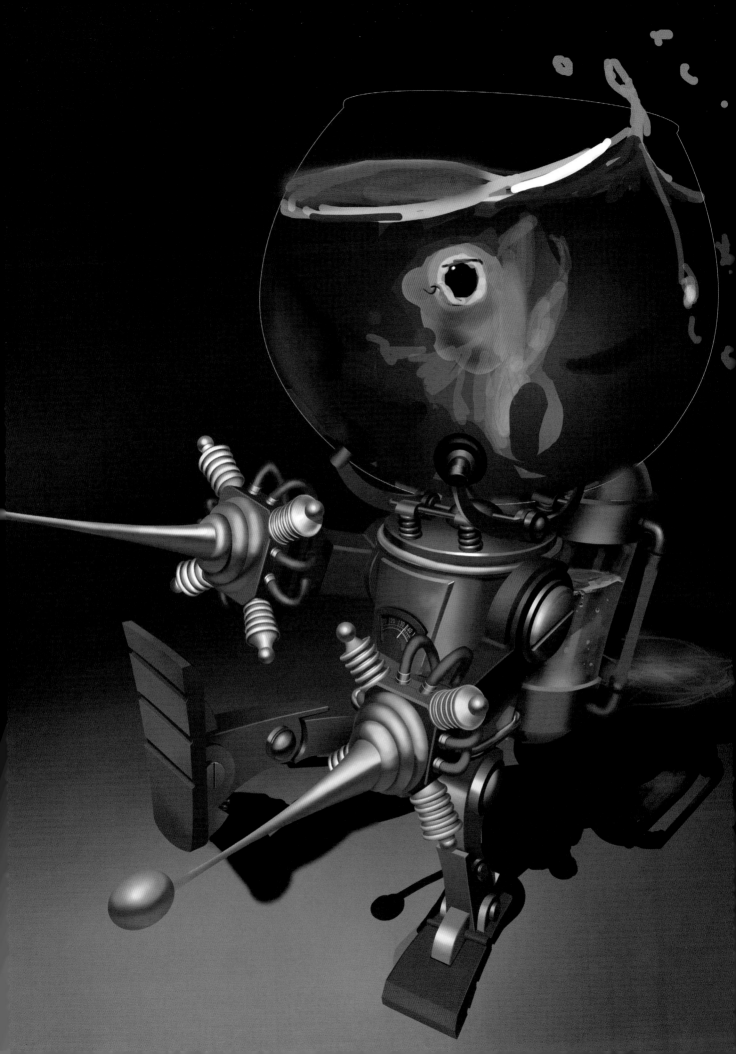

to carefully paint the basic shape of the
Catchaser 3000 (**Fig.04**).

At this stage I was aware of the texture of
each element, but was mostly concerned
with painting the shapes. To do this I used a
combination of hard edged brushes set to a
high opacity, the Eraser, the Pen tool, and the
Selection tool to create a clean edge for the
various elements, whilst working zoomed in. I
gave many of them their own layer so I could
select them individually again later (clicking
on the layer while holding down the Cmd key
loads that element up as a selection). This
process took me around two and a half days.
If you contrast this against the 20 minutes or
so I spent on my initial color rough, you may
be questioning my sanity (I know I often do)
but this is important, particularly when painting
something made of many different textures and
materials, like a robot.

SHADOWS
Next, using new layers just above these
shapes, I painted in the shadows using my light
source indicator and imagination as a guide.
Understanding your light source and adding
nice, well-defined shadows always makes
an image pop, and it is usually the first bit of
advice I give someone when they ask me how
to improve their work (**Fig.05**).

REFLECTION
Chrome, glass and water can have highly
reflective qualities, so unless you are copying
information from a direct reference source
(life or photo), it's important to understand
how to effectively calculate this. I work it out
by imagining sight lines beaming out at 90
degrees from the reflective surface, and where
those beams intersect with something the view
of that something is sent back as a reflection.
The same logic can be applied to find that
signature horizon line on chrome objects.
Sounds complicated? It's not really. If you look
at **Fig.06** you will see a visual explanation of
this.

It can be a little tricky because you have to
imagine what an object looks like from an
entirely different point of view from the one you

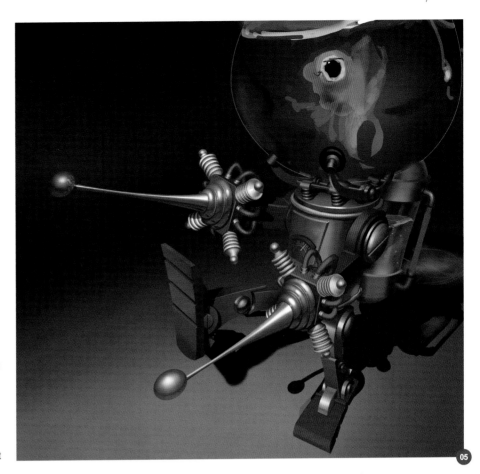

are painting, but learning to think in a three dimensional way is a good skill to develop (**Fig.07 – 10**).

On a flat surface the image is even because all the sight lines are parallel, but once you start using spheres or curving surfaces the beams start spraying in different directions and giving you entirely different information for the reflection. Because I am calculating this in my head as I paint, I can't be sure of any real degree of accuracy, but it's enough to look convincing and sell the surface reflections.

> " IMAGINING HOW
> SUCH A ROBOT
> WORKS HELPED ME
> TO FIGURE OUT
> WHERE TO APPLY
> THE FATIGUING AND
> WEATHERING TO THE
> METALS

TEXTURES

The key to painting metals is working out their properties (level of specular highlight, reflectivity, diffusion, etc.). Metals are often a mixture of both diffuse lighting and specular lighting, and this can allow you to go to town with rough brush strokes mixed with tightly controlled highlights. Have a close look at some metals (unpolished steel and copper, for example) and there is usually a fine layer of surface scratches/micro imperfections that helps scatter light. On these you will want to keep the contrasts on your tones less harsh. However with chrome, polished steel, etc., you will want to paint the shapes with cleaner, harder edges as they tend not to have the same scale of surface imperfections.

Imagining how such a robot works helped me to figure out where to apply the fatiguing and weathering to the metals. The feet would be subject to a lot of contact with various surfaces and would therefore show more wear (**Fig.11**).

Joints and rotation points would gather more grime, receive more scratches and show things like a little grease. Edges get bumped and worn, but often there is a build-up of grime just

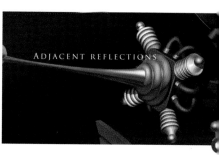
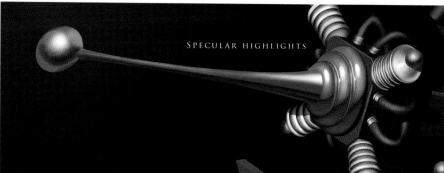
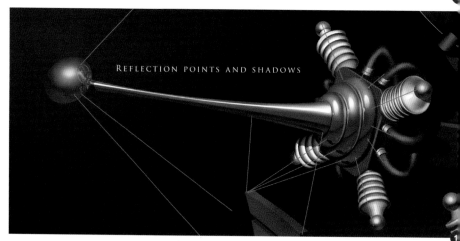

before them. This is often a good time to go and look at a whole stack of images of metals in various stages of wear and weathering, to get a better understanding of what's going on, but as I've done this a number of times for other jobs I didn't really need to.

Weathering and surfacing is fun! I usually create a new layer and select black from my palette. Using a standard dotted brush I paint in areas that I feel need a little base texturing and blur it slightly to make it softer. I then use the Eraser tool to make it a little more random and then scribble with a fine standard hard or soft edge brush, drawing in areas around joints and places I want subtle stains etc.

> ## I FIND A SINGLE PHOTOGRAPH IS LIKE A POLITICIAN AS IT'S PROBABLY NOT BEST TO TRUST IT COMPLETELY

Next I add fine scratch lines with a one or two pixel wide brush, following the object's surface or rotational points. Once I'm happy with my patterns and lines, I change the layer's properties from Normal to Soft Light and pull the opacity back to about 10% or 20%. This creates a less uniform surface. I create another layer and do something similar with white (**Fig.12 – 13**).

THE FISH

I felt my initial goldfish lacked personality and style so I went back to the drawing board and started sketching a few variations until I found one I was happy with. To paint our little manic friend I gathered a whole bunch of goldfish images (I find a single photograph is like a politician as it's probably not best to trust it completely), to get a better idea of how they look and the textures involved. I was more interested at this stage in learning the visual cues that said goldfish than mimicking something I saw. I spent a lot of time zoomed in with a very fine brush painting scales etc., though to keep the details on the fins tight and regular I created selection areas to paint in as well (**Fig.14**).

15

WATER

While water is transparent, it also changes
the visual information through refraction (light
slows down and can appear to bend when it
changes mediums). How much this happens
depends on the medium's density (water
slows light down by about 30%). This creates
interesting phenomena like the ability to view
the bottom of a bowl from both the side and
through the top water surface simultaneously,
the broken straw illusion etc. I didn't entirely
apply this information correctly when painting
the bowl, but knowing these things helps you to
understand what you are doing (**Fig.15**).

FINISH

Somewhere around this stage or a little earlier
I sat back and carefully ran a critical eye
over the whole picture, writing out a list of
things that still needed finishing, tweaking or
I felt were missing. These extras were such
things as a subtle yellow tint over the robot
to help increase the contrast against the blue
elements, adding some water droplets, painting
the cat prints on the ground, adding a flag, etc.

Sometimes when I'm finished an illustration
I will write another list where I use a harsh,
critical eye and work out what I can improve
or fix next time. With this illustration I'm fairly
happy with the end result, although I have
made a few notes to do some more work/
research with water, lightening and fish, and
to increase the dynamics of the shapes and
angles in my initial sketches.

Painting is for the curious of mind –
imagination, observation, experience and yes,
even a little physics.

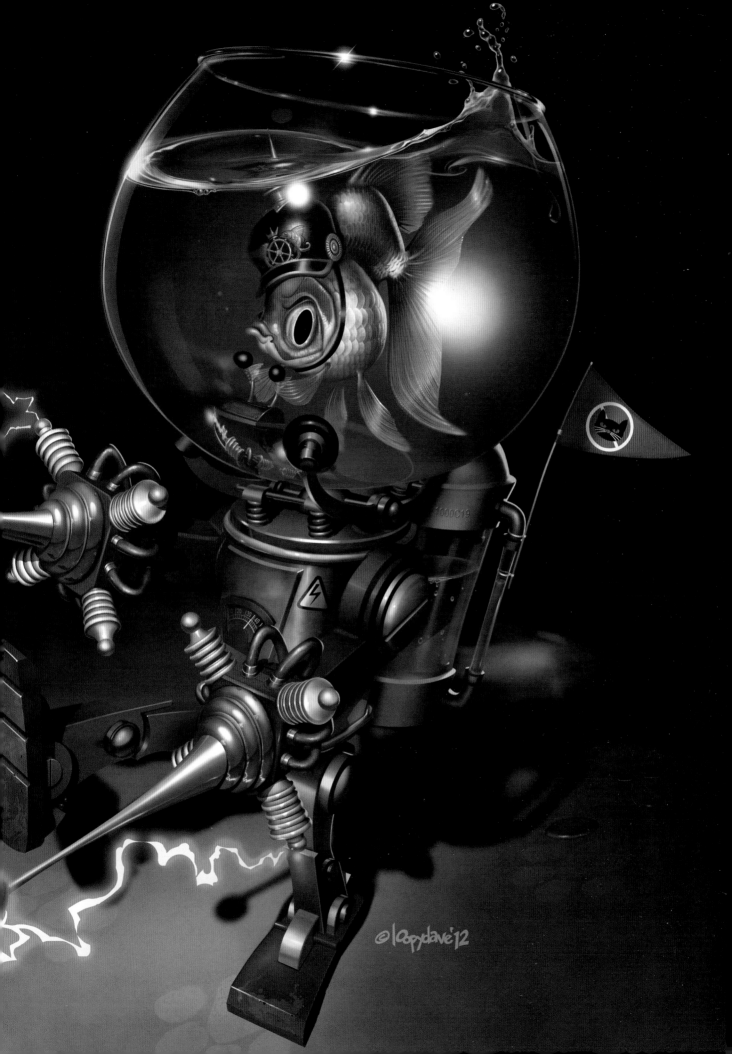

chapter 4 | PROJECT OVERVIEWS

Over time an experienced professional will refine his or her workflow, and develop new techniques and methods to more efficiently attain the desired results. Understanding their creative process is not only fascinating, but can also open your eyes to new possibilities and approaches that would otherwise seem daunting. Throughout the following pages artists will demonstrate the way they approach their paintings, from the initial idea through to the final illustration. They also share priceless tips and tricks along the way, which you can incorporate into your workflow to help create breathtaking art of your own.

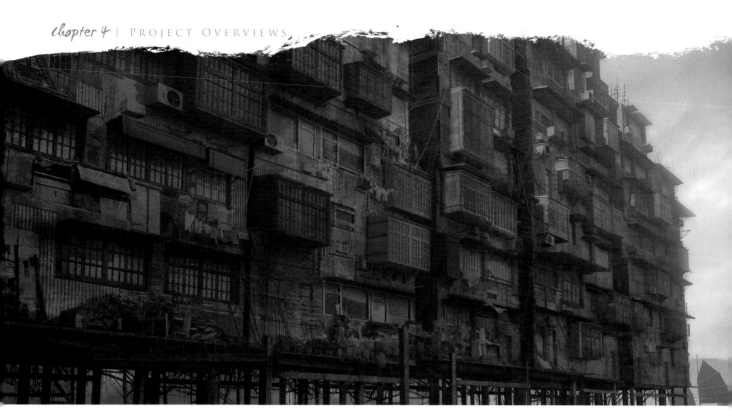

KOWLOON
BY ROBH RUPPEL

THUMBNAILS

I usually start a painting by exploring the composition with simple shapes. This may be the single most important step in the process. It's similar to having a good plot. Without it it's just a bunch of "things" happening. If it looks good here, the idea will carry through the entire process. If it isn't working here then keep exploring until you find a solution that works, or you will get frustrated while struggling to find a solution. You can see some of the shapes that I threw together while trying to find the right design in **Fig.01**.

I chose **Fig.02** as the thumbnail that I would develop into a complete painting.

REFINING THE IMAGE

The next step that I employ is to work on a low resolution color sketch. This is an extremely important part of the process as it gives me a clear goal for the final image. It's far more efficient to spend hours creating an image if you have a clear idea of what it is you're trying to accomplish first. I don't know about you, but I don't have a lot of success planning happy accidents. Sometimes you can spend hours adjusting and adding to an image, trying to find

a satisfactory goal, which means your file sizes can become huge. It is much easier to make sure you are happy with your overall plan from the beginning (**Fig.03**).

I then roughed in some base colors and indicated some simple plane changes between buildings. When I was happy with this I began to add some indications of the overhangs and shelters that hang from the side of the buildings. At this early stage this type of detail can be added quickly, but it should still be done accurately (**Fig.04**).

> IT'S LIKE LAYING THE FOUNDATION FOR A BUILDING. IF THE TONAL STRUCTURE IS SOUND, THE DETAILS WILL ONLY MAKE IT BETTER

ADDING DETAIL

Once the base is looking good it is quite simple to add the details. It's getting the initial tonality to work that takes time and experience. It's like laying the foundation for a building. If the tonal structure is sound, the details will only make it better. But if your structure is off, or noisy, you'll just keep adding details and it will get worse and worse. Usually when something is off, it's fundamentally off. And no amount of detail (frosting) will correct it (**Fig.05**).

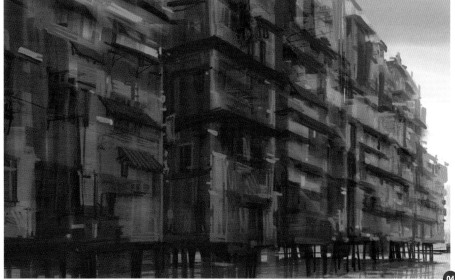

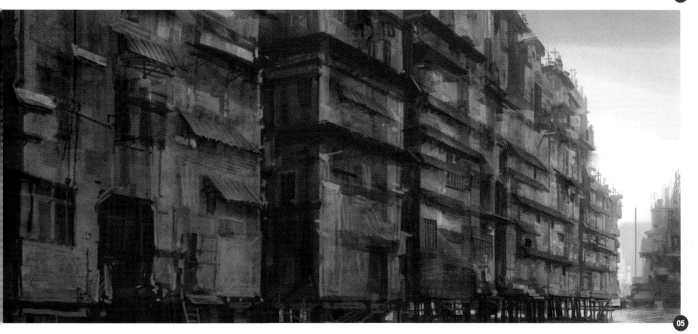

Detailing the image is a continual process that only ends when the image is finished. At this point I continued to add little details, mainly in Screen or Lighten layer mode.

At this point I was starting to think about the final image. I decided that I would use a slightly different approach to the one I had used up to this point, and built a basic model in Google SketchUp. I used this model as the base image and placed flat textures on top of it (**Fig.06**).

> EVEN IN THE HIGH DEFINITION WORLD WE LIVE IN, READABILITY IS STILL IMPORTANT. MAYBE EVEN MORE SO BECAUSE SO MUCH ATTENTION IS FOCUSED ON DETAIL THAT THE OVERALL DESIGN (PLOT) GETS LOST OR OVERLOOKED

On this image I worked from the ground up by first applying textures, then form and finally

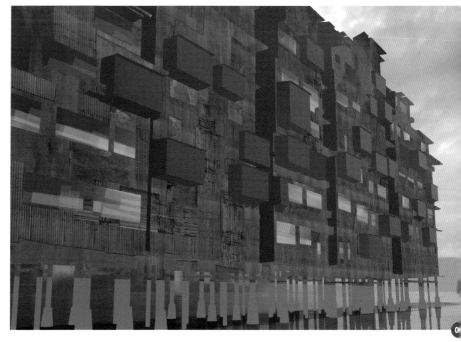

lighting. The start of the process wasn't a waste of time, even if I did replace the image with a 3D model, because it acted as a color key and helped me to visualize what the image would look like upon completion.

Then I added simple flat tones to represent the window boxes and side planes. I work flat first to make sure the tone is working. Poster artists from the 20's and 30's were masters of this. If it works in simple, flat tones, what more do you need to sell the image (**Fig.07**)?

Even in the high definition world we live in, readability is still important. Maybe even more so because so much attention is focused on detail that the overall design (plot) gets lost or overlooked.

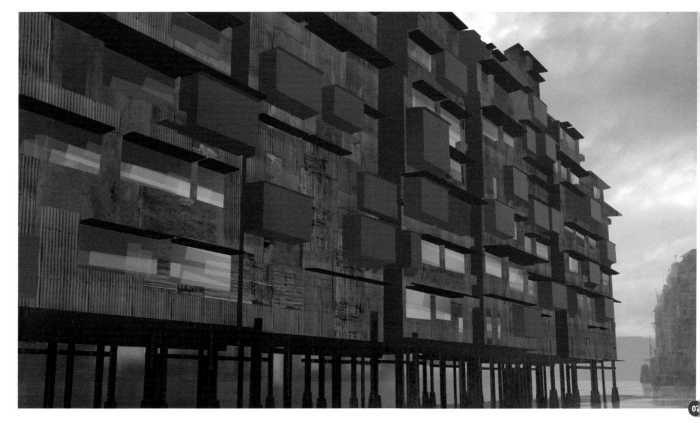

I then created flat shapes to apply to the windows. These were pretty easy to apply to the image by simply twisting and altering them by hand using the Transform tool (**Fig.08**).

As I had made the base of the image in 3D it meant that I could render out a simple Ambient Occlusion pass, which I could apply to the image and adjust to accentuate the forms and add depth to the painting (**Fig.09**).

> " ADDING THIS TYPE OF DETAIL AT THE END IS SO MUCH EASIER IF YOU ALREADY HAVE A GOOD BASE TO WORK FROM "

From this point on it was a case of adding grunge, dirt, noise and all the other types of detail you would expect to see on a building like this. This involved a lot of adjusting and transforming photographs, as well as hand-painting areas (**Fig.10**).

The final steps were also fairly straightforward. To add a little more depth and atmosphere, I painted into a layer set to Screen mode at low opacity. I also added further detail to the background, like the boat and the building. Adding this type of detail at the end is so much easier if you already have a good base to work from.

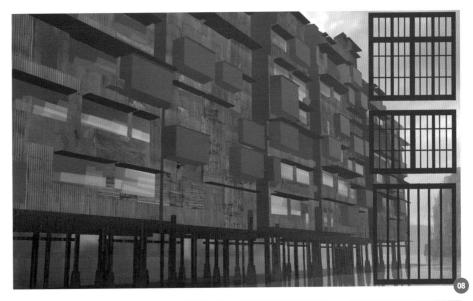

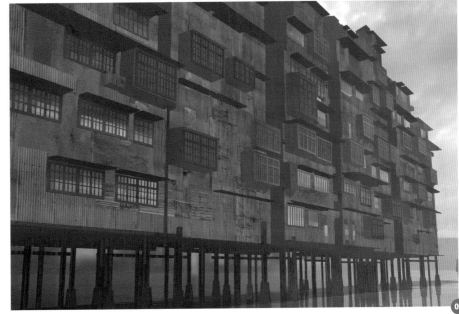

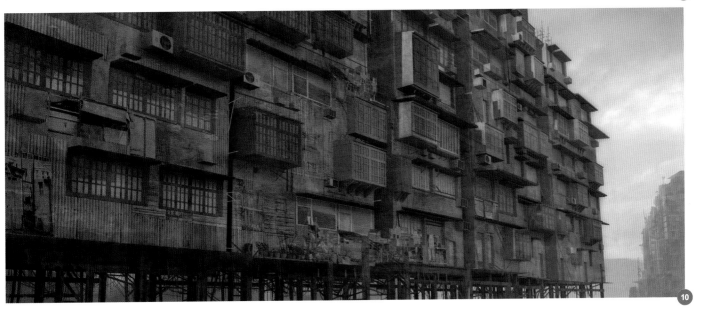

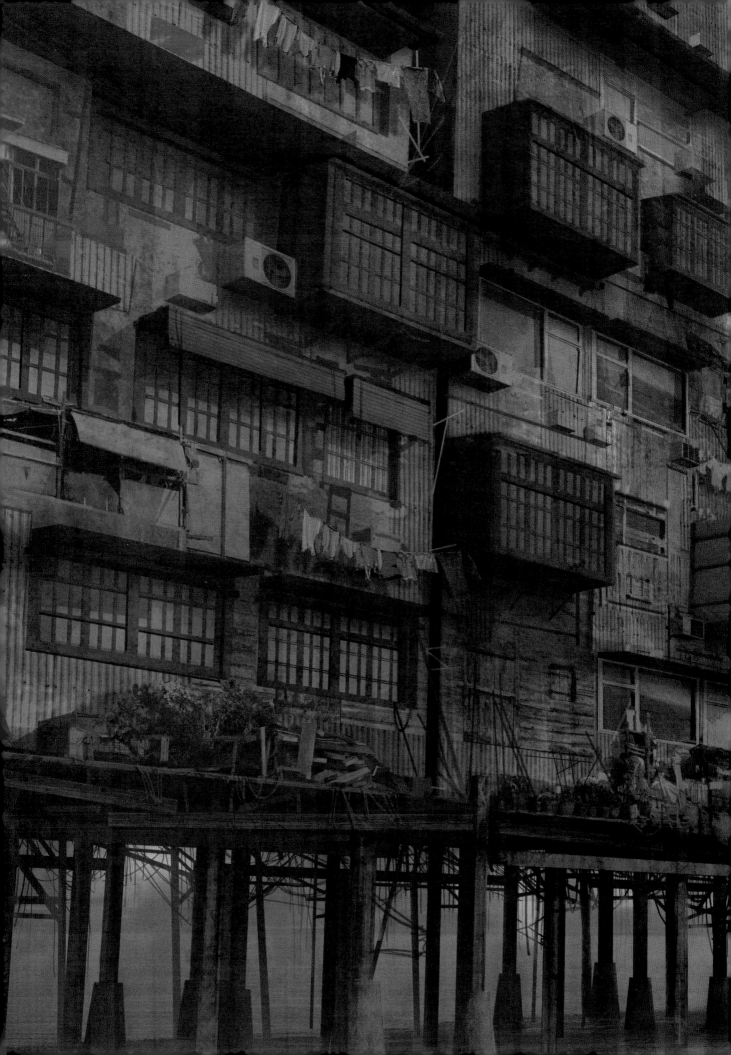

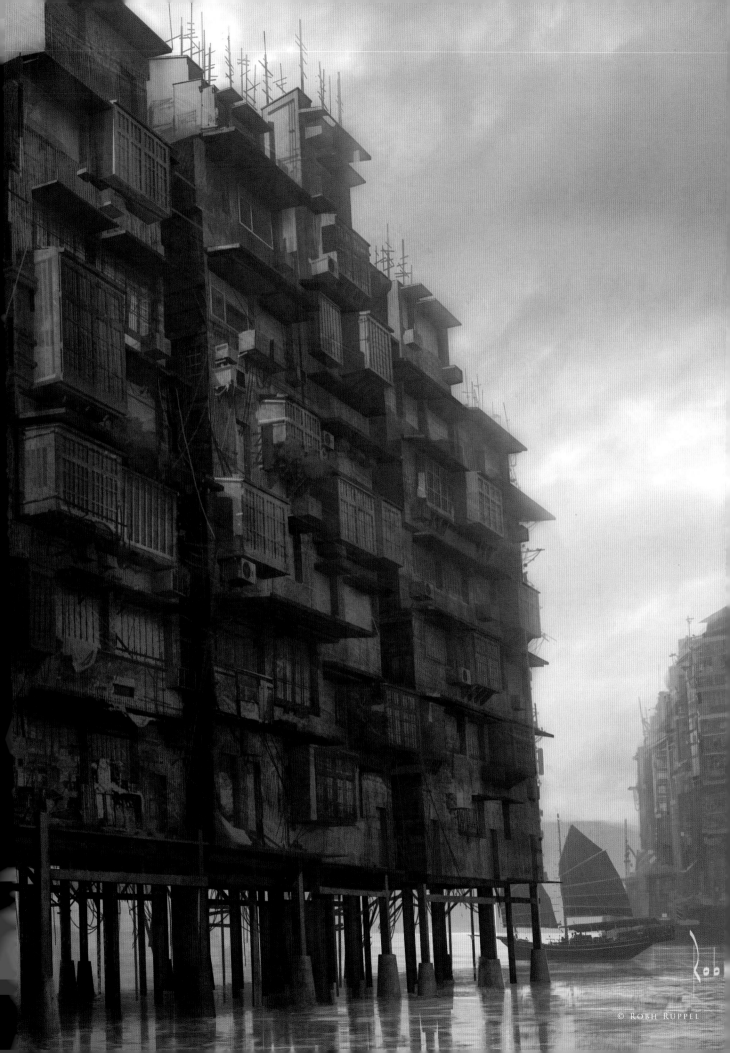

WETLAND OPPIDUM
BY THOMAS SCHOLES

MY PAINTING

I often use old paintings and studies as a base when beginning a new painting. It can be as indirect as giving abstract color and life to a blank canvas, or as direct as reusing elements from one of my existing illustrations.

Reusing previously completed work gives me the opportunity to focus precious motivation elsewhere, multiplying my efforts over the span of an entire portfolio. Nothing of interest goes to waste and a dead-end sketch often finds new life. I've discovered that this takes the pressure off of each creation, and allows me greater liberty to explore and expand its potential in each and every iteration.

At times I have a plan as to what can be reused and where, but often it seems the most enjoyable paintings and best results come from the freedom of pure experimentation and allowing a painting to evolve naturally. This painting started with just such experimentation and a previous sketch I was unable to push further (**Fig.01**).

In **Fig.02** you'll see that I transformed and flipped various instances of the sketch,

234

utilizing Normal, Lighten and Darken layers. Very quickly I found a compilation that had immediate, obvious potential, and which had all the energy necessary to create a great new image.

This method can be unpredictable and, as such, isn't always well-suited to production work, but it's through exploration and experimenting with different techniques that we improve upon our go-to methods. It's akin to taking the scenic route rather than the freeway, to give yourself the chance to enjoy the journey and absorb its enriching qualities. This is how we find alternate routes, new destinations and ways around the blocked traffic on the freeway. It is the diversity of perspective that contributes to truer understanding (**Fig.03**).

> ## IT'S NICE TO HAVE FINISHED WORK, BUT I FIND THAT ESTABLISHING A PAINTING IS MORE ENGAGING AND ENRICHING THAN THE TEDIUM OF FINISHING

Once the subject has been established or has manifested, my method becomes one of problem solving; starting first with what bothers me most. This stage is almost as

enjoyable as the initial creative process and often yields a few unexpected surprises and happy accidents. However as the problems become smaller and smaller, and the results more and more predictable, my enthusiasm and motivation likewise diminishes. It's nice to have finished work, but I find that establishing a painting is more engaging and enriching than the tedium of finishing.

Because of this I will, at times, employ a method of working on multiple paintings at various stages of completion. It can be of great motivational benefit to start a session with a

painting nearing the end of completion, and once these small problems become too much of a nuisance it's time to move onto a painting no closer to the end than it is to the beginning. Eventually I tire even of problems of a medium size and choose to reward myself with a new creative endeavor.

In **Fig.04** you will see that the painting has reached the middle stage and the general idea has been established in my mind. I extended the canvas to a more pleasing ratio, allowing some breathing room for the elements within. I also worked to establish a larger, uninterrupted

foreground to contrast the detailed middle ground, as well as create movement and flow throughout the composition with each edit or addition.

The lighting in this image is subtle and pushing the atmosphere is difficult but still necessary. To this effect I darkened the extreme foreground and started to add fog to distinguish different planes and subjects.

> " I'D ENCOURAGE
> EVERYONE TO
> EXPERIMENT WITH
> THESE TOOLS AND
> DISCOVER THAT
> EVEN THE IMAGES
> YOU ARE FOND OF
> CAN BE IMPROVED
> WITH MINIMAL
> INVESTMENT "

Towards the end of this stage and transitioning into the finish, I began to extract sections of the image and place them into new documents in order to work on them in isolation and at a greater resolution (**Fig.05**).

This technique not only allows increased technical fidelity, but also allows me to concentrate on the rendering, detailing and composition of a smaller area; something

06

I'm usually hesitant to do and even consider a bad habit with a full image. In short, it's a psychological tool allowing me to work differently than usual.

I was careful to keep my selection from the original document intact in order to help when it came to re-insertion. Once I had pasted the selection into a new document, I increased the resolution by 300%. Before doing that it's important to delete the default background layer or you'll run into re-sampling artifacts on the border when inserting your section back into the original document (**Fig.06**).

Throughout the process (but most often near the end) I'll use the many available tools in Photoshop to edit my image and search for ways to push depth, atmosphere and mood in any way possible (**Fig.07**).

I think digital painters would do well to remember that Photoshop was created as editing software, and it's important not to shy away from its powerful tools as they can really help to improve your images. I'd encourage everyone to experiment with these tools and discover that even images you are fond of can be improved with minimal investment (**Fig.08**).

07

237

© THOMAS SCHOLES

08

100 DOLLARS AND A BAG OF RAISINS
BY CRAIG SELLARS

INTRODUCTION

This image is an example of personal work I often create during downtime, between large projects, or just when drawing for fun. The goal here was to portray a lighthearted, hypothetical scene in a cinematic way, and have it allude to a larger story or scenario that may be occurring beyond the borders of this single image.

THE IDEA

Before working on this illustration I had been thinking about films that take place in limited settings, such as a single room, and about specific story scenarios, such as a standoff or hostage situations that lend themselves to such contained spaces. I decided to portray such a situation and since many classic cinema thrillers take place on a train, I thought a period passenger car would be an interesting location. Because this one was done just for fun, I also decided to juxtapose an unusual character into my hostage scenario, and since I find them quite funny, I chose a bear wearing a cape. Remember, this one is purely for fun!

Because the idea of this image was very much about the compositional relationship of the characters, instead of starting with a value

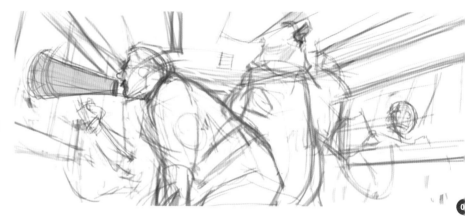

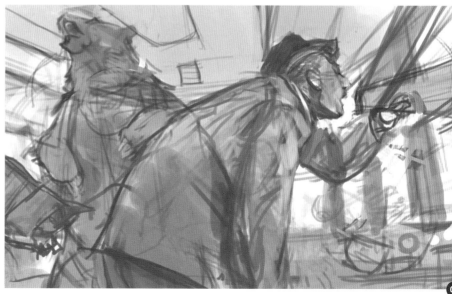

sketch, I began by roughing out the figures in line only (**Fig.01**). I decided early on that I wanted three figures in the scene as it worked compositionally and, of course, a kidnapper always needs an accomplice.

During this phase, I paid close attention to the pose of each character and their line of action. I tried to use this to help infer story. I also tried to keep the relationships open so that it is unclear who is in control and the viewer can come to their own conclusion as to who is the hostage and who is doing the kidnapping. At this point I also decided that one of the characters should be seen talking out the window to someone with an old-fashioned megaphone. This was done to imply a larger cast of characters beyond the view of this image and give the sense that this is just one moment in a larger story.

> ## I STARTED TO REFINE THE DETAILS, PARTICULARLY OF THE FOREGROUND CHARACTER, SUCH AS HIS FACE AND THE TILT OF HIS HEAD

ADDING COLOR

After I was comfortable with my very loose line drawing I began to add very rough overall value, working out the basic lighting scenario of a train car interior illuminated only by indirect daylight. At this point I was also flipping the image regularly left to right to help me see drawing and compositional problems (**Fig.02**).

Next I continued on with the values and changed things such as the foreground character's shirt, making it a lighter value so it would pop against the bear, which I knew would be a darker value (**Fig.03**). Also at this stage I started to refine the details, particularly of the foreground character, such as his face and the tilt of his head.

By this point I felt my idea was in place and I started to glaze in color. As it suited the period and the lighthearted tone I wanted for the

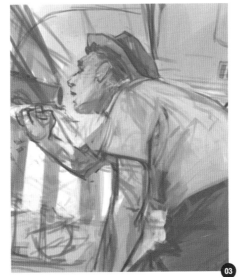
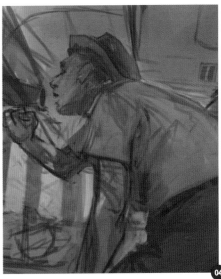
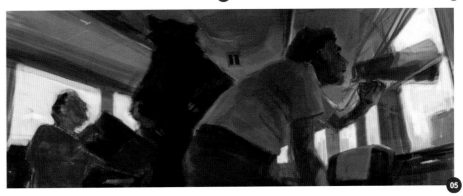
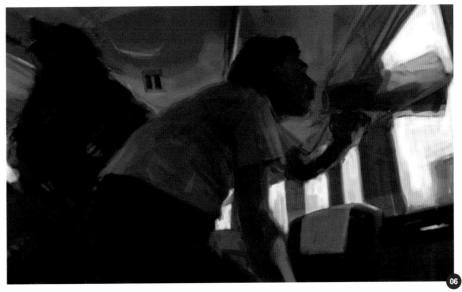

image, I knew I wanted to keep the hues warm, like a midsummer's afternoon. I glazed them in warm reddish hues, using both Normal and Overlay layers (**Fig.04**).

I started to concern myself with establishing local color and re-establishing my values. I painted in the darks of the cabin and bear, and

the lights of the exterior, as well as the man's white shirt and blue megaphone (**Fig.05**).

I continued working over the whole image with opaque color, solidifying the value range and color temperature of the figures, which were, for the most part, lit only by reflected light coming in through the windows (**Fig.06**).

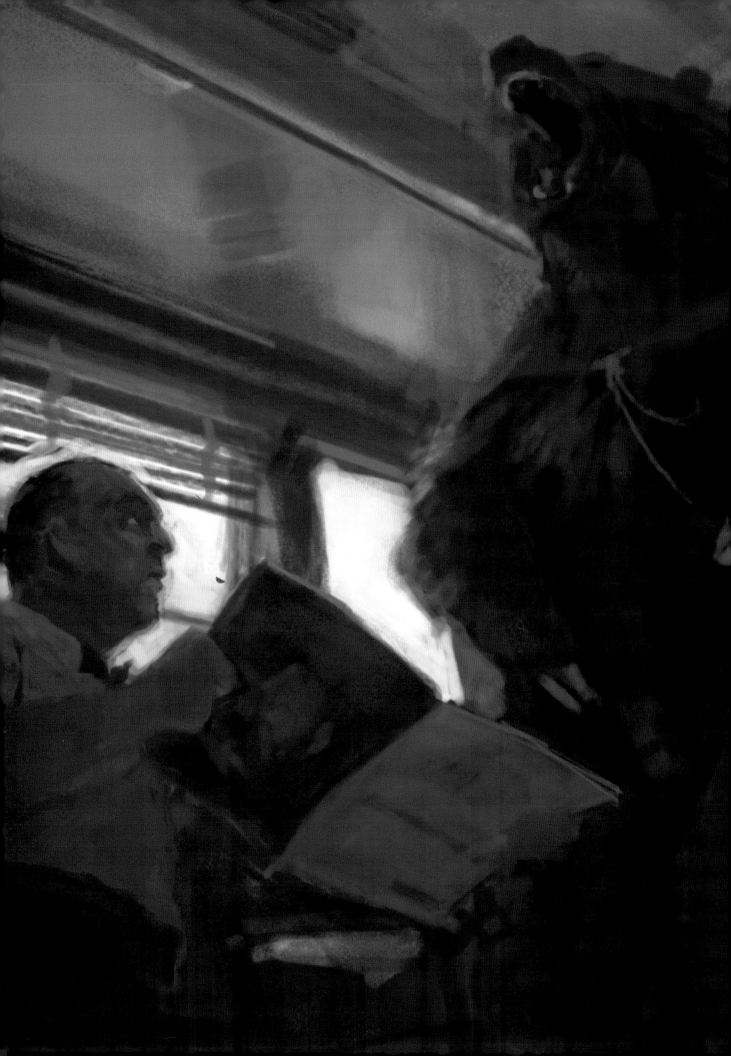

I continued to define the characters, and gave the bear his roaring expression and super-hero disguise. Also, in the spirit of cinematic comedy duos such as Laurel and Hardy, I changed the secondary figure in the far left to a more round and chubby character to contrast with the skinnier fellow in the foreground (**Fig.07**).

> " I CONSIDER IT A SUCCESSFUL ATTEMPT AT CREATING A SCENARIO THAT IS BOTH VISUALLY APPEALING, AND IMPLIES SOME LARGER STORY THAT IS LEFT FOR THE VIEWER TO FILL IN FOR THEMSELVES "

By now my image was at the stage where I was pretty happy with it. All that remained was cleaning some things up to improve focus, and adding some nice touches that helped improve what I kind of think of as the rhythm of an image. By this I mean that there should be a nice arrangement of areas of busy detail or interest (in this case, the magazine and window blinds), mixed with areas of rest where there is more or less just solid color and little detail (here, the panels of the train car interior or the body of the bear) (**Fig.08**).

At this point I also went in and refined areas of focus with tighter detail, such as the character's face and hand holding the megaphone. Also I refined certain brush strokes, such as the folds in the shirt, to help solidify his pose (**Fig.09**).

Since this image was just created for fun, intended to only portray a moment or scenario rather than illustrate large amounts of detail, I decided that this level of finish was perfect and that the image was now complete (**Fig.10**).

Overall I am very satisfied with the end result. I consider it a successful attempt at creating a scenario that is both visually appealing, and implies some larger story that is left for the viewer to fill in for themselves.

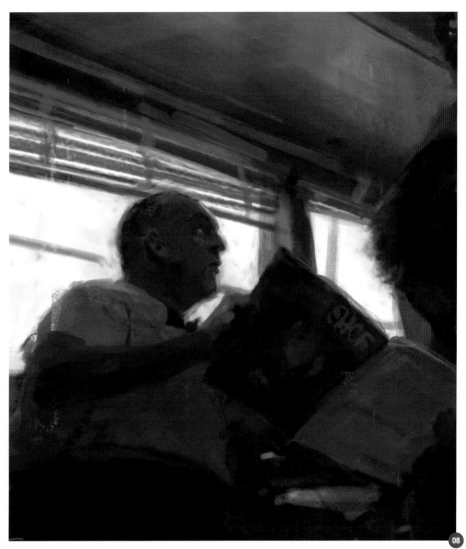
08

09

© Craig Sellars

THE LAST SPHERE
BY HERVÉ GROUSSIN

INTRODUCTION

I decided that I wanted to paint a symmetrical image, with the subject in the center of the image. This type of design is not simple to achieve in terms of composition, but that's what I wanted to try.

SKETCH

The first sketch is always the hardest part of creating an image because it's the beginning where everything is set in its place. I always try to have a good vision of how my image will look when completed, but also know that as the image progresses it will evolve and change. I started by painting my composition in black and white with a big brush (**Fig.01**). At this early stage I tend to use adjustments to get the correct contrast in my grays.

When I had done this I decided to transform my image into a panoramic picture by enlarging the canvas on each side. I think that it looks more epic this way. I always think that you should start with the base of your image, which is the background, so to begin with I started to add depth to the image by using darker grays in the foreground and on the features that stand out from the far background.

It's very important to show the details of light and perspective as soon as possible, and not to spend too long working on an abstract image. At first I started with simple shapes because they would be easier to change if I decided to take the painting along a different route. Because I used this type of approach it would have been easier for me to paint in something like a temple, and then turn it into something like a stele (**Fig.02**).

> ## IT'S IMPORTANT TO PLACE PHYSICALLY RECOGNIZABLE OBJECTS IN A SCENE SO THAT THEY PROVIDE SOME SORT OF IDEA ABOUT SCALE

I built my volumes in white and black while trying to continue to use very basic shapes, as it made it easier to keep control of the design of the image and move parts around. Only when I was happy with the way that things were heading did I change to a smaller brush to add more information or smaller details (**Fig.03**).

ADDING COLOR
At this point it was time to start to add some color information. It's important to place physically recognizable objects in a scene so that they provide some sort of idea about scale. I did this with the use of steps, beams and pillars. Once I was satisfied with the overall

structure, I began to spend time painting detail. I added a brown Overlay layer and began to add objects characterized by the lights in the center of my image, which was the main focus. With a fine brush I sculpted the volume with shadow and light, using the light sources in the image as my guide (**Fig.04**).

I continued to work on the volume with the same brush, starting from the bottom of the

foreground. I decided to remove the two light sources to make one in the middle. I also decided to change it to blue. It is great that these kind of adjustments can be done so quickly when digital painting. I then continued to use the same blue around the image to tie everything together. I also started to break the symmetry a little (**Fig.05**).

Although I was continually adjusting the image,

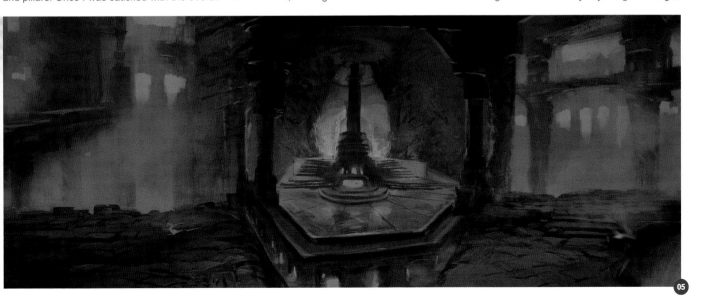

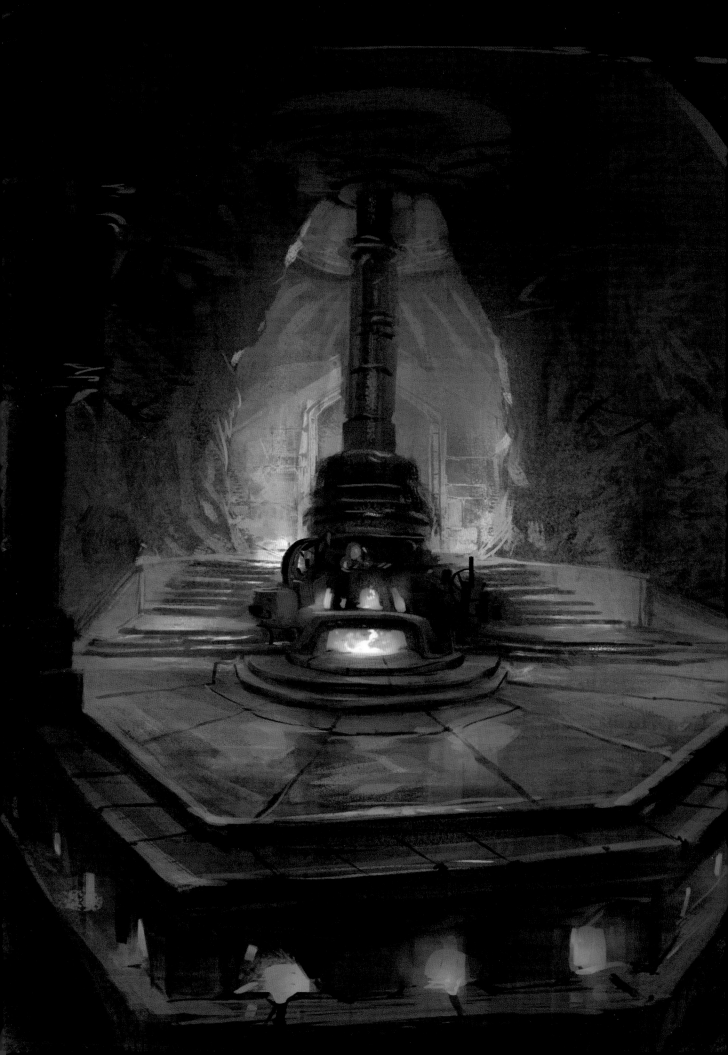

in general my focus was always on the main focus point: the center of the image. As an aid to doing this I started to add some of my strongest blues to this area (**Fig.06**).

When I was at this point I decided that I wasn't satisfied with the balance of my image. The composition looked lopsided and felt too centered. To fix these problems I decided to enlarge the bottom of my painting to add height

> " I LIKE PLAYING WITH THE FOG IN PAINTINGS AS IT HELPS TO ADD A SENSE OF DEPTH AND SHOW THE PLACEMENT OF THE INDIVIDUAL FEATURES "

to my overall structure (**Fig.07**).
I then continued to enlarge the bottom of the painting and started to add strong blues to the image, which unified the image as a whole. I also added more organic elements like rocks. I paint rocks like these quite quickly to make them look loose and similar in appearance, but still natural. I like playing with the fog in paintings as it helps to add a sense of depth and show the placement of the individual features. I simply painted the smoke with an airbrush (**Fig.08**).

As I was getting closer to the end of the project I turned my focus to the perspective at the top of the image to make sure it leads the viewers' eye into the painting. I also started to paint more detail into the columns to make them look larger and more imposing.

I changed the focus again here by painting a dome shape in the background that is full of blue light. I continued to develop the overall image by refining detail and accentuating the blue color at the bottom. I started to add a greenish gray to the rock structures to make them contrast with the blue.

THE FINAL PASS
At this point I had all the essential elements

of my image in place. The final pass over the image involved correcting details and tidying up areas of light and shadow. This helped to bring life to the image. I also used the airbrush further to add some mist coming from the bottom of the image (**Fig.09**).

Before I could call the image finished I straightened out a few mistakes in the perspective and added some beams over the

head of the viewer to further draw them into the scene. I also continued to use an airbrush to add atmospheric effects to the image.

Finally I made some major changes to the focus of the image by adding a glowing sphere to the center and a warrior discovering it. By having the character look at the light it further draws the viewer into the image and adds story to it. After these elements were added I was

© HERVÉ GROUSSIN

SHIP CONCEPT
BY ALEX FIGINI

MY IMAGE

As you can see in **Fig.01**, this piece actually started life as a fairly random and abstract collage. My aim at this early stage was to create interesting shapes and play about with color, hoping that whilst I painted something would jump out at me and spark my imagination; for example, when you see animals or faces in cloud formations. This isn't the way I start work when painting to a brief or a specific idea, but more of a playful exercise that helps loosen me up and can yield some interesting results.

At this early stage I think it's best to stay loose and try not to worry about making mistakes or working on fine details. I started by throwing down large blocks of color, which helped create some visual interest, as well as trying to define a volume of sorts. Quite early on in the process I had some kind of flying vessel in mind, probably triggered by the large green structure in the middle as it resembles an aircraft's tail, to a degree anyway. As I worked into the structure I used the Lasso tool to create some nice hard edges; this helps refine the form of the relatively loose initial volume, as well as adding some interest (**Fig.02**).

often play about with various textures and photos, overlaying them and playing with the blending modes to see if any shapes or colors jump out. I also find using Levels and Curves a good way to experiment at this stage. Amongst other things, these tools can help define a color palette. Using a combination of these techniques I boosted the already apparent complementary blues, greens, oranges and reds. The results probably look like total chaos to most people, however it did contain something of interest to me and I began to develop it in the direction I had in mind.

> ## ALTHOUGH ODD-LOOKING IN TERMS OF STYLE, I WASN'T TOO CONCERNED WITH PLAUSIBILITY AS THAT WASN'T THE AIM OF THE EXERCISE

Quickly and roughly I started to cut into the form, creating negative space and blocking in new structures (**Fig.03**). My mind was still thinking loosely about the idea of a flying vessel, but I was not worried about details at this point as my main concern was with the overall form. I soon realized that the initial canvas size restricted me and that I wanted to expand on what I had built already.

After I had expanded the canvas I was able to create a more solid structure (**Fig.04**). The idea was becoming cemented in my mind at this point and I knew that my aim was to create some sort of deck for my ship. Although odd-looking in terms of style, I wasn't too concerned with plausibility as that wasn't the aim of the exercise. Very quickly I realized that I still needed more room to expand, as I wanted to flesh out more of the vessel.

I began to block out the rest of the structure, as well as adding a very basic background and a horizon line (**Fig.05**). I reinforced the ad-hoc and faceted style of the core of the ship by adding plates to the rest of the structure, as well as bringing in a new element: the taut canvas canopies. I am not sure where the idea came from, but it just seemed to work.

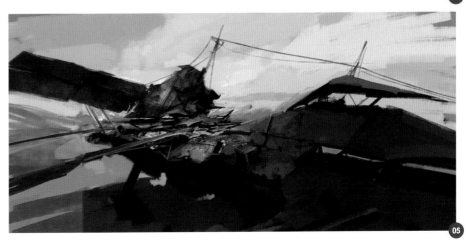

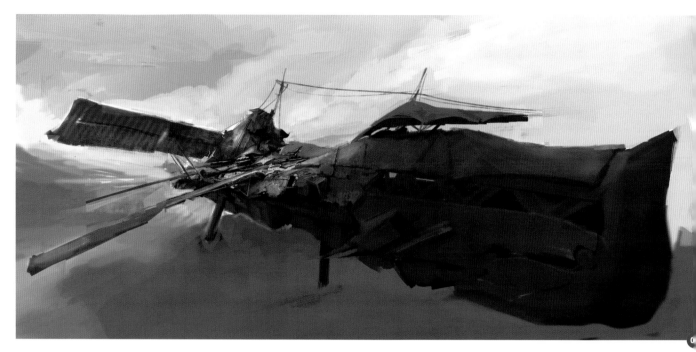

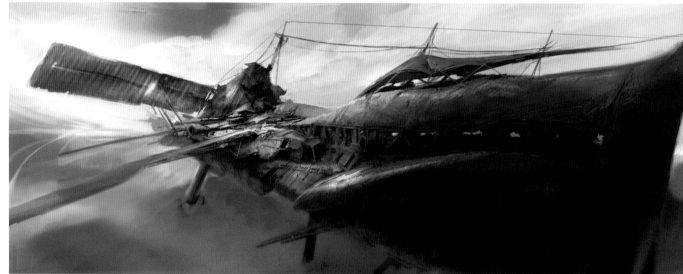

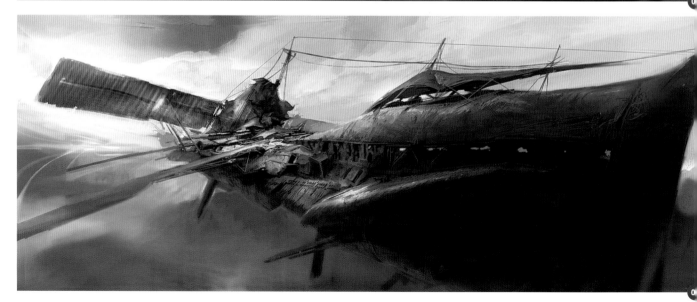

expanded the canvas again to block out more of the ship, however in the process I lost some of the dynamism of the previous composition. I was also not happy with the forms I had created near the front of the vessel (**Fig.06**).

I decided that I was going to crop the image, but before I did I took the whole image and used the Warp tool to help me quickly exaggerate the perspective and reintroduce some of the interest I'd had earlier on. I also worked quite heavily on the front of the ship, adding surface details like rust and aged metal, as well as reworking the overall forms. These now flowed a lot better and helped lead the eye (**Fig.07**).

As I was in the mood for some experimentation I ran a couple of quick tests and copied the whole image into a new document. One thing I wanted to try was to add some Chromatic Aberration, so I went into the Channels tab and individually shifted the separate RGB channels a few pixels until I got the desired effect (**Fig.08**). The other test was to paint directly into one of the channels. This is most apparent in **Fig.09** where you can see the top left of the image is shifting towards a red color, giving the feeling of a strong sun.

After running the tests I went back to the original file, refined the piece and implemented the techniques I had experimented with. At this point, although still rough around the edges, I was happy to leave the image as it is (**Fig.10**).

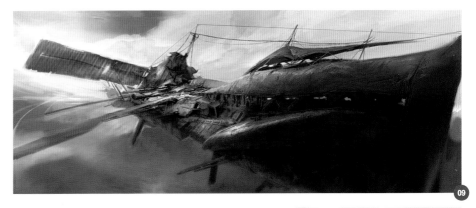

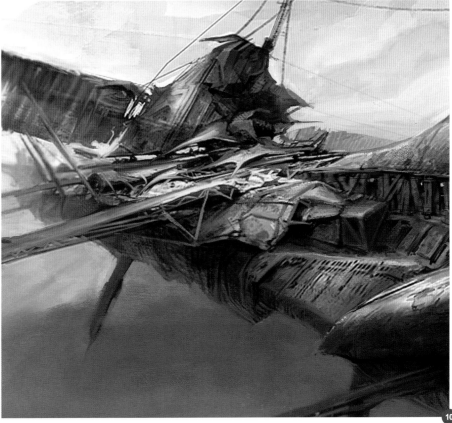

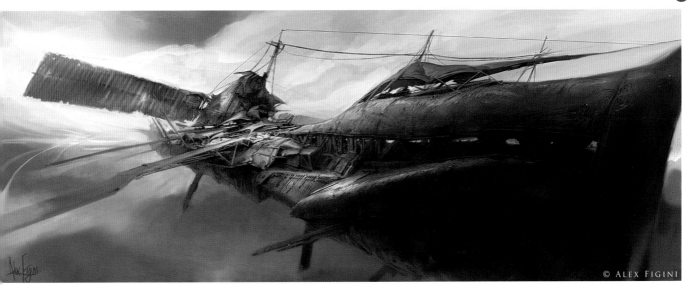

© Alex Figini

255

Chapter 5 | THE GALLERY

Looking at the work of other artists is a great way to fuel your imagination and gain inspiration to create your own images. Within this gallery you will find a host of illustrations from some of the most talented digital painters from around the globe, so as you look through the following pages hopefully the creative cogs in your mind will be fired into action, and you can use the techniques described in this book to create your own, gallery-worthy art.

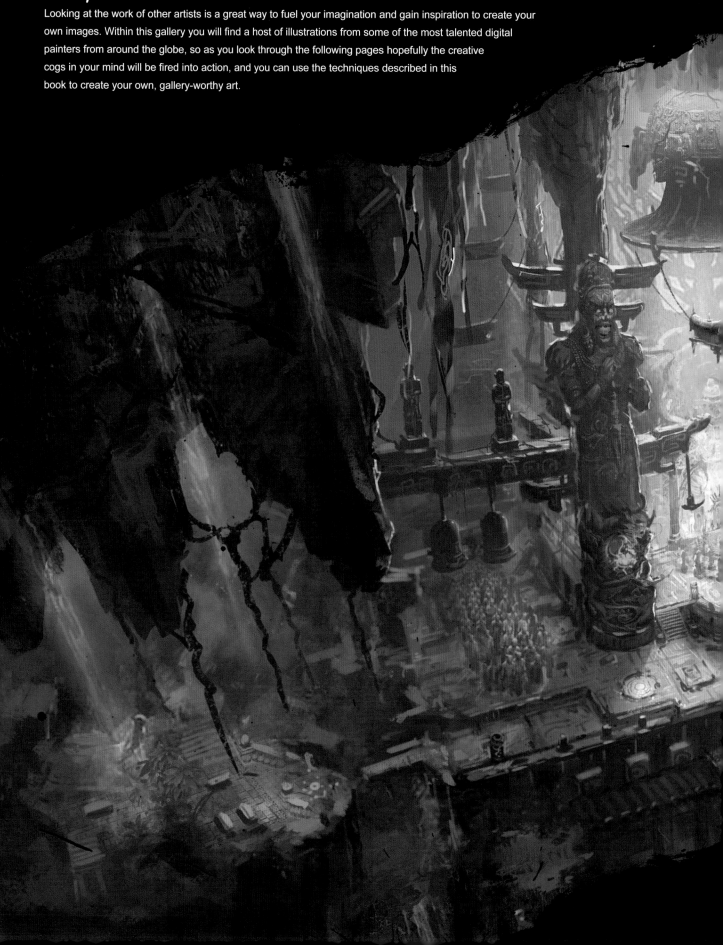

© Daren Horley

© Peter Popken

EMPEROR
PETER POPKEN
(Above)

SALENA
PETER POPKEN
(Far Left)

DRACULA
DAREN HORLEY
(Left)

FOG TOWN 1
PIOTR JABŁOŃSKI
(Below)

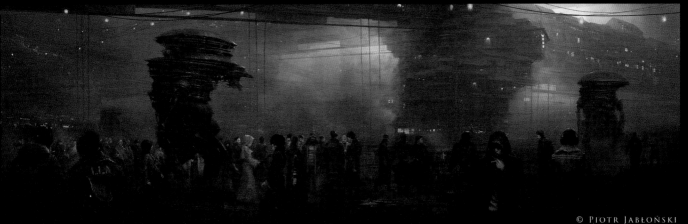

© PIOTR JABŁOŃSKI

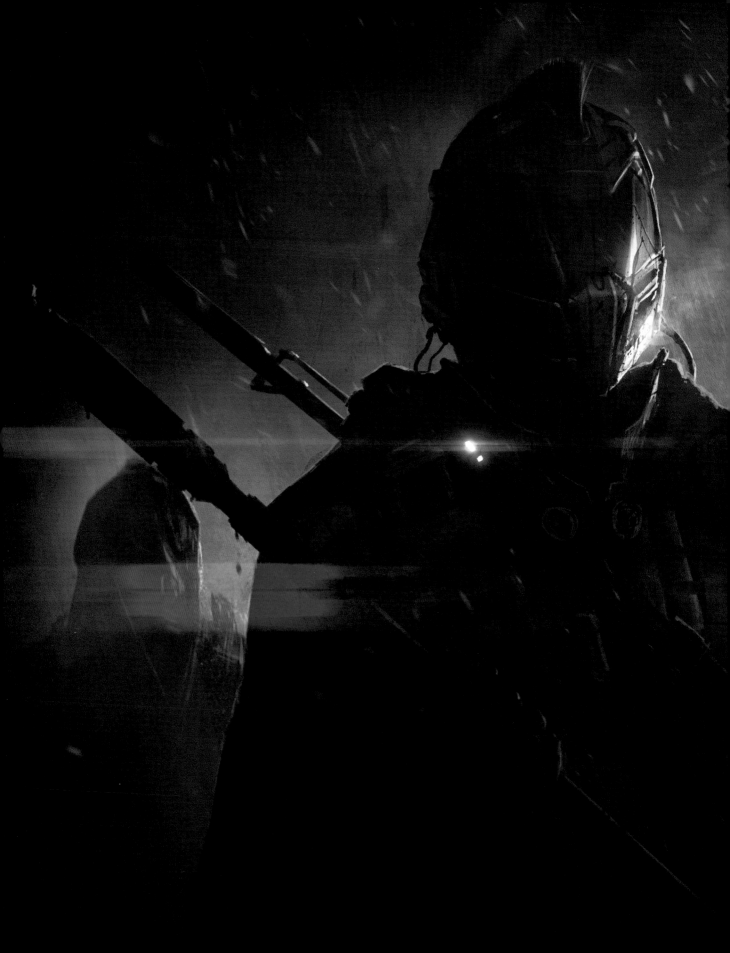

LEGIONNAIRES
ANDRÉE WALLIN

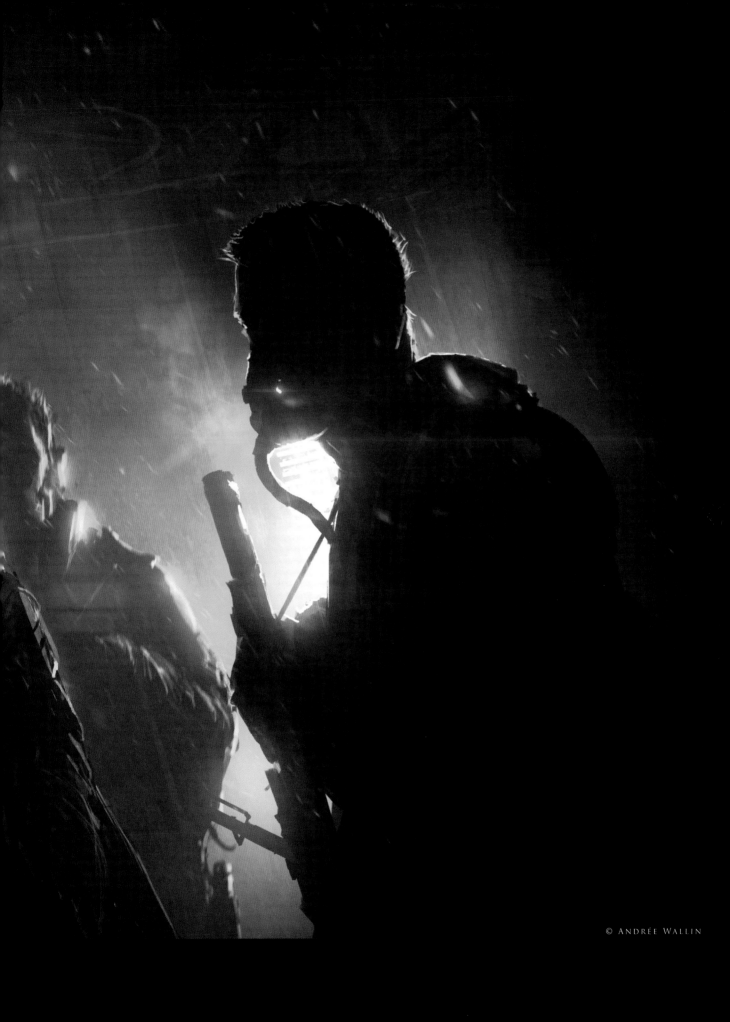

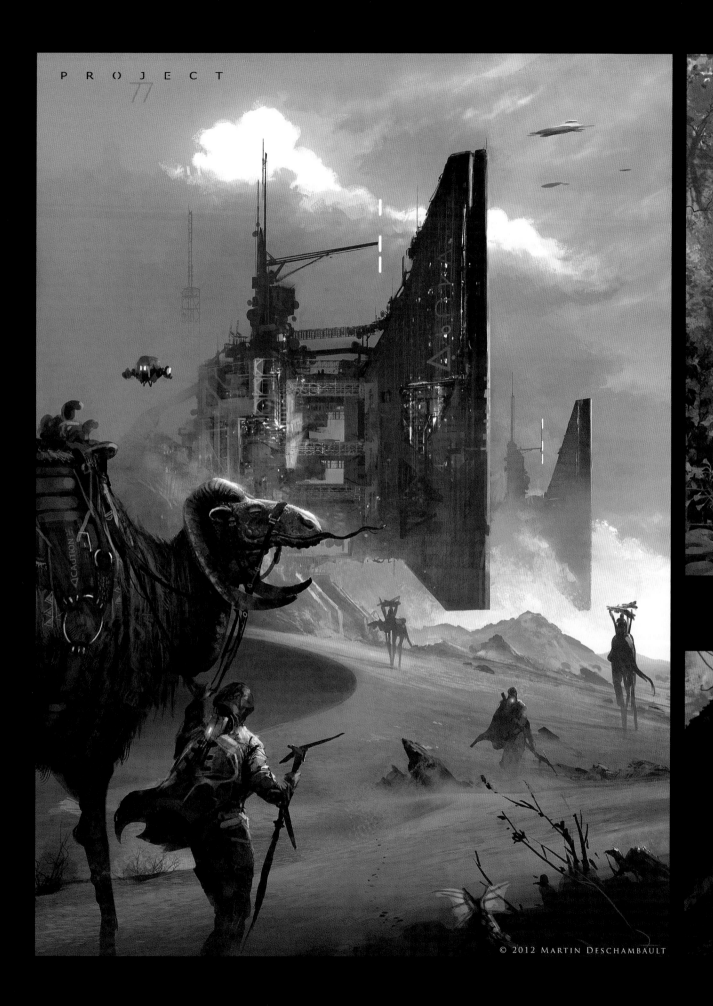

PROJECT
77

© ANDREI PERVUKHIN

PROJECT 77 DESERT OASIS
MARTIN DESCHAMBAULT
(LEFT)

SCOUT
ANDREI PERVUKHIN
(ABOVE)

PINK RIDERS
ANDREI RIABOVITCHEV
(BELOW

© ANDREI RIABOVITCHEV

CUSTOMER
MICHAL LISOWSKI

HUNTERS IN THE SNOW
IVAN LALIASHVILI

(TOP)

TO THE NORTH
IVAN LALIASHVILI

(ABOVE)

THE ORPHANAGE
PETER POPKEN

(BELOW)

© Jung Park

LONDON

JUNG PARK

(ABOVE)

RIDER

ANDREI RIABOVITCHEV

(BELOW)

© Andrei Riabovitchev

TROLLSKOGEN
ANDRÉE WALLIN

© Andrée Wallin

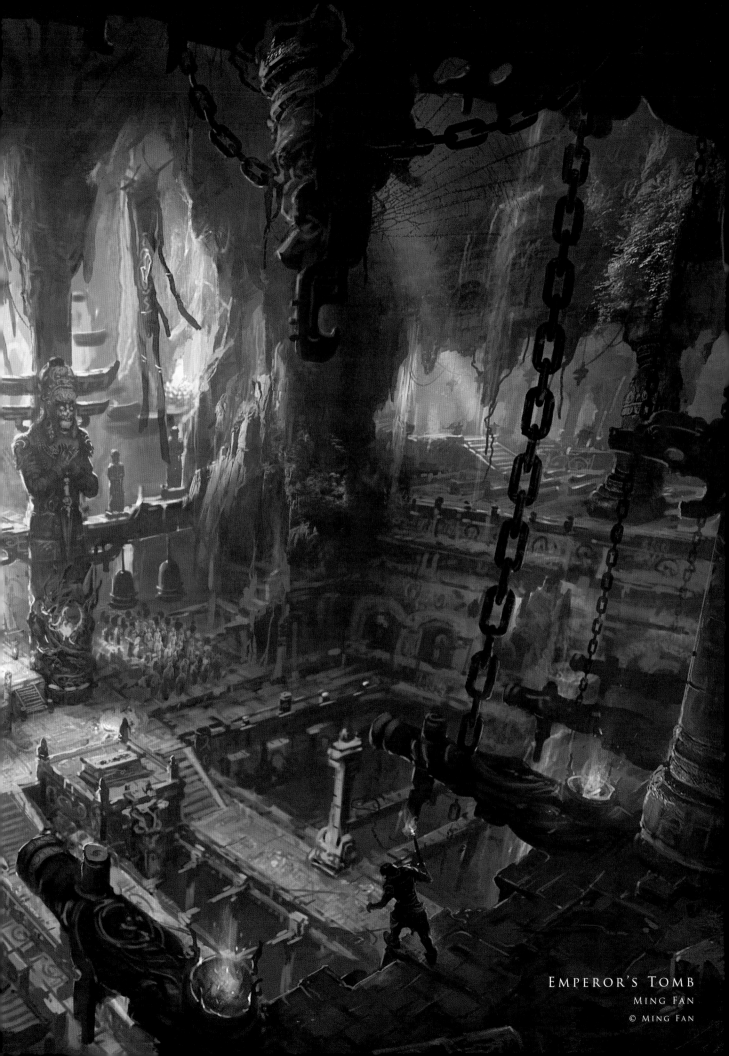

EMPEROR'S TOMB
MING FAN
© MING FAN

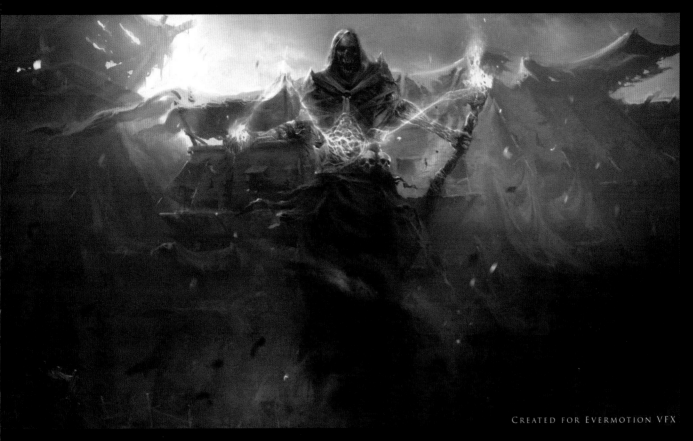

CREATED FOR EVERMOTION VFX

FATE 4
PIOTR JABŁOŃSKI
(ABOVE)

FATE 5
PIOTR JABŁOŃSKI
(BELOW)

THE KUNLUN MOUNTAINS

MING FAN

© MING FAN

© Piotr Jabłoński

Fog Town 2
Piotr Jabłoński
(Above)

LOST
Gerhard Mozs
(Below

© Gerhard Mozsi

CAVE TEMPLE
GERHARD MOZSI
(ABOVE)

A BRAVE NEW WORLD
ALEX FIGINI
(LEFT)

SPACESHIP
MICHAL LISOWSKI

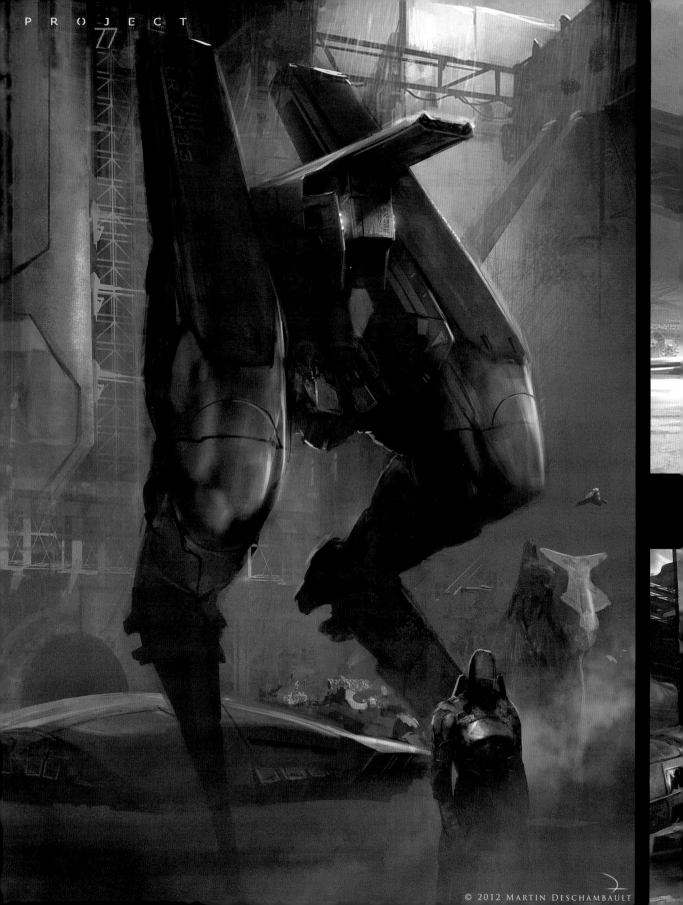

PROJECT

© 2012 MARTIN DESCHAMBAULT

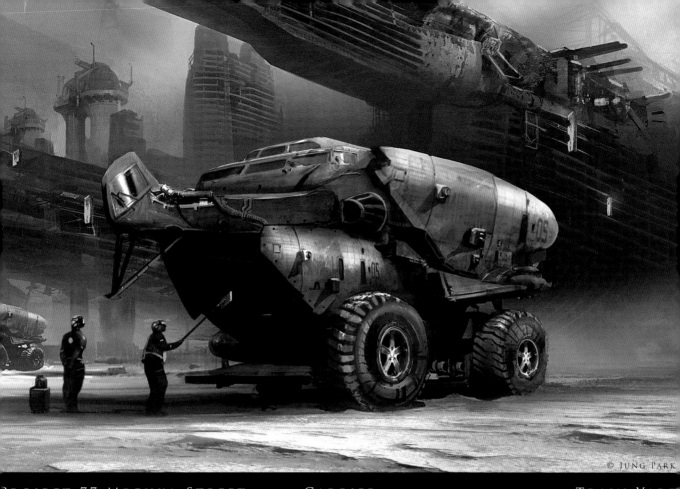

PROJECT 77 MECHKA STREET

MARTIN DESCHAMBAULT

(LEFT)

CARRIER

JUNG PARK

(ABOVE)

TRAIN YARD

JUNG PARK

(BELOW)

DIGITAL ART MASTERS

ZBrushCharacterSculpting

Projects, Tips & Techniques from the Masters

"Often you find a little information here or there about how an image was created, but rarely does someone take the time to really go into depth and show what they do, and more importantly why. This book contains clear illustrations and step-by-step breakdowns that bring to light the power of concepting directly in ZBrush, using it for full-on production work and using the software with other programs to achieve great new results."

Ian Joyner | Freelance Character Artist
www.ianjoyner.com

ZBrush has quickly become an integral part of the 3D modeling industry. *ZBrush Character Sculpting: Volume 1* explores the features and tools on offer in this ground-breaking software, as well as presenting complete projects and discussing how ZSpheres make a great starting point for modeling. Drawing on the traditional roots of classical sculpture, this book also investigates how these time-honored teachings can be successfully applied to the 3D medium to create jaw-dropping sculpts. Featuring the likes of **Rafael Grassetti**, **Michael Jensen** and **Cédric Seaut**, *ZBrush Character Sculpting: Volume 1* is brimming with in-depth tutorials that will benefit aspiring and veteran modelers alike.

This book is a priceless resource for:

- Newcomers to ZBrush and digital sculpting in general
- Artists looking to switch from a traditional medium
- Lecturers or students teaching/studying both traditional and digital modeling courses
- Hobbyists who want to learn useful tips and tricks from the best artists in the industry

Softback - 22.0 x 29.7 cm | 240 pages | ISBN: 978-0-9551530-8-2